Fra Angelico

Frontispiece:
SAINT LAWRENCE DISTRIBUTING ALMS.
Chapel of Nicholas V, Vatican.

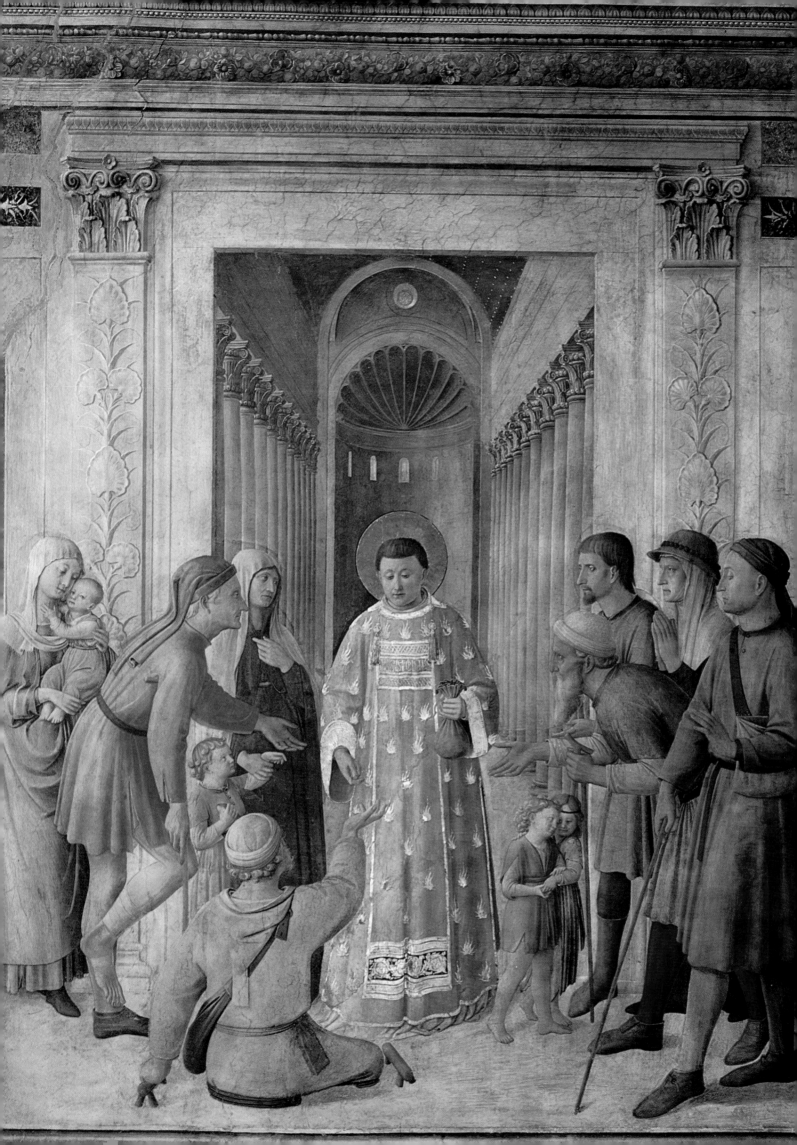

Fra Angelico

John Pope-Hennessy

Cornell University Press

ITHACA, NEW YORK

First published 1952
Second edition 1974
First published 1974 by Cornell University Press.

This edition is not for sale in the United Kingdom.

International Standard Book Number 0-8014-0855-5
Library of Congress Catalog Card Number: 74-9200

Text printed in Great Britain by Western Printing Services Ltd · Bristol
Plates printed by Cavendish Press Ltd · Leicester

CONTENTS

PREFACE TO THE SECOND EDITION

WHEN the first edition of this book appeared in 1952, I sent a copy of it to Bernard Berenson. 'Thanks for your Angelico,' he replied. 'It is full of fascinating heresies. Affectionately, B.B.' Heresy seemed to me rather a strong way of putting it. According to my dictionary, it meant 'opinion contrary to the accepted doctrine on any subject', and there was nothing heterodox about the book, save that in it an attempt was made to distinguish between works by Fra Angelico and works by members of his shop. My account of the artist was, by and large, conventional, and looking back on it after twenty years, my main criticism is that it was insufficiently unorthodox. From time to time I have been pressed by my publishers to reissue the book, but I refused to do so, since I feared that the revision would be no more than a defence of positions I had taken up. In 1972, however, I at last felt that it was possible to restudy the work of Fra Angelico objectively, as though I had not studied it before. The outcome is the present book.

I must say at once that I believe quite as firmly as I did when my monograph was published in the need to differentiate between the pictures Angelico painted and those that he did not. Accretions to an artist's work falsify the interpretation of his style and personality, and with Angelico the distortion factor is exceptionally large. I do not, however, stand by all the judgements I made previously, and the number of paintings credited to Zanobi Strozzi (a feature not only of my book but of antecedent criticism) seems to me much exaggerated. The changes in the present book result from a rethinking not simply of attributions, but of chronology and consequently of the painter's intellectual development. Today I regard Angelico as a more cerebral, more progressive artist than I thought him twenty years ago.

In two essential respects the data on which earlier judgements were founded have changed. In 1955, for the quincentenary of Angelico's death, an exhibition was held in Florence and Rome, and a start was made in stripping his pictures of the repaint that smothered them. This process has continued since. The *Last Judgment* in the Museo di San Marco has been cleaned, and so have the panels of the Annunziata silver chest, the great *Crucifixion* in the Sala del Capitolo at San Marco, the frescoes in the cloister, and many other works. More than that, the documentary background of Angelico's work has been re-examined by a Dominican scholar, Padre Stefano Orlandi, with very positive results. The first point that he cleared up was the date of Angelico's birth. According to Vasari, the artist was born in 1387, and received the Dominican habit in 1407 at the age of nineteen. Though universally accepted, these dates were difficult to reconcile with Angelico's surviving paintings. There were therefore two alternatives, artificially to extend his work back to the first decade of the fifteenth century (this expedient was adopted by Salmi, but even twenty years ago I recognised that it was wrong), or to admit that we knew no pictures painted by him before the fourteen-twenties. Padre Orlandi proved that Angelico joined the Dominican Order a good deal later than had been thought, in 1419 or 1420, and was born about 1400.

Vasari's Angelico was a contemporary of Masolino, Orlandi's was a contemporary of Masaccio. Angelico was thus moved bodily from one side to the other of the great psychological chasm that runs through Tuscan Early Renaissance painting. Of the other publications of which account is taken in this book the most important are those of Dr. Luciano Berti on Angelico as a miniaturist, of Dr. Umberto Baldini on the reconstruction of the predella of the San Marco altarpiece, of Dr. Casalini on the doors of the Annunziata silver chest, and of Professor Ulrich Middeldorf on Angelico's relations with Ghiberti.

1973 JOHN POPE-HENNESSY

INTRODUCTION

THE HISTORY of fifteenth-century Florentine art opens with an anomaly, that Renaissance style appears in painting later than it does in sculpture. At a time when the first of Ghiberti's bronze doors for the Baptistry was all but finished, and Donatello's *Saint Mark* and *Saint George* were already installed on Or San Michele, the norm of sacred painting remained the etiolated symbols of Late Gothic art. Not till the middle of the fourteen-twenties was it appreciated that the way lay open to a type of painting which was physically more convincing and might, as a didactic instrument, prove more potent and more purposeful. Initially two religious orders, and two only, recognised this possibility. The first were the Carmelites, who commissioned for their cloister a realistic fresco by Masaccio of a contemporary event and then authorised the painting of religious scenes in the same style in a chapel in the transept of their church. The second were the Dominicans, whose mouthpiece was Fra Angelico.

The Dominican rule, like the rules of other religious orders, was open to a number of different interpretations. In the last years of the fourteenth century the tendency towards reform, that is towards a stricter and more literal interpretation of its provisions, had taken shape in the movement known as the Dominican Observance. The originator of the Observant movement was Raymond of Capua, the confessor of Saint Catherine of Siena, and its leader was his disciple, the preacher Giovanni Dominici. With the return of Dominici to Central Italy from his apostolate in Venice, the vogue of the Observant movement spread, and the number of recruits whom it attracted became greater than the reformed houses at Città di Castello and Cortona could absorb. In 1405 the Dominican Bishop of Fiesole made available to the Observants a vineyard beneath the town, and here there rose the new foundation of San Domenico. A year later, with thirteen companions, Dominici took possession of the convent. Angelico may have had no direct contact with Dominici, but his teachings, perpetuated in the *Lucula Noctis* and the *Trattato della santa carità*, determined the intellectual climate of San Domenico, and through them and through one of his disciples, Antonino Pierozzi, the future Sant'Antonino (who joined the Order in 1405, and was Prior of San Domenico at Fiesole in 1422–4 and 1425–6), he exercised an oblique influence over Angelico's development.

Dominici's most important work, the *Lucula Noctis*, is a defence of traditional spirituality against the onslaughts of the humanists. Let the Christian cultivate the soil rather than study heathen books; let him read not the poetry of antiquity but 'the Holy Writ, in which the Lord has laid out the true poetry of wisdom, and the true eloquence of the spirit of truth'. Let those who have charge of the young remember that 'Christ is our only guide to happiness . . . our father, our leader, our light, our food, our redemption, our way, our truth, our life'; let them recall that 'as the years of tender youth flow by, the soft wax may take on any form. Stamp on it the impress not of Narcissus, Myrrha, Phaedra or Ganymede, but of the crucified Christ and of the Saints.' Let

1

them, above all, propagate the faith, through which the Christian is permitted year by year to warm his frozen mind before the crib. Two aspects of Dominici's thought are of special importance for an understanding of the paintings of Angelico. The first is his fear of rhetoric. 'The beautiful form of the poem', he writes, 'is like clothing. The body is worth more than the clothes which cover it, and the soul worth more than both.' The second is his rejection of personal revelation, that concomitant of mysticism. Whereas Savonarola, with his belief in the validity of individual visions, was to inculcate a personal religious imagery in the artists he inspired, the painting produced under the aegis of Dominici was the expression of collective, not of individual, mystical experience.

The thinking of Dominici was given an aesthetic focus by Sant'Antonino, for whom the duty of artists ('il loro dovere') was moral enlightenment. They betrayed their talent if they created 'precocious images, like naked women and similar things, depicted for their forms not for their beauty', and in the province of religious art they were beholden to avoid 'things that are curious and ill adapted to excite devotion, but tend on the contrary to promote laughter and vanity'. Never should they have recourse to physically unconvincing symbolism—the Trinity, for example, should not be represented with three heads, nor should paintings of the Annunciation include a figure of the Child Christ—and the presence of superfluous figures and redundant decoration must be eschewed. Sant'Antonino was, moreover, conscious of the factor of quality in works of art. Painters, he declared, might, as the price of their labour, justly claim a larger or a smaller sum, in the ratio of the quantity of work they executed and of their industry and skill. Translated into positive terms, these principles postulate a type of painting that is recognisably related to the art Angelico evolved, an ideal style distinguished for its naturalness but not debased by realism, in which religious scenes, reduced to their essential content, were portrayed in natural or man-made settings that would enhance their credibility.

Soon after his death, Angelico figures in the *De Vita et Obitu B. Mariae* of the Dominican, Domenico da Corella, as 'Angelicus pictor . . . Iohannes nomine, non Jotto, non Cimabove minor', and later in the century he is mentioned in a celebrated rhymed poem by Giovanni Santi between Gentile da Fabriano and Pisanello, and alongside Fra Filippo Lippi, Pesellino and Domenico Veneziano, as 'Giovan da Fiesole frate al bene ardente'. But with the advent of Savonarola, for whom art was a means of spiritual propaganda, there developed a new attitude towards painting; and after Savonarola's heroic death, his followers adopted Angelico, the friar artist, as the pivot around which their theories could revolve. Already in the first narrative account of the artist's life, a brief biography included in a volume of Dominican eulogies published by Leandro Alberti in 1517, is implicit the case that was formulated in the nineteenth century: that Angelico's superior stature as an artist was due to his superior stature as a man. Alberti's eulogy was one of the sources drawn on by Vasari when in 1550 he printed the first formal life of Fra Angelico. Another source was a Dominican friar, Fra Eustachio, who had received the habit from Savonarola, and who, as a man of almost eighty, transmitted to Vasari the conventual legends woven round the artists of San Marco. A fellow Dominican, Timoteo Bottonio, tells us how Vasari 'used often to come to gossip with this old man, from whom he obtained many beautiful details about these old illustrious artists'. From these and other sources Vasari built up his life. 'Fra Giovanni', he writes, 'was a simple man and most holy in his habits. . . . He was most gentle and temperate, living chastely, removed from the cares of the world. He would often say that whoever practised art needed a quiet life and freedom from care, and that he who occupied himself with the things of Christ ought always to be with Christ. . . . I cannot bestow too much praise on this holy father,

2

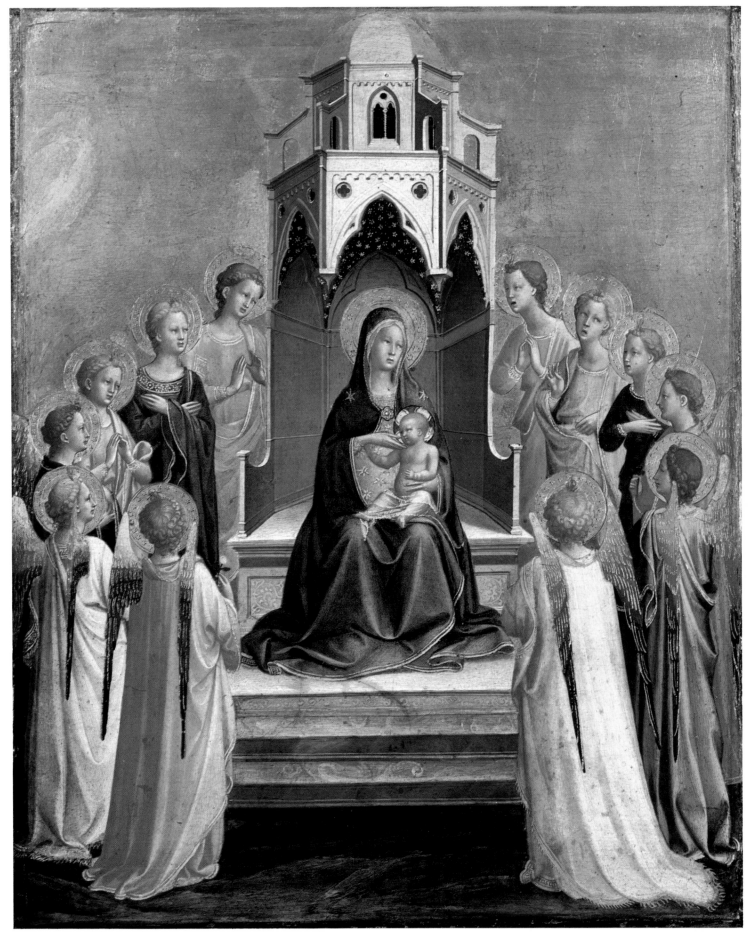

VIRGIN AND CHILD ENTHRONED WITH TWELVE ANGELS. Staedel Institute, Frankfurt-am-Main.

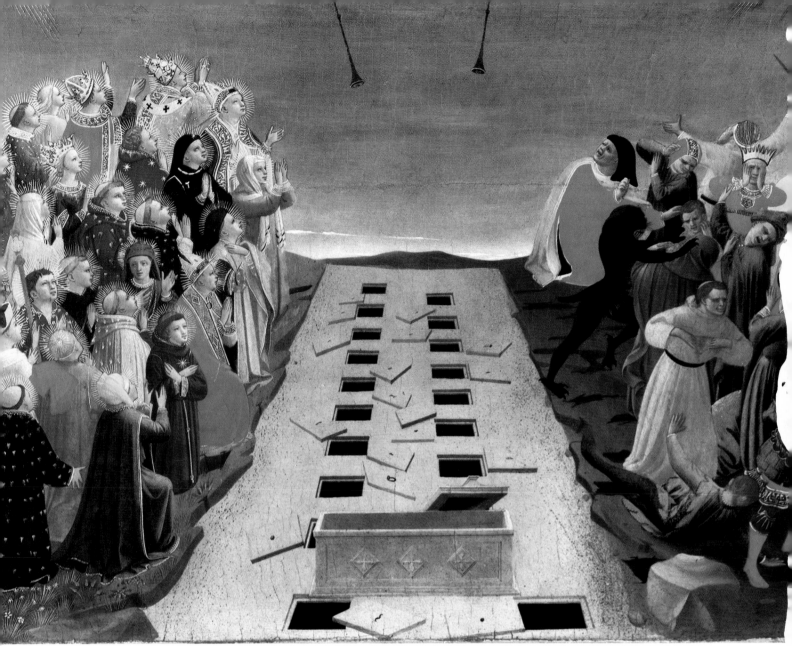

THE ELECT AND THE CONDEMNED. Detail from *The Last Judgment* (Fig. 2). Museo di San Marco, Florence.

who was so humble and modest in all his works and conversation, so fluent and devout in his painting, the saints by his hand being more like those blessed beings than those of any other. He never retouched or repaired any of his pictures, always leaving them in the condition in which they were first seen, believing, so he said, that this was the will of God. Some say that Fra Giovanni never took up his brush without first making a prayer. He never made a Crucifix when the tears did not course down his cheeks, while the goodness of his sincere and great soul in religion may be seen from the attitudes of his figures.' In the mouths of nineteenth-century commentators Vasari's words take on a romantic overtone. 'On peut dire de lui', runs a celebrated passage in Rio's *De l'Art Chrétien*, 'que la peinture n'était autre chose que sa formule favorite pour les actes de foi, d'espérance et d'amour; pour que sa tâche ne fût pas indigne de celui en vue duquel il l'entreprenait, jamais il ne mettait la main à l'oeuvre sans avoir imploré la bénédiction du ciel, et quand la voix intérieure lui disait que sa prière avait été exaucée, il ne se croyait plus en droit de rien changer au produit de l'inspiration qui lui était venue d'en haut, persuadé qu'en cela comme dans tout le reste il n'était que l'instrument de la volonté de Dieu. Toutes les fois qu'il peignait Jésus-Christ sur la croix, les larmes lui coulaient des yeux avec autant d'abondance que s'il eut assisté à cette dernière scène de la passion sur le Calvaire.'

This reliance upon inspiration, these empathetic tears, these acts of faith have been recounted by many writers since the time of Rio. Such stories still fulfil the purpose for which they were designed, that of commending the artist's work to simple-minded people in search of spiritual nourishment. They have no contemporary sanction, but they should not be disregarded on that account. As William James reminds us, 'many saints . . . have possessed what the church traditionally reveres as a special grace, the gift of tears. In these persons the melting mood seems to have held almost uninterrupted control.' This may have been the case with Fra Angelico. Only once, in a polyptych at Cortona where the underpainting was temporarily exposed, can the relation of the initial image to the finished work be judged. The underpainting lends some substance to Vasari's claim that Angelico did not retouch or modify his paintings, though whether this was due to belief in divine guidance or to preternatural manual precision is problematical. What cannot be denied is that the golden thread of faith runs through his work. There is no painter whose images are more exactly calculated to encourage meditation and to foster those moral values which lie at the centre of the spiritual life.

If all this be conceded, the fact remains that Fra Angelico, in conventional, lay terms, and for reasons largely unrelated to the devotional content of his work, was a great artist. The factor of exact aesthetic calculation is present in his paintings from the start, and if we compare his early and late altarpieces, the differences between them prove to be greater than those between the early and late works of any other Early Renaissance painter. The concept of pictorial space and the means by which it is established, the structure of the figures, the system of illumination, the interpretative content, one and all have been transformed. How then should we account for this development? One way of doing so is to assume that Fra Angelico, sealed off in his convent at Fiesole, was an imitative artist. Though we may not subscribe to the equation between devotion and simple-mindedness, it is all too easy to fall back on an alternative equation between devotion and passivity. This leaves us with a painter who learned slowly to master structural principles established by minds more adventurous and more speculative than his own. Any such reading runs counter to the chronology of the artist's work. The evidence of style is in the opposite sense, that Angelico was in the van of progress, and that the nature of his innovations was determined by the purpose his paintings were intended to perform.

Precisely for this reason, special importance attaches to the task of isolating those paintings for whose design or execution he was personally responsible. With most painters this can be achieved comparatively easily, but with Angelico the process is exceptionally difficult. In his own life-time he was regarded as a major artist, but he had a secondary role as a maker of religious artefacts, which were of value as aids to prayer or signposts to the good life. At Fiesole, therefore, there was an incentive towards productivity, and from quite an early time Angelico's studio seems to have been geared to the production of collaborative works. These could take many forms. They could be manuscripts, where the figure illuminations were distributed between Angelico and an unidentified assistant. They could be panels with innumerable little figures which were painted partly by Angelico and partly by studio hands. They could be whole altarpieces, like the *Annunciation* for San Domenico, now in the Prado (Fig. 10), which Angelico may have drawn out but which were realised by assistants. Collaborative activity was an accepted practice among illuminators, and the phenomenon with which we are confronted at Fiesole is the transfer of this practice to panel painting.

In this matter we can adopt one of two attitudes. The first, the line of least resistance, is to accept all the paintings produced in Angelico's orbit as works by Fra Angelico. In favour of doing so we have the doubtful argument of historicity; this is what people in the middle and second half of the fifteenth century would themselves have done. The second is to endeavour to define Angelico's share in the whole oeuvre. So far as can be judged from the completed panels, he worked relatively slowly, drawing his figures meticulously on the priming, and practising a style in which, effectively, there were no short cuts. In distinguishing figures painted by Angelico from figures painted by assistants from Angelico's cartoon the guideline is that of quality, and the margin of error may well be considerable. Where certainty is more nearly attainable is in respect of the designing of the panels, since there is abundant evidence for Angelico's compositional procedure in uncontested works. When, for example, we are told that Angelico painted a *Virgin and Child with two Angels* at Rotterdam (Fig. 101), or a *Virgin and Child with four Angels* at Leningrad, or a panel of the *Penitence of Saint Julian* at Cherbourg (Fig. 68), or the *Scenes from the Legend of Saints Cosmas and Damian* from the predella of the Annalena altarpiece (Fig. 37), we can object that they are one and all constructed in a way for which the authenticated panels offer no parallel, and that the attributions for this reason must be wrong. The principal area of doubt is that surrounding a number of minor paintings which at worst were made under the master's supervision and at best are by his hand. 'Stupisce come un'opera di così alta qualità sia relegata fra le cose apocrife,' writes an Italian scholar of one of these. To which we must reply that all that glisters is not by Fra Angelico.

LIFE

THE artist whom we know as Fra Angelico and who was known to his contemporaries as Fra Giovanni da Fiesole, was born in the Mugello in the vicinity of Vicchio, probably at San Michele a Ripecanina.[1] His Christian name was Guido, and he was still a layman on 31 October 1417, when, as 'Guido di Piero dipintore del popolo di santo Michele bisdomini,' he was proposed by a fellow artist, the miniaturist Battista di Biagio Sanguigni, for membership of the Compagnia di San Niccolò in the church of the Carmine in Florence.[2] He is thus likely to have been born between 1395 and 1400, roughly ten years later than is indicated by Vasari. In January and February 1418, again as Guido di Piero, he was paid for an altarpiece for the Gherardini chapel in Santo Stefano al Ponte in Florence.[3] The decoration of the chapel, like that of two earlier chapels in Santo Stefano, had been entrusted to Ambrogio di Baldese,[4] and in the absence of other evidence it is tempting to suppose that Angelico was trained in Ambrogio di Baldese's workshop, and was initiated into miniature illumination by Sanguigni. Not till June 1423 does his name occur in the familiar form 'frate Giovanni di San Domenico di Fiesole', in connection with a painted Crucifix for the hospital of Santa Maria Nuova.[5] During the first year of his novitiate he would have been prohibited from painting, and he must therefore have joined the community of San Domenico between 1418 and 1421.[6] An entry in the sixteenth-century chronicle of San Domenico reporting that 'Fr. Johannes Petri de Mugello iuxta Vichium, optimus pictor, qui multas tabulas et parietes in diversis locis pinxit' received the Dominican habit has wrongly been construed as proving that the artist was received into the Order in 1407 and was professed in 1408.[7] Angelico's brother, Fra Benedetto di Piero del Mugello, who was active as a scribe, entered the Dominican Order during the fourteen-twenties, and was ordained priest in September 1429.[8]

The first document that can be connected with a surviving painting refers to a sum due to the community of San Domenico for an altarpiece executed for the convent of San Pietro Martire in Florence (Fig. 3; Plates 11–12). The record dates from 30 March 1429, and the painting is now in the Museo di San Marco.[9] On 22 October 1429 'frate Johannes petri de Muscello' was present at the capitular reunion of the brethren of San Domenico; he attended other capitular reunions in January 1431 and December 1432, in January 1433, when he was Vicario of the convent in the absence of the Prior, and in January 1435.[10] In 1432 a payment of nine ducats was made by the

1. Orlandi, 1964, pp. 3–6. According to the *Chronica quadripartita* of San Domenico di Fiesole, f. 97v., Angelico was born 'de Mugello iuxta Vicchium'.
2. W. Cohn, in *Rivista d'Arte*, 1955, reprinted by Orlandi, 1964, p. 169, Doc. I.
3. W. Cohn, in *Memorie Domenicane*, lxxiii, 1956, pp. 218–20, reprinted in full by Orlandi, 1964, p. 169, Doc. II. The payments are for sums of 5 florins on 28 January 1418 and 7 florins on 15 February of the same year.
4. The painting of the chapel was commissioned from Ambrogio di Baldese on 17 August 1413, was begun in 1415, and was completed by 6 April 1417. The commission for the altarpiece is likely to date from after this time. For a summary of the relevant documents see Orlandi, 1964, p. 8.
5. W. Cohn, loc. cit., reprinted by Orlandi, 1964, p. 173, Doc. VII: 'A frate Giovanni de' frati di san Domenicho da fiesole per dipintura d'una croce fine del giugnio 1423 lire dieci.'
6. Orlandi, 1964, p. 18.
7. Orlandi, 'Beato Angelico: note cronologiche', in *Memorie Domenicane*, lxxii, 1955, pp. 4–8, with a useful analysis of the relevant passages in the *Chronica quadripartita* of Tolosani (begun 1516).
8. Orlandi, 1964, pp. 183–4, Doc. XI.
9. Orlandi, 1955, p. 23, Doc. I: 'Monasterium sancti petri martiris adhuc tenetur dare de pictura tabule sue ff. x vel circa.'
10. Orlandi, 1955, pp. 23–5, Doc. II, III.

church of Sant'Alessandro at Brescia for a painting of the *Annunciation* 'fatta in Fiorenza, la quale depinse Fra Giovanni', of which two ducats represented the cost of gold 'quali hebbe Fra Giovanni —Giovanni de' Predicatori da Fiesole—per dipingere la tavola'.[11] A year later, in July 1433, Angelico received a major commission in Florence, for the great triptych for the guild-hall of the Arte dei Linaiuoli (Plates 24–31; Fig. 15).[12] This is the first painting by the artist whose planning can be assigned to a specific year on documentary grounds. There is no evidence of the date at which the triptych was completed, but we know that three years later, in 1436, a much smaller and less ambitious painting, the *Lamentation over the dead Christ* in the Museo di San Marco (Plates 46–47; Fig. 25), was commissioned for the oratory of the Compagnia del Tempio in mid-April and was finished after seven months.[13] Throughout this time Angelico's clerical status was no impediment to his fulfilling the obligations of a secular artist, and on 14 January 1434 we find him acting as assessor jointly with the Late Gothic painter Rossello di Jacopo for a painting produced by Bicci di Lorenzo and Stefano d'Antonio for San Niccolò Maggiore.[14] On two occasions in these years, the first in 1434 and the second in 1436, he was responsible for negotiating interest-free loans from the convent of San Domenico to 'Martino di Giovanni da Moriano nel Mugello' and his son Antonio, a maker of furniture or boxes (*cofanaio*) in Florence. It has been inferred that the recipients of these loans were members of his family.[15]

In 1435 a body of friars from the community at San Domenico took possession of the Florentine church of San Giorgio sulla Costa, and a year later, in January 1436, they were confirmed in the possession of the premises of San Marco, where, in 1438, the building of a new convent by Michelozzo was begun. Angelico was not among the friars who moved to San Giorgio sulla Costa in 1435 or to San Marco in the following year, but remained on as Vicario at Fiesole.[16] The first evidence of his presence at San Marco dates from 22 August 1441.[17] He attended a capitular meeting of the two communities in August of the following year,[18] and in July 1445 signed the act separating the community at San Marco from that at San Domenico in the form: 'Ego frater Joannes de florencia assencio omnibus supradictis in cujus testimonium me manu propria subscripsi.'[19] The probable inference is that Angelico retained his workshop at San Domenico till after 1440, when the painting of the high altarpiece for San Marco (Plate 48) was well advanced and the frescoed decoration of the convent was begun, and thereafter transferred it to San Marco. In 1443 he was 'sindicho' of the convent, a post which seems to have involved some measure of financial control.[20]

At an uncertain date, probably in the second half of 1445, Angelico was summoned to Rome by Pope Eugenius IV, who had lived in Florence for some years and was familiar with his work. During the summer of that year the archbishopric of Florence became vacant, and in August a

11. See p. 237.
12. See pp. 194–5.
13. Orlandi, 1955, pp. 31–3, Doc. IX, and 1964, pp. 187–8, Doc. XVII.
14. W. Cohn, 'Maestri sconosciuti del Quattrocento fiorentino', in *Bollettino d'Arte*, 1959, p. 67, reprinted by Orlandi, 1964, p. 53.
15. These documents are printed and analysed by Orlandi, 1964, pp. 3–5 and 174–9, Doc. VIII, and 187, Doc. XV, XVI.
16. Orlandi, 1955, pp. 26–7, Doc. III.

17. Orlandi, 1955, p. 29, Doc. VI. In this same year a reference is made in the will of Guglielmina degli Albizzi, mother of a Dominican friar, Fra Alessio degli Albizzi, to 'domine Checche sorori fratris Johannis pictoris et fratris benedicti ordinis observantie sancti dominici de fesulis', a sister of the artist (for this see Orlandi, 1955, pp. 28–9, Doc. V).
18. Orlandi, 1955, pp. 29–30, Doc. VI.
19. Orlandi, 1955, pp. 33–5, Doc. X.
20. Orlandi, 1955, p. 30, Doc. VII.

number of names were recommended by the Signoria to the Pope. One of them was a member of the Medici family, Donato de' Medici, Bishop of Pistoia, another was a subdeacon and canon of the Cathedral in Florence, Giovanni di Neroni di Nisio, a third was the Bishop of Fiesole, Benozzo Federighi, a fourth was the Bishop of Volterra, Roberto Cavalcanti, and a fifth was the secretary of the Signoria, Canonico Andrea. For one reason or another the Pope disallowed these candidates, and six months later, on 9 January 1446, he appointed Fra Antonino Pierozzi, then Vicar of San Marco, as Archbishop. There is a persistent tradition first that before this decision was made, the archbishopric was offered to Angelico, and second that Angelico was instrumental in securing the appointment of Fra Antonino. When the process for the canonisation of Fra Antonino was under way in the first quarter of the sixteenth century, no less than six witnesses affirmed that this was so. Typical of this testimony is that given by Raffaelle del fu Antonio Ubaldini in 1516, that 'quod dici audivit quod fuit assumptus testimonio opera et intercessione cuiusdam fratris Johannis pictoris ord. pred. qui in eo tempore [erat] apud Ponteficem maximum.'[21] There is no way of telling whether these statements should be given credence, but the fact that little more than half a century after his death the view entertained of Fra Angelico was of a man capable of administering an archdiocese and of tendering advice on the appointment to the Pope must be reflected in the judgements that we form of his intellectual capacity.

Angelico remained in Rome through 1446 and 1447 (when he was also active during the summer months in the Cathedral at Orvieto), returning to Florence at the end of 1449 or the beginning of 1450. By 10 June 1450 he was Prior of San Domenico at Fiesole (where he succeeded his brother, Fra Benedetto di Piero del Mugello, who had died earlier in the year).[22] He retained the post for the normal two-year period, and was still living at Fiesole in March 1452, when, according to the account books of the Duomo at Prato, the Provveditore of Prato Cathedral came to Florence bearing a letter to Sant'Antonino requesting that 'frate Giovanni da Fiesole maestro di dipignere' should undertake the painting of the choir of the Cathedral. Eight days later the Provveditore again visited Florence, this time to interview the painter, who agreed to return with him to Prato to discuss the proposal with four deputies of the Cathedral and the Podestà. On the following day horses were hired to take 'el Frate che dipigne' to Prato and back to Fiesole. For reasons we can no longer reconstruct these conversations were inconclusive. On 1 April Angelico returned to Fiesole, and on 5 April the Provveditore was once more in Florence, seeking a painter and master of stained glass to decorate the choir. This time his quest was successful, and the contract for the frescoes was awarded to Fra Filippo Lippi.[23]

After the Prato negotiations Fra Angelico disappears from view. He is mentioned on 2 December 1454, when it was prescribed that frescoes carried out in the Palazzo dei Priori at Perugia should be assessed either by him, or by Fra Filippo Lippi, or by Domenico Veneziano, that is by

21. The best analysis of the evidence is that of Orlandi, 1964, pp. 85–9 and 190–2, Doc. XVIII.

22. Orlandi, 1964, pp. 114–16, has shown that on 27 March 1450 the communities of San Marco and San Domenico were both administered by Vicars, Fra Benedetto di Piero del Mugello, who had been elected Prior of San Domenico in 1445 on the separation of the two communities, having died earlier in the month. The first reference to Angelico's appointment occurs in a valuation of miniatures by Zanobi Strozzi 'sechondo la stima di frate Giovanni dipentore priore del chonvento di Fiesole', at one time referred to 20 September 1448 but later redated to 1450. Angelico presided at a capitular reunion at Fiesole on 10 June 1450. He is also mentioned as Prior in payments of 11 February and 23 October 1451.

23. Marchese, *Memorie dei più insigni Pittori, Scultori e Architetti domenicani*, 1878, i, p. 562.

one of the three living Florentine painters who were most widely admired.[24] In 1453 or 1454 he is thought to have gone back to Rome, but if he did so there is no indication of the work on which he was employed. He died in Rome in February 1455, a few weeks before his patron Pope Nicholas V. The little information that we have about his death comes from the *Chronica Magistrorum generalium Ordinis Praedicatorum* of Girolamo Borselli. It reads as follows:

> A.D. 1455. F. Johannes de Fesulis, in sanctitate devotus, et pingendi arte peritissimus, hoc anno obiit XVIII februarilis sepultus in ecclesia sancte Marie super Minervam Ordinis nostri, ad dexteram partem capelle S. Thome de Aquino in sepulcro marmoreo super terram cum eius ymagine in ipso marmore sculpta. In hujus sepulcro incribi fecit Nicolaus papa quintus, duo epitaphia: unum super sepulchrum in pariete aliud in ipso sepulcro.

The epitaphs for his tomb in the Dominican church of Santa Maria sopra Minerva were reputedly written by the humanist Lorenzo Valla. That on the wall, now lost, read:

> The glory, the mirror, the ornament of painters, Giovanni the Florentine is contained within this place. A religious, he was a brother of the holy order of St. Dominic, and was himself a true servant of God. His disciples bewail the loss of so great a master, for who will find another brush like his? His fatherland and his order lament the death of a consummate painter, who had no equal in his art.[25]

On the marble tomb-slab the body of the painter is shown in his habit in a Renaissance niche (Plate 143); beneath his feet is a second inscription:

> Here lies the venerable painter Fra Giovanni of the Order of Preachers. Let me not be praised because I seemed another Apelles, but because I gave all my riches, O Christ, to Thine. For some works survive on earth and others in heaven. The city of Florence, flower of Etruria, gave me, Giovanni, birth.[26]

24. A. Mariotti, *Lettere pittoriche perugine*, 1788, p. 132, reprinted by Orlandi, 1964, p. 128: 'Et piu volemo che fornito e sopradicto lavoro, se deggia stimare per uno di queste tre Maiestre, cioe o 'l frate del Carmine, o maestro Domenico da Vinegia, o el frate da Fiesole . . . doy de Decembre MCCCCLIIII.'

25. GLORIA PICTORVM SPECVLVMQVE. DECVSQVE JOANNES. VIR FLORENTINVS. CLAVDITVR HOCCE LOCO. RELIGIOSVS ERAT FRATER SACRI ORDINIS ALMI DOMINICI AC VERVS. SERVVLVS IPSE DEI. DISCIPVLI PLORENT. TANTO DOCTORE CARENTES. PENNELI SIMILEM. QVIS REPERIRE QVEAT. PATRIA ET ORDO. FLEANT SVMMVM PERIISSE MAGISTRVM PINGENDI SVI PAR. NON ERAT ARTE SVA.

26. NON MIHI SIT LAVDI QVOD ERAM VELVT ALTER APELLES SED QVOD LVCRA TVIS OMNIA CHRISTE DABAM ALTERA NAM TERRIS OPERA EXTANT ALTERA CAELO VRBS ME IOANNEM FLOS TVLIT ETRVRIAE.

EARLY WORKS: 1418–32

T H E earliest datable painting by Fra Angelico is a triptych in the Museo di San Marco (Plates 11–12, Fig. 3), which was installed on the high altar of the convent church of San Pietro Martire in Florence before March 1429 and was probably completed in the preceding year. In the central panel the Virgin is seated on a gold-brocaded stool in front of a gold curtain, with the Child standing on her lap. Her body is not set frontally, but is slightly turned, with the right knee thrust forwards in the centre of the panel. Her heavily draped cloak is illuminated from the left, and the light falls on the orb held in the Child's left hand and on his raised right arm. No concession is made to decoration save in the gold-brocaded curtain behind the group, in the lion's feet beneath the stool, and in the edging of the Virgin's cloak, which is caught up at the bottom in a number of small folds.

Though a triptych, this is a reluctant triptych in that the step beneath the Virgin's seat intrudes into the panels at the sides and the marble pavement at the sides extends into the central panel. That this was a purposive and not a casual device is proved by the four lateral Saints. As in a conventional triptych their heads lie on a common horizontal, but the two outer Saints stand slightly forward of those adjacent to the throne, and two of them, Saint John the Baptist on the left and Saint Thomas Aquinas on the extreme right, reveal, even more markedly than the central group, a concern with volume and plasticity. Both in the Virgin and the Baptist a debt to Masaccio is apparent, but the Masaccio whom they recall is the artist of the *Virgin and Child with Saint Anne*, not of the Pisa polyptych or the Brancacci Chapel.

An unusual feature of the altarpiece is that the area between the finials is filled with narrative scenes. They represent on the left Saint Peter Martyr preaching and on the right the death of Saint Peter Martyr (Plates 12a–b), and are unified at the back by a curved line of trees which is continued in two panels at the sides. Their date and attribution have been questioned on more than one occasion—they have been regarded as accretions to the triptych by an imitator of Angelico, perhaps Benozzo Gozzoli—but they must from the outset have formed an integral part of the painting, and their style is wholly consistent with that of the figures beneath. They are treated with emphatic rectangularity, almost as though they were excised from two square panels. The firm drawing of the pulpit and of the adjacent buildings in the *Preaching of Saint Peter Martyr* and the triangular formulation of the figures of the assassin and the slain Saint anticipate the style of Angelico's predella panels in the early fourteen-thirties. The views of the deserted forest at the sides offer an intimation of the part that nature was to play throughout his work. The presumed predella of the altarpiece, at the Courtauld Institute Gallery in London (Fig. 4), contains seven roundels with single figures. The central roundel, with the vertical body of Christ in a horizontal tomb flanked by the uprights of the sponge and lance, has a close parallel in a book illuminated by Angelico about this time.

There is no evidence in the Saint Peter Martyr triptych of a connection with Lorenzo Monaco, and the approach of the two artists to book illumination was antithetical. At Santa Maria degli Angeli a cursive miniaturist's style was transferred by Lorenzo Monaco to panel painting; at San Domenico the opposite occurred, and the only illuminated volume by Fra Angelico we know, a Missal at San Marco (No. 558) made for Fiesole about 1428–30, shows that he was unresponsive to the decorative demands of book illumination. Thus in the *Annunciation* (c. 33v.) (Plate 13) the Virgin looks up at the Angel, who floats down towards her from the right, as though she were oblivious of the illuminated letter that impedes her view, while from the top of the

initial a foreshortened God the Father drops the Holy Ghost on a gold cord plumb over her head. In a splendid page with the *Glorification of St. Dominic* (Plate 14) five circles protrude from the initial I, four of them filled with solidly modelled Saints, and the fifth with the scene of the *Meeting of St. Francis and St. Dominic*, treated with the weight of a small panel painting. At the top in a mandorla is the figure of St. Dominic accompanied by four flying angels, whose heads and bodies are lit with the same consistency as the figures in the triptych from San Pietro Martire. The most monumental of the miniatures is *The Virgin as Protectress of the Dominican Order* (c. 73v.), where the upper part of the initial S is filled by a frontal figure of the Virgin with arms outstretched, while below five kneeling Dominicans are grouped round the pink column of her robe. A number of the miniatures in the San Marco Missal were executed by a second hand (Fig. 6), weaker than that of Angelico but working essentially in the same style. It has been suggested that this second artist is the miniaturist Zanobi Strozzi, but we have no evidence for Strozzi's style at so early a time—his first documented miniatures date from 1446—and it is preferable to regard the second hand as that of an unidentified assistant of Angelico. The significance of his presence in the workshop transpires very clearly from the subsidiary parts of other early paintings for which he was responsible.

In 1428, when the Saint Peter Martyr triptych was executed, Angelico had been active as a painter for upwards of eleven years. The sequence of his works during that time is, and in the absence of further documents is likely to remain, a matter of hypothesis. The most important of them is an altarpiece for San Domenico (Fig. 1). In 1418, when the Observant community returned to Fiesole after nine years of exile at Foligno and Cortona, the church and convent of San Domenico were re-endowed under the will of a rich merchant, Bernabò degli Agli, whose patron Saint, St. Barnabas, was associated with the dedication of the church. A condition of this gift was that the convent should be rendered habitable within two years. On historical grounds, therefore, the altarpiece painted by Angelico for the high altar could have been painted at any time between 1418 and the dedication of the church in October 1435, but in practice it must date from the middle of the fourteen-twenties, three or four years before the painting of the triptych for San Pietro Martire. Some seventy-five years after it was finished, it was transformed by Lorenzo di Credi into a Renaissance altarpiece in which the Virgin is shown beneath a baldacchino and the Saints stand in an architectural setting before a landscape. The original form is legible from the front of the painting, and from the back it can be confirmed that it consisted, like the Saint Peter Martyr triptych, of three Gothic panels, that in the centre containing the Virgin and Child enthroned with angels (Plate 1), and those at the sides with Saints Thomas Aquinas and Barnabas on the left and Saints Dominic and Peter Martyr on the right (Plates 2–3). It was completed with a predella, now in the National Gallery, London, showing the Risen Christ adored by saints, prophets, angels and members of the Dominican Order (Plates 4–5), and with ten pilaster panels, four of which, two in the Musée Condé at Chantilly and two in a private collection (Plates 6–7), survive. Presumably the framing followed the form of the Saint Peter Martyr triptych, and included medallions of the Virgin Annunciate and Annunciatory Angel in the gables of the lateral panels and a God the Father above the Virgin and Child; the former have been identified with two small paintings formerly in the Tucher collection (Fig. 100). A painted tabernacle, now in the Hermitage at Leningrad, is closely related to the London predella, and seems to have stood under the altarpiece.

A decisive argument in favour of the view that the altarpiece precedes and does not, as is frequently assumed, follow the Saint Peter Martyr triptych is afforded by the space representation.

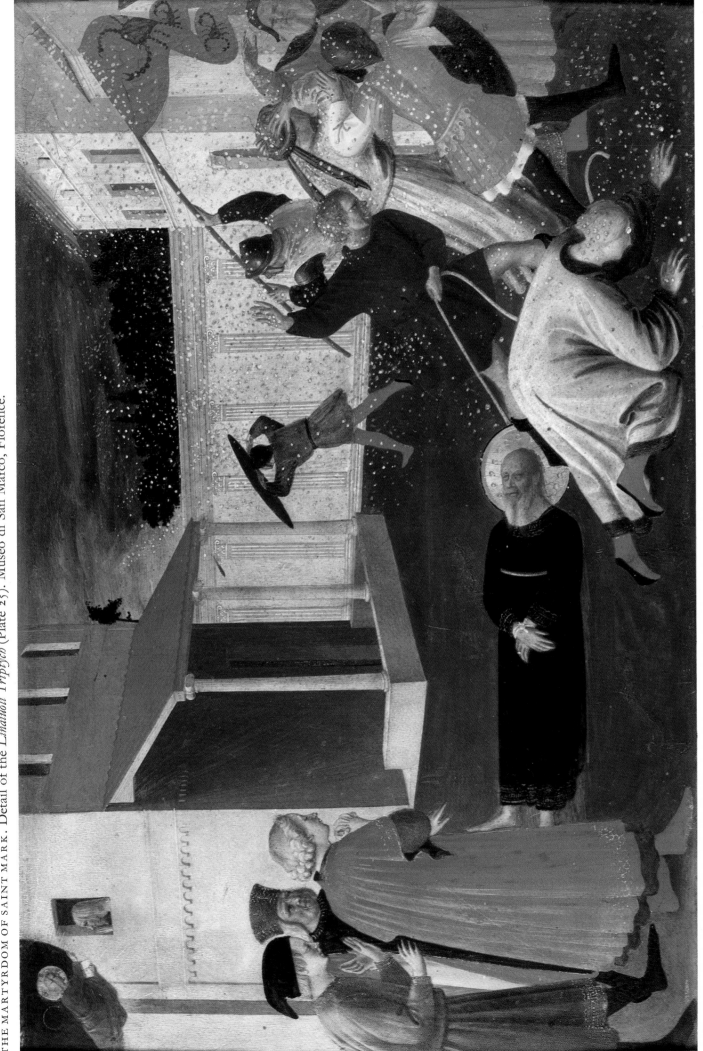

THE MARTYRDOM OF SAINT MARK. Detail of the *Linaiuoli Triptych* (Plate 25). Museo di San Marco, Florence.

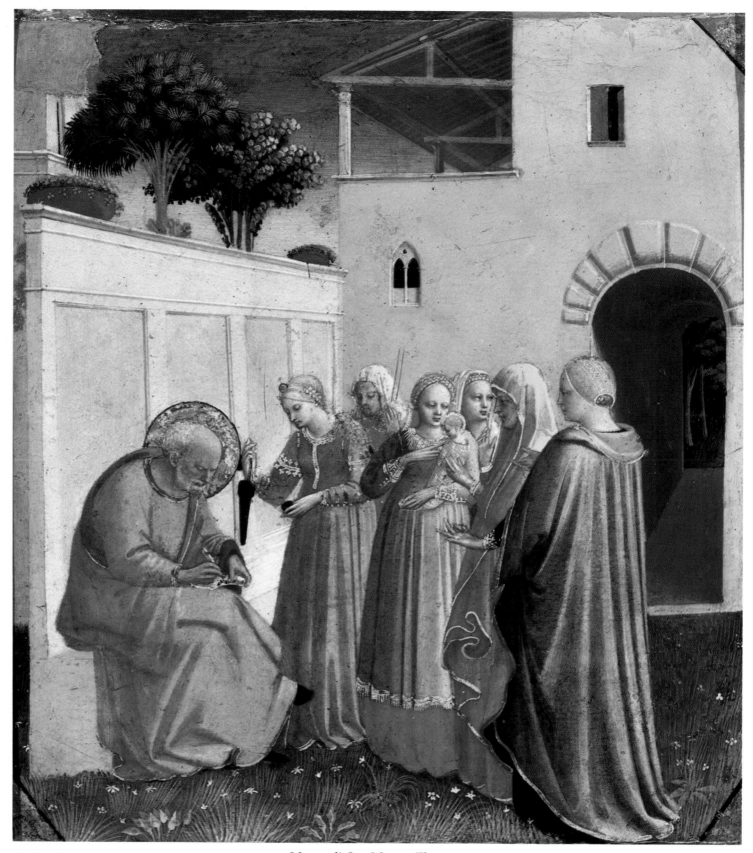

THE NAMING OF SAINT JOHN THE BAPTIST. Museo di San Marco, Florence.

The figures stand on a tiled pavement, which is solidly constructed in the shallow area before the throne but splays outwards in the lateral panels. This feature recurs, to cite two examples only, in an anonymous Florentine triptych of 1419, of which the central panel is at Cleveland, and in an altarpiece by the same artist with Saint Julian enthroned at San Gimignano. The lateral Saints are set on a single plane, the Saint Barnabas and Saint Peter Martyr turned slightly towards the Virgin and the Saint Dominic and Saint Thomas Aquinas posed frontally. Those parts in which cleaning tests have been carried out, especially the pink cloak of Saint Barnabas and the dresses of the angels, suggest that when the painting was first installed the effect it made must have been one of great brilliance and transparency. The Virgin's head is thinner and more elegant than in the painting from San Pietro Martire, and the linear movement of her cloak is more pronounced, while the naked Child is shown reaching towards two flowers held in her raised right hand.

In Florence in the field of painting the first half of the fourteen-twenties was a period of intense activity which is no longer fully reconstructible. In 1422 a painter from the Marches, Arcangelo di Cola, produced an important altarpiece for the Bardi chapel in Santa Lucia dei Magnoli. A year later another Marchigian artist, Gentile da Fabriano, completed the *Adoration of the Magi* for Santa Trinita, and thereafter started work on the Quaratesi polyptych for San Niccolò. In 1423 a polyptych for an unknown destination was painted by Masolino, of which only the central panel, at Bremen, survives, and this was followed, perhaps in 1424, by a triptych by the same artist for the Carnesecchi altar in Santa Maria Maggiore, of which the central panel is known from photographs and one of the lateral panels, with Saint Julian, is preserved. In the shadow of Masolino there moves another artist, sometimes thought to be identical with the documented painter Pesello, who is known only through two works, a *Madonna of Humility* in the Contini-Bonacossi collection and a *Virgin and Child with two Angels* at Rotterdam (Fig. 101). This phase reaches its climax in about 1425 in the more tactile style of Masolino's elaborate *Madonna* at Munich and in a work painted by Masaccio and Masolino for the church of Sant'Ambrogio, the *Virgin and Child with Saint Anne*. The central panel of Angelico's altarpiece for San Domenico (Plate 1) shows some affinity to Masolino's Santa Maria Maggiore triptych, but the contrast in the decorative content of the two paintings is very marked. The cloak of Masolino's Virgin sweeps forward in impulsive, self-indulgent folds, whereas that of Angelico's Madonna is handled with self-imposed restraint. More important for the structure of the painting is the influence of an artist whose pre-eminence was recognised by every progressive painter in the half-decade before the emergence of Masaccio, that of the sculptor Ghiberti. In Angelico's painting the carefully rendered throne is surrounded by eight angels, two kneeling in the foreground and the remaining six forming a niche behind the central group. This use of the principle of circularity is not a unique phenomenon—it recurs, for example, in the Ghibertesque *Crucifixion* from which another contemporary painter, the Master of the Griggs *Crucifixion*, derives his name, and in miniature painting in the work of Matteo Torelli—but in every case it seems to go back to Ghiberti, and specifically to the stained glass window of the *Assumption of the Virgin* made from Ghiberti's cartoon in 1404–5 for the façade of the Cathedral, where the angels surrounding the massive figure of the Virgin establish the space in which the scene takes place.

The influence of Ghiberti was of continuing importance for Angelico, and so was that of an artist whose shadow also falls across the altarpiece, Gentile da Fabriano. From the time of his arrival in 1422 till his departure three or four years later, Gentile was the dominant painter in Florence, and the decorative splendour and restrained naturalism of his style could not but leave their mark on younger artists. Angelico's prime debt was to the Quaratesi polyptych, as can be

seen clearly enough if we pass from Gentile's Baptist, gazing out at the spectator with hand thrust forward and with head tilted to one side, to the pilaster panel of Saint Matthew at Chantilly (Plate 6b), which was originally part of the San Domenico high altarpiece. The type of Angelico's Child, with distended cheeks and curly hair, and those of the angels beside the throne also owe more than a little to Gentile. To exponents of the Dominican Observant aesthetic, the highly ornate style of Gentile's *Adoration of the Magi* would have been unacceptable, but the description of natural phenomena in its predella and in the predella of the Quaratesi altarpiece struck a responsive chord in Fra Angelico, and a decade later inspired the vivid lighting of the storm in the Linaiuoli *Martyrdom of Saint Mark* (Plate 31).

The predella of the San Domenico high altar, now in the National Gallery in London, contains five panels, of which three in the centre are substantially by the second artist of Missal No. 558. Especially weak is the Risen Christ, which is set slightly askew. Perhaps Angelico drew out part of the cartoon—two kneeling angels playing hand organs in the central panel, one seen from behind, reveal a sudden taste of the inventiveness he was to bring, eight or nine years later, to the frame of the Linaiuoli tabernacle—perhaps he finished some of the heads, but the only parts in which he had a major share are the two panels under the pilasters filled with Dominican Beati (Plates 4-5). The Dominicans attached special importance to maintaining records of the features of members of their Order, and it is far from surprising that Angelico should have taken special pains over these panels. On many of the figures the names of the individuals represented are inscribed in his own hand. That he also painted them can be established if we compare the strongly differentiated heads with the heads of Dominican Saints on a page of Missal No. 558 (Plate 14), for which he was undoubtedly responsible.

If the Fiesole altarpiece was designed, as is likely, about 1424 or 1425, there are still seven years of anterior activity to be accounted for, and we have three panels which can reasonably be assigned to them. Two of these are the wings of a small triptych, with on the left Saints Catherine of Alexandria and John the Baptist and on the right an episcopal Saint, possibly Saint Nicholas, and Saint Agnes (Figs. 7-8; Plates 8-9). The touchstone for this attribution is the pilaster panel of Saint Michael from the Fiesole high altar, where the drawing of the head is closely similar to that of the Saint Agnes. In the Saint Catherine of Alexandria, where the same type is repeated in reverse, the exquisite, rather languid line of the Saint's cloak recalls that of the Chantilly *Saint Mark* (Plate 6a). Particularly beautiful is the rendering of the wheel, which is drawn with the same precision as the detail in the miniatures of Missal No. 558. The head of Saint John the Baptist is flattened like that of Saint Peter Martyr in the altarpiece at San Domenico, and his right hand, gripping the cross, is represented in precisely the same fashion as the right hand of Saint Michael in the pilaster panel, with the receding surface shown in shadow and the four fingers brightly lit. At the time these panels were painted Angelico must already have been in contact with Arcangelo di Cola or Gentile da Fabriano.

In a half-length *Virgin and Child* in the Fogg Museum (Fig. 61), Angelico approximates still more closely to Gentile. The proof of this connection is found in the gold ground, which is decorated with elaborately punched flowers and plants, in the rose held by the Child and in the beautiful detail of the veil covering the Virgin's hand. The types are closely similar to those at San Domenico, and the sleeves of the Child's dress are treated with the same fastidious delicacy as the detail in the altarpiece.

Angelico's development in the years which separate the Fiesole high altar from the Saint Peter Martyr triptych must have been rapid, and proof of his burgeoning self-confidence is found in a

work of about 1427, the *Madonna and Child enthroned with two Angels* in the Alba collection in Madrid (Fig. 5; Plate 10). This is the first painting in which the influence of Gentile is superseded by that of Masaccio. The knees of the Virgin are disposed precisely as they are in the Saint Peter Martyr triptych, though lit in this case from the right not from the left, and her head, turned almost in full face, recalls in its inflated surface that of Saint Thomas Aquinas in the later painting. Two angels above the throne define the spatial content of the scene, and at the same time serve to reinforce the curved edge of the panel. A number of the devices used in this work are employed again in later *Madonnas* by Angelico and members of his shop.

Angelico's evolving concern with space and the increasing lucidity with which his images are formulated are illustrated in a *Virgin and Child* of unknown provenance in the Museo di San Marco (Fig. 60). The central panel of a disassembled polyptych, it is based on the central panel of an altarpiece painted by Lorenzo Monaco for Monte Oliveto in 1406–10. The relationship is one of iconography rather than of style, and if the cartoons of the two paintings are compared, it will be found that in Angelico's the linear features of the Virgin's cloak are much reduced and the Child's pose is more erect. New features introduced into the scheme are a carefully rendered marble seat and step. The latter extends to the front plane, and looks forward to the more elaborate step in the central panel of the Linaiuoli tabernacle of 1433. Further proof of Angelico's new-found command of space is afforded by a small *Madonna and Child with twelve Angels* at Frankfurt (Plate 15), which uses some of the same motifs as the central panel of the Fiesole altarpiece, but is enriched by the introduction of a beautifully rendered perspective throne raised on three steps with a hexagonal tabernacle over it. Though the architectural forms are less classical than those used by Ghiberti in the later panels of the first bronze door, the means by which they are portrayed, and the relation to them of the carefully spaced ring of angels, are deeply Ghibertesque.

The device of the receding rectangle used in the foreground of this *Madonna* is employed in a rather different form in the *Last Judgment* in the Museo di San Marco (Fig. 2; Plates 16–17), which must have been painted about 1430 and may have been commissioned for the Oratorio degli Scolari in Santa Maria degli Angeli in the summer of 1431. The panel formed the upper part of a seat used by the priest during High Mass, and its shape for that reason is unorthodox. The upper lobe, containing the figure of Christ as judge, is extended at the base to form an oval mandorla framed by angels and flanked by the Virgin and St. John, with saints and apostles at the sides set on two shallow diagonals. Paradise and Hell are depicted in two rectangular extensions at the sides, and in the centre is the Resurrection of the Dead, unified by a perspective of open graves which carries the eye through the whole depth of the picture space to the pale blue horizon at the back. The only parallel for this device occurs on the Arca di San Zenobio of Ghiberti, and the system whereby it is projected is also found in Ghiberti, in the *Story of Isaac* on the Gate of Paradise. Angelico cannot have drawn directly on either of these models—the relief of the *Miracle of St. Zenobius* dates from 1437, and the *Story of Isaac* was evolved at some time between 1429 and 1436—but the analogies leave little doubt that Ghiberti must have been Angelico's mentor at this time. This applies also to the figures of the condemned, which recall those in the only scenes of violent action by Ghiberti that we know, the *Expulsion of the Money-Changers from the Temple* on the first bronze door and the *Arrest of the Baptist* on the Siena font. Impressive as is its design, it is debatable how far the panel was executed by Angelico. The Christ and the saints and apostles at the top must be in great part autograph, but the angels on the left are much inferior to those in the *Madonna* at Frankfurt or in a tiny, damaged *Madonna* of the same date at Detroit (Fig. 76), and may be due to the assistant of Missal No. 558. The *Last Judgment* was not a major commission,

and the decision to entrust part of its execution to members of the studio suggests that at the time Angelico must have been personally involved in the execution of some more important work. This was not the Linaiuoli triptych, which was commissioned in 1433, but the work that immediately precedes it, an altarpiece of the *Annunciation*.

PANEL PAINTINGS AND FRESCOES: 1432–8

IN 1432 Angelico is known to have been at work on a painting of the *Annunciation* for the church of Sant'Alessandro at Brescia. The commission is explained by the fact that the church was ceded in that year to the Servite Order, and was placed under the direction of a member of the Servite community in Florence, who must have been familiar with the artist's altarpieces. Nothing further is known about the picture. It has been stated that it was delivered to Brescia and was destroyed, but there is no proof of its delivery nor indeed of its presence in the church. Moreover, eleven years later another painting of the *Annunciation* was commissioned for Sant'Alessandro, an altarpiece by Jacopo Bellini for which payments were made in 1443, and which is still preserved at Brescia. There is, however, one altarpiece of the *Annunciation* by Angelico, formerly in the Gesù at Cortona, now in the Museo Diocesano (Plates 18–23), which dates from these same years —it has been argued with great cogency that it was already in existence in 1433–4—and it is possible that this is the painting planned for Brescia, which, for lack of funds or for some other reason, was diverted to a new recipient.

At least two notable paintings of the *Annunciation* were produced in Florence in the fourteen-twenties. One of them, by Masaccio, stood in San Niccolò oltr'Arno and is described by Vasari; it represented 'a house full of columns drawn in perspective of singular beauty . . . in which he showed his thorough understanding of perspective'. Another, by Masolino, survives in the National Gallery of Art in Washington. The Washington painting is wholly unrelated to the picture Angelico produced, and the relevance to it of the altarpiece in San Niccolò must, in the absence of the painting, remain conjectural. The fact that the space projection in the Cortona *Annunciation* is consistent with that of the *Last Judgment* from Santa Maria degli Angeli suggests that Angelico's indebtedness to Masaccio's lost painting may not have been very great.

The *Annunciation* at Cortona (Plate 18) is Angelico's first indubitable masterpiece. The scene is set beneath a loggia closed on two sides by Brunelleschan columns and at the back by an arcaded wall. On the right the Virgin, her hands crossed on her breast, leans forward from her gold-brocaded seat, reciting the words of St. Luke inscribed in gold letters on the surface of the panel: 'Behold the handmaid of the Lord; be it unto me according to thy word.' Confronting her with a half-genuflection is the Angel, his forefinger raised in expostulation as his lips recite the sentence: 'The Holy Ghost shall come upon thee, and the power of the Highest shall overshadow thee.' A golden dove hovers over the Virgin's head. To the left is an enclosed garden with a symbolic palm-tree, and beyond it, at a point to which the eye of the spectator is directed by the pink cornice of the building, is the scene of the Expulsion from Paradise (Plate 19). The painting of the flesh of the two figures is richer than in any previous painting—particularly striking is the Masolino-like facture of the Virgin's hands—and the Angel's wings, so disposed that the forward tip falls in the exact centre of the panel, have a sweep and grandeur that are indeed miraculous.

Just as the altarpiece of the *Annunciation* painted by Simone Martini in 1333 dictated the treatment of this scene in Siena for more than half a century, so the Cortona altarpiece, with its pervasive sense of mystery, its gentle, symbolic lighting and its infectious earnestness, formed the source of countless adaptations and variants. The first of them, now in the Prado in Madrid (Fig. 10), was painted for San Domenico at Fiesole. In this, as in all the later representations of the scene from Angelico's shop, the space is centralised; the Angel is contained in the perspective of the central arcade, the arch on the right conforms to the same perspective scheme, and in the equivalent area on the left we see the expulsion of Adam and Eve from Paradise. That this design is later than that of the Cortona altarpiece, and not earlier as is sometimes claimed, is demonstrated by the fresco of the scene painted by Angelico about 1450 in the corridor of the cloister of San Marco, where the structure is related to that of the painting in the Prado, not to that of the Cortona altarpiece. Still later, probably from the fifth decade of the century, is a version of the composition at Montecarlo (Fig. 11), where the figures are framed in two arches of equal width and the scene of the Expulsion is visible through an archway on the left. Neither the Prado painting nor that at Montecarlo was executed by Angelico.

The predella of the Cortona *Annunciation* is in large part autograph, and contains five scenes from the life of the Virgin and two scenes from the legend of St. Dominic (Plates 22–3; Fig. 9). Two of the most magical are the scenes of the *Visitation* and the *Presentation in the Temple*. In the former the Virgin and St. Elizabeth are isolated against a shady wall; on the left is a distant view over Lake Trasimene, and in front of it is a woman climbing up the hill, painted with such gravity that it has been ascribed, wrongly, to Piero della Francesca. In the *Presentation in the Temple* the Virgin, the High Priest and the Child are shown in a perspective of receding columns. Should any doubt remain that the Cortona altarpiece was planned before Angelico's next documented work, the Linaiuoli triptych, and before the *Annunciation* in the Prado, it can be set at rest by comparing the panels of the *Adoration of the Magi* in the centre of the three predellas (Plates 23a, 29; Fig. 10), which present a compositional progression that leaves the date of the Cortona painting in no doubt. In the frieze-like *Adoration of the Magi* at Cortona the Virgin is seated on the right and the three Kings and their retinue are spread across the scene. In the Linaiuoli triptych, on the other hand, the composition is circular; the Virgin is seated on the right with two of the Magi kneeling in the foreground, and St. Joseph is shown in conversation with the third Magus behind. In Madrid the composition is centralised; the Virgin sits before the stable facing the spectator, much as she does in a late work of Angelico, the *Adoration of the Magi* on the Annunziata silver chest. The notion that the Cortona panel could have been evolved after that of the Linaiuoli triptych, or that the Prado panel could precede that at Cortona, runs counter to everything we know of Angelico's development.

The project for the triptych commissioned by the Arte dei Linaiuoli, or guild of flax-workers, for the Residenza of the guild in Piazza Sant'Andrea (Plates 24–31) dates back to October 1432, when a wooden model for the tabernacle was prepared to the design of Ghiberti. A contract for the painting destined for the tabernacle, to be painted 'inside and out with gold, blue and silver of the best and finest that can be found', was awarded to Angelico on 2 July 1433, at a cost of 'one hundred and ninety gold florins for the whole and for his craftsmanship, or for as much less as his conscience shall deem it right to charge'. Its content was to correspond with a drawing, presumably prepared by the artist. Five weeks after this contract was concluded, two assistants of Ghiberti, Jacopo di Bartolommeo da Settignano and Simone di Nanni da Fiesole, began work on the marble frame. The frame, with its arched central aperture, dictated the form of the painting,

which consists of a central panel of the Virgin and Child enthroned between two mobile wings. On the inside of the wings (and therefore visible only when the triptych was open) are figures of the two Saints John; on the outside (and therefore visible only when the triptych was closed) are Saints Peter and Mark, scenes from whose legends are illustrated in the predella beneath.

If the Linaiuoli triptych were shown today in the Uffizi, and not in the Museo di San Marco, its exceptional size would register more strikingly; among panel paintings it would be comparable only with Cimabue's high altarpiece from Santa Trinita and Duccio's *Ruccellai Madonna*. In the first document relating to the tabernacle there is a reference to the position it was to occupy 'dove oggi è dipinta la figura di nostra donna'; and it may well be that the size of the tabernacle, and therefore of the painted panels, was determined by some dugento *Madonna* which they replaced. The scale of the four saints on the wings is greater than that of any other Florentine panel painting of the time. How then is Angelico's success in rendering them to be accounted for? The most likely explanation is that Ghiberti played a part in the designing not only of the frame but of the triptych as a whole. There is indeed a passage in the *Commentari* which may refer to this commission, in which Ghiberti describes the assistance he gave to painters and sculptors by providing them with models in wax and clay, and continues: 'etiandio chi avesse avuta affare figure grandi fuori del naturale forma, [ho io] dato le regole a condurle con perfetta misura.' The saints in the wings are an equivalent in painting for the statues of guild patrons on Or San Michele. Particularly striking is the calculated tri-dimensionality of the four figures, the Baptist, whose cross is held forward of his body, St. John the Evangelist, who extends his right hand in benediction and in his left holds a volume of the Gospels with its edge turned to the spectator, St. Mark, whose pose is established by the diagonals of the feet and of the foreshortened book, and St. Peter, whose volumes of epistles is supported by both hands, the right held slightly forward of the body and the left thrust outwards beneath his cloak. The two inner figures may indeed be regarded as pictorial transcriptions of Ghiberti's *St. Matthew* and *St. Stephen*, and the outer figures as examples of the statues Ghiberti might have produced had he continued to practise as a monumental sculptor after 1429. The space structure of the much damaged central panel, however, proceeds logically from the painter's earlier works. At the bottom is a receding platform, which is boldly aligned on the front plane and has as its counterpart at the top a star-strewn roof like that in the Washington *Annunciation* of Masolino. The panel is surrounded by a wooden frame decorated with twelve music-making angels (Plate 28), which have become the most popular figures in Angelico's whole oeuvre. They are designed with greater freedom than the angels in the earlier works—so much so that we might once again suspect the intervention of Ghiberti—but are so much damaged that it is difficult to judge whether they were painted by Angelico or by a studio hand.

What we do not know about the Linaiuoli triptych is the year in which it was installed, but if, as is likely, the main panels occupied Angelico for about two years, work on the predella may have been begun only in 1434 or 1435. The subject of the first panel is not the scene of St. Peter exhorting the faithful depicted by Masolino in the Brancacci Chapel but St. Peter dictating the Gospel of St. Mark. In the centre St. Peter preaches from an hexagonal wooden pulpit, and at the left in profile sits St. Mark taking down his words with the assistance of a kneeling acolyte, who holds an ink-horn, and of two scribes, who carry the completed manuscript (Plate 30). The type of the Saint Peter seems to contain a conscious reference to the Saint Peter of Masaccio, and the realistic figures in profile framing the composition at the sides likewise recall the lateral figures of the *Saint Peter enthroned and the Raising of the Son of Theophilus* in the Brancacci Chapel. The spatial thrust is

16

deeper than in any previous scene, and the buildings at the sides and in the background are more carefully defined. This too must be due to study of Masaccio. The corresponding panel on the right shows the body of St. Mark dragged in a hailstorm through the streets of Alexandria (Plate 31). Nothing in the artist's earlier work prepares us for this incomparably vivid scene. The figures are portrayed in violent action, with a repertory of gesture on which Angelico, when he came a few years later to portray the legend of Saints Cosmas and Damian in the San Marco altarpiece, made little significant advance; and one of them, the youth with arm raised pulling the body of the Saint, once more recalls Gentile da Fabriano. Still more remarkable is the depiction of the hailstorm and the lowering sky seen over the wall, which have a partial equivalent in Siena in Sassetta's *Miracle of the Snow* but none in Florentine painting. At the time he was working on these panels, in the middle fourteen-thirties, Angelico's must have been the most frequented Florentine studio —its only competitor was that of Fra Filippo Lippi—and it is thither that young artists like Piero della Francesca and Domenico Veneziano would have gravitated when they arrived in Florence. In the central panel of the Linaiuoli predella indeed there is one head, of a youth beside two horses, whose upturned face and flaxen hair suffused with light are painted with a pointilliste technique that is unlike Angelico's and could well be due to the young Piero.

Angelico's next dated work is of a very different character. It is a painting of the *Lamentation over the dead Christ*, now in the Museo di San Marco (Fig. 25), commissioned for the confraternity of Santa Maria della Croce al Tempio in April 1436 and completed in December of the same year. The donor, Fra Sebastiano di Jacopo Benintendi, was a nephew of the Beata Villana de' Botti, over whose relics the Confraternity held certain rights. According to a life of the Beata Villana extracted by Razzi from a volume of biographies of the Saints and Beati of the Dominican Order, she ardently aspired to share the sufferings of Christ, her celestial spouse, and 'in her visions had always before her mind the image of her Jesus Christ, beaten and crucified, whose torments she wished to emulate'. She is seen kneeling on the right, with the words CRISTO IESV LAMOR MIO CRVCIFISSO issuing from her mouth. The panel is unique in Angelico's work in that it consists of a foreground filled with figures and of an unrelated townscape at the back. The reason for this is that the foreground figures are adapted from a trecento panel of the *Lamentation* by Niccolò di Tommaso, now in the Congregazione della Carità at Parma. Some of the figures are of inferior quality, but Angelico alone could have painted the elegiac landscape on the left. The long wall of the city of Jerusalem recalls the distant view of Florence on the right of Ghiberti's *Miracle of Saint Zenobius*.

From the following year, 1437, dates a polyptych painted for the chapel of St. Nicholas in the church of San Domenico at Perugia, now in the Galleria Nazionale dell'Umbria (Figs. 22, 24; Plates 39, 42–5). Dismantled before the middle of the nineteenth century, its panels were later reintegrated in a modern frame; they are now shown unframed. Those parts that are autograph, the Virgin and Child in the centre and the fine figures of Saints Dominic and Nicholas of Bari on the left-hand side, are less monumental than the comparable figures of the Linaiuoli tabernacle. The St. John the Baptist and St. Catherine of Alexandria on the right are largely studio work. In the solidly constructed throne and the table covered with a cloth which runs behind each pair of Saints the artist attempts for the first time to escape from the tyranny of the gold ground. The predella panels are unlike those of the Linaiuoli tabernacle in that the scale of the figures is reduced. In the first panel, with the birth of St. Nicholas and St. Nicholas and the three maidens (Fig. 24a; Plates 44–5), the effect is a trifle tentative, but in the third, with St. Nicholas saving three men condemned to execution and the death of the Saint (Fig. 24c), the vanishing point of

the city wall depicted on the left falls in the centre of the panel and the perspective of the chamber on the right converges on the friar behind the bier. By one of those strokes of sheer pictorial genius with which Angelico so often surprises us, the two scenes are illuminated from a common source, which irradiates the figures on the left and floods into the chamber on the right-hand side.

The qualitative standard by which the Perugia polyptych must be judged is established by an altarpiece painted for San Domenico at Cortona a year or two before, probably in 1436 (Figs. 21, 23; Plates 38, 40-1). Its form, a Gothic polyptych with pointed panels, remains faithful to that of the Fiesole high altar. As a result of the action of damp and the consequent deterioration of the wood, it proved necessary in 1945 to remove the film of paint from all three panels, and this, studied from behind with the underdrawing uppermost, yields valuable information on the way in which Angelico's panels were built up. In each the forms are sketched in in *terra verde* on the priming, the linear features, hair, eyelids, lips and nostrils being indicated with great refinement and subtlety. All the underdrawing is by a single hand. While it establishes the main areas of light and shadow, it has none of the heavy recession of the underdrawing in the triptych executed by Sassetta at about this time for the same church, and the volume of the completed figures is no more than hinted at. Not unnaturally the process of completion involved some coarsening of the linear qualities of the cartoon. Comparison of the head of St. John the Baptist with the corresponding part of the cartoon beneath (Plate 41) gives a fair impression of this impoverishment. In those figures that are autograph it is clear that Angelico himself deliberately sacrificed some of the delicacy of the initial image to recession and solidity.

The dilution of quality in the Perugia altarpiece and to a less extent in the polyptych at Cortona reflects the pressure under which the workshop at Fiesole was operating at this time. It was producing small autograph paintings, like the predella panels of the *Naming of the Baptist* in the Museo di San Marco (Plate 33) and *Saint James the Great freeing Hermogenes* in the collection of the Duc des Cars (Plate 32), where the figure style is strongly Ghibertesque, and two panels of *The Nativity* and *The Agony in the Garden* at Forlì (Figs. 78-9), which seem likewise to have been painted after the predella of the Cortona *Annunciation* and before that of the Perugia altarpiece. These two nocturnal scenes are lit internally like the predella panels of Lorenzo Monaco. It was producing small paintings that are not, or are not wholly, autograph, like the three reliquary panels from Santa Maria Novella, now in the Museo di San Marco (Figs. 69-71), which were painted for Fra Giovanni Masi before 1434. In one of these, the *Adoration of the Magi*, Angelico may himself have intervened, and in another, the *Coronation of the Virgin*, he may have painted a frieze of figures across the bottom of the panel. It was producing more substantial paintings, in which Angelico was responsible for the cartoons, but which were carried out with studio assistance. One of these is the beautiful *Coronation of the Virgin* in the Uffizi (Plate 34), which was painted about 1435 for Sant'Egidio and had as its predella two panels of the *Marriage* and *Dormition of the Virgin* in the Museo di San Marco (Figs. 13-14). Another is a rather earlier *Madonna and Child* at Parma, with in the foreground figures of Saints John the Baptist, Dominic, Francis and Paul (Fig. 108). If we imagine these paintings drawn out by Angelico with the same exactness as the figures on the Cortona polyptych, and coloured partly by the artist and partly by assistants, we can understand readily enough why the execution of the *Coronation* is unequal, and why the foreground figures in the Parma painting differ in handling from the Virgin and Child.

More important for our knowledge of Angelico are the frescoes which he executed at Fiesole and at Cortona at this time. Two of them, a *Virgin and Child with Saints Dominic and Thomas Aquinas*, formerly in the dormitory, and a *Christ on the Cross adored by Saint Dominic with the Virgin*

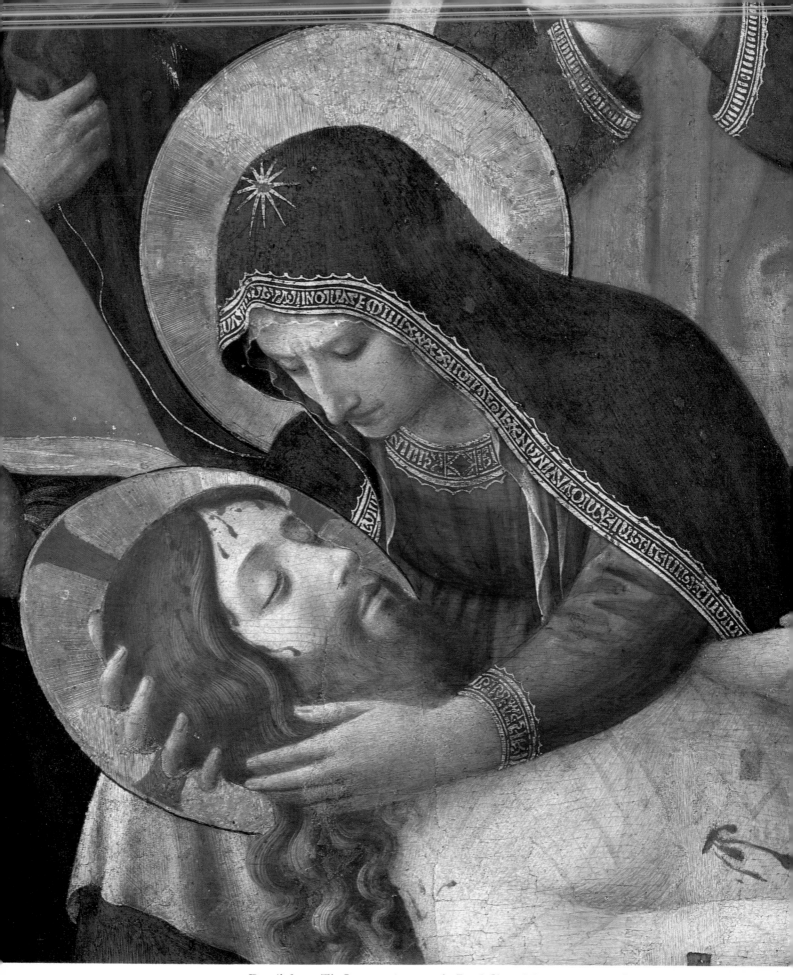

THE DEAD CHRIST AND THE VIRGIN. Detail from *The Lamentation over the Dead Christ* (Fig. 25). Museo di San Marco, Florence.

LANDSCAPE. Detail from *The Lamentation over the Dead Christ* (Fig. 25). Museo di San Marco, Florence.

and Saint John, formerly in the refectory, are now in Leningrad and Paris (Figs. 16–17). Of a third fresco, which was moved from its original position, there survives only part of the Virgin and Child, which has been much repainted but proved to cover an autograph *sinopia*. A somewhat similar fresco of the *Virgin and Child with Saints Dominic and Peter Martyr* was painted by Angelico over the portal of San Domenico at Cortona (Plates 36–7), probably about 1438. In the history of conventual decoration the paintings from Fiesole mark a new departure in idiom and iconography. They are free from distraction and devoid of decorative accidentals, and in two of them the spectator, in the person of the founder of the Dominican order, participates in the holy scene. Presented with the minimum of incident, they are designed to be filled out by the religious imagination of the onlooker, and represent the first stage in the evolution of an art which was calculated to stimulate and to enrich the community's spiritual life.

FRESCOES AT SAN MARCO

THE recall of Cosimo de' Medici to Florence in 1434 opened a new chapter in the history of the Dominican Observants at Fiesole. As early as 1420 Cosimo had exercised his patronage in favour of the reformed Franciscan convent of Bosco ai Frati, and two years after his return he obtained the assent of the Pope, Eugenius IV, then resident in Florence, to the requisitioning and handing over to the Observant Dominican community of the Silvestrine convent of San Marco. When the Dominicans took over the premises, the convent buildings were in ruins, and only the church was structurally sound. Since the Dominican title to the convent was contested by the Silvestrine community, rebuilding did not start till 1437, and for two years the friars were housed in damp cells and wooden huts. When the Council of Basle at length confirmed the Dominican claim to the convent, the task of reconstruction was begun, and from this time on work was pressed forward at the commission of the Medici by the architect and sculptor Michelozzo. The sequence of the buildings can be established with a fair measure of certainty from the *Cronaca di San Marco* compiled by Giuliano Lapaccini, a companion of Angelico who received the habit of the order at Fiesole in 1433 and in 1444 became Prior of San Marco. In 1439 the *cappella maggiore* of the church was finished, and by 1442 the church was ready to be dedicated. The convent premises were rebuilt at the same time. In 1438 twenty cells in the central dormitory over the refectory were rebuilt or repaired, and by 1443 all the cells on the upper floor, to a total of forty-four, were fit for habitation. Structural work in one part of the building or another continued until 1452. Close contact must have been maintained between Angelico and Michelozzo during the years in which the convent was being built. The fruits of this are to be found in the convent frescoes, where the settings depend for their effect upon the same unerring use of interval as do the cloister and library of Michelozzo.

Describing the most notable features of the convent Lapaccini mentions the Library (conspicuous alike for its great length and for its thirty-two benches of cypress wood), the residential buildings (so harmonious, yet so convenient), and the garden, and goes on: 'A third feature is the paintings. For the altarpiece of the high altar and the figures in the Sala del Capitolo and the first cloister and all the upper cells and the Crucifixion in the refectory are all painted by the brother of the Dominican Order from the convent at Fiesole, who had the highest mastery in the art of painting in Italy. He was called Brother Johannes Petri de Mugello, and was a man of the utmost

modesty and of religious life.' The frescoes on the ground floor of the convent comprise a *Christ on the Cross adored by Saint Dominic* (Plate 66) and five lunettes in the cloister (Plates 67–70), and a large *Crucifixion with attendant Saints* in the Sala del Capitolo (Plates 73–5). A fresco of the *Crucifixion* in the refectory was destroyed in 1554. On the first floor there are three frescoes in the corridor (a *Christ on the Cross adored by Saint Dominic*, an *Annunciation*, and a *Virgin and Child with Saints*) and forty-three frescoes in the forty-five cells opening off it. All the frescoes on the ground floor are wholly or partly by Angelico. On the extent of his responsibility for the remaining frescoes a wide variety of view has been expressed, and at one time or another he has been charged with as many as forty-one and as few as six of the narrative scenes. The *Cronaca di San Marco* proves beyond all reasonable doubt that as early as 1457 (the terminal date for the completion of the chronicle) Angelico was credited with the entire fresco decoration of the convent as it then stood. But this view is sanctioned neither by examination of the frescoes nor by common sense, for the execution of so many frescoes in so short a time was beyond the capability of a single artist, and the frescoes themselves reveal the presence of three or four main hands. That the class of frescoes in the cells was ideated by Angelico and that Angelico himself supervised the decoration of the convent is not open to doubt, but the frescoes for which he was directly responsible are vastly outnumbered by the scenes in which assistants were charged with executing his cartoons, or which were conceived by his disciples within the framework of his style.

The *Scenes from the Life of Christ* which decorate the cells follow no natural sequence. Frescoes whose subjects are inter-related are sometimes separated by the whole length of the corridor. The frescoes in the eleven cells on the east side of the corridor represent the *Noli Me Tangere*, the *Entombment*, the *Annunciation*, *Christ on the Cross with four Saints*, the *Nativity*, the *Transfiguration*, the *Mocking of Christ*, the *Resurrection*, the *Coronation of the Virgin*, the *Presentation in the Temple*, and the *Virgin and Child with two Saints*. With the exception of a fresco of the *Adoration of the Magi* in Cell 39 on the north-west corner of the building (which is considerably larger than the other cells, and was occupied by Cosimo de' Medici, Pope Eugenius IV, and other distinguished visitors to the convent), these include the only frescoes in the cells for which a direct attribution to Angelico is warranted. Even these scenes vary appreciably in quality, but applying criteria based on his other works, we may credit Angelico with the design and execution of the *Noli Me Tangere* in Cell 1 (Plates 77–8), the *Annunciation* in Cell 3 (Plates 76, 79), the *Transfiguration* in Cell 6 (Plates 86–9), the *Mocking of Christ* in Cell 7 (Plates 80–1), the *Coronation of the Virgin* in Cell 9 (Plates 84–5), and the *Presentation in the Temple* in Cell 10 (Plates 82–3). The frescoes in Cells 2, 4, 5, 8 and 11 are by a single hand, the Master of Cell 2 (Figs. 28–30). All these five frescoes were executed under the general direction of Angelico, who possibly supplied small drawings for certain of the figure groups (the *Entombment* is a case in point), but was not responsible for the cartoons. An indication of the close association that must have existed between Angelico and his disciple is afforded by the presence in the *Maries at the Sepulchre* in Cell 8 of an angel's head painted by Angelico. The Master of Cell 2 seems to have been a member of the master's studio from the mid-thirties on, and was responsible for executing parts of the Croce al Tempio *Lamentation* and of the *Deposition* from Santa Trinita.

The frescoes in the cells on the inner side of the corridor overlooking the cloister are greatly inferior to the frescoes in the outer cells. Cells 15 to 23 (which housed members of the novitiate and were therefore of relatively little consequence) contain figures of *Christ on the Cross adored by Saint Dominic*, which depend from the frescoes of this subject by Angelico in the cloister beneath and by a studio assistant in the corridor; these are seemingly the work of a single artist, and maintain

a level of undistinguished competence. They are followed, in Cells 24, 25, 26 and 27, by four scenes (the *Baptism of Christ, Christ on the Cross,* the *Man of Sorrows* and the *Flagellation*), which are almost certainly by the Master of Cell 2 (Fig. 31), but are less closely indebted to Angelico than the frescoes opposite. A fresco of *Christ carrying the Cross* in Cell 28 (Fig. 32) is by another hand, and the *Crucifixion* in Cell 29 is by Benozzo Gozzoli. Turning the corner, along the north side of the cloister, we come to six scenes by a single hand (*Christ in Limbo,* the *Sermon on the Mount,* the *Arrest of Christ,* the *Temptation of Christ,* the *Agony in the Garden* and the *Institution of the Eucharist*), where the loose grouping and curvilinear compositions (Figs. 33–4) are at variance with the frescoes in the earlier cells. Passing to Cells 36, 37 and 42, we find a *Christ nailed to the Cross* (Fig. 35) and two frescoes of the *Crucifixion with attendant Saints,* in which the style and spirit, if not the handling, once more conform to Angelico's intentions in the autograph frescoes. The author of these scenes followed Angelico to Rome in 1445, and was employed in the upper cycle of frescoes in the Vatican. He is likely to be identical with one of the secondary artists listed in 1447 as members of the painter's Roman studio.

We do not know in what year the frescoes at San Marco were begun. From 1437 or 1438 Angelico's principal concern lay with the altarpiece for the high altar of the church, a work of great elaboration which reveals scarcely the least trace of studio assistance. If the altarpiece was finished only in 1440 or 1441, the painting of the frescoes may have started after this time. The single fixed point is that the large *Crucifixion* in the Sala del Capitolo seems to date from 1441–2. The fresco on the upper floor most closely related to it, the *Adoration of the Magi* in Cell 39, is likely also to date from 1442. The conjectural sequence which would most readily reconcile the style testimony of the frescoes with the known facts is that the first to be carried out were those in Cells 1 to 11, some of which are by Angelico and some of which were executed by a close assistant under his supervision. These may date from 1440–1. Thereafter the main focus of interest was the Sala del Capitolo, followed by the *Adoration of the Magi.* The frescoes in Cells 24 to 28, in which Angelico did not participate, may have been painted at this time. The frescoes over the doorways of the cloister, for which Angelico was himself responsible, seem to follow the *Crucifixion* in the Sala del Capitolo, and are in turn followed by what is probably the latest of Angelico's pre-Roman frescoes, the *Christ on the Cross adored by Saint Dominic* on the north wall of the cloister. There is no evidence whatever for the dating of the frescoes in Cells 31 to 37, and no indication whether they were executed before 1445, when Angelico was still in Florence, or after that year, when he was in Rome. Two frescoes in the upper corridor, the *Virgin and Child with Saints* and the *Annunciation,* are later in style than the remaining frescoes, and were probably painted in 1450 after his return.

The largest fresco in the cloister, that opposite the entrance, shows *Christ on the Cross adored by Saint Dominic* (Plate 66). Developed from the fresco from Fiesole in the Louvre (Fig. 16), where the Saint is shown in profile and a less explicit and emotional relation is established with the figure on the Cross, it establishes the central theme of the frescoes on the upper as well as on the lower floor, the mystical participation of members of the Dominican Order, personified by the figure of their founder, in the life and sufferings of Christ. The shape of the fresco field was changed in the seventeenth century, when an irregular marble surround was added to it. By comparison with the fresco from Fiesole, the body of Christ is modelled more richly and with a new naturalism and tactility. The five lunettes in the cloister (Plates 67–70) are in poor condition. Four of them, the *Saint Peter Martyr* enjoining silence above the entrance to the sacristy, the much abraded *Saint Dominic* holding out his rule, the *Saint Thomas Aquinas* with the *Summa* open on his breast, and the

Christ as Man of Sorrows, are distinguished principally for their sense of volume and for the masterly placing of the figures on their grounds. The fifth, above the doorway of the hospice, shows *Christ as Pilgrim received by two Dominicans*. The lunettes, like the *Crucifixion* in the Louvre, are surrounded by carefully constructed illusionistic frames.

A work of greater intrinsic importance is the *Crucifixion* in the Sala del Capitolo (Plates 72–5). This large arched fresco fills the entire north wall of the room. Its programme emerges from the pages of Vasari, who relates how Angelico was instructed by Cosimo de' Medici 'to paint the Passion of Christ on a wall of the chapter-house. On one side are all the saints who have founded or been heads of religious orders, sorrowful and weeping at the foot of the Cross, the other side being occupied by St. Mark the Evangelist, the Mother of God, who has fainted on seeing the Saviour of the world crucified, the Maries who are supporting her, and Saints Cosmas and Damian, the former said to be a portrait of his friend Nanni d'Antonio di Banco, the sculptor. Beneath this work, in a frieze above the dado, he made a tree, at the foot of which is St. Dominic; and in some medallions, which are about the branches, are all the popes, cardinals, bishops, saints and masters of theology who had been members of the Order of the Friars Preachers up to that time. In this work he introduced many portraits, the friars helping him by sending for them to different places.' Like the Croce al Tempio *Lamentation*, the fresco at San Marco is a mystical representation of the Crucifixion and not a narrative scene. The figures of the crucified Christ, the women beneath the Cross, and the attendant saints (on the left Saints Cosmas and Damian, Lawrence, Mark and John the Baptist, on the right Saints Dominic, once more kneeling beneath the Cross, Ambrose, Jerome, Augustine, Francis, Benedict, Bernard, Giovanni Gualberto, Peter Martyr and Thomas Aquinas) are ranged along the front plane of the painting, and the single intimation of space is in the crosses of the two thieves, which recede diagonally into the dark ground. The vertical shaft of the Cross divides the fresco into two halves, and fills the whole height of the fresco field. The theme of the painting is elaborated in inscriptions on the scrolls held by the prophets in the decorative border surrounding the scene. Among these are the VERE LANGORES NOSTROS IPSE TVLIT ET DOLORES NOSTROS of Isaiah, the O VOS OMNES QVI TRANSITE PER VIAM ATTENDITE ET VIDETE SI EST DOLOR SICVT DOLOR MEVS of Jeremiah, and the QVIS DET DE CARNIBVS EIVS VT SATVREMVR of Job. An impressive exposition of an intellectual concept, the *Crucifixion* is not one of Angelico's most successful paintings, and owing in part to its condition (the original blue ground has been removed, leaving the figures like cut-out silhouettes on the restored red underpainting) and in part to the weight of its didactic scheme, it remains a manifesto which falls short of a great work of art.

Those who know the frescoes in the cells upstairs only from photographs miss their essential character. In relation to the rooms in which they find themselves, most of the scenes (and all of those associable with Angelico) are relatively large in scale. In each case the scene is represented on the window wall opposite the door, and the wall thus contains two apertures, one opening on the physical and the other on the spiritual world. Dominating their austere surroundings, they were designed as aids to meditation, not as decoration, and were intended to secure for the mysteries they described a place in the forefront of the friar's mind by keeping them constantly before his eyes. In this respect they form a spiritual exercise. The cursory examination of the frescoes which we make as we walk from cell to cell today is the exact opposite of the use for which they were designed. At Fiesole the frescoed decoration of the convent seems to have been confined to public rooms, and we do not know to whom the decision to extend this decoration to the cells occupied by individual friars was due. Perhaps its instigator was Fra Cipriano, the first

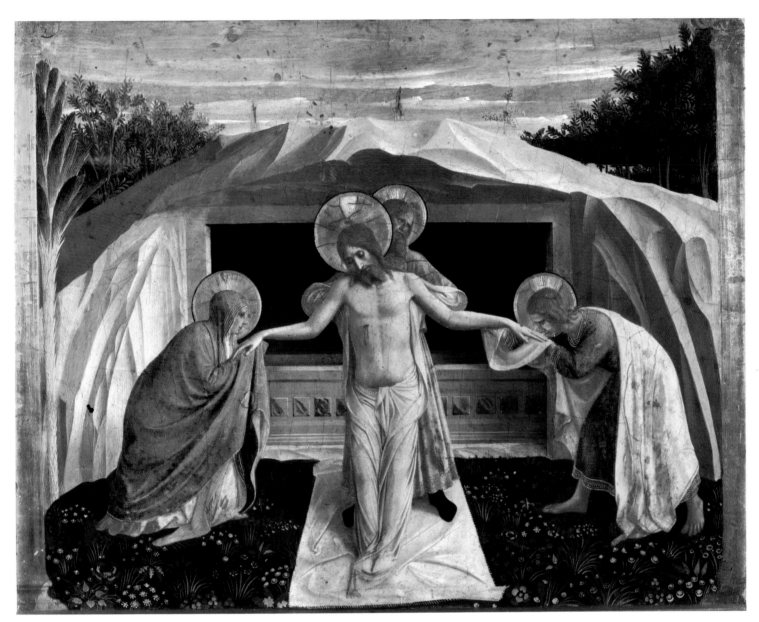

THE ENTOMBMENT. Alte Pinakothek, Munich.

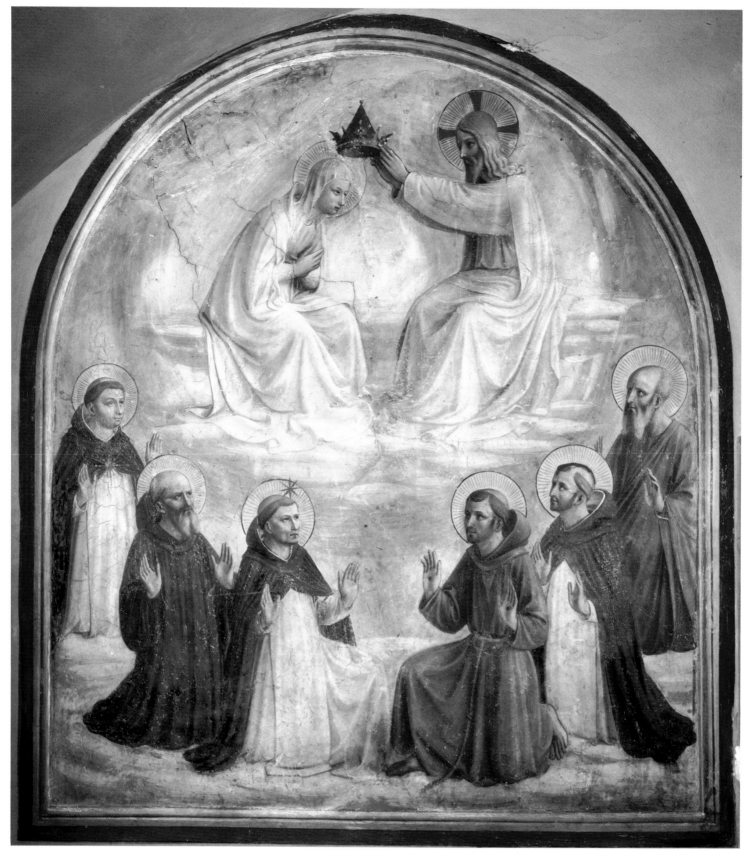

THE CORONATION OF THE VIRGIN. Cell 9, San Marco, Florence.

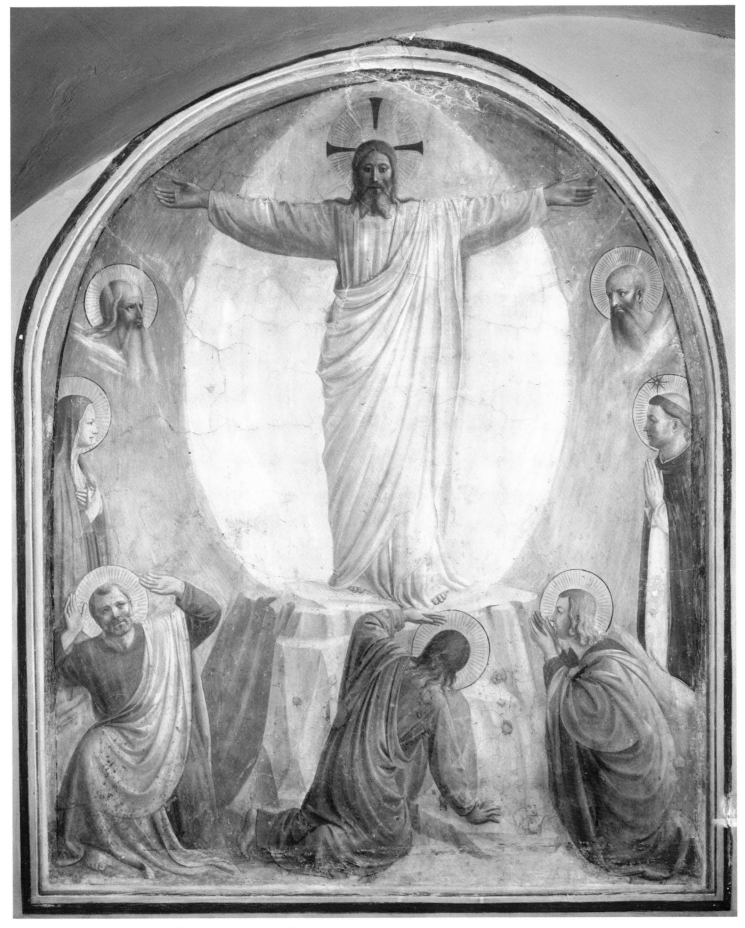

THE TRANSFIGURATION. Cell 6, San Marco, Florence.

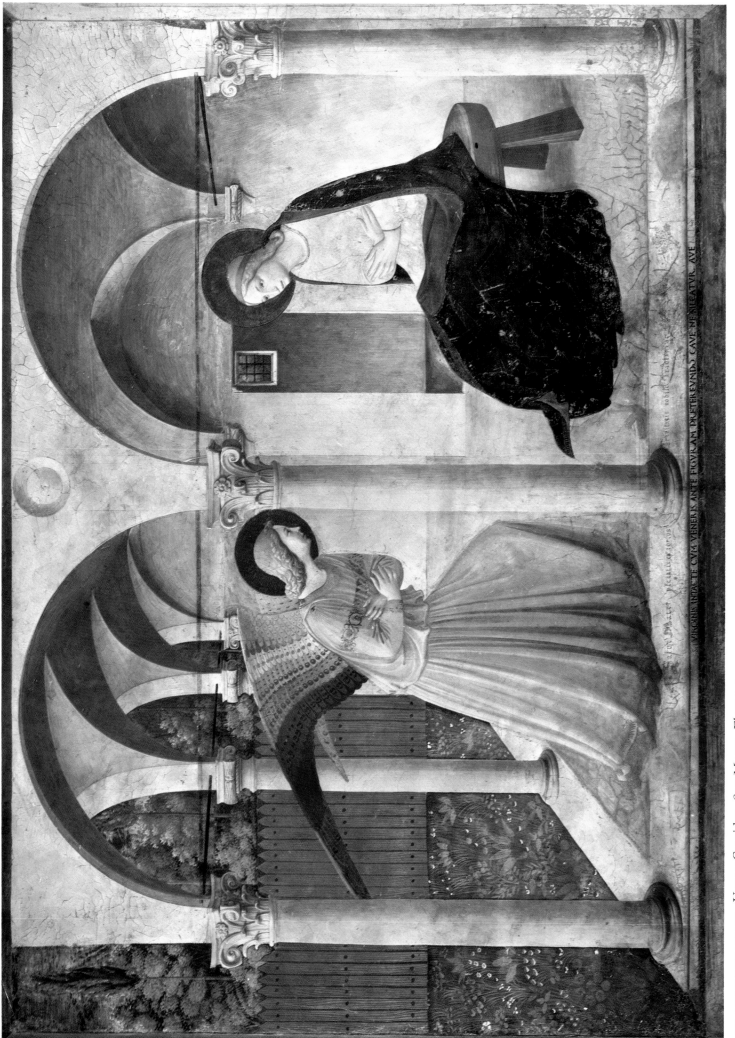

THE ANNUNCIATION. Upper Corridor, San Marco, Florence.

prior of San Marco, perhaps Sant'Antonino, who recommends the contemplation of devotional pictures as one of the reasons why the faithful should pay frequent visits to a church. But it is indicative of Angelico's contribution to this conception that the simplest and sparsest of the frescoes in the cells are those for which he was responsible, while those in which he had no hand revert, by some process of natural attraction, to the norm of fresco painting.

One of the finest of the autograph frescoes on the upper floor is the *Annunciation* in the third cell (Plate 76). Here almost all the characteristic features of the *Annunciation* at Cortona (Plate 18) and of the paintings based on it are abandoned in favour of a composition of the utmost severity. Instead of the Brunelleschan loggia of the earlier painting, with its garden and doorway leading into another room, it depicts a cell-like chamber closed by a blind wall, which has the double function of providing a background for the figures and of discouraging the mind from straying from the confines of the scene. It is characteristic of a tendency to eliminate extraneous detail that even the capitals of the two columns are covered by the angel's wings. Alberti in his theory of architecture distinguishes between beauty and ornament, the one deriving from a system of harmonious proportion, the other consisting of the columns and other ancillary decorative features of the building. Angelico's consistent avoidance in the frescoes in the cells of architectural features which Alberti would have considered ornamental, and his rigid adherence to a system of visual harmony, suggests that at San Marco he may have had some such distinction in mind. The Michelozzan vaulting above, realised with the finality of an abstract pattern, is not the least beautiful aspect of the fresco. In the figures the intimation of movement which contributes so much to the appeal of the earlier altarpiece is put aside, and the Virgin and Angel are treated like a sculptured group, restrained and motionless.

The *Noli Me Tangere* in the first cell (Plates 77–8) follows the same compositional procedure as the *Annunciation*. Once again the visual interest of the scheme depends on the relation between two figures in repose, and once again a flat surface, in this case a wooden paling, is used to isolate the head of the main figure. In the foreground is a plethora of minutely observed and carefully rendered flowers, grasses and trees. This scene is the only one of Angelico's cell frescoes into which there obtrudes the interest in nature that we find in the *Deposition* altarpiece (Plates 104–7) and other panel paintings. The composition of the *Nativity* in the fifth cell (Fig. 29), where the figures are backed by the firm rectangle of the stable and the heads of the Virgin and St. Joseph are set against a wicker door, once more recalls Angelico. The sixth cell brings us to what is in some respects the greatest of the frescoes, the *Transfiguration* (Plates 86–9), where the majestic figure of Christ, with arms outstretched in a pose prefiguring the Crucifixion, is outlined against a wheel of light. Beneath this splendid sculptural figure, there crouch the three apostles in poses instinct with astonishment and awe. The heads of Moses and Elias beneath the arms of Christ illustrate very clearly the strength of modelling of which Angelico was capable. The *Mocking of Christ* (Plates 80–1) shows the central figure seated, again in full face, against a rectangle of curtain, on which are depicted the symbols of his suffering. This use of emblematic iconography, for which precedents occur in the trecento, may have been dictated by the wish to avoid violent action and strong narrative interest in these frescoes. Few forms in the frescoes are realised with greater sureness and accomplishment than the white robe of Christ. Seated on a low step in the foreground are the contemplative figures of the Virgin and St. Dominic, the former wholly, the latter in part by the studio assistant responsible for the second, fourth and fifth scenes. This hand appears once more in the *Maries at the Sepulchre* in the eighth cell (Fig. 30), where the figure of the Virgin peering down into the tomb seems to have been designed, and the head of the angel was

almost certainly executed, by Angelico. In the left-hand corner of the fresco a praying figure of St. Dominic fulfils the same function as the St. Peter Martyr in the *Annunciation* (Plate 76). The *Coronation of the Virgin* in the ninth cell (Plates 84-5) is strikingly at variance with Angelico's earlier paintings of this theme, for the act of coronation is performed not, as in the painting in the Uffizi and the reliquary panel at San Marco, before a host of onlookers, but in isolation, with six kneeling saints who proclaim, but do not assist in, the main scene. Apart from these frescoes stands the much-restored lunette of the *Adoration of the Magi* in Cell 39 (Plate 71). In design and handling this fresco is more closely related to the *Crucifixion* in the Sala del Capitolo than to the frescoes in the cells. Not only are the figures once more deployed in a frieze along the front plane of the painting, but certain of them seem to have been executed by the same assistant who was responsible for parts of the larger scene. This assistant has been plausibly identified with the young Benozzo Gozzoli. A number of the poses used in the *Adoration* are anticipated in the predella of the San Marco altarpiece, and both the elaborate, studied composition and the light, decorative palette of the fresco are more secular in spirit than those in the frescoes in the other cells.

PANEL PAINTINGS: 1438-45

THE Dominican take-over at San Marco was by no means a simple operation. In addition to the Silvestrine claim to the convent, which was disallowed, a certain Mariotto de' Banchi exercised rights over the high altar and tribune of the church. In 1438 an arrangement was made whereby these were made over to the chapter and convent of San Marco, and were then presented by the community to Cosimo and Lorenzo de' Medici, who in turn paid a sum of five hundred ducats to the original owner. The Medici saints, Cosmas and Damian, were associated with St. Mark as titularies of the high altar. On the old altar there stood an altarpiece of the *Coronation of the Virgin* painted in 1402 by Lorenzo di Niccolò with a predella containing scenes from the lives of St. Mark and St. Benedict. It was agreed in 1438, at the instance of the Prior, Fra Cipriano, that this should be transferred to the convent of San Domenico at Cortona as a gift from Cosimo de' Medici, and in 1440 it was installed there, with the names of the Medici donors inscribed on it. The new high altarpiece was entrusted to Fra Angelico, presumably in 1438 when the decision was taken to do away with the old altar, and was not finished ('necdum perfecta erat') in 1440 when the old altar was moved. It must, however, have been completed before Epiphany 1443, when the church and high altar were dedicated, in the presence of Eugenius IV, by the Archbishop of Capua.

A letter written to Piero de' Medici by the young Domenico Veneziano in April 1438 refers to an altarpiece of great splendour which Cosimo was commissioning at that time. The passage reads: 'I have heard just now that Cosimo is determined to have executed, that is painted, an altarpiece, and requires magnificent work. This news pleases me much, and would please me still more if it were possible for you to ensure through your magnanimity that I painted it. If this comes about, I hope in God to show you marvellous things, even considering that there are good masters, like Fra Filippo and Fra Giovanni, who have much work to do.' In view of the coincidence of date, it is very possible that this letter refers to the San Marco altarpiece. Whether it does or no, there is abundant evidence that the commission was regarded as one of exceptional sig-

nificance. Not only was it a Medicean manifesto, the most important commission for a painting placed by Cosimo de' Medici up to that time, it was also the cynosure of the principal Dominican Observant church in Florence. It had, moreover, one other unusual aspect, that the architectural setting for which it was destined was under construction at the time the altarpiece was planned. The picture, or rather the complex of paintings, that resulted was a truly revolutionary work (Plates 48-55).

There are two impediments to an appreciation of the painting. The first is that a number of devices which appear in it for the first time were copied in many later paintings. The carpet in the foreground and the figures kneeling on it recur in the San Giusto alle Mura altarpiece of Ghirlandaio. The line of cypresses and palm trees seen at the back behind the wall was imitated by Baldovinetti in the Cafaggiolo altarpiece in the Uffizi. The looped gold curtains, which enclose the foreground like a proscenium arch, were adopted by Raffaellino del Garbo and Verrocchio. As we look at the main panel we have forcibly to remind ourselves that when it was conceived these expedients were original. The second impediment is that of physical condition; at some time in the past the surface was cleaned with an abrasive, and it is very difficult today to form a clear impression of its drawing, lighting or tonality. What is immediately apparent is that its spatial content is greater than that of any previous altarpiece. Whereas the *Madonna* of the Linaiuoli triptych fills a deep cupboard in the centre of the painting and the Saints in the Perugia polyptych are fortified by the presence of a table at the back which divorces them from their gold ground, in the San Marco altarpiece monumental use is for the first time made of advanced constructional principles. It is projected from a high viewing point, roughly in the centre of the panel, and the orthogonals of the beautifully rendered Anatolian carpet and the steep perspective of the cornice of the throne converge to a vanishing point in the main group. The recession of the unprecedentedly extensive foreground is established by the diminishing pattern of the carpet and by Saints Cosmas and Damian, who kneel in the front plane, one directing his gaze to the spectator and the other facing towards the Child. The planes which separate them from the throne are demarcated by three figures on each side, on the left St. Lawrence with hand raised in wonder and Saints John the Evangelist and Mark in conversation, and on the right St. Francis praying in profile between Saints Peter Martyr and Dominic. In the middle distance, in front of a gold-brocaded curtain, are set the Virgin and Child, flanked by four angels at each side. Behind the angels runs a wall covered with woven fabric, over which we see two palm trees and a grove of cedars and cypresses and between their trunks what must have been the most beautiful of Angelico's landscapes. Though the perspective devices are unostentatious—much more so than in the emphatic shallow structure of contemporary paintings by Fra Filippo Lippi like the *Coronation of the Virgin* in the Uffizi and the Barbadori altarpiece in the Louvre—they achieve a continuum of space greater than that in any earlier altarpiece. Of the lighting which once softened and unified the figures no more than a faint indication survives.

Two other aspects of the painting deserve mention. The first (which is best analysed by a Dominican scholar) is its programme. The volume of the Gospels held by St. Mark is open at Chapter VI, 2-8, which begins with the description of Christ teaching in the synagogue, and how his auditors 'were astonished, saying, From whence hath this man these things? And what wisdom is this which is given unto him, that even such mighty works are wrought by his hands?', and which close with an injunction to the apostles 'that they should take nothing for their journey save a staff only; no scrip, no bread, no money in their purse'. On the left, two of the saints reflect the astonishment of Christ's hearers in the synagogue, and opposite are representatives of the two

orders which observed the rule of apostolic poverty. Round the edge of the Virgin's robe is a quotation from *Ecclesiastes*, and *Ecclesiastes* is again the source of the palm-trees, cedars and cypresses at the back and of the rose garlands which hang behind the curtains at the front. The second aspect of the altarpiece that should be noted is its highly charged emotional character. The only area in which some impression of this can still be gained is the head of Saint Cosmas, which strikes a note of pathos that is absent from earlier Renaissance paintings. Its implications are underlined in the small *Crucifixion* at the base, which originally surmounted the central panel of the predella with the *Lamentation over the dead Christ*.

The artistic complexion of the altarpiece can be read more clearly in the predella panels (Plates 56-65), of which all but the first, the *Healing of Palladia by Saints Cosmas and Damian* in Washington (Fig. 36), are well preserved. Probably the panels were painted in the sequence in which they stood on the altar, since the first of them is relatively conventional—it makes use of the same constructive principles as the two Dominican scenes beneath the pilasters of the *Annunciation* at Cortona—and in the second, the *Saints before Lycias*, where the architectural setting is planned with greater boldness, there is a miscalculation in the scale of two figures on the right. In the third panel, *Lycias possessed by Devils and Saints Cosmas and Damian thrown into the Sea*, the two scenes, one in the foreground isolated by a wall, the other at the back, are integrated with complete assurance. The figure of Lycias is invested with the same diagonal thrust as the figures on the right of the Linaiuoli *Martyrdom of Saint Mark* (Plate 31), and the depiction of the water at the back, in the centre, where the bodies of the Saints throw up a shower of spray, and on the left, where they are seen partly submerged, show an intensity of natural observation the only precedent for which is in Gentile da Fabriano. In its unification of distant and rear planes and its luminous representation of distant architecture this panel marks a significant advance on the scene of *Saint Nicholas saving three men condemned to execution* at Perugia (Fig. 24c). It is, however, less brilliant and authoritative than the *Attempted Martyrdom of Saints Cosmas and Damian by Fire*, where the group of Saints in the centre and the figures of the executioners behind them are silhouetted against a distant wall aligned on the projection plane. The ring of flames and two soldiers in the foreground whom they consume are depicted with unprecedented vividness. The palace in the background on the left confirms the evidence of the preceding panel, that at this time Angelico mastered or developed a system of projection more consistent and more advanced than that used in his earlier works. The device of a flat surface parallel with the front plane of the painting is employed again, in a somewhat different form, in the *Crucifixion of Saints Cosmas and Damian*, where it is established by a distant city wall, with the five Saints above it, two raised on crosses and three tied to a crossbeam between them. The distant landscape in this panel gives some impression of the effect the background of the main panel of the altarpiece must originally have made. In the *Decapitation of Saints Cosmas and Damian* the flat plane, which had become an indispensable feature of the panels, is established not by architecture, but by a row of cypress trees. The distant city on the left recalls that in the St. Nicholas predella at Perugia, but since the scene is lit from the right not from the left, those faces of the wall which were in shadow in Perugia are brightly lit and those faces which were illuminated are in shadow. Structurally the most remarkable of the narrative scenes is the *Burial of Saints Cosmas and Damian*, where the grave is represented in perspective, like the open graves in the *Last Judgment* (Fig. 2), but is integrated in an architectural scheme of great complexity, which anticipates that of Domenico Veneziano's *Miracle of St. Zenobius*. Along with the last scene, the *Dream of the Deacon Justinian*, it represents the summit of spatial sophistication achieved in Angelico's pre-Roman works.

A BYSTANDER. Detail from *The Deposition* (Plate 98). Museo di San Marco, Florence.

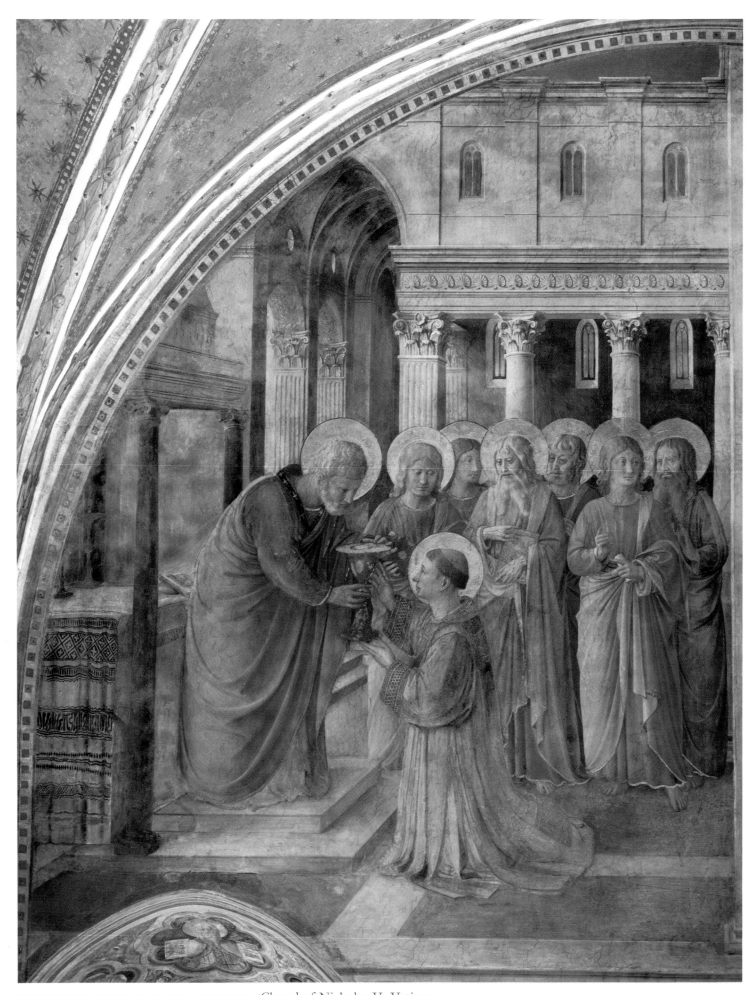

THE ORDINATION OF SAINT STEPHEN. Chapel of Nicholas V, Vatican.

Somewhat apart from the narrative panels stands that in the centre with the *Lamentation over the dead Christ* (Plate 65), which is conceived with an incomparable combination of logic and sentiment. The flat plane is here established by a rectangular void over the tomb, against which Christ's body, supported by Nicodemus, is shown with arms raised horizontally by the adoring figures of the Virgin and St. John. Under it is the receding rectangle of the winding sheet, where the delicate naturalism of the folds and of the shadow cast by Christ's body surpasses that in any earlier work. Like the companion panels, the scene is illuminated from the right, but from a lower level, so that the beautifully rendered torso and the upper surfaces of the hands and forearms are strongly lit.

In the first half of the fourteen-forties the style of the San Marco predella was deployed on a larger scale in an altarpiece of the *Deposition*, now in the Museo di San Marco, executed for the Strozzi chapel in Santa Trinita (Plates 98–107). Painted on a single panel, the *Deposition* is surmounted by three finials by Lorenzo Monaco. In shape it recalls another altarpiece painted for Santa Trinita, the *Adoration of the Magi* of Gentile da Fabriano, and this, in conjunction with Lorenzo Monaco's close association with the church, suggests that it may originally have been commissioned from the older artist. Though the composition is deployed across the entire panel, the figures fall into three separate groups. In the centre the body of Christ is let down from the cross. As in the *Lamentation* panel from the San Marco altarpiece, the Christ is shown with arms outstretched, filling the whole of the centre of the scene. One of the two figures letting down the body, the Nicodemus, is said by Vasari to represent the architect Michelozzo. But if Michelozzo is portrayed, this is more probably in the head of a man wearing a black *cappuccio* below the Christ's right arm. Beneath, the body is received by an older male figure and by St. John. The group is completed by the Magdalen, kissing the feet of Christ, and by a kneeling Beato, perhaps the Beato Alessio degli Strozzi. Like the kneeling saints of the San Marco altarpiece, this figure, with eyes fixed on the central group and hand extended towards the onlooker, marks the transition from the real world of the spectator to the false world of the picture space. In the halo of Christ appears the words CORONA GLORIE, and below is a quotation from the eighty-seventh Psalm: ESTIMATVS SVM CVM DESCENDENTIBVS IN LACVM. To the left are the holy women, in their centre the Virgin kneeling behind the winding sheet, and on the right is a group of male figures, one of whom exhibits the nails and crown of thorns. In the halo of the Virgin are the words: VIRGO MARIA N(ON) E(ST) T(IBI) SIMILIS, and beneath is the inscription: PLANGENT EVM QVASI VNIGENITVM QVIA INOCENS, while under the right side of the painting appears the verse: ECCE QVOMODO MORITVR IVSTVS ET NEMO PERCIPIT CORDE. The deliberate avoidance of the realistic detail proper to a normal narrative of the Deposition, the tender gestures with which the figures in the centre perform their ritual, and the restraint of the spectators, consumed by inner sorrow which finds expression in sympathetic lassitude rather than in rhetoric, are explained by the inscriptions, which lend the painting the character of a homily rather than of a narrative. The crown of glory won by the sacrifice of Christ, the sorrow of the Virgin with which no human sorrow can compare, the lament of the women for the innocent victim on the Cross as for their only sons, and the body of the Saviour, instinct with the promise of the Resurrection,—all these are phases in a meditation on the sufferings of Christ.

The *Deposition* is at the same time a work of great intellectual inventiveness. Confronted by the Gothic panel prepared for Lorenzo Monaco, Angelico fills it with a composition which makes scarcely the least concession to its form. At the sides the scene is closed by standing figures whose verticality is accentuated on the left by the tower of a distant building and on the right by a tree.

In the centre likewise the design is strongly vertical, and is established by the ladders standing against the Cross, by the right arm of Nicodemus lowering the body, and by the upright figure of Saint John. The body of Christ is set diagonally against the flat plane of the ladders, with the arms on an opposite diagonal and the head resting on the left shoulder, so that the long bridge of the nose is depicted horizontally, parallel to the steps of the ladders and the arms of the Cross.

An interesting feature of this painting are the intact pilasters, which are painted on the front and sides with twelve full-length figures of Saints and eight medallions. The Saints stand on gilded plinths, which are adjusted to the place they were designed to occupy. Thus on the left pilaster at the front the plinth of St. Michael is depicted from beneath, with the upper surface hidden, and in that of St. Andrew, in the centre, part of the upper surface is shown, while the lowest, that of San Giovanni Gualberto, is represented from above. An important group of dispersed pilaster panels of this type survives, with figures of Saints Jerome, Bernard, Roch, Thomas Aquinas, Benedict and Anthony the Abbot. Though they stand on cloud, they are represented essentially in the same way as the Saints in the pilasters of the *Deposition*; those at the bottom (Jerome and Roch) are depicted from a high viewing point, with feet and ankles exposed, with that from the centre (Thomas Aquinas) only the feet are visible, and with those from the top (Benedict and Bernard) the feet are concealed by clouds. It is likely that these panels formed part of the pilasters of the San Marco altarpiece. This is the more probable in that Saint Thomas Aquinas is omitted from the main panel. There is, moreover, a tradition that three of the panels, at Altenburg, come from San Marco.

Immediately before he left for Rome, Angelico seems to have undertaken a second Medicean altarpiece. Now in the Museo di San Marco, it shows the Virgin and Child with Saints Peter Martyr, Francis, Lawrence, John the Evangelist and Cosmas and Damian, and is commonly known as the Annalena altarpiece (Plates 96-7). The Dominican convent of San Vincenzo d'Annalena was, however, founded only in 1450, was not rebuilt till 1453, and had no substantial oratory till after 1455, and we are bound therefore to suppose that the painting was commissioned for some other purpose and was transferred to the convent in the fourteen-fifties after the painter's death. Support for this view is afforded by the fact that the altarpiece omits the Saints, Vincent Ferrer and Stephen, to whom the convent church was dedicated. It has repeatedly been claimed (not least in the first edition of this book) that the altarpiece was painted in the fourteen-thirties and precedes the high altar of San Marco. For a number of reasons this cannot be correct. First, the concentrated composition must follow, and not precede, that of the San Marco altarpiece. The system of projection used in it is essentially the same, and one device, the use of a curtain stretched across the back to isolate the figures, is common to both paintings, but in the Annalena altarpiece the front step of the throne is extended to a forward plane, and the six Saints are grouped on two levels at the sides. Second, the architectural background, with its central tabernacle and arcaded wall unified by a common moulding at the top, would be inexplicable in the context of the Cortona and Perugia polyptychs. Third, the predella, originally consisting of a central *Pieta* and of eight scenes from the legend of Saints Cosmas and Damian, of which seven survive (Fig. 37), though not designed or executed by Angelico, makes use, in the figures on the left of the *Saints before Lycias*, in the onlookers at the back of the *Attempted Martyrdom by Fire*, and in the winding river of the *Decapitation* scene, of motifs which are manifestly drawn from the predella of the San Marco altarpiece. The hand responsible for these seven panels is the same that painted the *Annunciation* altarpiece at Montecarlo (Fig. 11), and, on the strength of illuminated manuscripts produced in the late fourteen-forties and early fourteen-fifties, may tentatively be regarded as Zanobi

Strozzi's. The fact that Angelico did not himself intervene in the predella, even to the extent of supplying the cartoons, suggests that at the time he moved to Rome only the main panel can have been complete.

ROME, 1445-9

In the second half of 1445 Angelico was summoned to Rome by Pope Eugenius IV to undertake frescoes in the Vatican. A sponsor of the Observant Movement, the Pope had lived for upwards of nine years in Florence, and in 1443 was himself present at the consecration of San Marco, when 'for the consolation of the friars in the convent he remained there the whole day, and spent the night in sleep in the first cell looking over the second cloister, which is now called the cell of Cosimo'. Whether or not the *Adoration of the Magi* in this cell was completed at the time of the Pope's visit, Eugenius must have been familiar with the painter and with his works in Florence.

The Rome of 1445 was no longer the desolate city to which Pope Martin V had returned a quarter of a century before. The pagan Pantheon had been restored, and a long line of artists from Central and North Italy—Masaccio and Masolino in San Clemente and Santa Maria Maggiore, Gentile da Fabriano and Pisanello in the Lateran basilica, Donatello and Filarete in St. Peter's—had left their mark upon its monuments. The Vatican, however, was not as yet the main focus of activity for artists in the papal city, and the work in the palace carried out by Fra Angelico forms the opening phase in a campaign of decoration and improvement that was to be pursued uninterruptedly until the Sack of Rome. At the Dominican convent of Santa Maria sopra Minerva, where he resided while in Rome, Angelico may have come in contact with the painter Jean Fouquet, or 'Giacchetto francese' as he was known to Filarete, who was engaged at some uncertain date between the autumn of 1443 and the winter of 1446 in painting a portrait of Eugenius IV to commemorate the Pope's election at a conclave held in the convent in 1431.

There is no direct evidence as to the task on which Angelico was engaged in 1445 and 1446, but it can be inferred that this was almost certainly the Cappella del Sacramento or Chapel of St. Nicholas, which was destroyed in the sixteenth century by Paul III. The chapel was rebuilt by Eugenius IV, and according to the Codice Magliabechiano and to Vasari, contained frescoes by Angelico. It was, says the Anonimo Magliabechiano, 'veramente un paradiso, con tanta gratia et honesta erano dipinte dette fi(g)ure. Come anchora qualche parte, che venne restata, si può vedere.' According to Vasari, it contained 'alcune storie della vita di Gesù Cristo'. Unfortunately Vasari also tells us that the frescoes contained a number of portraits which were excised by Paolo Giovio for his museum, and that among them were representations of Pope Nicholas V, the Emperor Frederick III, Flavio Biondo, Sant'Antonino and Ferrante of Aragon. The presence of these portraits would be most readily consistent with a later dating—the Emperor Frederick III, for example, visited Rome only in the spring of 1452—and it has been assumed for this reason that the chapel was painted during Angelico's last years in Rome in 1453-5. There is, however, nothing to show that at that time Angelico was again active in the Vatican, and we are bound to suppose either that the information about the portraits is incorrect and that the whole chapel was frescoed in 1445-7, or that its decoration was begun under Eugenius IV, was interrupted at the Pope's death, and was completed at some later date.

Eugenius IV died on 23 February 1447, and his successor Nicholas V was elected Pope on

6 March. The documents referring to Angelico's work in the Vatican under the new Pope are more explicit than some writers on the artist have supposed. Between 9 May and 1 June 1447 three documents refer to payments for work 'nela chapella di s° Pietro'. In May an arrangement was made, no doubt with the Pope's sanction, whereby Angelico spent the summer months at Orvieto, decorating the Cappella di San Brizio in the Cathedral. During June, July, August and the first half of September the master and his assistants were employed upon this work. The document from which we learn the terms of this commission is dated 11 May 1447, and mentions in parenthesis that at this time Angelico was engaged in painting the 'capellam Smi. D.N. in palatio apostolico sancti Petri de Urbe', or the Pope's private chapel in the Vatican. In view of the coincidence of date, we are bound to assume that this is identical with the commission referred to in the Roman documents, and that the term 'chapel of St. Peter' is an abbreviation of the full title given in the Orvieto contract, the 'chapel of His Holiness Our Lord the Pope in the apostolic palace of St. Peter's'. There can thus be no reasonable doubt that the only surviving work painted by Angelico in Rome, the frescoed decoration of the Chapel of Nicholas V in the Vatican, was under way in the spring of 1447. The decoration of the chapel was probably completed by the end of 1448, for by 1 January 1449 Angelico was engaged on another apartment in the Vatican, the 'studio di N.S.' or study of Nicholas V. This room, which had the double function of workroom and library, seems to have been adjacent to the chapel. Work in the study must have been less extensive than in the chapel, and it appears to have been well advanced by June 1449, when Gozzoli, Angelico's principal assistant, returned to Orvieto, and to have been completed by the end of the year or the first months of 1450 when Angelico returned to Florence.

Throughout his years in Rome Angelico must have been on terms of intimacy with the Pope in whose apartments he was employed. As Tommaso Parentucelli, Nicholas V had won fame as a scholar and bibliophile, and during his pontificate the papal court at Rome became a centre of humanistic studies. 'All the scholars of the world,' writes Vespasiano da Bisticci, 'came to Rome in the time of Pope Nicholas, some of them on their own initiative, others at his invitation since he wished to see them at his court.' 'Under what pontiff,' asks Birago in his *Strategicon adversus Turcos*, 'was this throne more splendid or magnificent?' The humanistic interests of Nicholas V found expression in his patronage of architecture and in his conservation of the monuments of Rome, and led to the commissioning of Piero della Francesca's lost frescoes in the Vatican. In addition to Angelico, two Umbrian painters, Bartolommeo di Tommaso da Foligno and Benedetto Bonfigli, were also employed at the papal court. For Angelico, trained in the sequestered precincts of San Domenico under the gaunt shadow of Dominici, the court of Nicholas V, with its wide intellectual horizons, represented a new world, the impact of which can be traced in the frescoes in the papal chapel.

They fill three sides of a small room, and consist of three lunettes, containing six scenes from the life of St. Stephen, and three rectangular frescoes beneath, containing five scenes from the life of St. Lawrence (Plates 108-23). Flanking the frescoes on the lateral walls are eight full-length figures of the Fathers of the Church, and on the roof are the four Evangelists. Beneath the frescoes are traces of a green textile design, which originally filled the lower part of the wall surfaces. The scheme was completed by an altarpiece of the *Deposition*, which was noted by Vasari but has since disappeared. The idiom of the frescoes in the Vatican is strikingly different from that of the frescoes at San Marco. In wealth of detail and variety of incident, in richness of texture and complexity of grouping, they violate the canons of the earlier scenes. But if we had to reconstruct the probable appearance of a fresco by the author of the San Marco predella, our mental image would

resemble the frescoes in the Vatican more closely than those in the convent cells. Not only was the style of the San Marco frescoes governed by considerations which did not apply to the frescoes in the Vatican, but the narrative problem of the Vatican frescoes was, of its very nature, more intimately linked with Angelico's predella panels than with his frescoes. Hence it is wrong to regard the discrepancy between the fresco cycles as a measure of Angelico's development. In the normal course the lunettes above would have been painted before the scenes below. The upper frescoes are divided vertically in the centre by a wall serving a dual function in relation to the two parts of the scene. Thus the raised platform on which the *Ordination of Saint Stephen* takes place is continued in the contiguous scene of *Saint Stephen distributing Alms* (Plate 108); the background of towers and houses in the *Saint Stephen preaching* is common also to the *Saint Stephen addressing the Council* (Plate 109); and a single strip of landscape unifies the *Expulsion of Saint Stephen* and the *Stoning of Saint Stephen* (Plate 110). This consecutive narrative has no counterpart in the lower cycle, where each scene is independent of the next and three of the designs are centralised. Whereas the upper scenes have something of the character of enlarged predella panels, the scenes below establish a type of composition which remained constant in Florentine painting till the time of Ghirlandaio.

At the time the Saint Stephen frescoes were begun, Angelico had been in Rome for between twelve and eighteen months, and the change which this effected both in his style and in his architectural preconceptions is apparent in the first lunette, where the background of *Saint Stephen distributing Alms* is recognisably by the same artist as the *Burial of Saints Cosmas and Damian* in the predella of the San Marco altarpiece (Plate 63), while in the scene on the left, *The Ordination of Saint Stephen*, the setting takes on a strongly Roman character. Typically Roman are the ciborium over the altar before which Saint Stephen kneels and the columnar basilica depicted at the back. The stooping figure of St. Peter and the Saint kneeling in profile are isolated in a forward plane, and behind, in the space between the altar steps and the columns of the nave, are six apostles, posed with the confidence and fluency of the saints in the Annalena altarpiece. Not the least unusual feature of this beautiful design is the use of the patterning of the floor to establish the axis of the scene.

The scene of *Saint Stephen preaching* in the second lunette (Plate 109) makes use of a rather different procedure, in which figures are deployed through the whole depth of the constructed space, and contrasts with the right half of the fresco, where the scene of *Saint Stephen addressing the Council* takes place in a low hall closed by a curtain on the wall behind. Here the figure of the Saint is turned inwards, and the orthogonals of the pavement lend force to the gesture of his raised right hand. The third lunette (Plate 110) is divided by the city wall, which curves round at the back of the left scene, and like the figures and the distant landscape is illuminated from the right. The figures occupy the foreground of both scenes, and are dominated on the right by the kneeling figure of the Saint and on the left by the beautifully conceived figure of the Saint forcibly conducted through the gate. The landscape develops from the landscape of the *Deposition*, but is at once more panoramic and less intimate; in this it recalls the distant landscape of the predella panel of the *Visitation* at Cortona (Plate 22b). In the use of trees on the right to establish the recession of the planes it owes something to the background of Masaccio's *Tribute Money*, and in the cosmic vision of the hill town on the left it recalls Masolino's *Crucifixion* fresco in San Clemente.

The scenes from the life of Saint Lawrence beneath mark the climax of Angelico's surviving work in Rome. Perhaps the most impressive of them is the first, which is set between the windows of the Chapel and can therefore be read as a self-consistent unit without reference to a companion

scene. The act of ordination (Plate 111) takes place in a columnar basilica of the type represented in the background of the *Ordination of Saint Stephen*, but here depicted from a cross section of the nave with five columns at each side receding to a central niche behind. The figures are not centralised, and the only feature in the foreground that is set decisively on a vertical through the vanishing point is the chalice extended by Pope Saint Sixtus II to the kneeling Saint. The Pope is represented with the features of Nicholas V and thus provides a precedent for the papal portraits incorporated in the Stanza della Segnatura and elsewhere in the Vatican. The second centralised fresco, *Saint Lawrence distributing Alms* (Plate 112), is treated rather differently. The nave, seen through the bold rectangle of the church entrance, is no more than a background, and the apse behind is used to lend emphasis to the figure of Saint Lawrence, who is shown forward of the façade in the centre of the scene. The figures in the *Ordination* scene and the figure of the Saint in the *Almsgiving* fresco (Plates 119-20) are treated with new plastic emphasis.

No attempt is made to link the *Saint Lawrence distributing Alms* to the scene of *Saint Lawrence receiving the Treasures of the Church* to its immediate left, though the main action in both scenes takes place in the same plane. The *Saint Lawrence before Valerianus* and the *Martyrdom of Saint Lawrence*, on the other hand (Plate 113), are connected by a cornice, which runs across the whole width of the two scenes. Visually this is not a wholly satisfactory device, the less that the two scenes are not artificially divided from each other, like the paired scenes which precede them, but are separated by the episode of the conversion of the jailer Hippolytus, seen through a window in the centre. The *Martyrdom* is the most seriously damaged of the frescoes. Its scheme goes back to that of *The Attempted Martyrdom of Saints Cosmas and Damian by Fire* (Plate 61), where the line of spectators above and behind the scene of martyrdom originates. The field occupied by the fresco is considerably less high than of the contiguous scene, and there must, from the outset, have been an awkward disparity of scale between them, but at least two of the executioners, and especially that on the left with green tights and a mustard-coloured shirt, are executed with great vigour and veracity.

Throughout these frescoes there was, to a greater extent than in any of Angelico's earlier commissions, a premium on enrichment. This is manifest in the architecture, which is less closely related to reality than that in the San Marco predella or in the earlier frescoes and reflects the influence of Alberti. A curious feature which recurs throughout the frescoes is the depiction of pilasters whose surfaces are covered with foliated ornament; these are related neither to classic pilasters nor to pilasters carved in the second quarter of the fifteenth century. The effect of the architecture is, moreover, weakened by colouristic emphasis. Whereas the buildings in the *Burial of Saints Cosmas and Damian* from the San Marco altarpiece (Plate 63) are devoid of local colour, those in the Chapel of Nicholas V are diversified, like the architecture in Masolino's frescoes in San Clemente, with contrasting passages of pink. An extreme instance of this ambivalence is the fresco of *Saint Lawrence receiving the Treasures of the Church*, where the building on the left, largely by virtue of its colouring, makes an effect of artificiality, while on the right the distant vision of a cloister seen through an archway is portrayed with Angelico's customary veracity.

The factor of restoration makes it difficult to determine the exact extent of Angelico's responsibility for the two cycles. It has been suggested that the right half of the first and the whole of the third lunette were executed solely by assistants, and one student has gone so far as to deny Angelico's authorship of the cartoons of all of the six upper scenes. Both these views imply some measure of misunderstanding of the procedure by which the frescoes were produced. A document of 1447 records the names of the painters employed in the chapel under the direction of Angelico.

These are Benozzo Gozzoli, who received a higher salary than his companions and was evidently the master's chief assistant, Giovanni d'Antonio della Cecha, Carlo di ser Lazaro da Narni, and Giacomo d'Antonio da Poli. Three of these painters were again associated with Angelico at Orvieto, where one of them, his nephew Giovanni d'Antonio della Cecha, met with a fatal accident. Of the junior members of the studio we know nothing. But the senior member, Benozzo Gozzoli, has left us a dated work at Montefalco painted two years after the completion of the chapel in the Vatican. With a group of cognate works, this enables us to assess, at least approximately, his share in the Vatican frescoes. This was apparently limited to single heads and figures (three in the background of the first of the scenes from the life of St. Stephen, three in the second, a number of the seated women in the third, two standing figures in the fourth, three figures in the fifth, and four heads in the sixth), and there is no case in which we would be justified in crediting Gozzoli with the whole of any scene. The three assistants paid at a lower rate would have been employed largely on the backgrounds and drapery, though one of them seems to have intervened from time to time in certain of the heads; this hand appears again in Cell 36 and the related frescoes at San Marco. The figure of the Saint is invariably by Angelico. As we would expect, the share of Angelico is smallest in the relatively unimportant frescoes on the chapel roof.

Beside the frescoes in the Vatican, the work completed by Angelico during his fourteen-week residence at Orvieto has attracted comparatively little interest. Engaged at the same salary as in the Vatican to paint for three months a year in the Cappella di San Brizio in the Cathedral, where the venerated corporal of the miracle of Bolsena was preserved, he filled two of the four triangular spaces on the ceiling of the chapel with a *Christ in Majesty with Angels* and *Sixteen Prophets* (Plates 124-5). Angelico's part in these frescoes was smaller than in the Vatican, and seems to have been limited to the much damaged figure of Christ and a group of angels on the left of the first fresco and to the heads of a number of the seated prophets in the second. A receipt of September 1447 shows that the assistants engaged upon this work were the same as those employed in Rome. The fact that two spaces so large could be painted in three and a half months throws some light on the speed at which Angelico operated, and it is clear both in the Vatican and at Orvieto that the collaborative effort of his studio was the condition of his productivity. The contract for the frescoes must have been abrogated by 1449, when Gozzoli, who was working in Orvieto from July to December of this year, attempted to obtain the reversion of the commission. Forty years later Perugino was invited by the authorities of the Cathedral to complete the decoration of the chapel, and in 1499 this was at length entrusted to Signorelli. Criticism has tended to concentrate on the uneven handling of the ceiling frescoes of Angelico, and to underrate their spacious compositions and their noble forms.

LATE WORKS: 1450-5

IN documentary terms little is known of Fra Angelico's activity between 1449 or 1450, when he returned to Fiesole as Prior, and 1455, when he died in Rome. Probably the first works he painted in Florence after his return were two frescoes in the upper corridor at San Marco, the *Annunciation* and the *Virgin enthroned with eight Saints* (Plates 90-5). In the *Annunciation* the simple Michelozzan architecture of the *Annunciation* in Cell 3 is replaced by heavier columns with foliated capitals of a type which recur in the *Ordination of Saint Stephen* in the Vatican, and the figures are disposed

on a diagonal, not as in the cell fresco and the altarpieces on a single plane. It has sometimes been suggested that this fresco is the work of an assistant, but the setting and the placing of the figures in it speak strongly against this view. In the second fresco the screen behind is articulated with pilasters which again recall the *Ordination of Saint Stephen*, and the Virgin's seat is placed well forward of the throne. This new spaciousness in the design and the new equilibrium between the figures and their background are found again in an altarpiece in the Museo di San Marco (Plate 126), which can be shown, on grounds of iconography, to have been executed after Angelico's return to Florence.

This was a commission from Cosimo de' Medici, and was designed for the high altar of the Franciscan church of San Buonaventura at Bosco ai Frati, not far from Cafaggiolo, which had been rebuilt by Michelozzo in the fourteen-thirties at Cosimo's charge. The date of the altarpiece is established by its predella, which contains a *Pieta* and six half-length figures of Saints, among them San Bernardino, who was canonised only in 1450. The altarpiece must therefore have been painted after that year. It differs from the Annalena altarpiece in that the Virgin sits not on an architectural throne, but on a wide seat set on a middle plane. Behind her are two angels, whose types and dresses recall those of the angels in the Orvieto vault, and in the foreground are six Saints, on the left Saints Anthony of Padua, Louis of Toulouse and Francis, and on the right Cosmas and Damian and Peter Martyr. The marble screen behind recalls the frescoes in the Vatican. In the centre is a niche of exceptional width, and at the sides are narrow arched recesses, where the relation of height to width is similar to that of the recesses in the wall behind the *Martyrdom of Saint Lawrence*. In the closely calculated composition Angelico transposes to panel painting the style he had evolved in Rome.

More problematical is the case of a second altarpiece, the *Coronation of the Virgin* in the Louvre (Plates 127-9), which seems to have been executed at this time. It was painted for San Domenico at Fiesole, and there has always been a consensus of opinion that it was produced either before 1430 or between 1430 and 1438. If that were correct, the adoption, for the pavement in the foreground, of a low viewing point would be the main fact to be explained, since this system of projection appears in Florence only in the fourteen-forties in Domenico Veneziano's St. Lucy altarpiece. The visual evidence suggests that the altarpiece must have been planned at a considerably later time. One of the features most often cited as proof of its early date is the Gothic tabernacle of the throne. The only true analogy for the tabernacle, however, occurs in a late work, the chapel in the Vatican, where the Fathers of the Church are depicted beneath canopies of the same kind. True, the canopy in the altarpiece is supported on spiral columns, not on flat pilasters, but the pilasters above the capitals (and a very odd architectural feature they are) are the same in both, and so are the three front faces of the canopy. This dating is corroborated by the angels, who stand so stolidly beside the throne, their curls carefully crimped and their dresses starched in prim regular folds. They have little in common with the angels beside the throne in the San Marco altarpiece, but find an evident parallel in those in the frescoed vault of the Cappella di San Brizio at Orvieto, which were painted in the summer of 1447, in part by Angelico and in part from his cartoons.

A distinguished critic of Italian painting has described the *Coronation of the Virgin* as 'one of the few works in which Fra Angelico was thrown off his stride by strenuous efforts to keep up with the innovations around him'. The truth is rather that the artistic problem presented by the altarpiece was insoluble within the limits of the system of space projection Angelico employed. In the earlier *Coronation of the Virgin* from Santa Maria Nuova (Plate 34), the Saints at the sides sweep back in steady diminution till they reach the distant angels, and the figures of Christ and the

THE BOSCO AI FRATI ALTARPIECE: The Virgin and Child enthroned with two Angels and Saints Anthony of Padua, Louis of Toulouse, Francis, Cosmas, Damian, and Peter Martyr. Museo di San Marco, Florence.

THE MASSACRE OF THE INNOCENTS. Museo di San Marco, Florence.

Virgin, though smaller in size than the figures in the foreground, receive, by virtue of their isolation, appropriate emphasis. For Angelico about 1450 such a solution would have been unacceptable, and there was no alternative but to transfer the scene from notional space to real space like that of the San Marco altarpiece. If this were done, however, a steeply shelving foreground like that of the San Marco altarpiece would have been a liability since it would have given undue prominence to the foreground figures and insufficient prominence to the figures at the top. The solution Angelico adopted, therefore, was a compromise. The viewing point was lowered—Domenico Veneziano's St. Lucy altarpiece was already in existence to prove how that could best be done—the foreground was projected on the new system, the canopy was portrayed from underneath, and the intervening area of the steps was filled in empirically. This is the only one of Angelico's large paintings in which the vanishing point and the narrative focus do not correspond, though the jar of ointment held out by St. Mary Magdalen, like the chalice in the *Ordination of Saint Lawrence* in the Vatican, falls on a central vertical.

The *Coronation of the Virgin* suffers from extensive studio intervention, especially on the right-hand side. To take three examples only, the weakly drawn wheel held by St. Catherine, the tilted head of the female figure on the extreme right, and the blank-faced deacons above would be unthinkable in an autograph work. The artist who intervened in this part of the panel was also responsible for some of the pilaster panels of the *Deposition* in the Museo di San Marco. The parts painted by Angelico, and especially the figures of Christ and the Virgin, are, however, of great distinction. Probably the altarpiece was still unfinished when Angelico died. Something of the kind is suggested by the predella, in which he had no share. It contains scenes from the life of Saint Dominic, which depend from a much earlier model, the predella of the polyptych at Cortona. In the predella at Cortona (which was painted from Angelico's designs by a studio hand) the figures are silhouetted against flat wall surfaces. In the predella of the *Coronation of the Virgin* (Fig. 42), on the other hand, there is a marked preference for receding compositions, and even in the last panel, which represents not the death of Saint Dominic as at Cortona but the dying Saint enjoining the discipline of voluntary poverty, the artist avoids the expedient of a wall parallel to the projection plane. Decisive proof of the presence in the predella of a second mind, and not simply of a second hand, is offered by the central panel of the *Pieta* (rather a trivial, Gozzoli-like *Pieta* where the Virgin and Saint John seated in the foreground are smaller in scale than the dead Christ, the sword and lance tip slightly outwards, and the body of Christ is lit with hesitancy, almost with timidity) which differs in kind as well as quality from the sublime *Entombment* in the San Marco altarpiece. More than this, the scenes cannot be reconciled with the only fully authenticated late narrative panels by the Angelico we know, a cycle of scenes from the life of Christ painted for the Annunziata, now in the Museo di San Marco.

These panels (Figs. 43-4; Plates 130-8) are assumed, on the strength of a passage in the chronicle of Benedetto Dei, to have been commissioned by Piero de' Medici as the doors or shutter of the cupboard containing offerings in precious metal presented to the shrine of the Virgin Annunciate. The commission was bound up with a project for developing an oratory for Piero de' Medici's use between the chapel of the Virgin Annunciate and the convent library, and since the oratory was not roofed over till 1451 it is likely that the commission dates from this or the preceding year. The last payment relating to this phase in the production of the silver chest dates from 1453. Probably at this time what was envisaged were two doors opening outwards, but at a later stage, in 1461-3, the conception seems to have been revised, and the panels were incorporated in a single shutter hoisted by a pulley. In the form in which they are preserved, they consist of thirty-five scenes,

but they may originally have comprised an even larger number, since, with one exception, the groups of panels read from left to right. The exception is the three scenes of the *Marriage Feast at Cana*, the *Baptism of Christ* and the *Transfiguration*, where the sequence runs from top to bottom; these are likely to be the concluding scenes from a block of nine which would have been devoted to the youth and early manhood of Christ.

The panels are mentioned after 1460 by Fra Domenico da Corella in the *Theotocon* as works of Fra Angelico, and on this account alone it is difficult to follow the many critics who deny his intervention in, or general responsibility for, these little scenes. All the panels directly attributable to Angelico form part of the first block of nine paintings. The three succeeding scenes are by a younger artist, Baldovinetti, and the six missing scenes may have been by Baldovinetti too. The remaining twenty-three scenes are executed in the style of Angelico by another hand. Some of them incorporate motifs from the San Marco frescoes; this is the case with the *Mocking of Christ*, *Christ carrying the Cross* (where the Virgin corresponds with the related figure in the fresco of this scene), and the *Coronation of the Virgin* (where the central group is a variant of the fresco in Cell 9). Despite this, it is extremely difficult to regard these scenes as mere pastiches in the style of Fra Angelico, and a number of motifs—the continuous landscape behind the *Stripping of Christ* and the *Crucifixion*, the cloister in the scene of *Christ washing the feet of the Apostles*, the diagonal rhythm of the *Lamentation*—are so distinguished as to suggest that at the very least drawings for the whole cycle must have been made by the master. In January 1461 a payment was made to an otherwise unknown painter Pietro del Massaio for what is described as 'insegnare dipingere l'armario' (showing how the cupboard is to be painted). This might well refer to the execution in paint of antecedent cartoons. It has been noted correctly that the palette of the later scenes, and especially the extensive use of yellow in the *Betrayal*, differs from the practice of Angelico.

At the top and bottom of each panel are scrolls containing sentences respectively from the Old and the New Testament. Thus in the first scene (Plate 131) Isaiah's prophecy of the Annunciation is balanced against the ECCE CONCIPIES IN VTERO ET PARIES FILIVM ET VOCABIS NOMEN EIVS IHESVM of St. Luke, and in the sixth (Plate 133) a passage from the Psalms, ELONGAVI FVGIENS ET MANSI IN SOLITVDINE, is accompanied by the words put by St. Matthew into the mouth of the angel warning St. Joseph to flee. The programme must have been drawn up in its entirety before the panels were begun, and was thus planned by or in conjunction with Angelico. A key to the conception is to be found in the first and last panels, one executed under the master's supervision, the other by the artist who completed the chest. The first (Plate 130) shows a landscape, in the lower corners of which are the seated figures of Ezekiel and Gregory the Great. Between them flows the River Chobar, beside which Ezekiel received his vision of God. In the upper left corner are passages from the fourth, fifth and sixteenth verses of the first chapter of Ezekiel, describing the appearance of four 'animalia' and a wheel within a wheel. In the opposite corner is the gloss of St. Gregory the Great upon this passage. The greater part of the panel is filled with two concentric circles, that in the centre containing eight standing figures of the Evangelists and writers of the canonical epistles, and that on the outside twelve figures of prophets. Round the perimeter of the smaller wheel run the opening words of the Gospel of St. John, and round the larger the account of the Creation. The last panel shows a flowery field. On the left stands a female figure, the Church, holding a shield inscribed with the words LEX AMORIS. In the centre is a candlestick with seven branches, through which are threaded seven scrolls. On each scroll is the name of a sacrament, accompanied to left and right by quotations from the Old and the New Testament. From the middle of the candlestick rises a pennant, surrounded by a twisted

scroll, and to right and left, supported by twelve apostles and twelve prophets, are the articles of the Creed and the passages from the Old Testament with which they were habitually juxtaposed.

Though their handling and condition are unequal, the first nine scenes are distinguished by exquisitely lucid schemes, in which the essence of Angelico's late style is distilled. In the *Annunciation* (Plate 131) the kneeling Virgin and the Angel are silhouetted against the central wall surface, the Angel pointing towards the Holy Ghost, which is represented naturalistically as a bird flying in the sky. The folds of their drapery are treated with great delicacy, and the haloes are shown in profile, not as in earlier paintings as flat circles on the picture plane. In the *Flight into Egypt* (Plate 133), where the haloes are fully visible, they are portrayed as metal discs which refract light and reflect the shadow of the head. A corollary of this is the exact rendering of the forms, witness the careful way in which the Virgin's forward leg beneath her robe has been defined. In the *Nativity* (Plate 132) the stable is set in an alcove of landscape, and the play of perspective, in the handling of the horizontal struts and the forward-tilting manger, is more elaborate than in any earlier painting. In front it is divided by vertical supports into three equal parts, in one of which, behind St. Joseph, the straw comes down to shoulder height, while in the other, behind the Virgin, it is almost completely torn away. This three-fold division of the picture space is common also to the *Circumcision* (Plate 135), where the planes of the three end walls of the choir repeat the relationship of the three foreground figures, and to the *Presentation in the Temple* (Plate 134). The panel which reminds us most forcibly of the San Marco predella is the *Massacre of the Innocents* (Plate 138), where the wall at the back recalls that in *Saints Cosmas and Damian before Lycias*, but is enriched by a receding trellis. The spatial platform in the foreground is much deeper than before (in this is conforms to the structure of the frescoes in the corridor of San Marco), and the women filling it are treated realistically, with a repertory of posture that must, in its freedom and expressiveness, have appeared unsurpassed. There is (and this must be stressed very firmly) nothing archaic in these paintings. They prove that in the last years of his life Angelico was what he had been in youth and middle-age, a progressive, forward-looking artist.

The readiest explanation for the inconsistency of handling in the silver chest panels is that work on them was interrupted by some other commission; and since the break probably occurred in 1453 and Fra Angelico died in Rome in February 1455, it is a common assumption that this was a commission from the Pope. Alternatively it has been suggested that the source of the commission may have been the church of Santa Maria sopra Minerva in Rome, for which, according to Vasari but no other source, Angelico painted the high altarpiece. There is no documentary proof of either supposition. We have, however, two small paintings by Angelico which may date from 1450-5, and a third more substantial picture on which work seems to have been started before his death. The first of the finished pictures is a panel in the Fogg Museum of *Christ on the Cross with the Virgin and Saint John adored by a Dominican Cardinal* (Fig. 41; Plate 141). This was originally the centre of a triptych, and the lower part of one of the two wings, with a cut-down figure of Saint Peter (Plate 140), survives. In type the Christ conforms, not to the fresco in the cloister of San Marco, but to the figure in the *Crucifixion* on the silver chest. The arms of the cross run the whole width of the panel, and above it burgeons a tree with at its tip a nesting pelican. The Virgin and Saint John, set slightly behind the cross, show the same tendency to elongation as the figures in the autograph *Presentation in the Temple* on the silver chest (Plate 134), and the Cardinal, Juan de Torquemada, kneels in profile in the front. Both in its restrained intensity of feeling and in the severity of its design, this is the most impressive of the artist's late paintings. The second work is a triptych with the *Ascension, Last Judgment and Pentecost* in the Palazzo Barberini (Fig. 45; Plate 139).

The central panel depends from the *Last Judgment* painted for Santa Maria degli Angeli, and among the blessed on the left two figures in the foreground are drawn with little variation from the earlier painting. In place, however, of the perspective view of the double line of open tombs, the foreground is divided by a single line of tombs running irregularly through the centre of the scene. The late date of the panel is asserted on the right by the figure of a woman chastised by a devil which is closely bound up with the women in the *Massacre of the Innocents* on the silver chest (Plate 138), and above in a still more decisive fashion by the Christ, which employs the same rhetorical pose as the *Christ in Glory* at Orvieto (Plate 124). The lateral panels are less fine in quality, but it is difficult to believe that the Christ of the *Ascension*, where the forms look back to the *Transfiguration* at San Marco, was not likewise painted by Angelico, and that he was not also responsible for the design of the two scenes. The lower part of the right wing and the whole of the left wing are related to the panels of the *Ascension* and *Pentecost* on the silver chest.

The more substantial picture is a famous tondo of the *Adoration of the Magi* in the National Gallery of Art in Washington (Fig. 46). This is a bewildering work, not least because the bulk of the painting as we know it now was executed not by Angelico but by Fra Filippo Lippi. It was indeed consistently ascribed to Lippi until Berenson, in 1932, suggested that it was planned and partly painted by Angelico and an assistant about 1442 and was then completed by Lippi. This theory was later withdrawn, and the tondo was reascribed to Lippi. In both cases the analysis rested on the figurative content of the panel, not on its design. If, however, we look first at the ruined building on the left, whose structure is typical of Fra Filippo Lippi, and then at the walled city on the right, whose structure is typical of Fra Angelico, the dichotomy between the two appears so great that we are bound to postulate two separate designing minds. This deduction is confirmed by the irregular structure of the stable in the centre, which represents a point of compromise between two inconsistent schemes. That on the right is the more primitive, and we are bound therefore to suppose that work on the panel started in this area. This inference is warranted also by the fact that the figures on the left are in the main by Lippi, while the figures in the distance on the right are either by Angelico or by some member of his shop. The correct point of reference for them is not, however, the San Marco altarpiece or other paintings of the early fourteen-forties, but the panels of the silver chest, and this is corroborated by the only one of the main figures painted by Angelico, the seated Virgin in the centre (Plate 142), where the type and handling of the head are wholly different from those of Fra Filippo Lippi and the hair is braided like the hair of the silver chest *Maries at the Sepulchre*. It follows that the error in Berenson's analysis was not his explanation of the genesis of this great panel, but the date to which it was assigned. Though the panel as a work of art must in great part be credited to Lippi and its dominant style is undeniably Lippesque, it is not to be wondered at that in 1492, thirty-seven years after Angelico's death, when it hung in a large room on the ground floor of the Medici Palace used by Lorenzo de' Medici, it was described as being 'di mano di fra Giovanni', that is by the hand of the legendary artist by whom it was begun.

CONCLUSION

WHEN he died in 1455, Angelico was the most influential Florentine painter of his time. His influence was diffused first through his autograph paintings, second through paintings turned out in his studio, and third through the work of imitators of his style. The first of these categories has already been discussed. So far as concerns the second, judgment is hampered by lack of documents. The sole occasions on which the members of the workshop are listed are at Rome and Orvieto. At San Marco no names whatever are available, and earlier the situation is still more confused. Among the artists to be reckoned with is the miniaturist Battista di Biagio Sanguigni (1393–1451), who knew Angelico as early as 1417, and who after 1430 seems to have lived at Fiesole in the vicinity of San Domenico. The only works by him that we know are two codices from San Gaggio dating from 1432, which have formed the basis for ascribing to him certain paintings from Angelico's shop. From 1430 till 1446 Sanguigni was associated with Zanobi di Benedetto degli Strozzi (1412–68), to whom many works from Angelico's studio have also been attributed. Strozzi is known to have executed panel paintings—a number of documents relate to an altarpiece in Santa Maria Nuova which he painted in the middle of the fourteen-thirties at San Domenico di Fiesole—and some of his documented miniatures (notably a *Miracle of Saint Zenobius* of 1446–50 in Lezionario Edili No. 146 in the Biblioteca Laurenziana) are related to panel paintings by Angelico. Strozzi's name was first associated with a number of late works by Fra Angelico, among them the panels of the Annunziata silver chest, and he has gradually come to be regarded as the principal hand at work in the shop paintings. There is a consensus of opinion that he must have collaborated with Angelico in the fourteen-thirties and later, but none of the lists of paintings with which he is credited possesses the inner coherence necessary to ensure its credibility. The painter Giovanni Gonsalvi da Portogallo, who was joint witness with Strozzi to notarial acts at San Domenico di Fiesole on two occasions in the first half of 1435, has also to be reckoned with. To the third category belongs Benozzo Gozzoli, who in the fourteen-fifties reduced the master's style to a myopic descriptive formula. Though his presence in the workshop is documented, his mature style owes less to Fra Angelico than do those of two artists whose presence in the studio is not attested by any source. The first of these associates of Angelico is Domenico di Michelino (1417–91), whose earliest authenticated painting, *Dante expounding the Divina Commedia* in the Duomo in Florence, dates from 1465, ten years after Angelico died. The second is an anonymous painter, the Master of the Buckingham Palace *Madonna*, who seems to have imitated Angelico's style for a decade and a half, and whose most revealing work is an altarpiece of the *Last Judgment* dated 1456, formerly in Berlin.

Angelico's altarpieces represent a superior reality in which the instinct for decoration that was present in his personality from the beginning is rigorously curbed. This austere sense of function, this careful balancing of ends and means, are the factors that distinguish his work from Fra Filippo Lippi's. When we contrast Lippi's Barbadori altarpiece in the Louvre with Angelico's exactly contemporary polyptych at Perugia, or Lippi's *Coronation of the Virgin* with the contemporary San Marco altarpiece, or Lippi's Medici altarpiece in the Uffizi with the contemporary altarpiece for Bosco ai Frati, it can be seen that the precipitate, Donatellesque perspective and the elaborate, mannered architecture of Lippi's paintings fail to reinforce and indeed do something to diminish the impact of his figures, whereas with Angelico the scene is conceived as logically articulated space and the architecture and the figures together build up a sense of actuality.

From the fourteen-thirties on the styles of Fra Filippo Lippi and of Angelico run parallel

to one another, but nowhere, save in the tondo for the Palazzo Medici, do they intersect. With Domenico Veneziano, on the other hand, the circumstantial evidence for some form of conjunction is very strong. Arriving in Florence about 1438, he seems to have executed as his earliest work there the frescoed *Virgin and Child* for the Carnesecchi tabernacle, now in the National Gallery. The schemes of the San Marco altarpiece and its predella, as well as those of later paintings, may owe something to Domenico Veneziano, but in the present state of our knowledge of his style and in the absence of his narrative frescoes it is impossible to determine the nature of the debt. The Carnesecchi *Madonna*, great fresco as it is, must from the first have been impaired by an implicit conflict between the figures and the spatial cage in which they are confined, and even in a later, more developed work, the Saint Lucy altarpiece, notice is initially directed to the space, not to the figures it contains. At the single point at which their paintings are strictly comparable, in Angelico's *Burial of Saints Cosmas and Damian* in the Museo di San Marco and Domenico Veneziano's *Miracle of Saint Zenobius* at Cambridge, we find that in Angelico the setting and the narrative are perfectly adjusted, whereas in Domenico Veneziano the narration is disturbed by an intrusive representational technique. In 1439 Domenico Veneziano, then at work in the church of Sant'Egidio, had as his assistant the young Piero della Francesca. It has been suggested on more than one occasion that, at a still earlier time, in the mid-fourteen-thirties, Piero was in contact with Angelico. There is no proof of this, but it is not open to doubt that Piero's work from the middle of the fourteen-forties through the following decade, that is between the *Baptism of Christ* in London and the earlier Arezzo frescoes, owes more than a little to the sublime geometry of Fra Angelico.

THE five hundred years that have elapsed since the death of Fra Angelico have produced no artist with so universal an appeal. The *Annunciation* at Cortona, the *Deposition* from Santa Trinita, the *Transfiguration* at San Marco form part of our common imaginative currency. They eschew the private idiom of other great religious artists, and reflect the serenity, the discipline, the anonymity of communal religious life. In the case of Fra Angelico, more truly than in that of any other painter, the artist and the man are one. His paintings are informed with a tenderness, indeed affection, that gives tangible expression to the mystical virtue of charity, are undisturbed by profane interests and untinged by doubt. The language he employed resulted not from failure to keep abreast of the developments of his own day, but from intentions which differed fundamentally from those of other artists. For all the translucent surface of his paintings, for all his pleasure in the natural world, there lay concealed within him a Puritan faithful to his own intransigent ideal of reformed religious art.

In the empathy of his approach to religious iconography (it is as though in every painting the artist himself were present as an unseen participant), in the compassion which bulks so large throughout his work, in the sense of divine immanence in nature (which proceeds directly from Dominican Observant doctrine), in the benign light of faith that gives his paintings their warmth and their consistency, in the undeviating single-mindedness with which he followed his allotted path, Fra Angelico is unlike any other artist. No painter's work have been so widely reproduced, and though from the standpoint of good taste we may deplore the copies of them that surround us on all sides, they still perform the function they were originally designed to serve, and testify to the continuing value of his apostolate.

PLATES

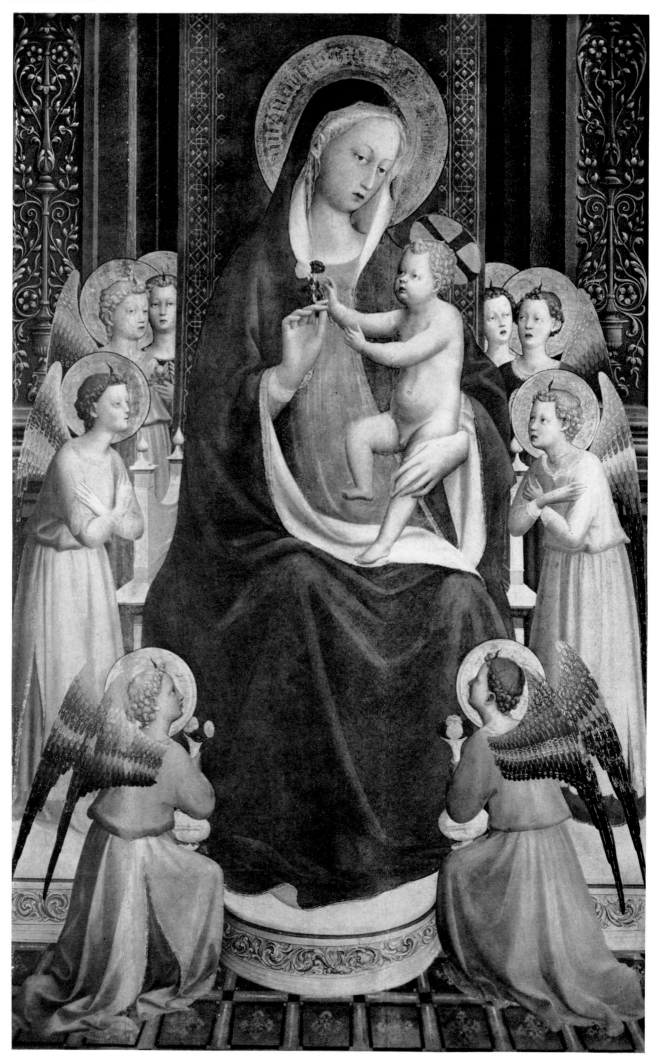

I. VIRGIN AND CHILD ENTHRONED WITH EIGHT ANGELS. Detail of Figure 1. San Domenico, Fiesole.

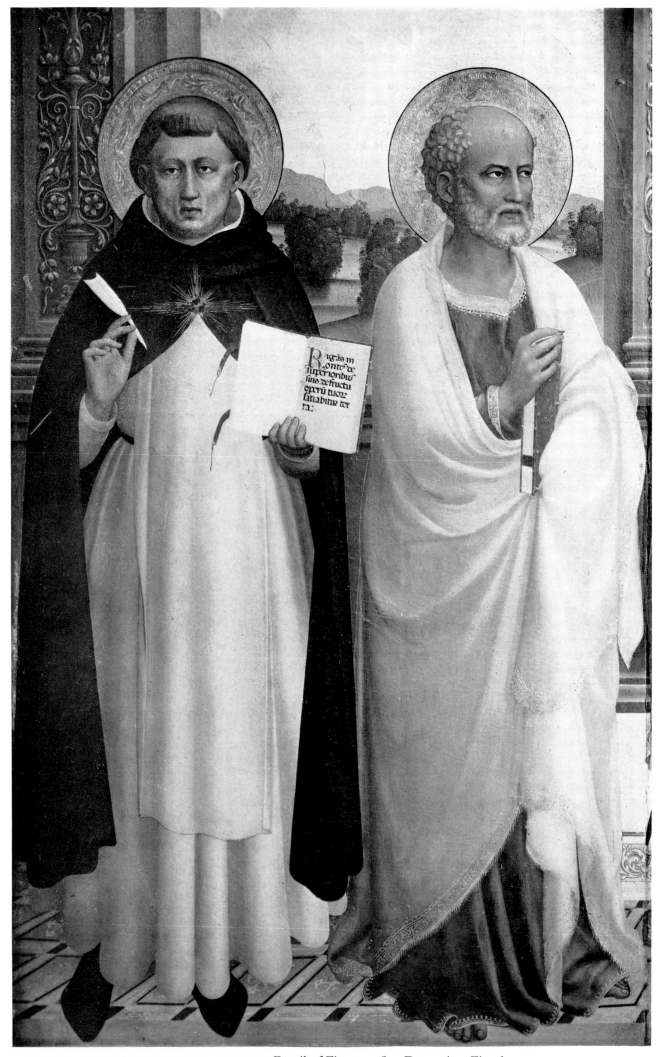

2. SAINTS THOMAS AQUINAS AND BARNABAS. Detail of Figure 1. San Domenico, Fiesole.

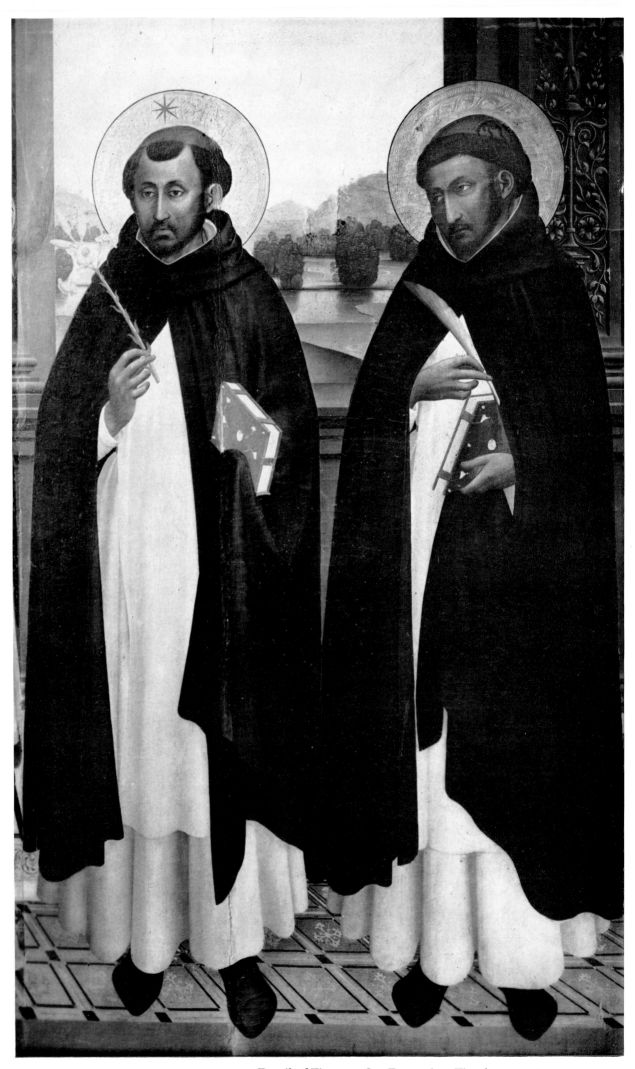

3. SAINTS DOMINIC AND PETER MARTYR. Detail of Figure 1. San Domenico, Fiesole.

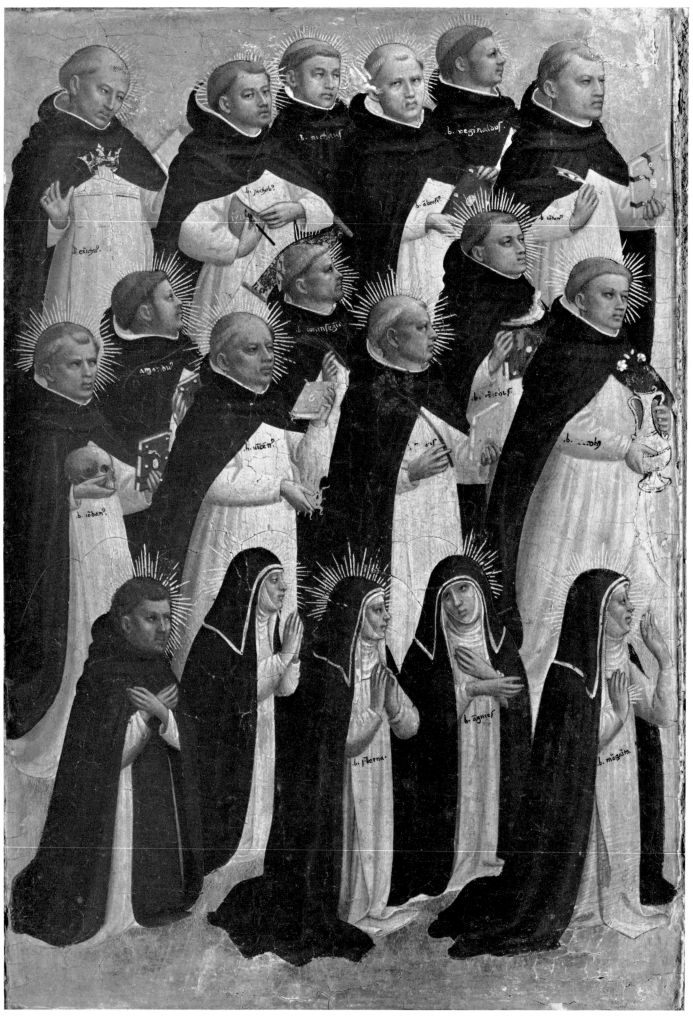

4. SAINTS AND BEATI OF THE DOMINICAN ORDER. Detail of Figure 1. National Gallery, London.

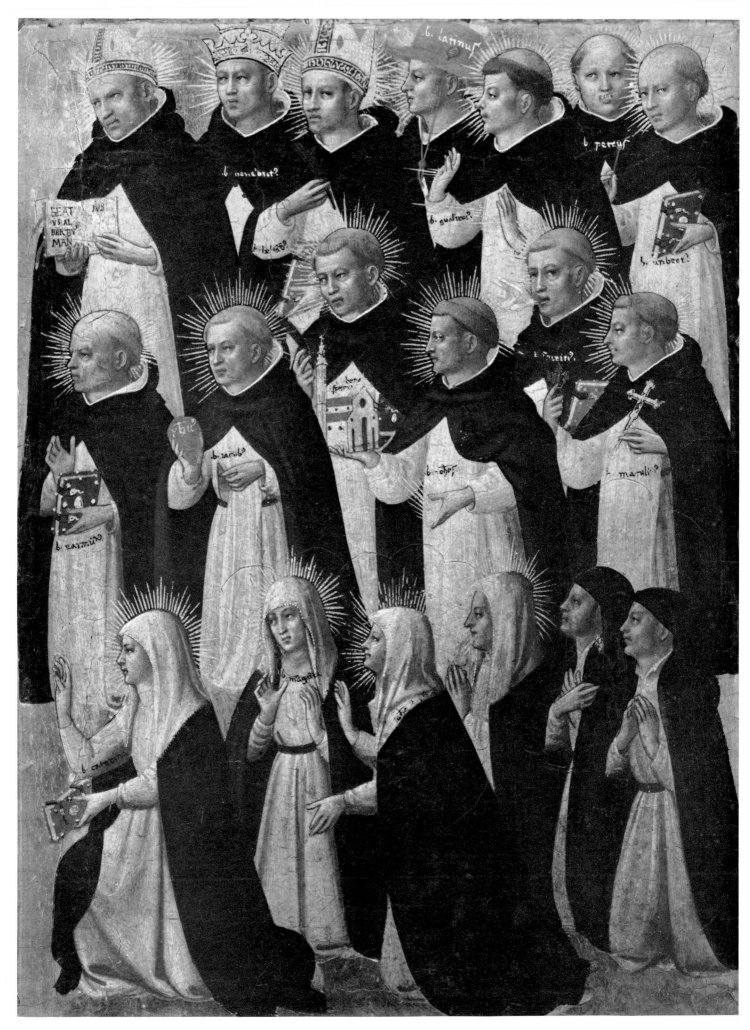

5. SAINTS AND BEATI OF THE DOMINICAN ORDER. Detail of Figure 1. National Gallery, London.

6a. SAINT MARK. Musée Condé, Chantilly. 6b. SAINT MATTHEW. Musée Condé, Chantilly.

7a. SAINT NICHOLAS. Private Collection. 7b. SAINT MICHAEL. Private Collection.

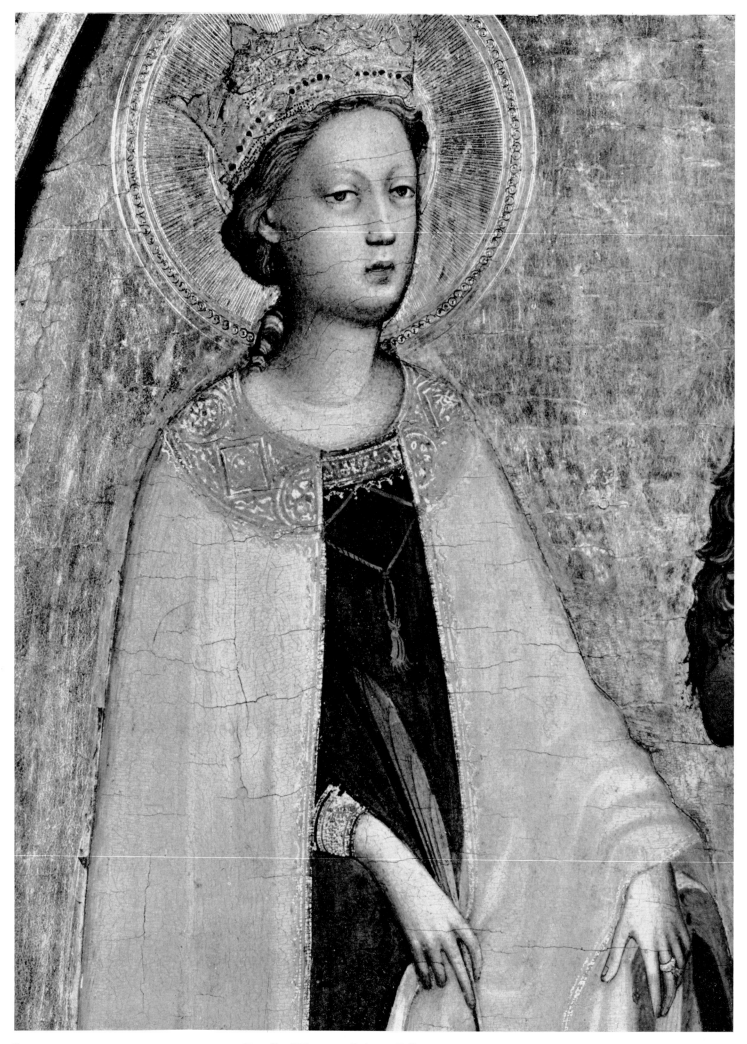

8. SAINT CATHERINE OF ALEXANDRIA. Detail of Figure 7. Private Collection.

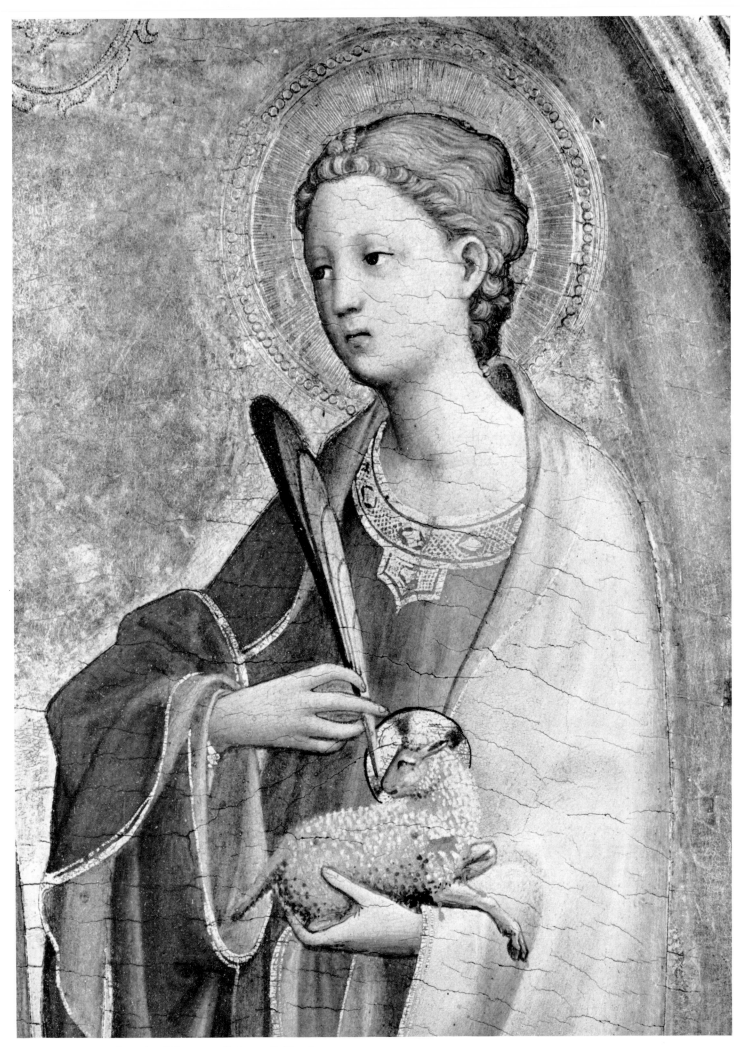

9. SAINT AGNES. Detail of Figure 8. Private Collection.

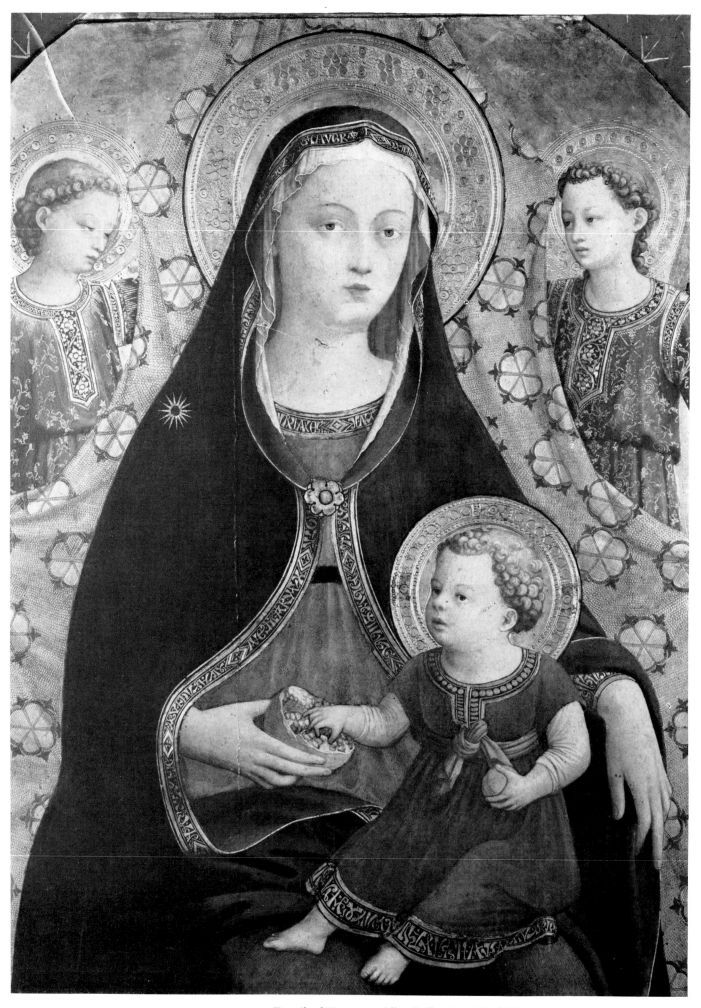

10. VIRGIN AND CHILD WITH TWO ANGELS. Detail of Figure 5. Alba Collection, Madrid.

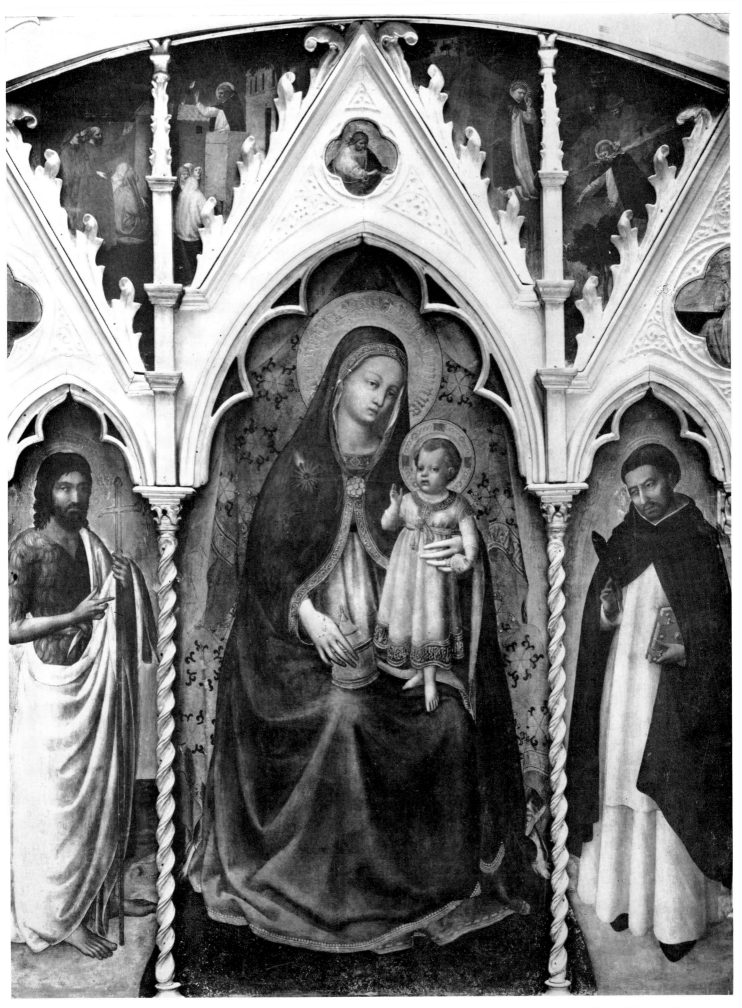

11. VIRGIN AND CHILD WITH SAINTS JOHN THE BAPTIST AND DOMINIC. Detail of Figure 3. Museo di San Marco, Florence.

12a. SAINT PETER MARTYR PREACHING. Detail of Figure 3. Museo di San Marco, Florence.

12b. THE DEATH OF SAINT PETER MARTYR. Detail of Figure 3. Museo di San Marco, Florence.

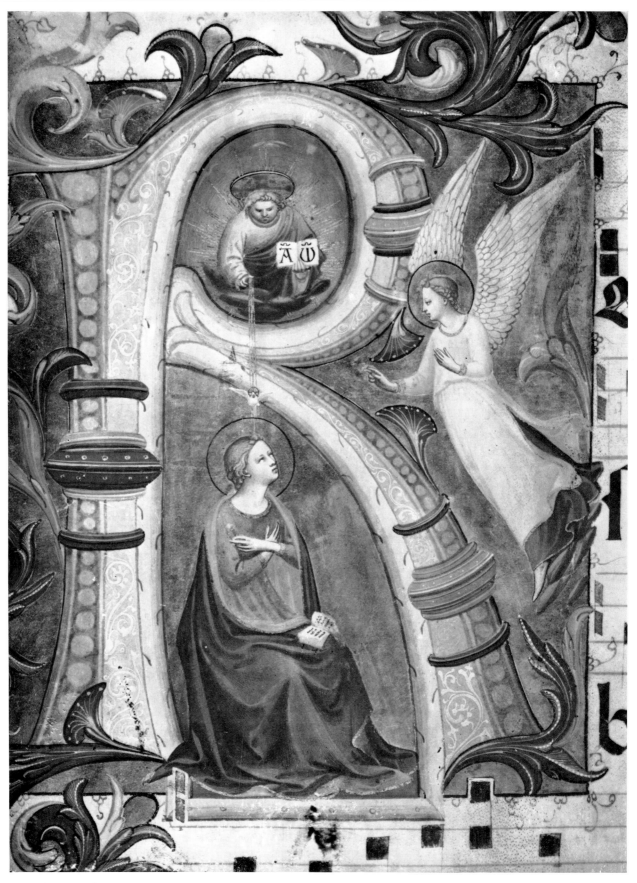

13. THE ANNUNCIATION. Museo di San Marco, Florence (Missal No. 558).

14. THE GLORIFICATION OF SAINT DOMINIC. Museo di San Marco, Florence (Missal No. 558).

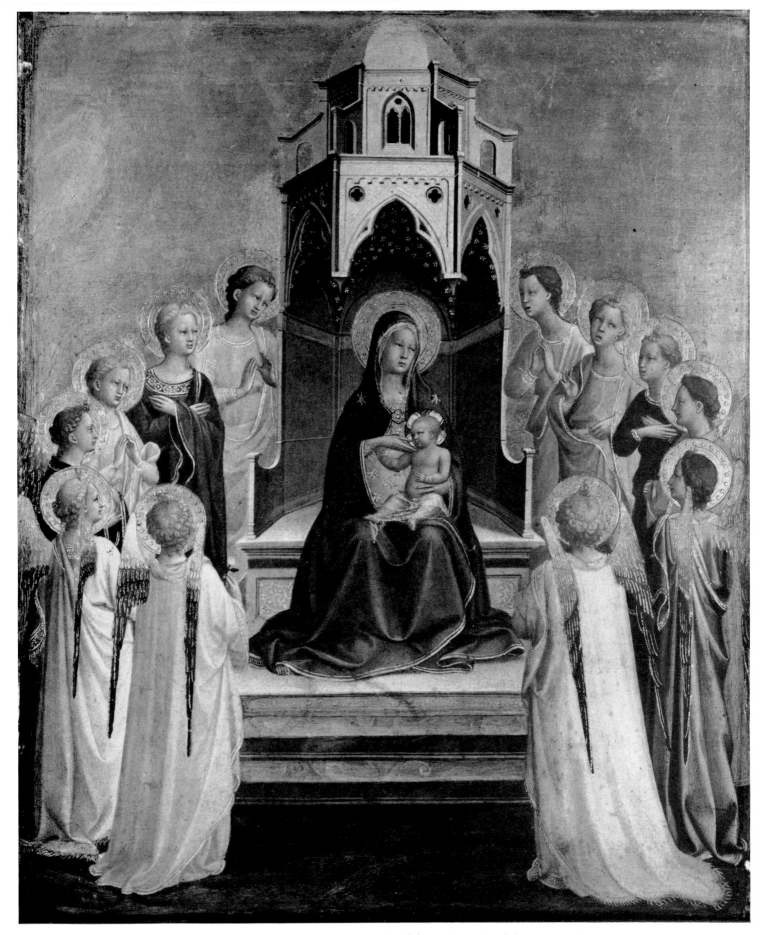

15. VIRGIN AND CHILD ENTHRONED WITH TWELVE ANGELS. Staedel Institute, Frankfurt-am-Main.

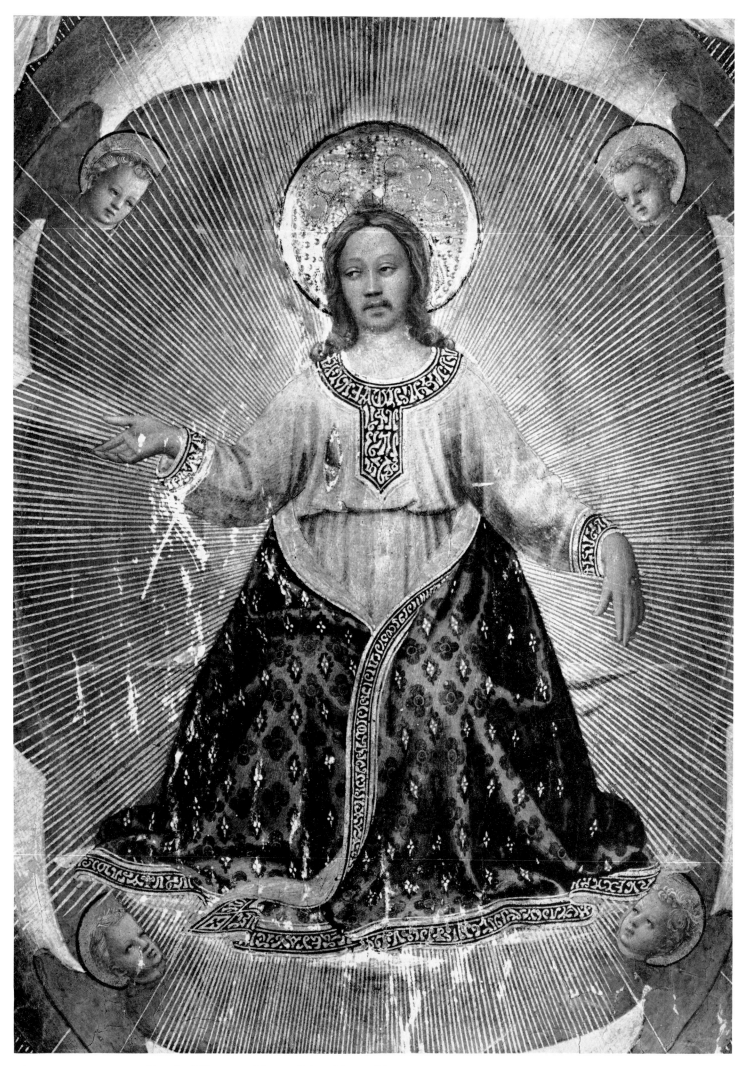

16. CHRIST AS JUDGE. Detail of Figure 2. Museo di San Marco, Florence.

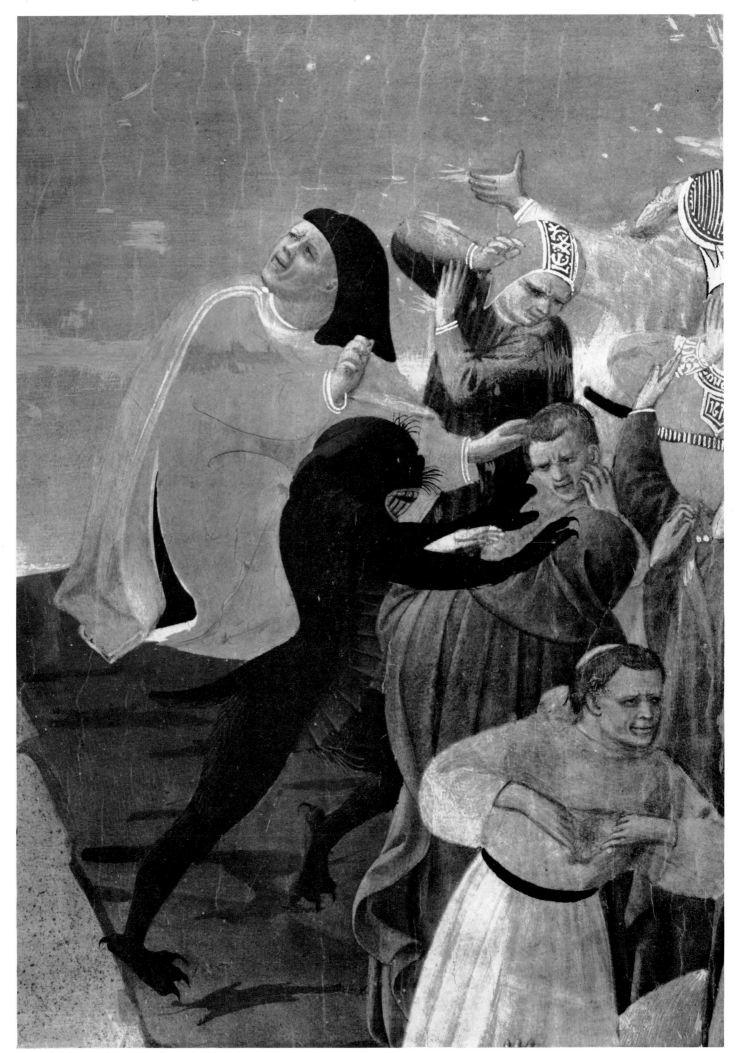

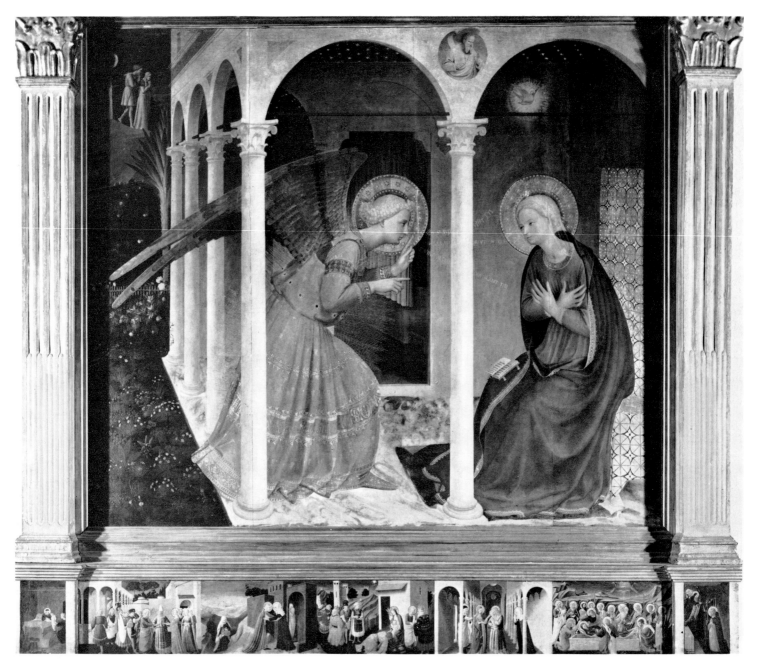

18. THE ANNUNCIATION. Museo Diocesano, Cortona.

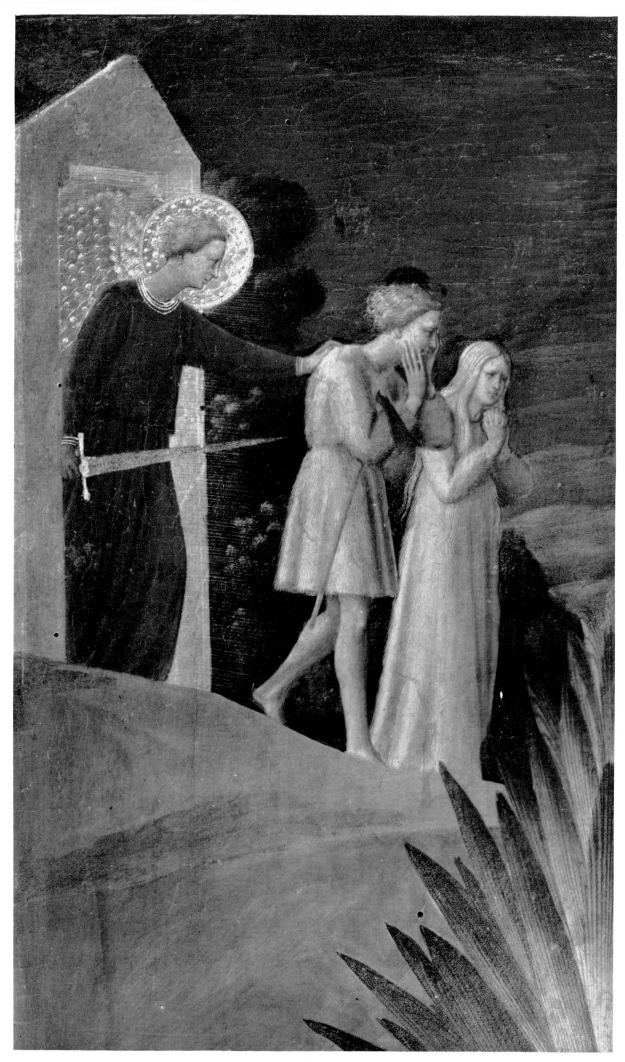

19. THE EXPULSION OF ADAM AND EVE. Detail of Plate 18.

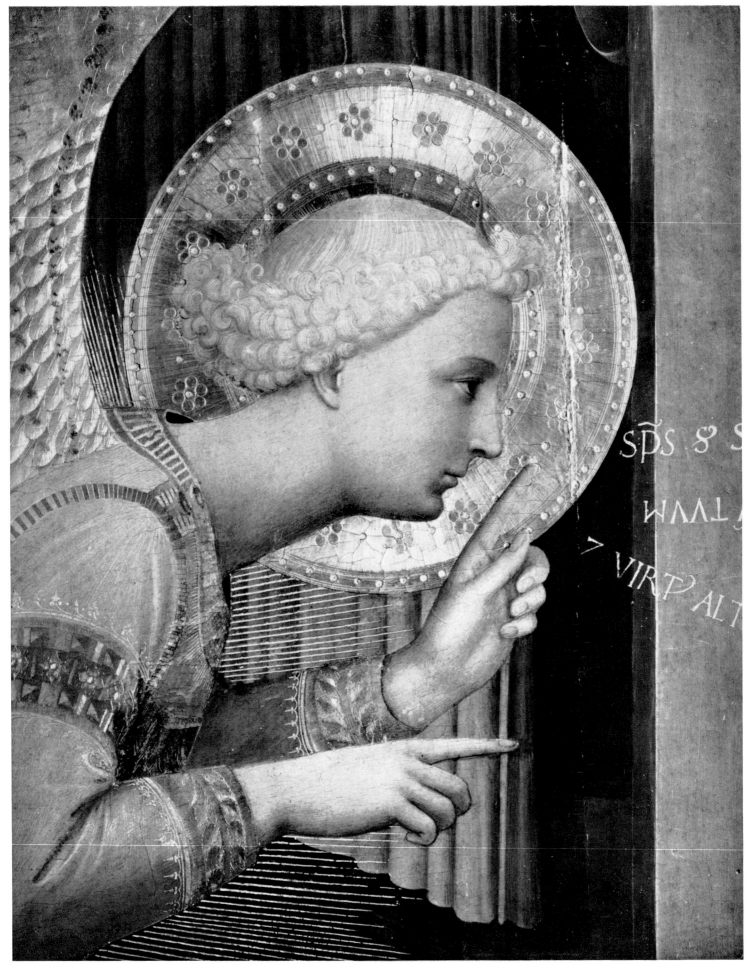

20. THE ANGEL OF THE ANNUNCIATION. Detail of Plate 18.

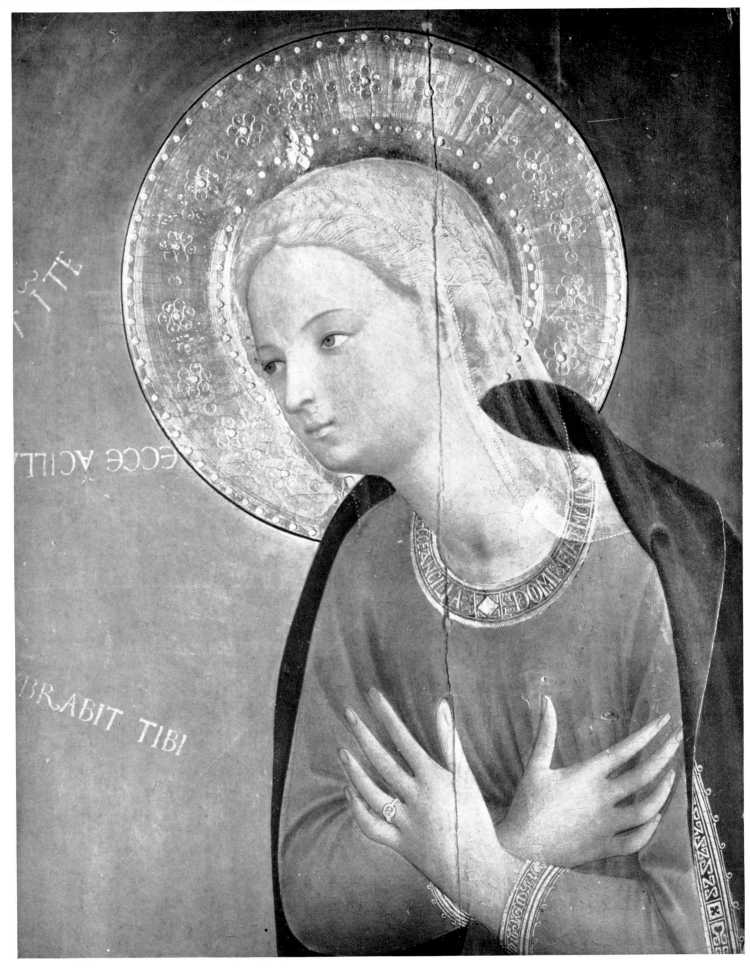

21. THE VIRGIN ANNUNCIATE. Detail of Plate 18.

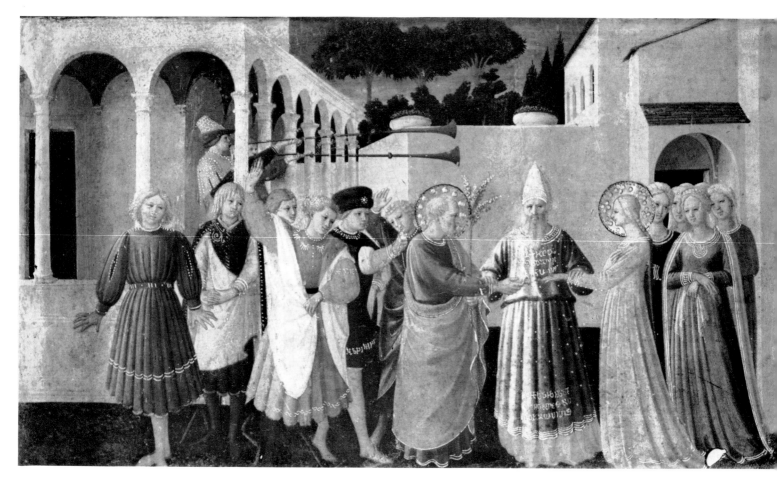

22a. THE MARRIAGE OF THE VIRGIN. Detail of Plate 18.

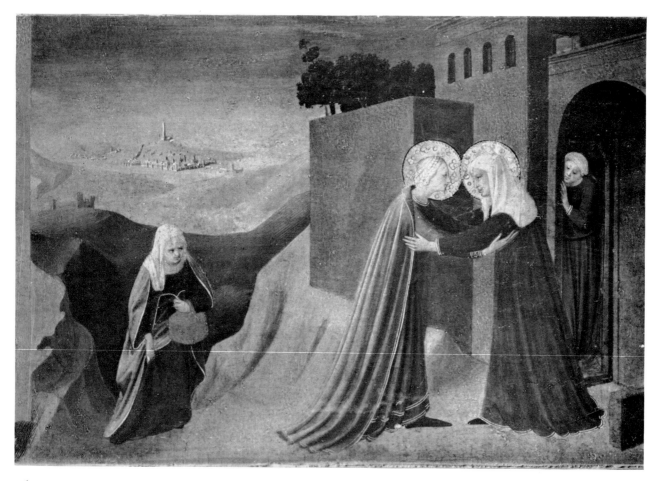

22b. THE VISITATION. Detail of Plate 18.

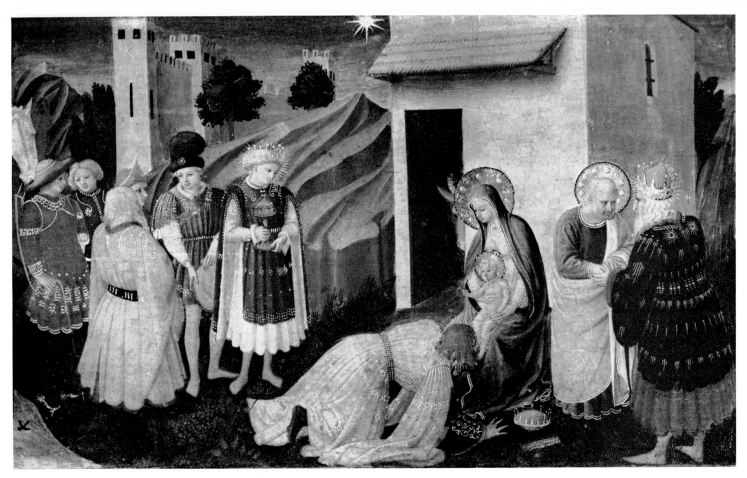

23a. THE ADORATION OF THE MAGI. Detail of Plate 18.

23b. THE PRESENTATION IN THE TEMPLE. Detail of Plate 18.

24. THE LINAIUOLI TRIPTYCH (closed). Museo di San Marco, Florence.

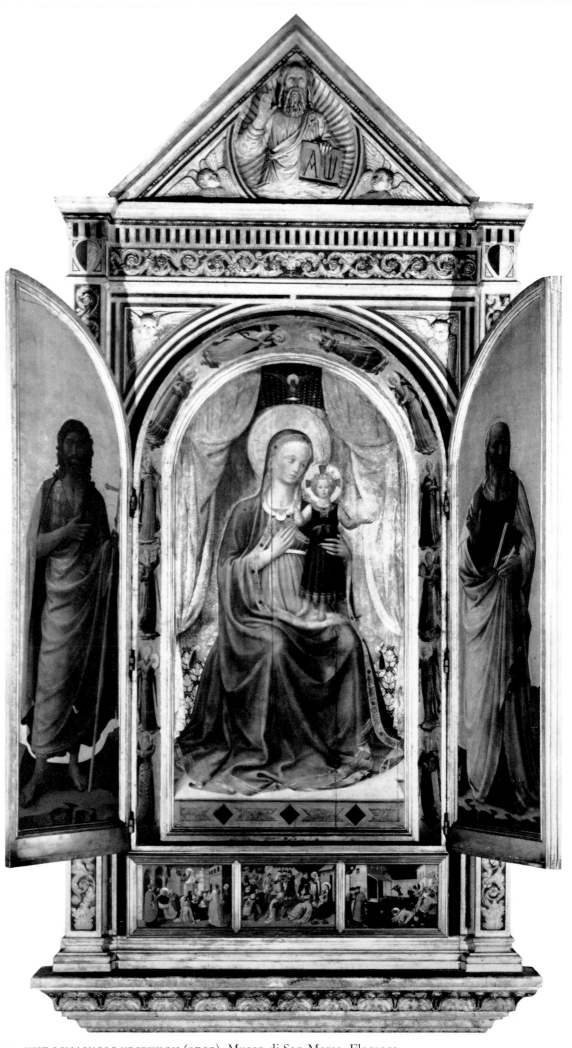

25. THE LINAIUOLI TRIPTYCH (open). Museo di San Marco, Florence.

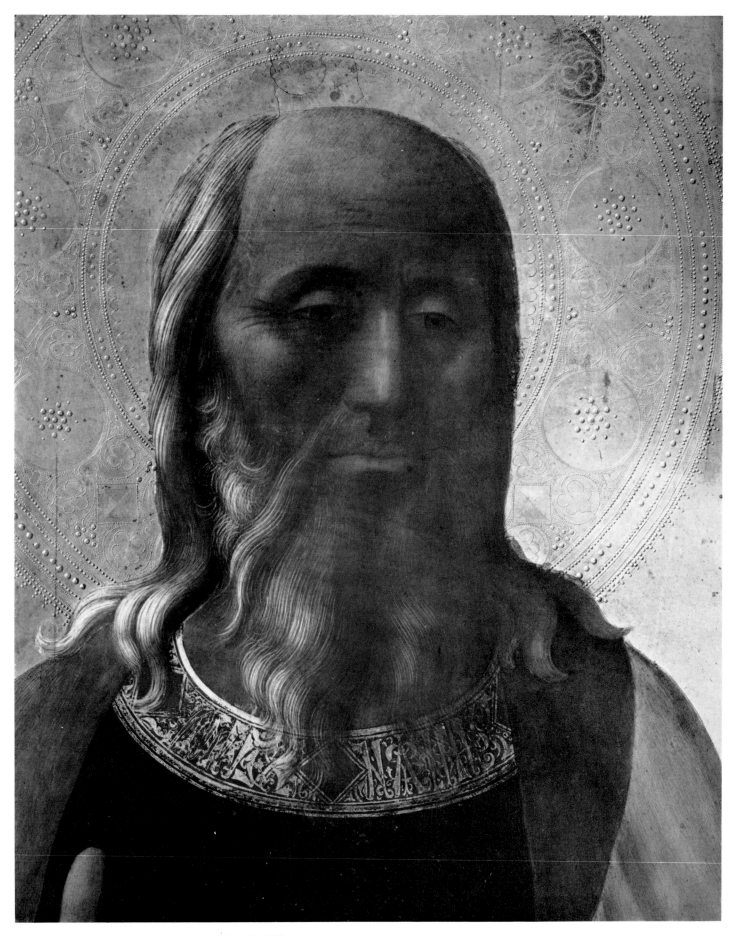

26. SAINT JOHN THE EVANGELIST. Detail of Plate 25.

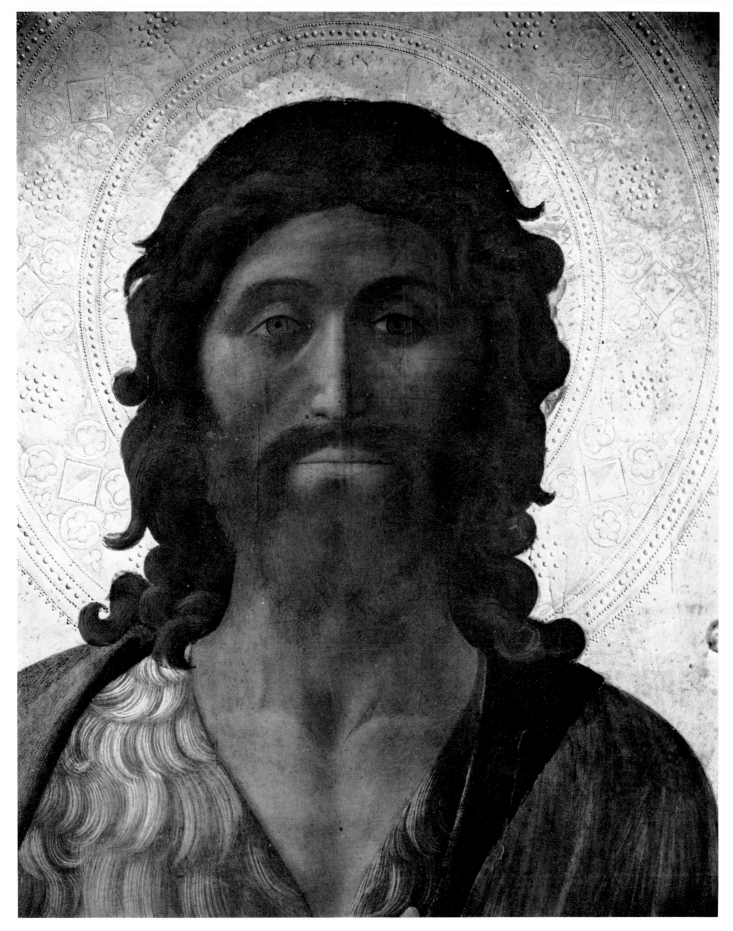

27. SAINT JOHN THE BAPTIST. Detail of Plate 25.

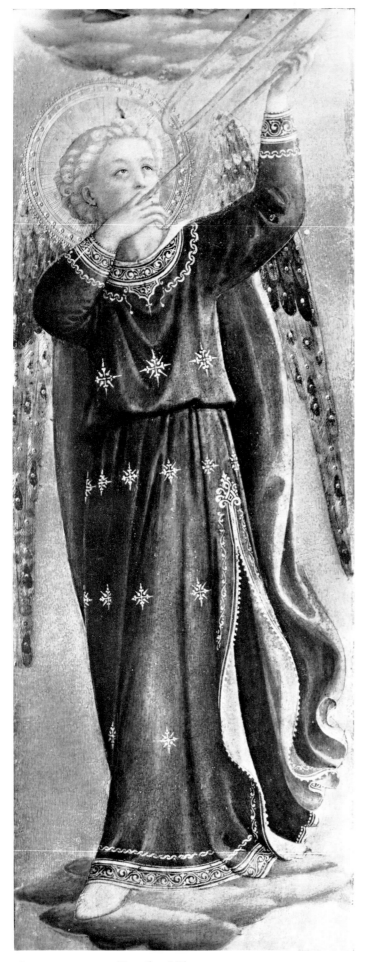

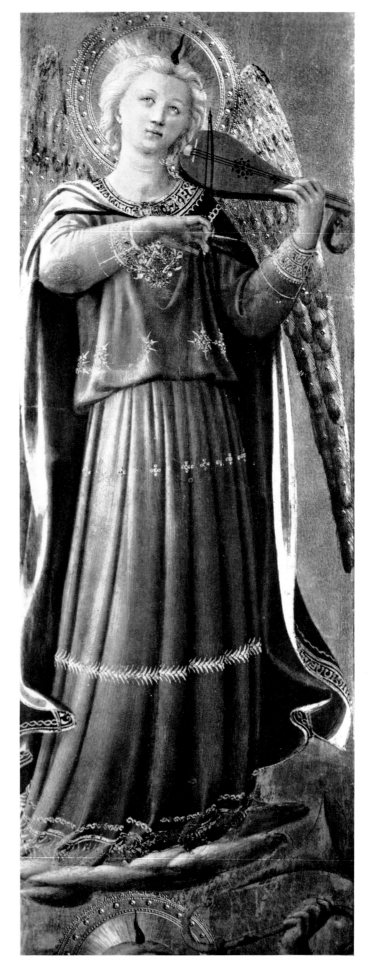

28. TWO ANGELS. Details of Plate 25.

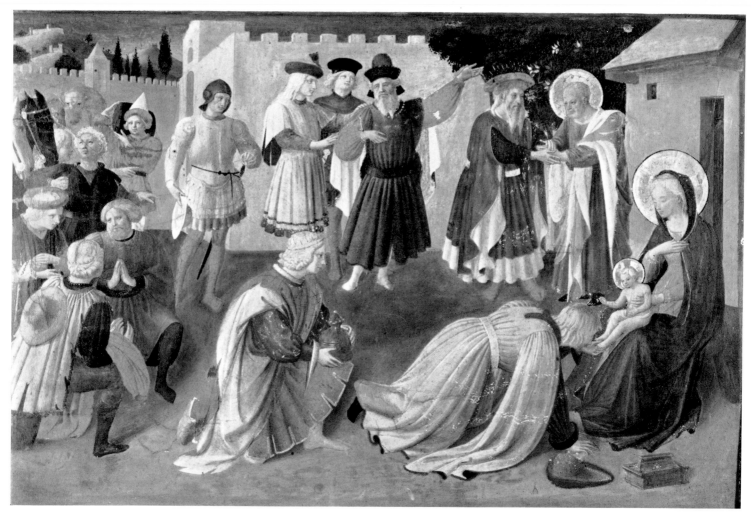

29. THE ADORATION OF THE MAGI. Detail of Plate 25.

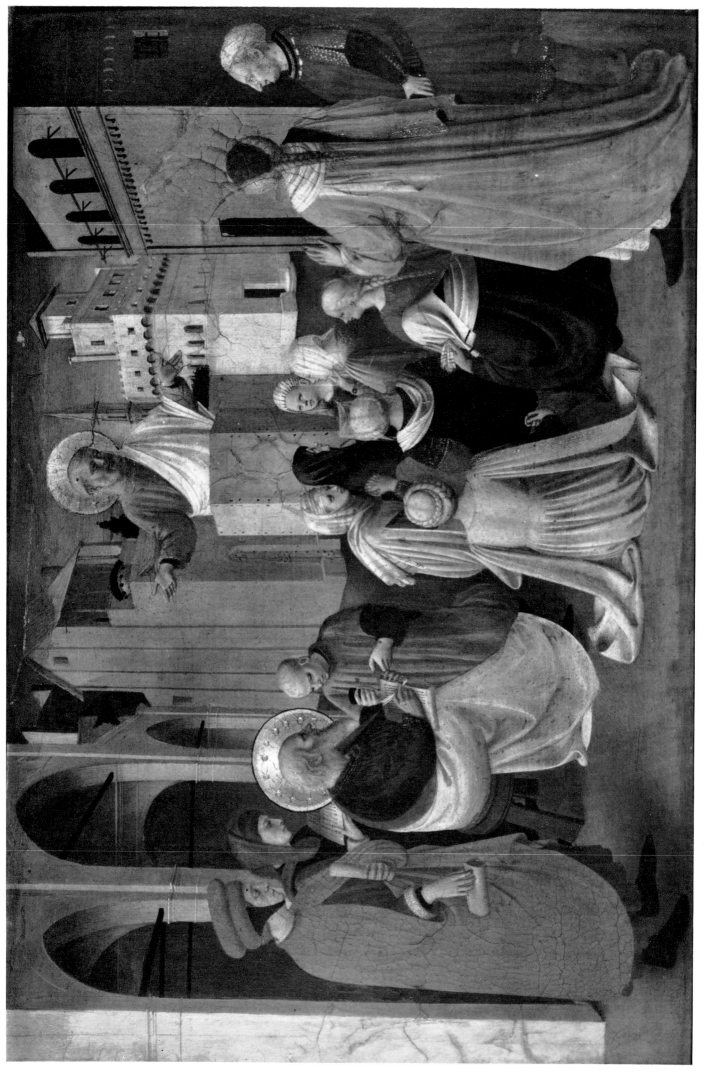

30. SAINT PETER PREACHING. Detail of Plate 25.

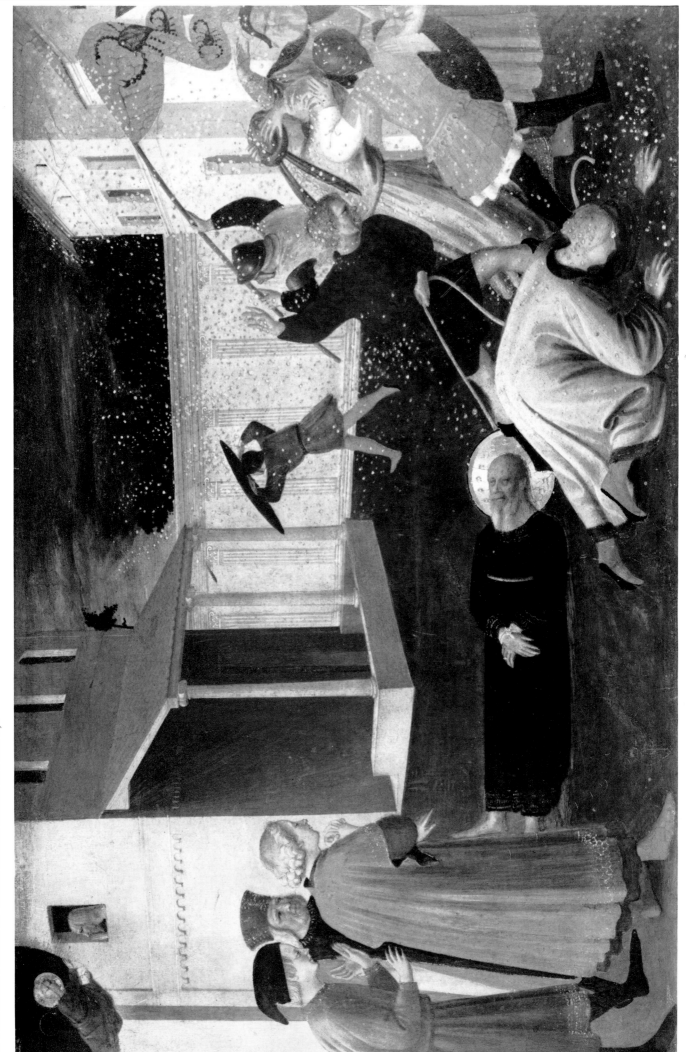

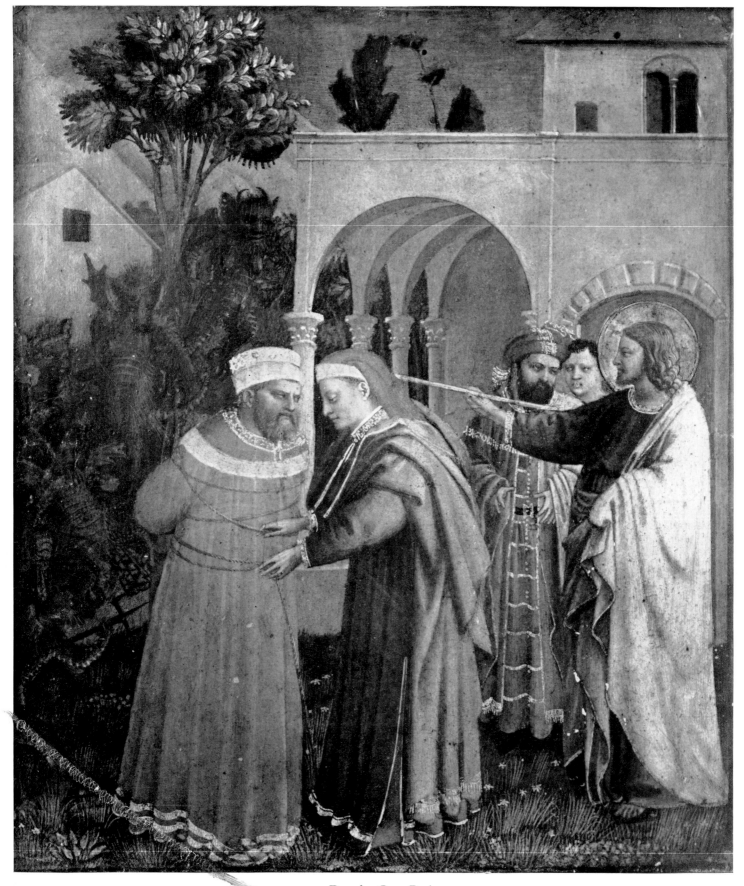

32. SAINT JAMES THE GREAT FREEING HERMOGENES. Duc des Cars, Paris.

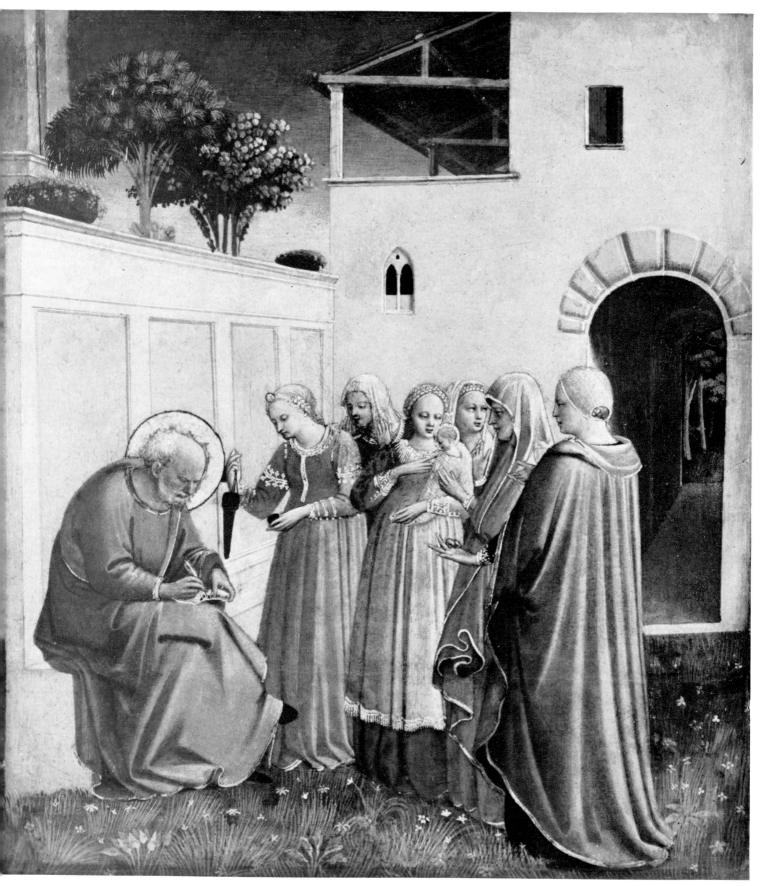

THE NAMING OF SAINT JOHN THE BAPTIST. Museo di San Marco, Florence.

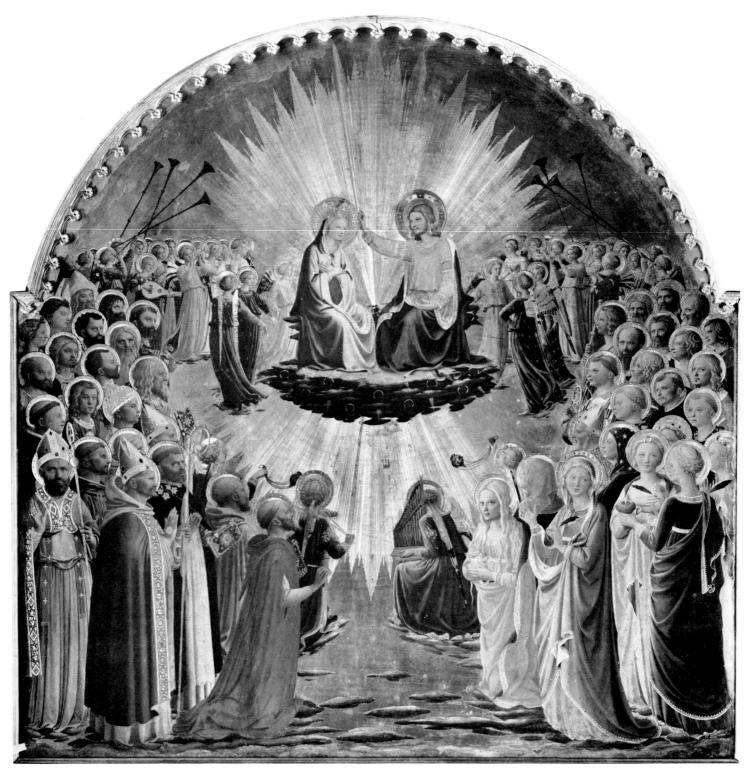

34. THE CORONATION OF THE VIRGIN. Uffizi, Florence.

35. SINOPIA OF THE VIRGIN AND CHILD. San Domenico, Fiesole.

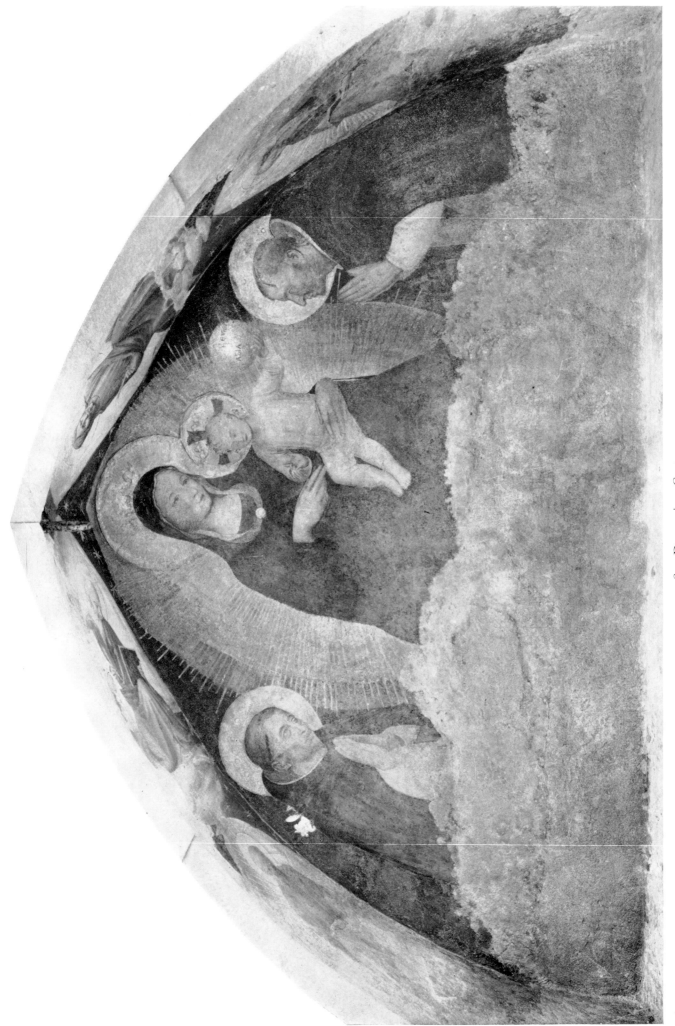

36. VIRGIN AND CHILD BETWEEN SAINTS DOMINIC AND PETER MARTYR. San Domenico, Cortona.

37b. SAINT LUKE. Detail of Plate 36.

37a. SAINT JOHN THE EVANGELIST. Detail of Plate 36.

38. VIRGIN AND CHILD ENTHRONED WITH FOUR ANGELS. Detail of Figure 21.
Museo Diocesano, Cortona.

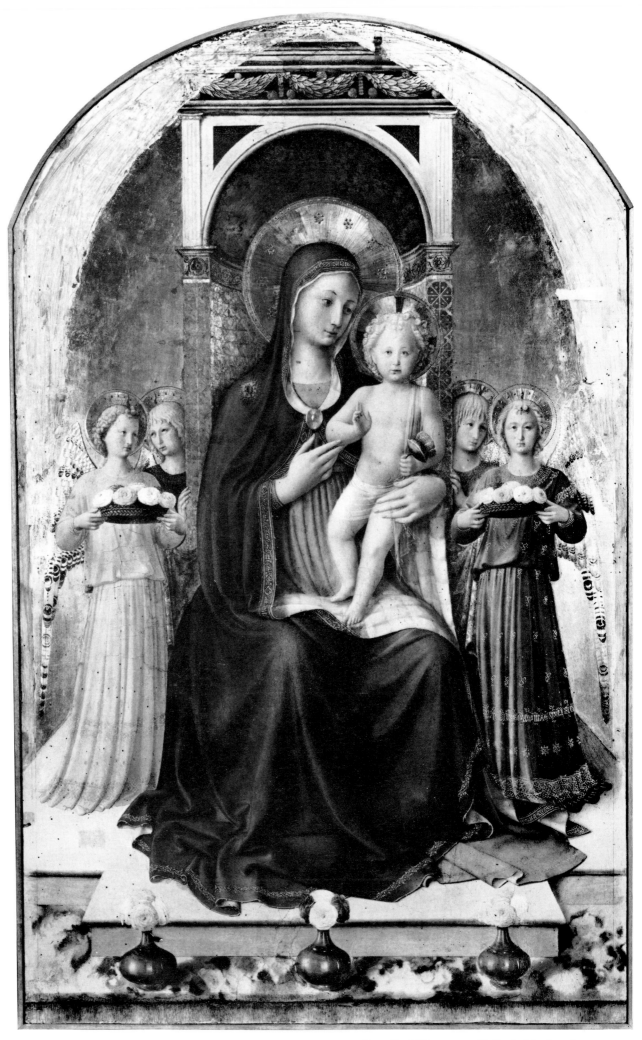

39. VIRGIN AND CHILD ENTHRONED WITH FOUR ANGELS. Detail of Figure 22. Galleria Nazionale dell'Umbria, Perugia.

40. SAINT JOHN THE EVANGELIST (underdrawing). Detail of Figure 21. Museo Diocesano, Cortona.

41. SAINT JOHN THE BAPTIST (underdrawing). Detail of Figure 21. Museo Diocesano, Cortona.

42. SAINT NICHOLAS. Detail of Figure 22. Galleria Nazionale dell'Umbria, Perugia.

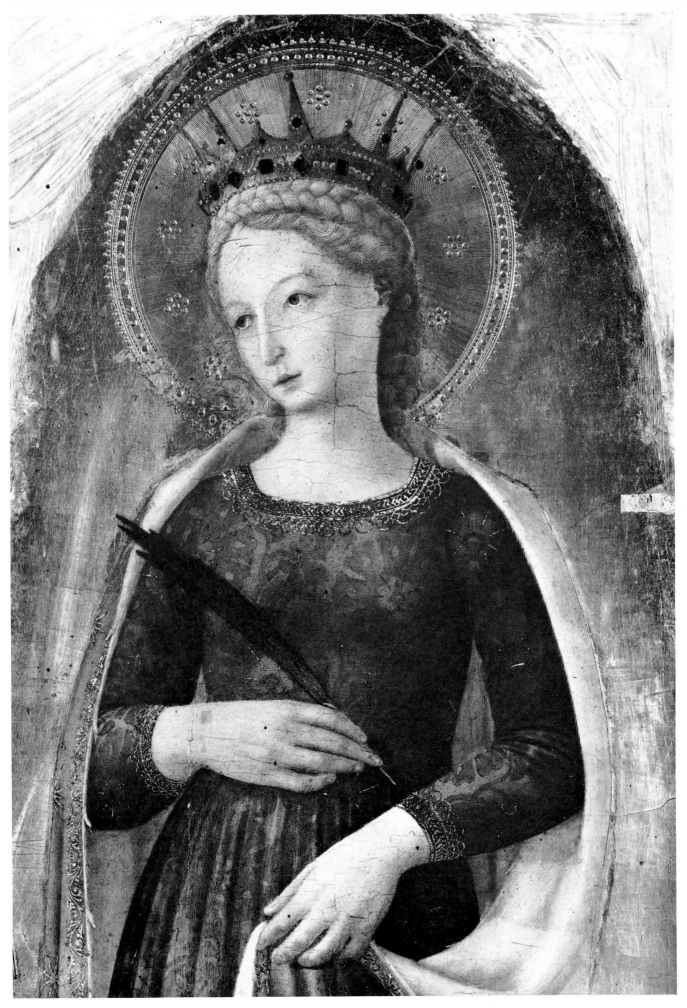

43. SAINT CATHERINE OF ALEXANDRIA. Detail of Figure 22. Galleria Nazionale dell'Umbria, Perugia.

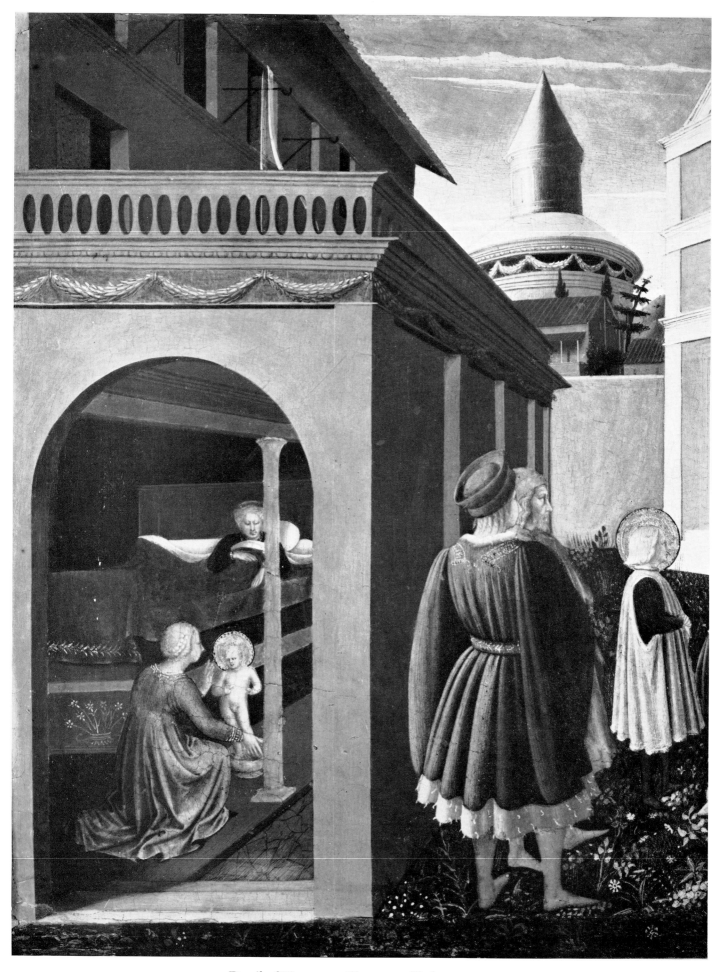

44. THE BIRTH OF SAINT NICHOLAS. Detail of Figure 24a. Pinacoteca Vaticana.

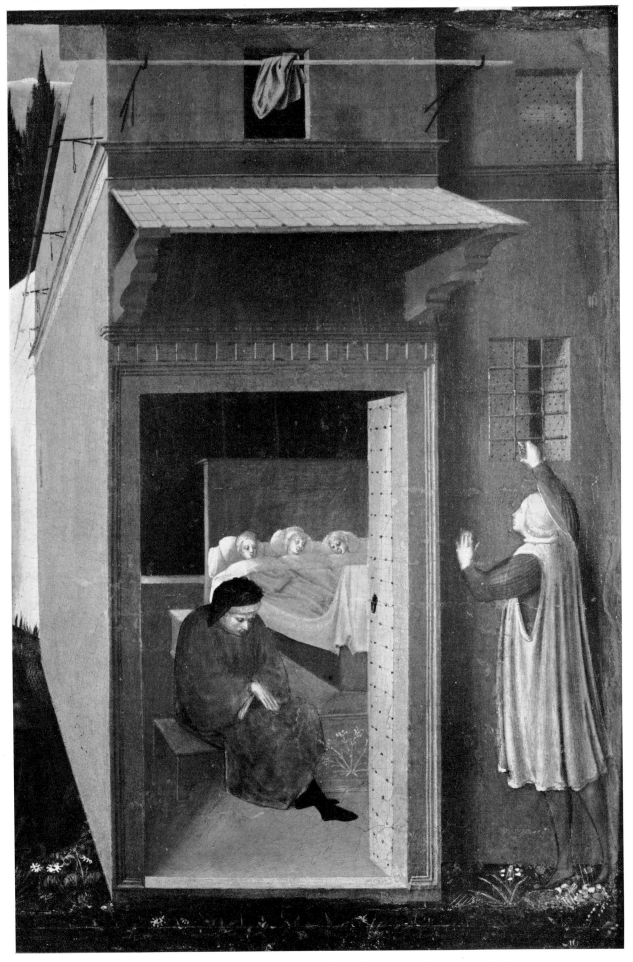

45. SAINT NICHOLAS AND THE THREE MAIDENS. Detail of Figure 24a. Pinacoteca Vaticana.

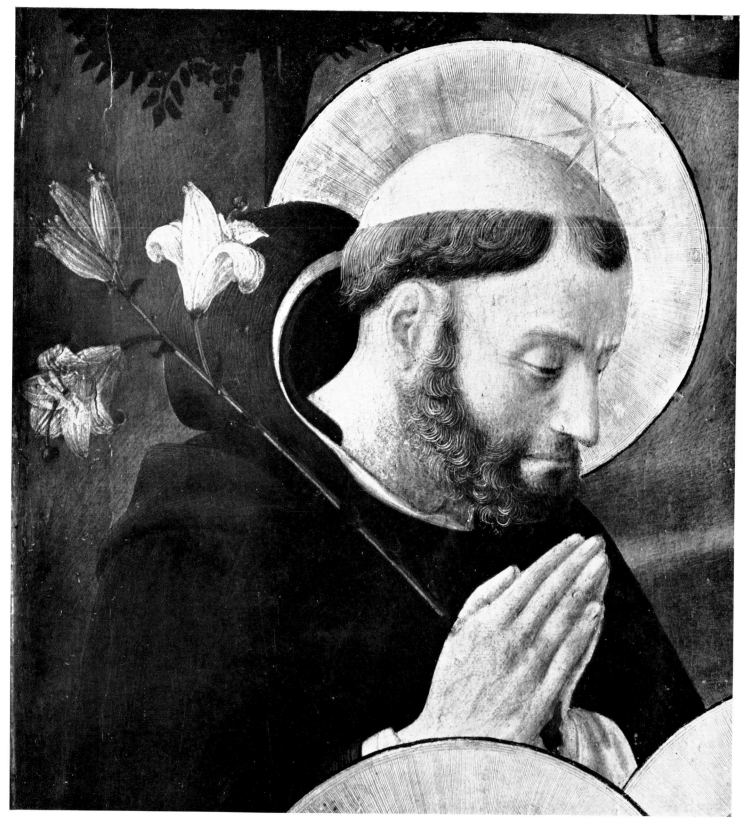

46. SAINT DOMINIC. Detail of Figure 25. Museo di San Marco, Florence.

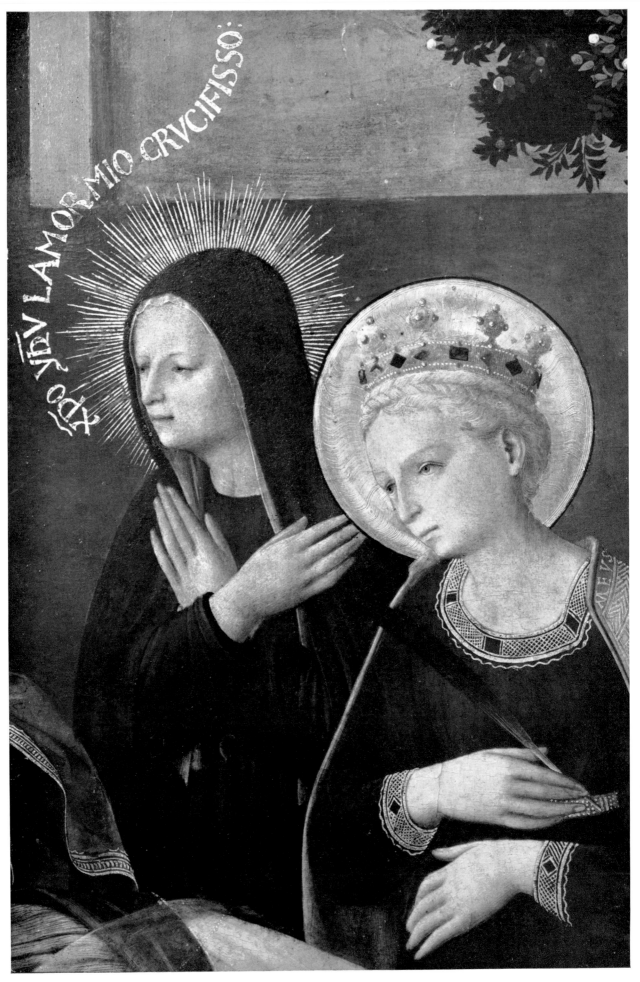

47. THE BEATA VILLANA AND SAINT CATHERINE OF ALEXANDRIA. Detail of Figure 25. Museo di San
Marco, Florence.

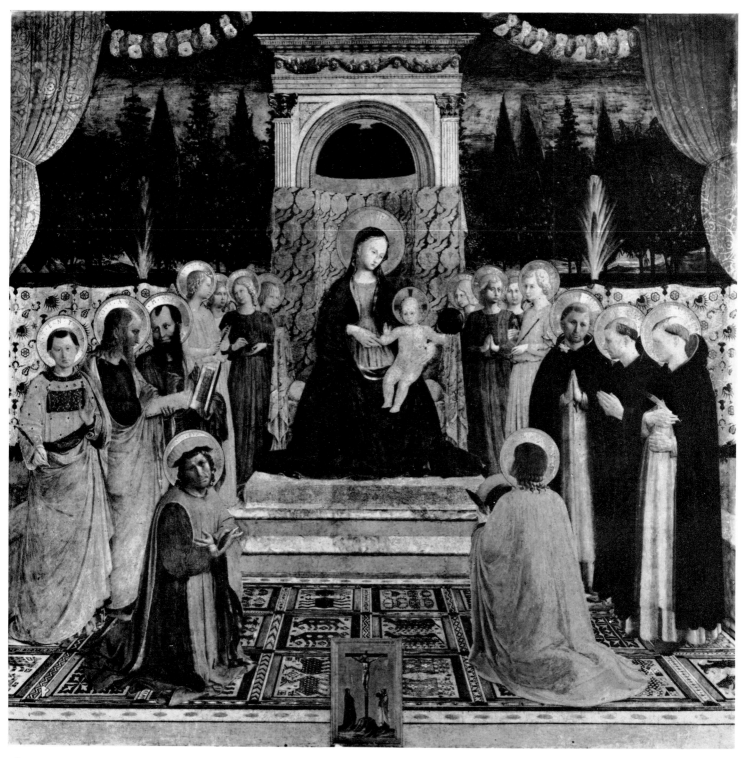

48. THE SAN MARCO ALTARPIECE: THE VIRGIN AND CHILD ENTHRONED WITH ANGELS AND SAINTS COSMAS AND DAMIAN, LAWRENCE, JOHN EVANGELIST, MARK, DOMINIC, FRANCIS AND PETER MARTYR. Museo di San Marco, Florence.

49. HEAD OF THE VIRGIN. Detail of Plate 48.

50. SAINT COSMAS. Detail of Plate 48.

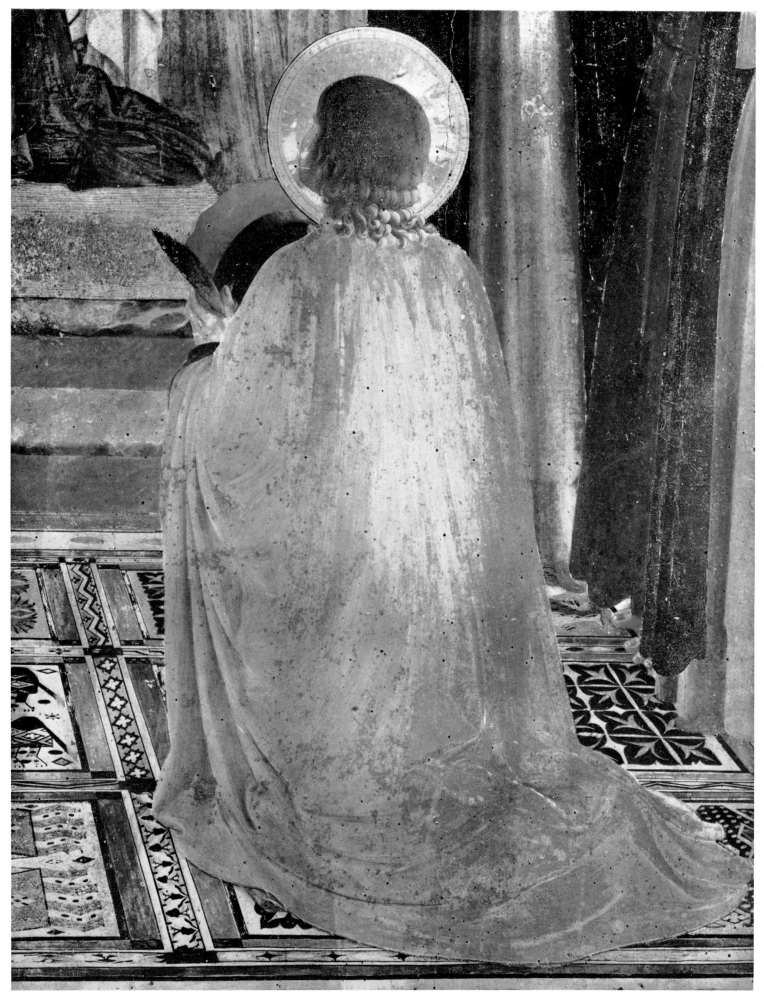

51. SAINT DAMIAN. Detail of Plate 48.

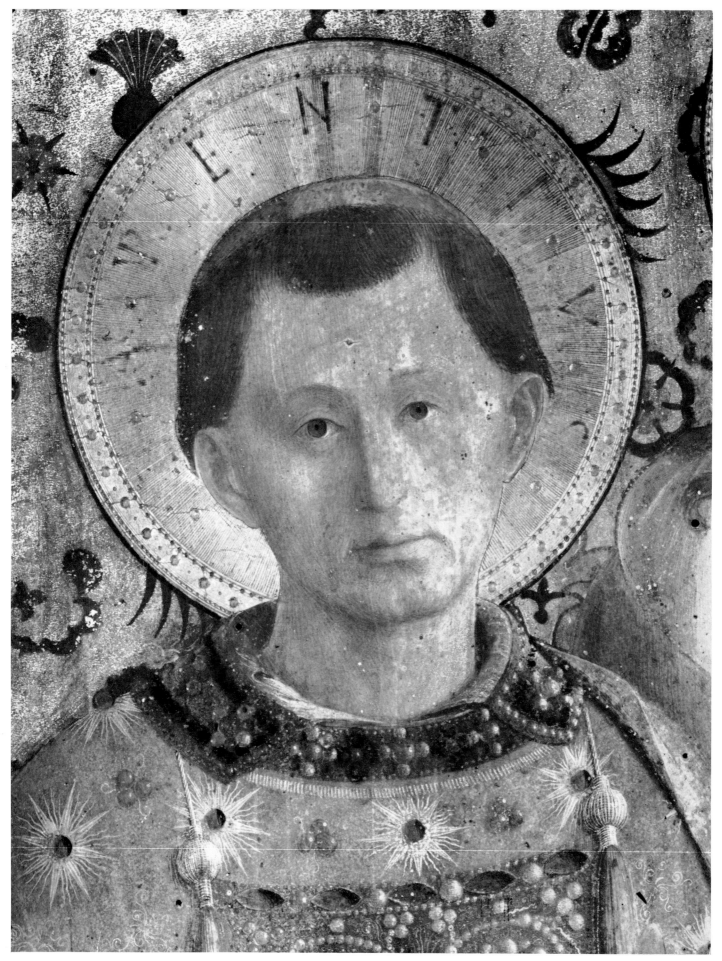

52. SAINT LAWRENCE. Detail of Plate 48.

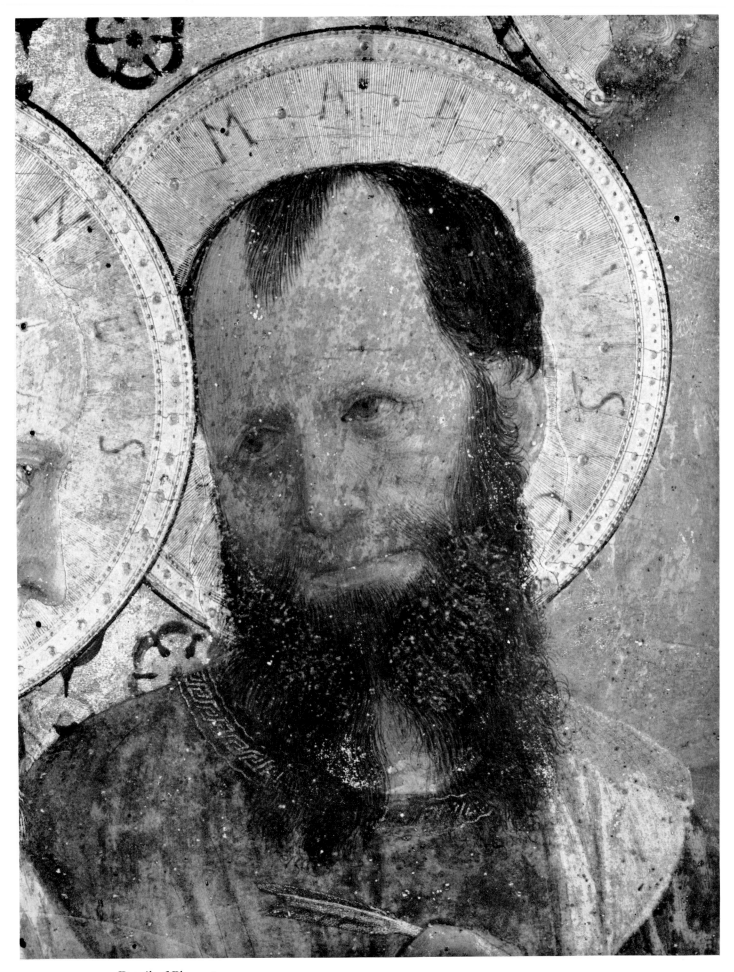

53. SAINT MARK. Detail of Plate 48.

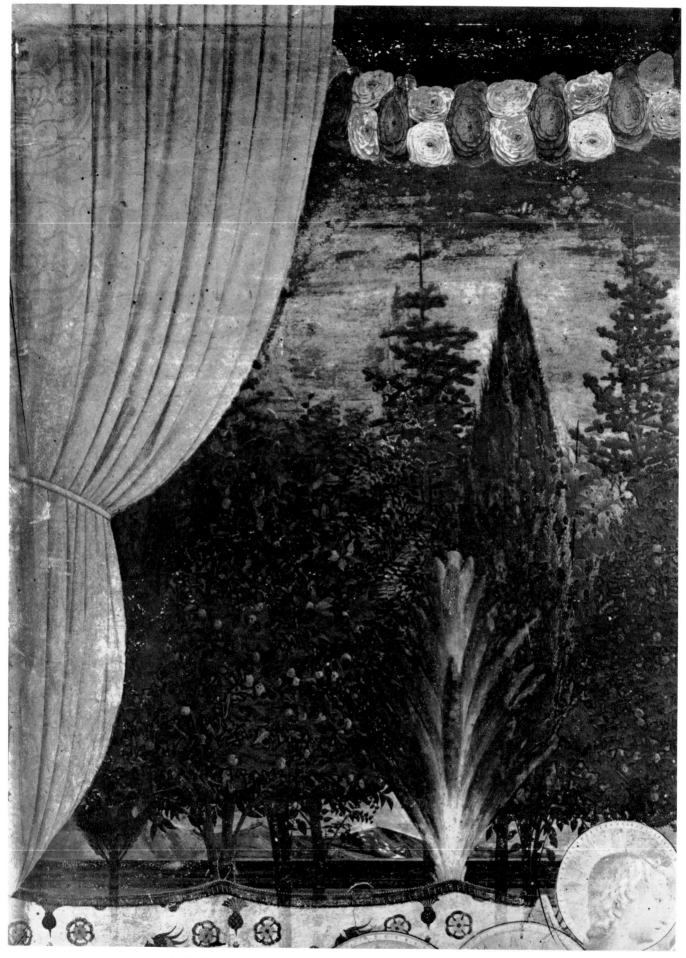

54. VIEW OVER WALL. Detail of Plate 48.

55. VIEW OVER WALL. Detail of Plate 48.

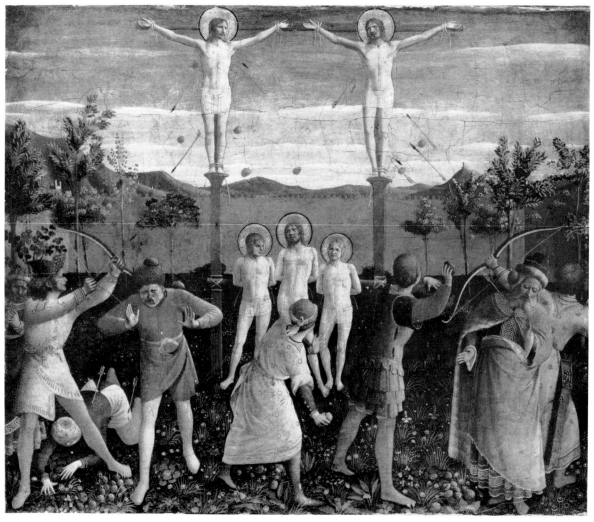

56a. THE CRUCIFIXION OF SAINTS COSMAS AND DAMIAN. Alte Pinakothek, Munich.

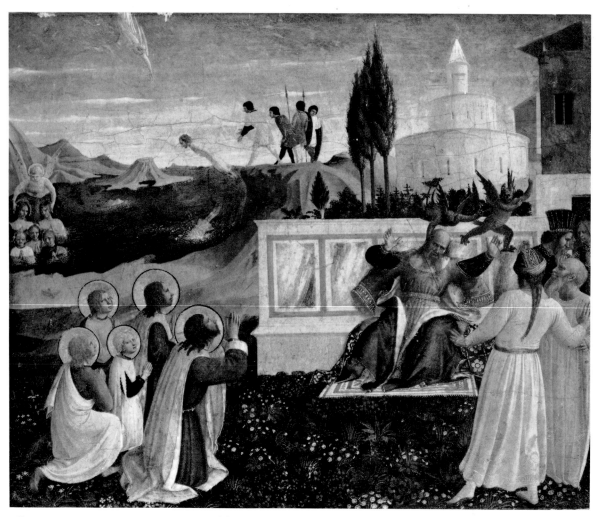

56b. LYCIAS POSSESSED BY DEVILS. Alte Pinakothek, Munich.

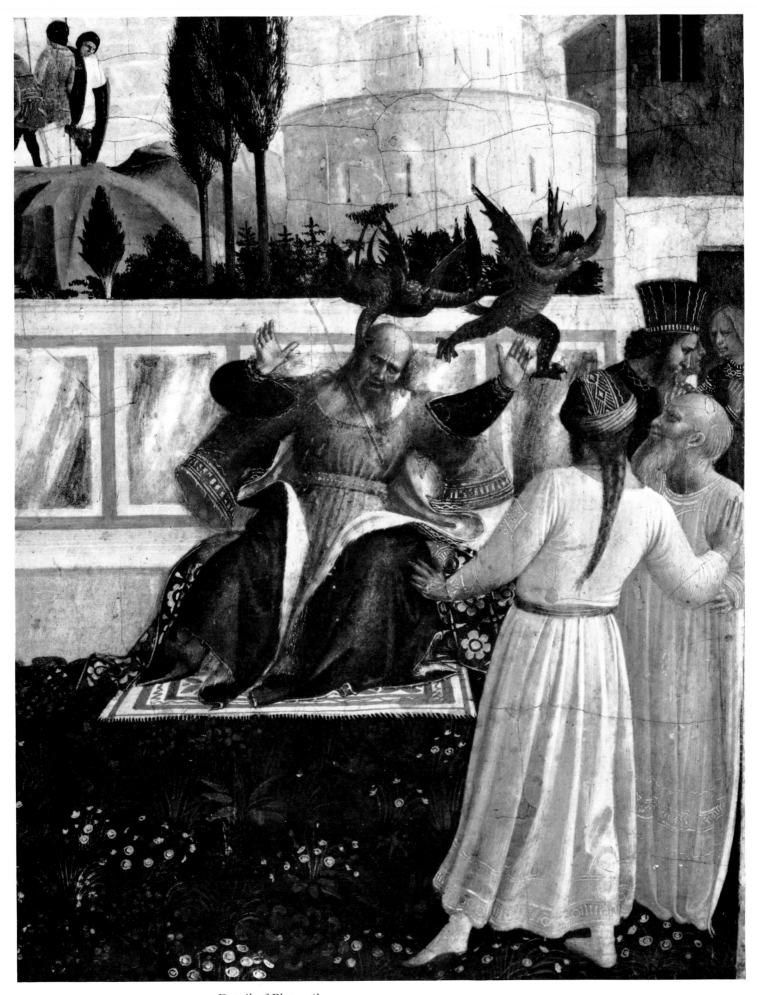

57. LYCIAS POSSESSED BY DEVILS. Detail of Plate 56b.

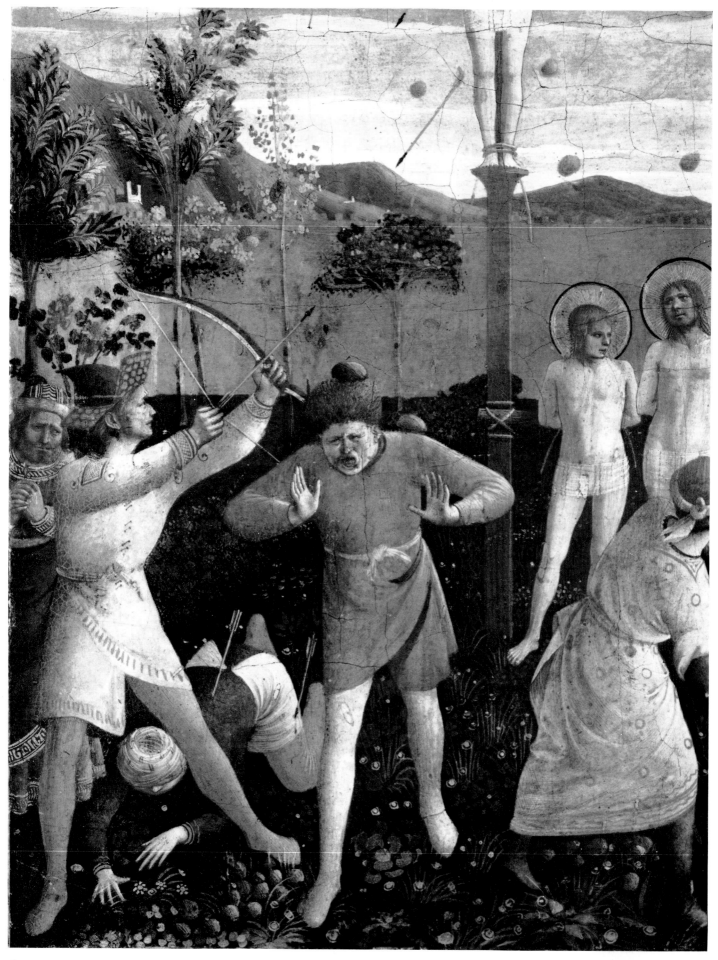

58. THE CRUCIFIXION OF SAINTS COSMAS AND DAMIAN. Detail of Plate 56a.

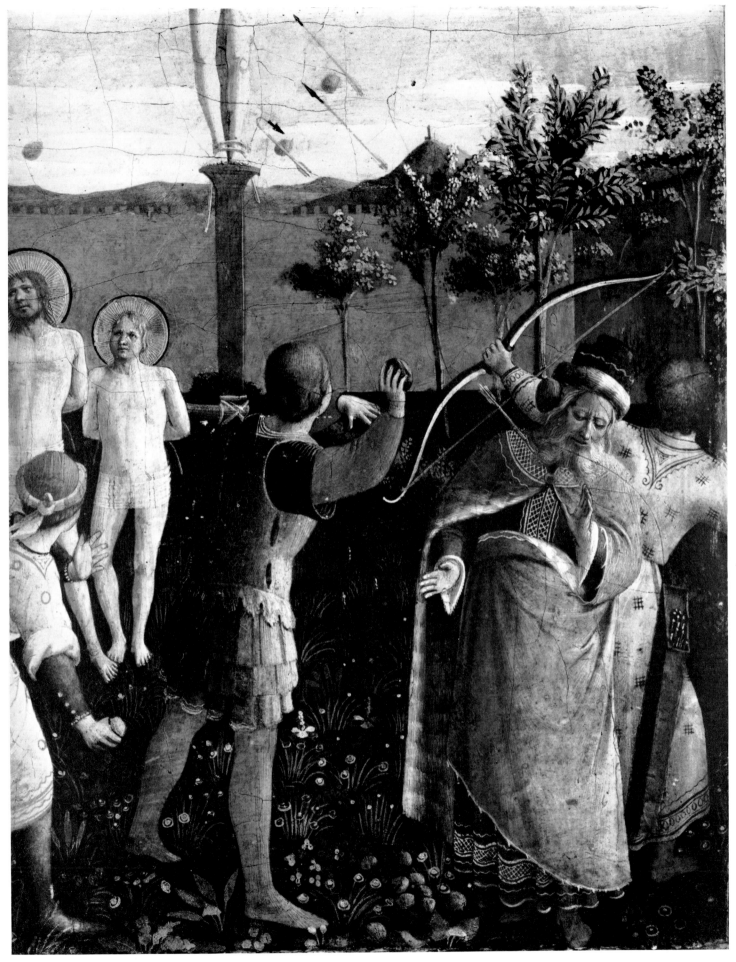

59. THE CRUCIFIXION OF SAINTS COSMAS AND DAMIAN. Detail of Plate 56a.

60. SAINTS COSMAS AND DAMIAN BEFORE LYCIAS. Alte Pinakothek, Munich.

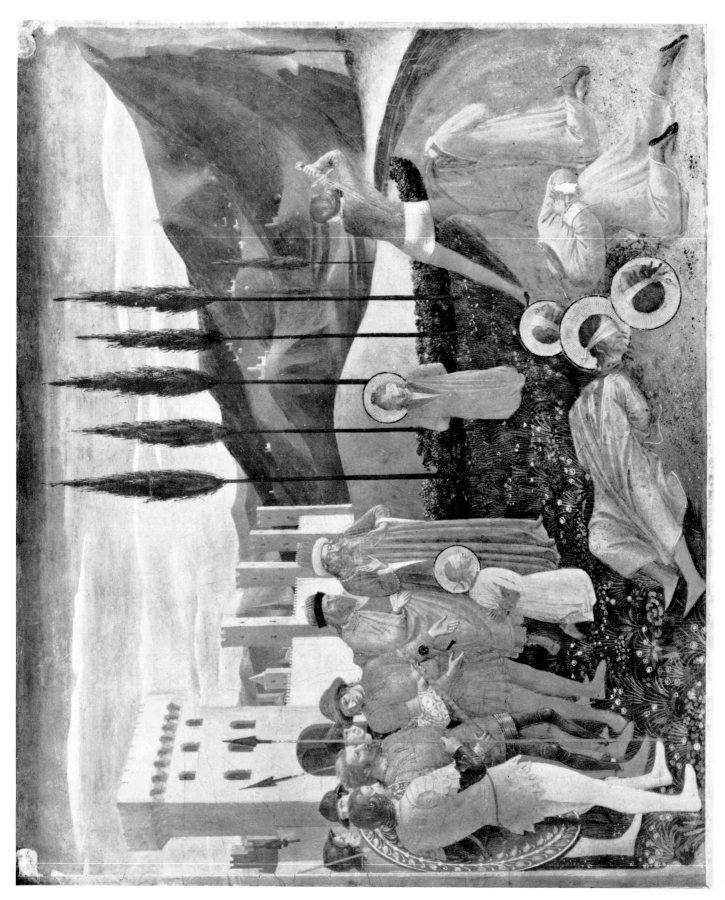

62. THE DECAPITATION OF SAINTS COSMAS AND DAMIAN. Louvre, Paris.

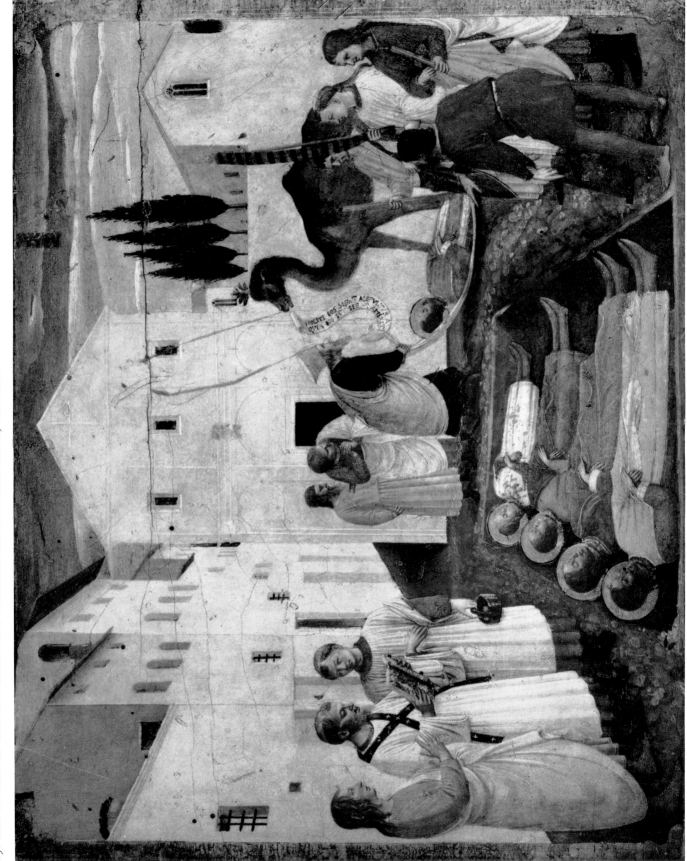

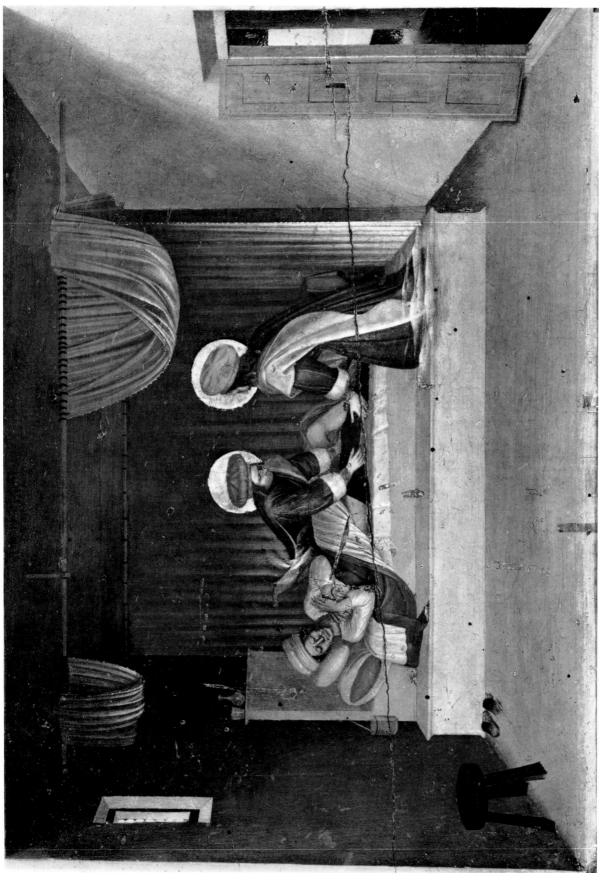

64. THE DREAM OF THE DEACON JUSTINIAN. Museo di San Marco, Florence.

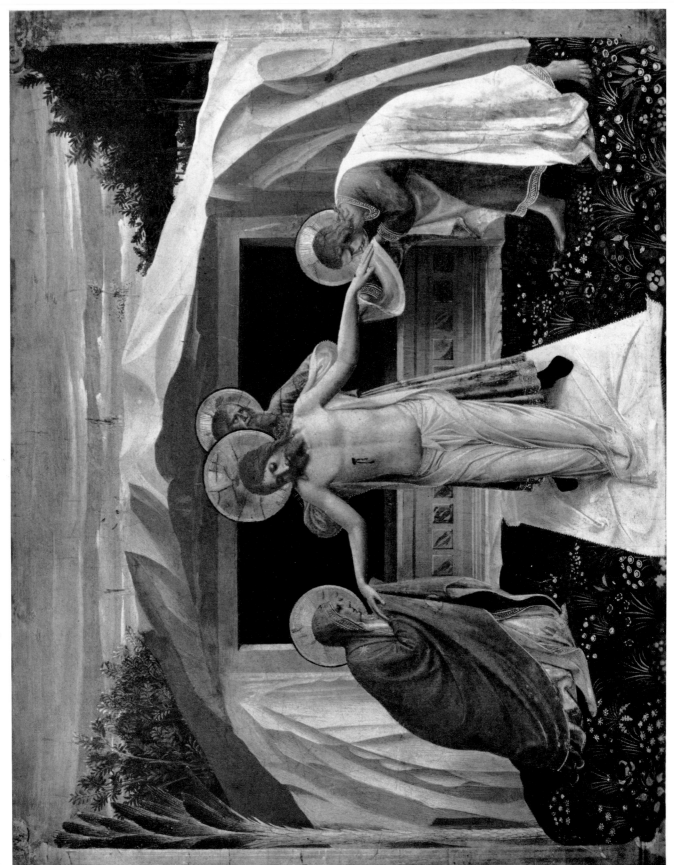

65. THE ENTOMBMENT. Alte Pinakothek, Munich.

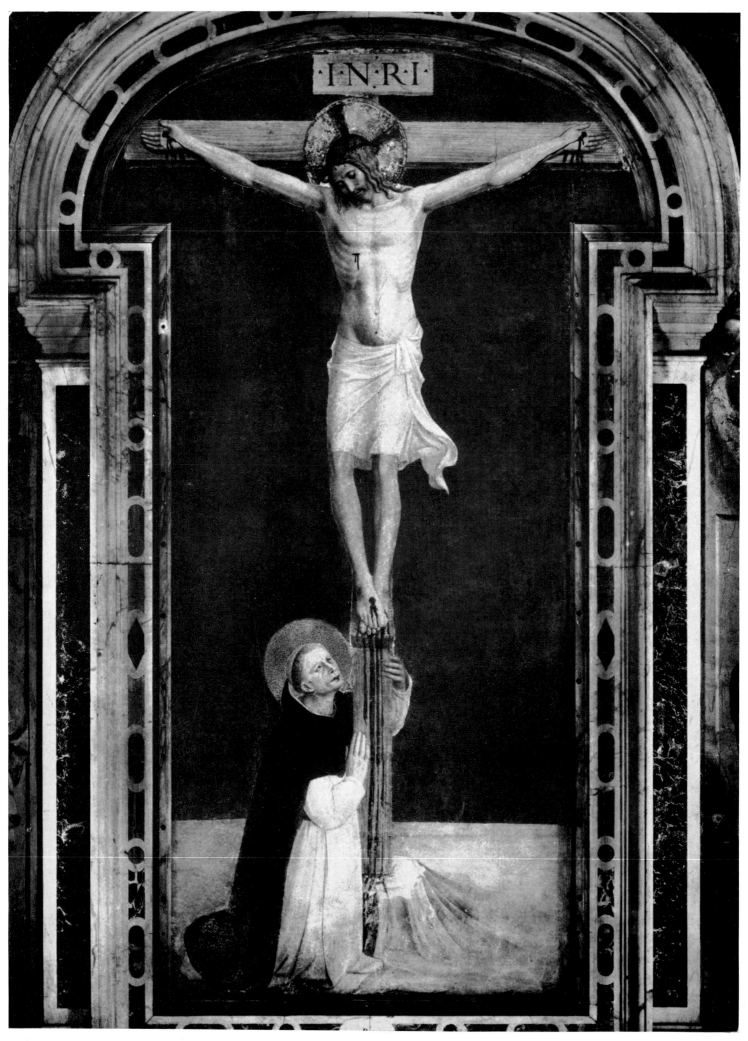

66. CHRIST ON THE CROSS ADORED BY SAINT DOMINIC. Cloister, San Marco, Florence.

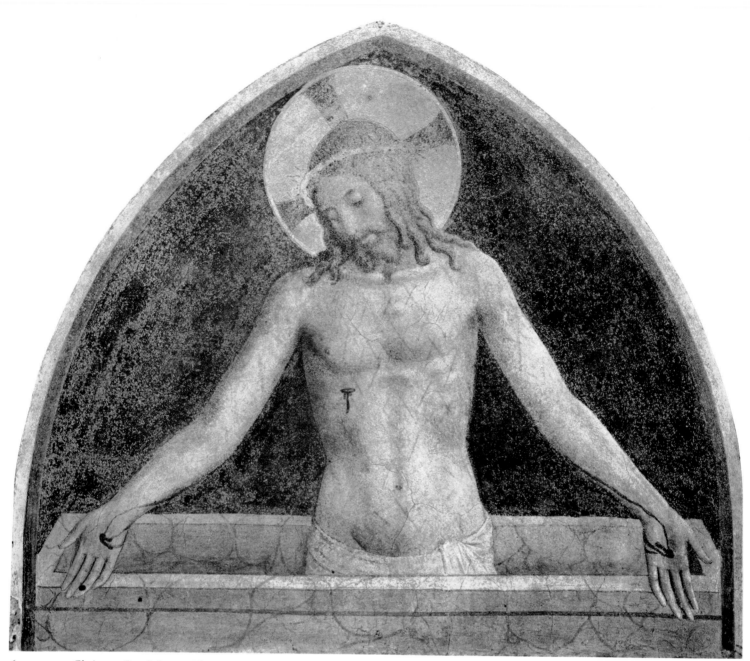

67. PIETA. Cloister, San Marco, Florence.

68. SAINT THOMAS AQUINAS. Cloister, San Marco, Florence.

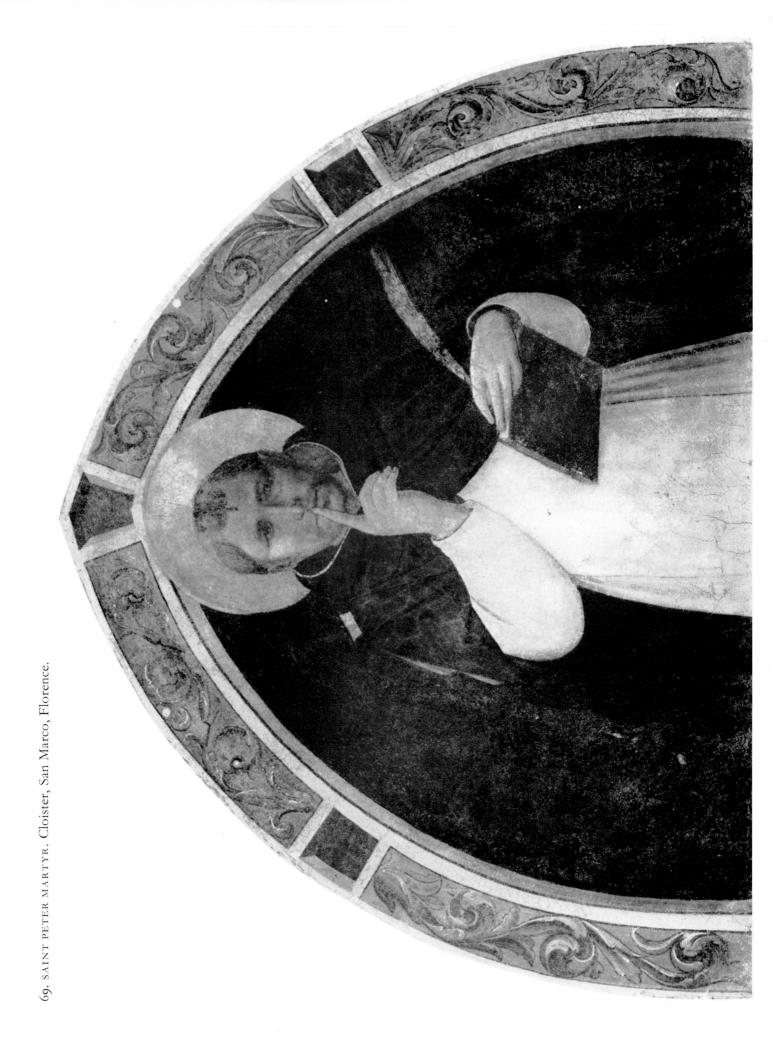

69. SAINT PETER MARTYR. Cloister, San Marco, Florence.

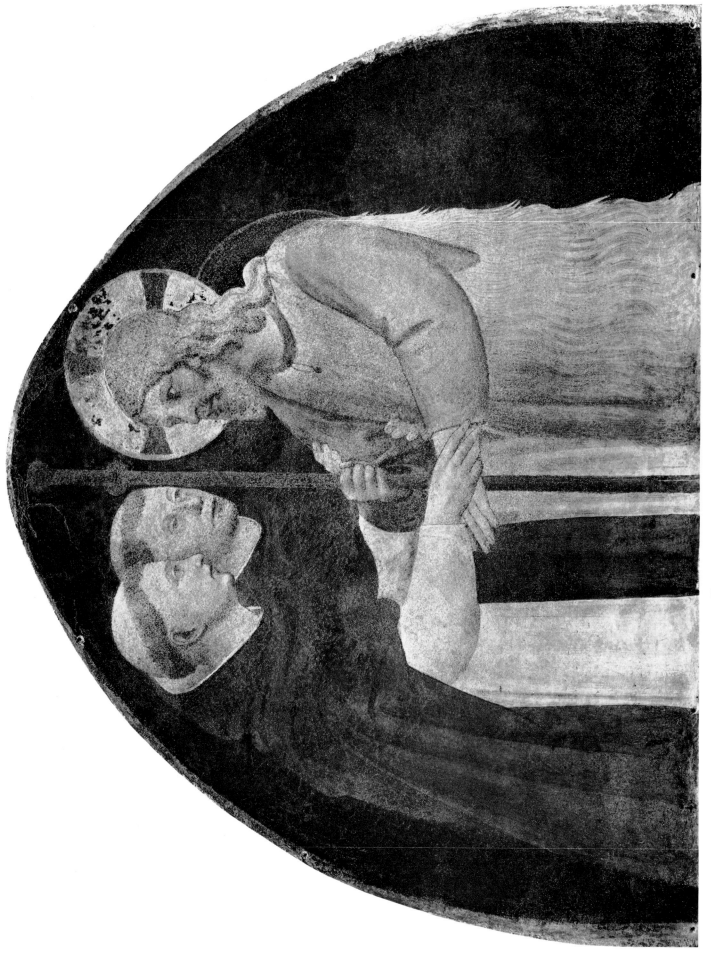

70. CHRIST AS PILGRIM RECEIVED BY TWO DOMINICANS. Cloister, San Marco, Florence.

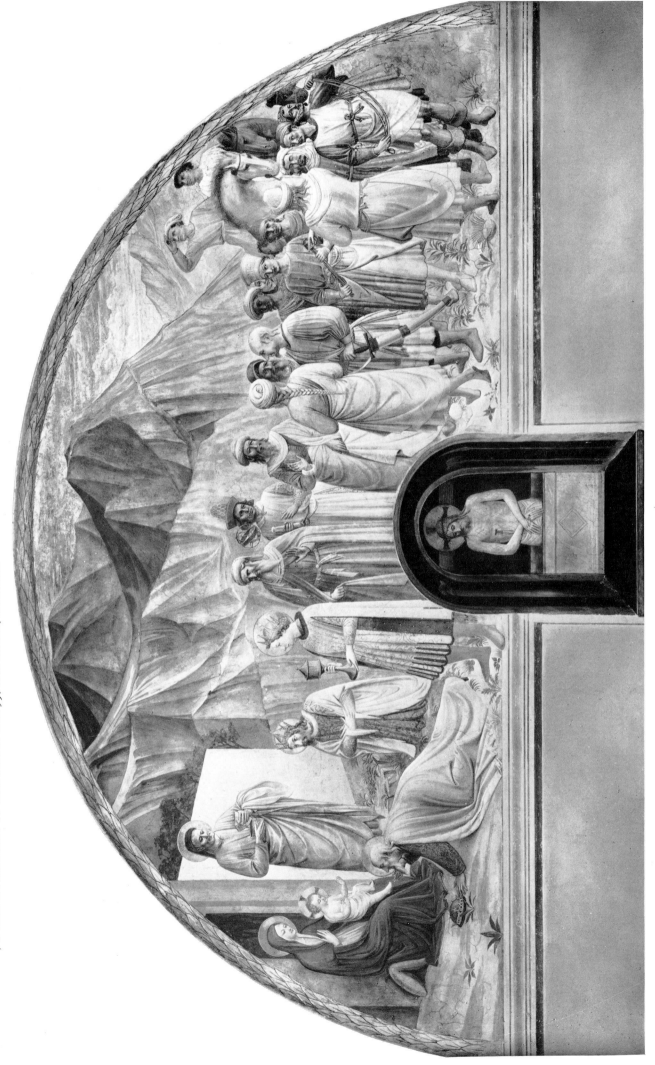

71. THE ADORATION OF THE MAGI. Cell 39, San Marco, Florence.

72–73. THE CRUCIFIXION. Sala del Capitolo, San Marco, Florence.

74. SAINTS COSMAS AND DAMIAN. Detail of Plate 73.

75. SAINTS FRANCIS AND BERNARD. Detail of Plate 73.

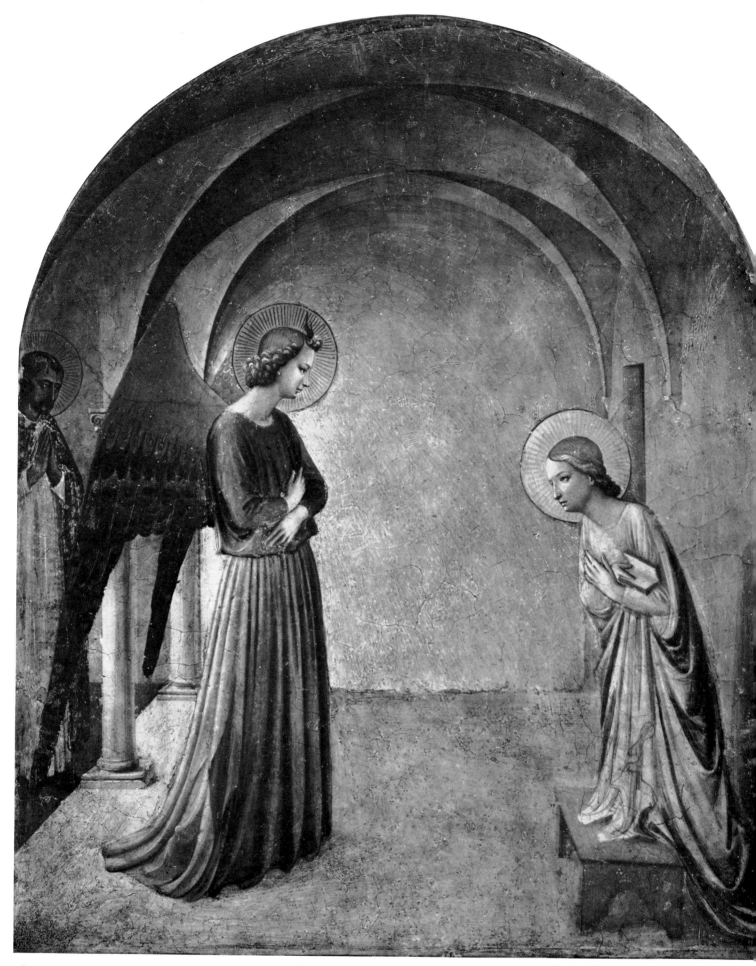

76. THE ANNUNCIATION. Cell 3, San Marco, Florence.

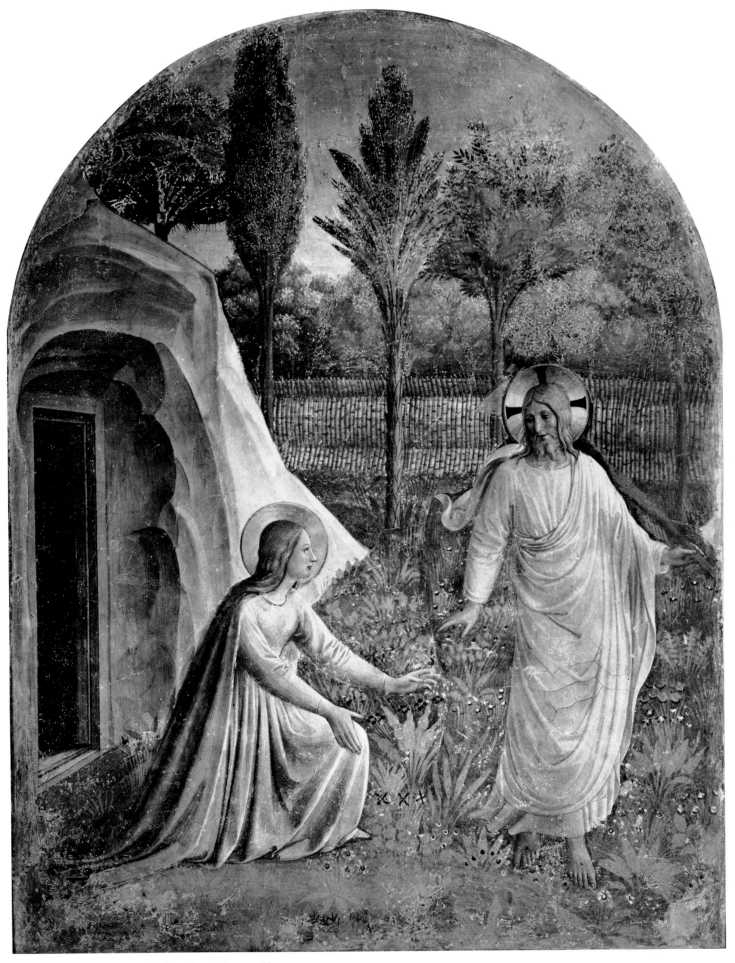

77. NOLI ME TANGERE. Cell 1, San Marco, Florence.

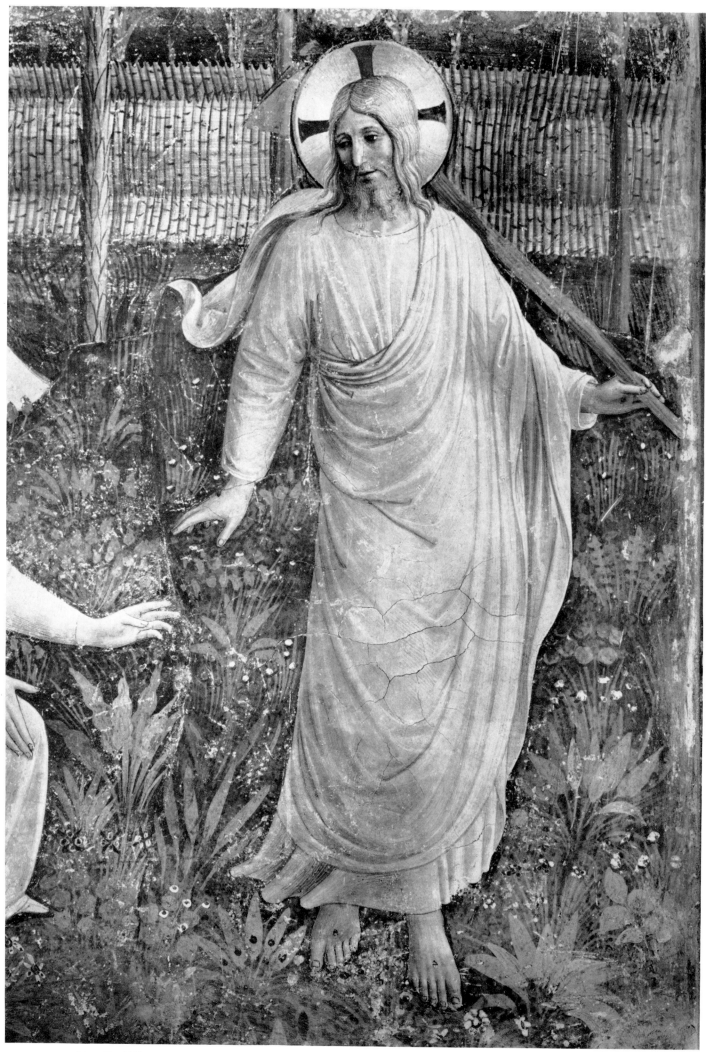

78. CHRIST. Detail of Plate 77.

79. THE VIRGIN ANNUNCIATE. Detail of Plate 76.

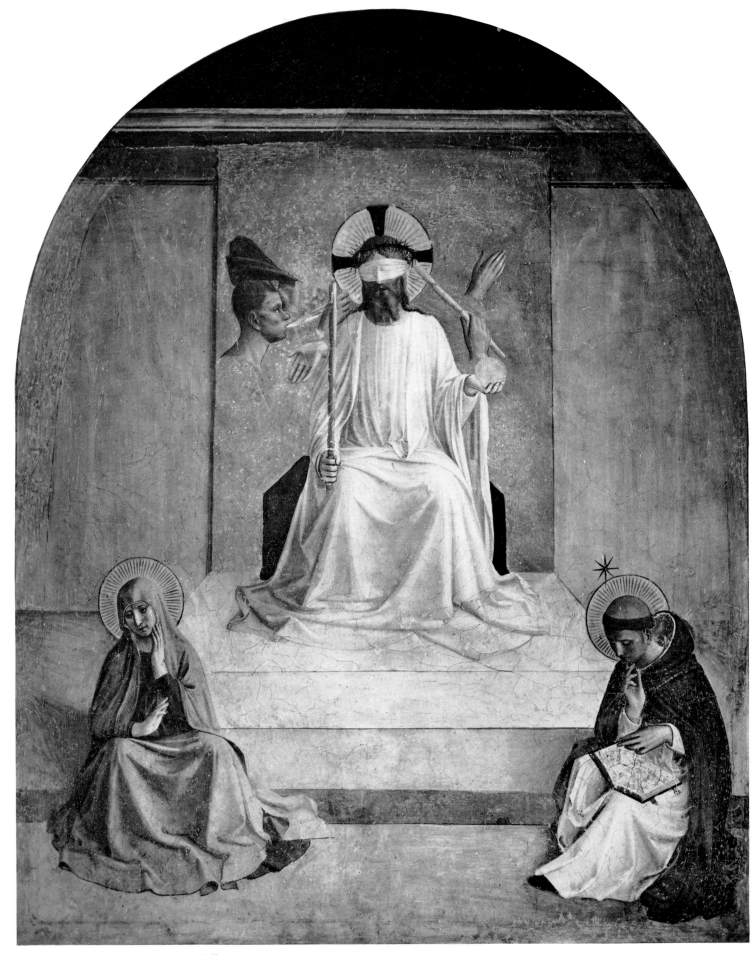

80. THE MOCKING OF CHRIST. Cell 7, San Marco, Florence.

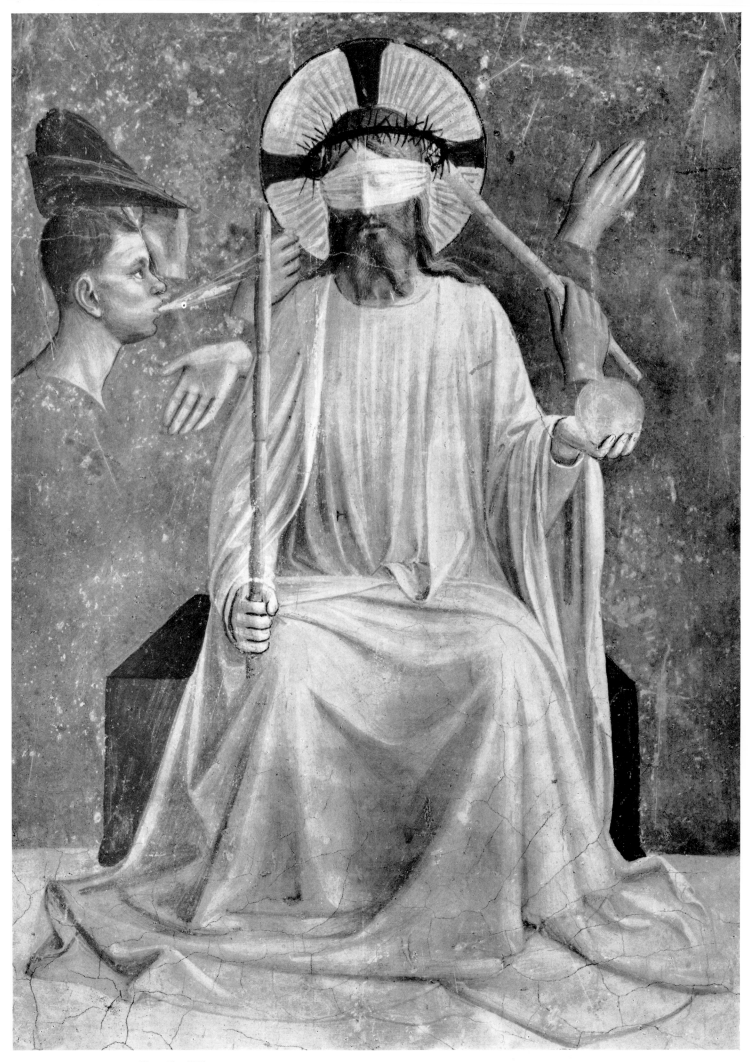

81. CHRIST MOCKED. Detail of Plate 80.

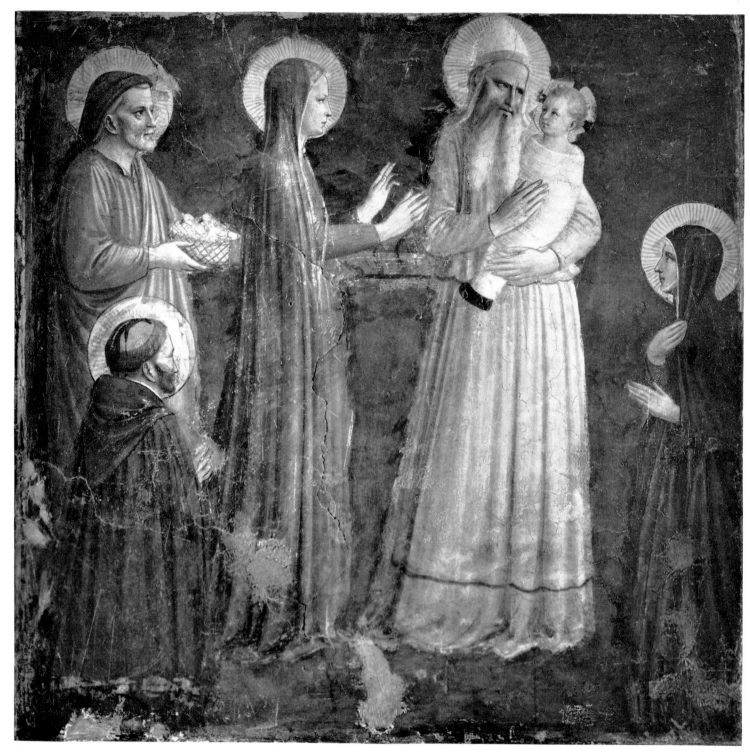

82. THE PRESENTATION IN THE TEMPLE. Cell 10, San Marco, Florence.

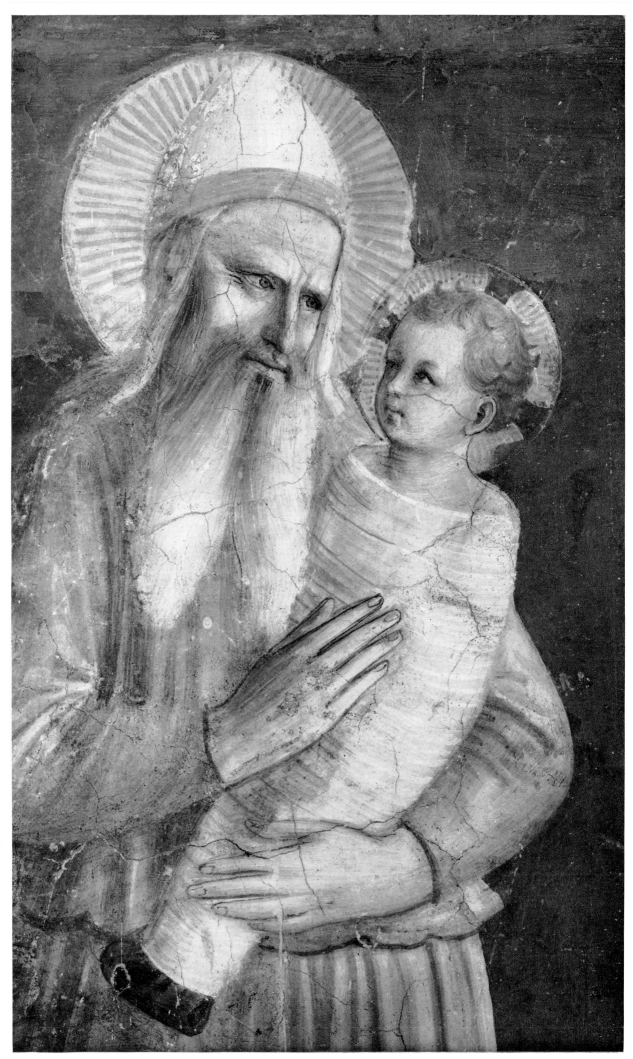

83. SIMEON WITH THE CHILD CHRIST. Detail of Plate 82.

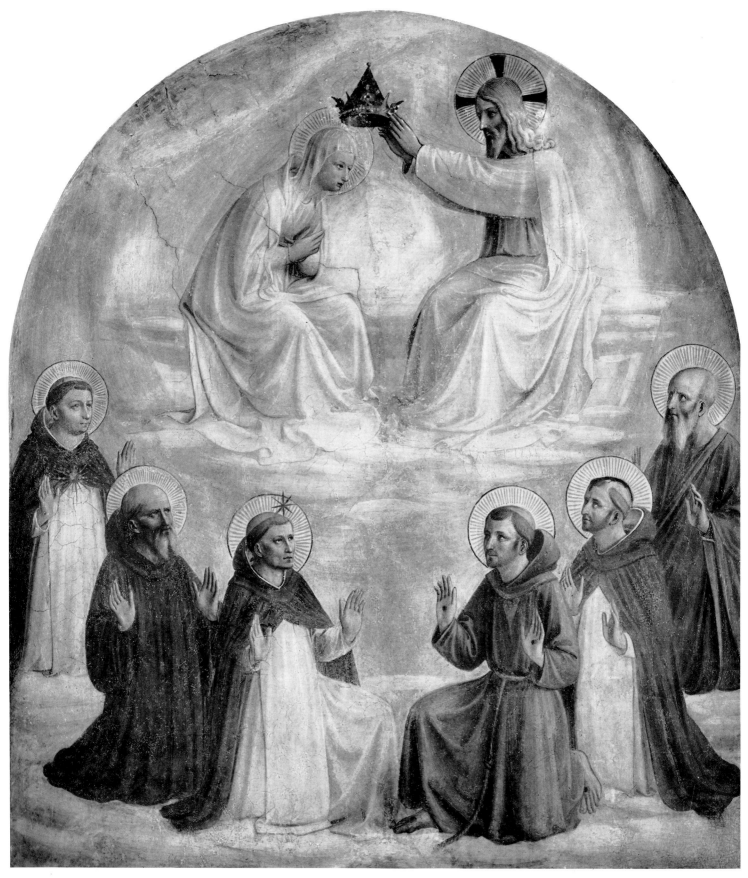

84. THE CORONATION OF THE VIRGIN. Cell 9, San Marco, Florence.

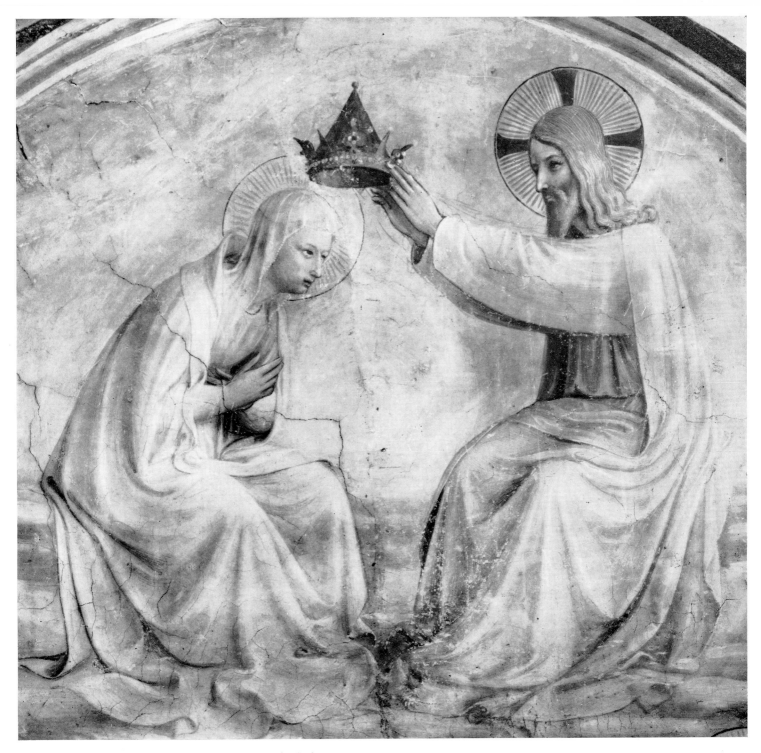

85. THE CORONATION OF THE VIRGIN. Detail of Plate 84.

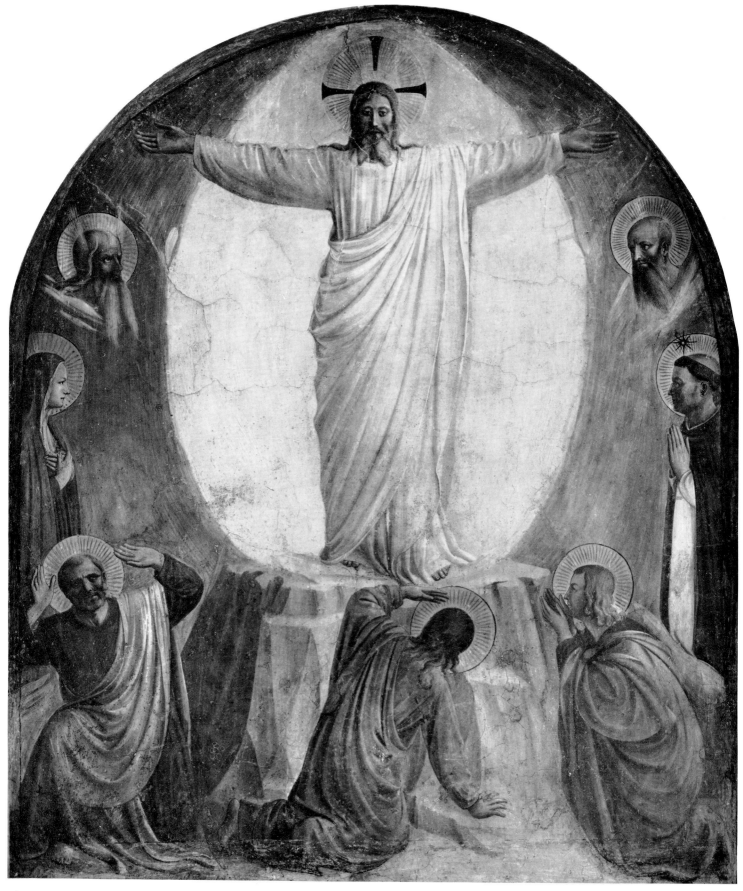

86. THE TRANSFIGURATION. Cell 6, San Marco, Florence.

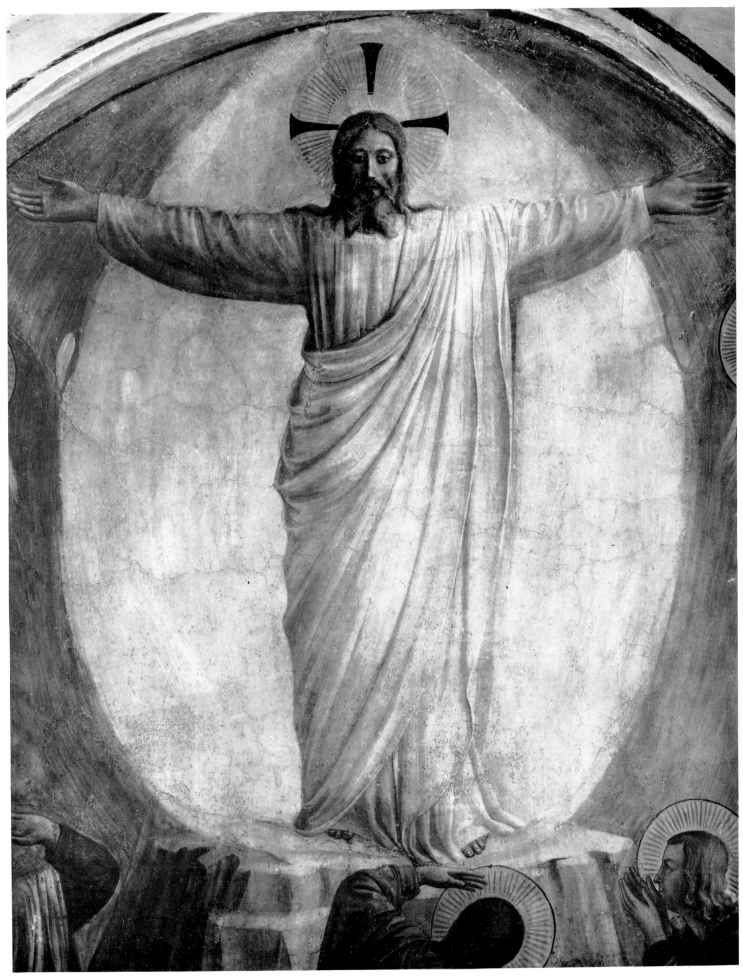

87. THE TRANSFIGURED CHRIST. Detail of Plate 86.

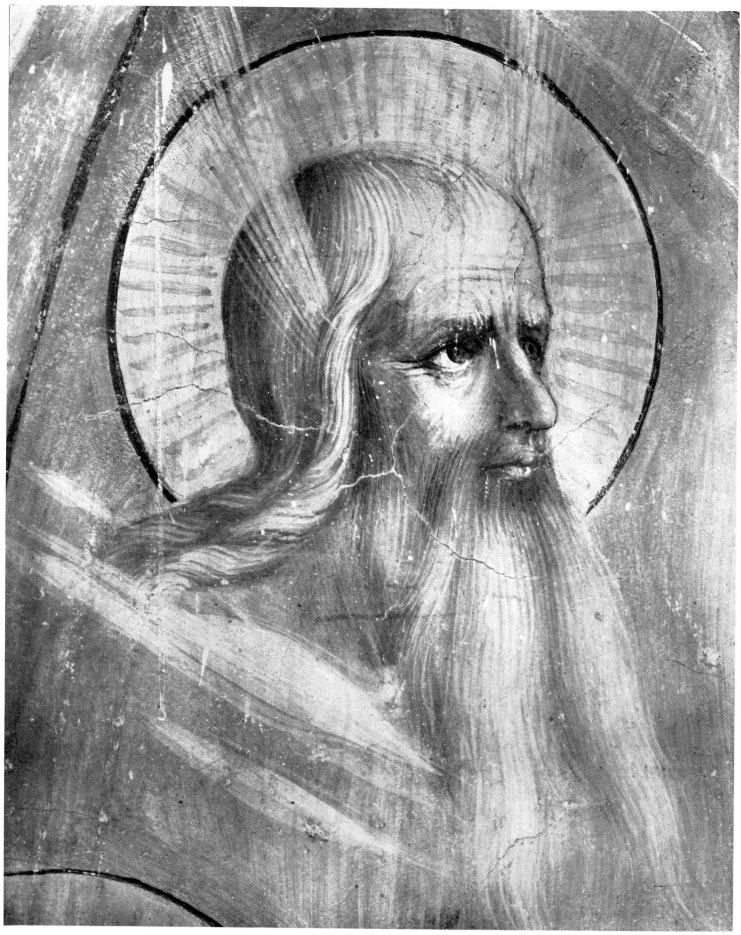

88. MOSES. Detail of Plate 86.

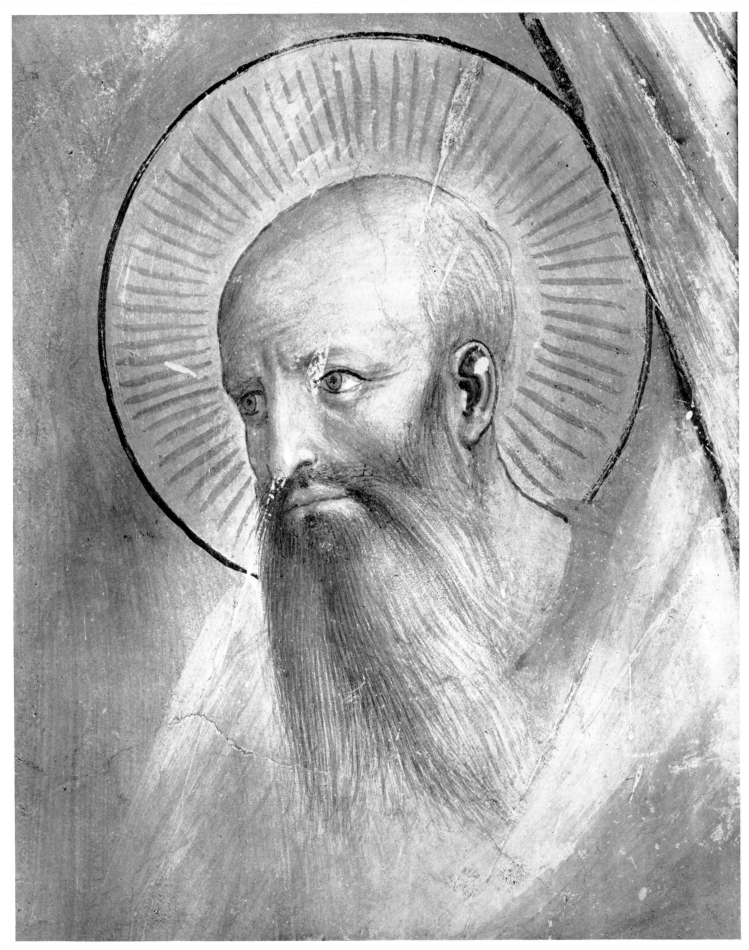

89. ELIAS. Detail of Plate 86.

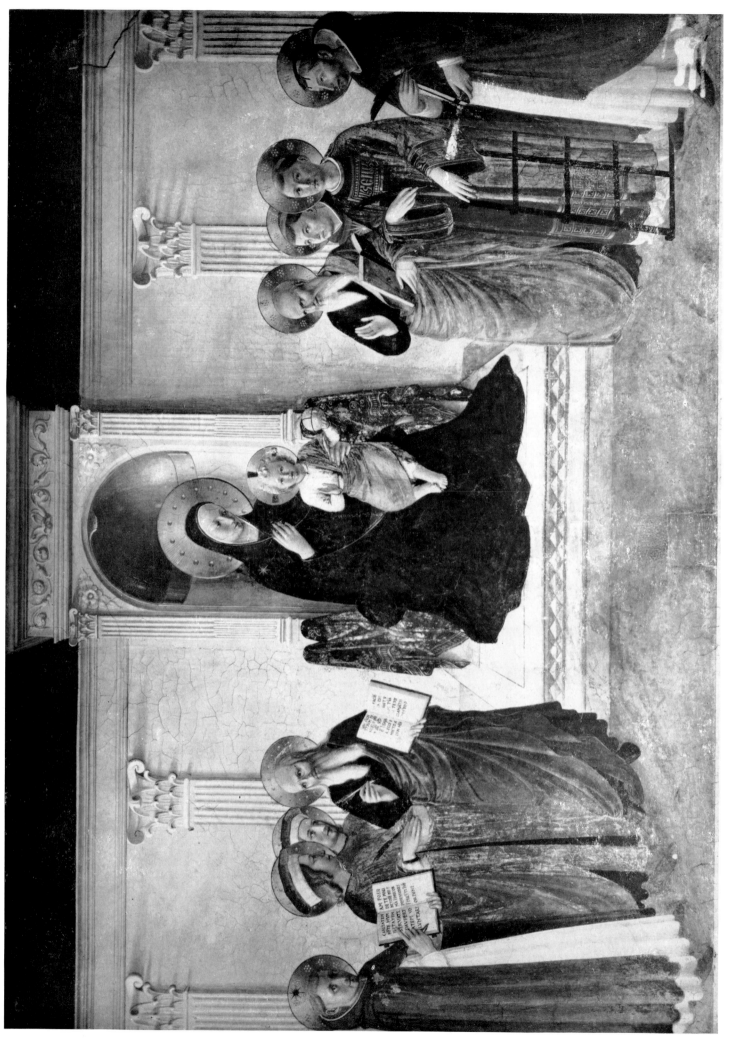

90. VIRGIN AND CHILD ENTHRONED WITH SAINTS DOMINIC, COSMAS, DAMIAN, MARK, JOHN THE EVANGELIST, THOMAS AQUINAS, LAWRENCE AND PETER MARTYR.
Upper Corridor, San Marco, Florence.

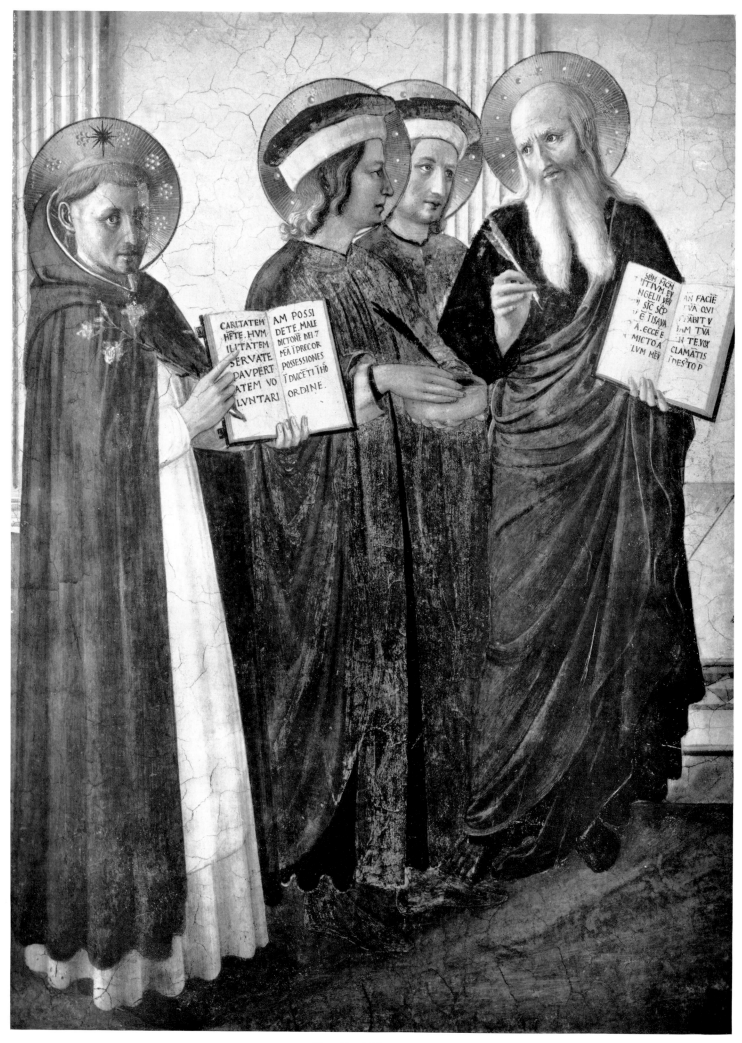

The books held by the saints bear inscriptions:

CARITATEM / AM POSSI
HETE. HVM / DE TE. MALE
ILITATEM / DICTOE DEI. 7
SERVATE / MEA I PRECOR
PAVPERT / POSSESSIONES
ATEM VO / I DVCETI THO
LVNTARI / ORDINE.

SBM MCN / AN FACIE
ITIVM EV / TVA QVI
NGELII VRI / PABIT V
SIC SCD / IAM TVA
E IISAYA / EN TE.VOX
A.ECCE E / CLAMATIS
MICTO A / IDESTO P
LVM MEV

92. SAINTS DOMINIC, COSMAS, DAMIAN AND MARK. Detail of Plate 90.

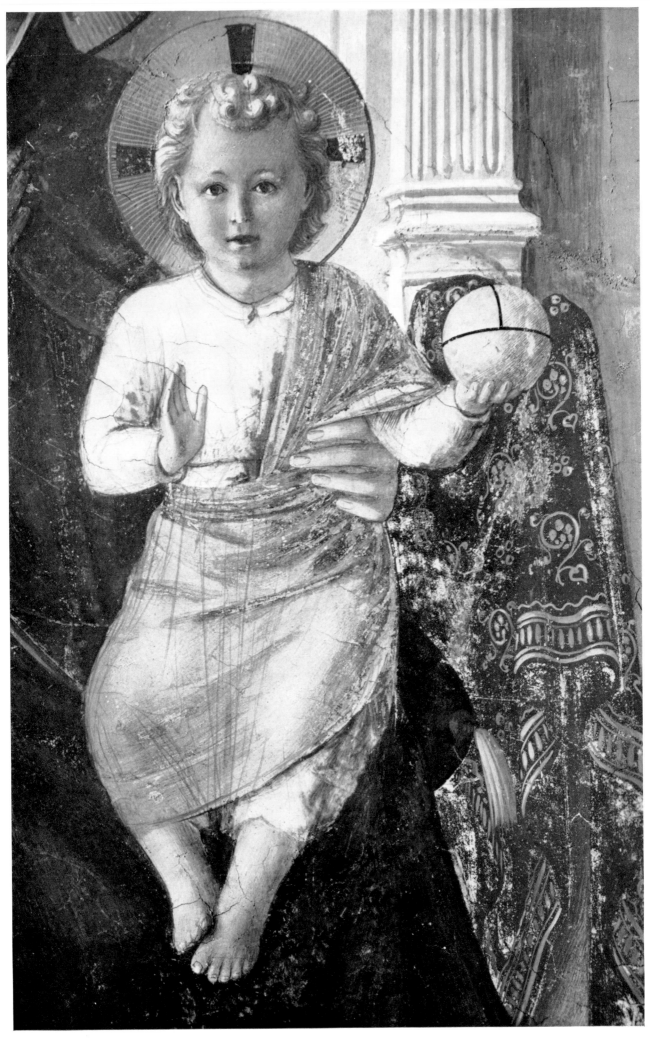

93. THE CHRIST CHILD BLESSING. Detail of Plate 90.

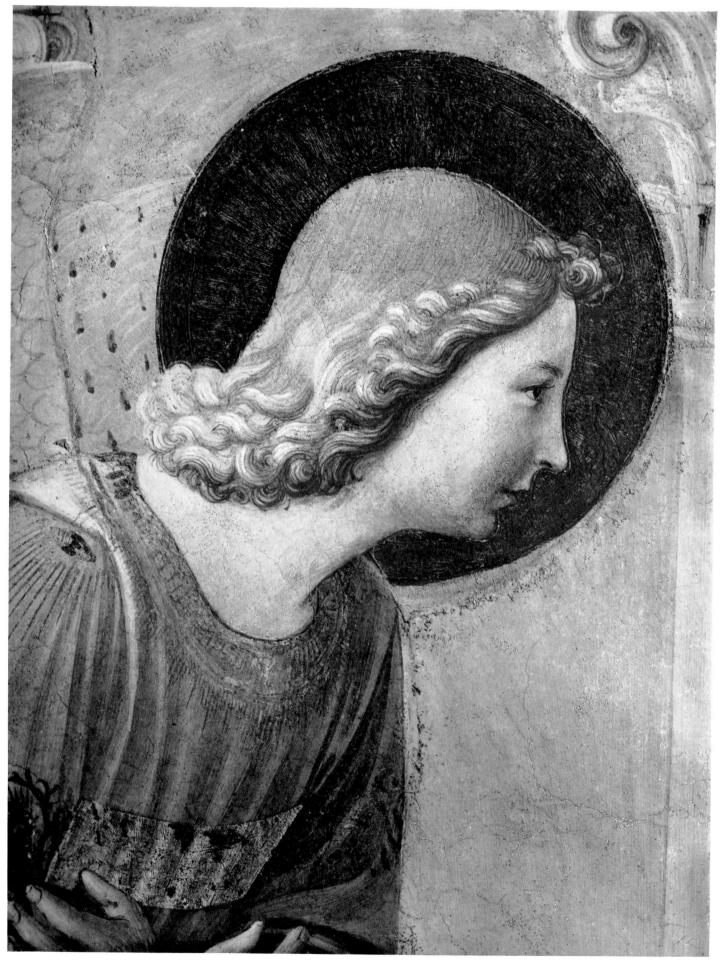

94. THE ANGEL OF THE ANNUNCIATION. Detail of Plate 91.

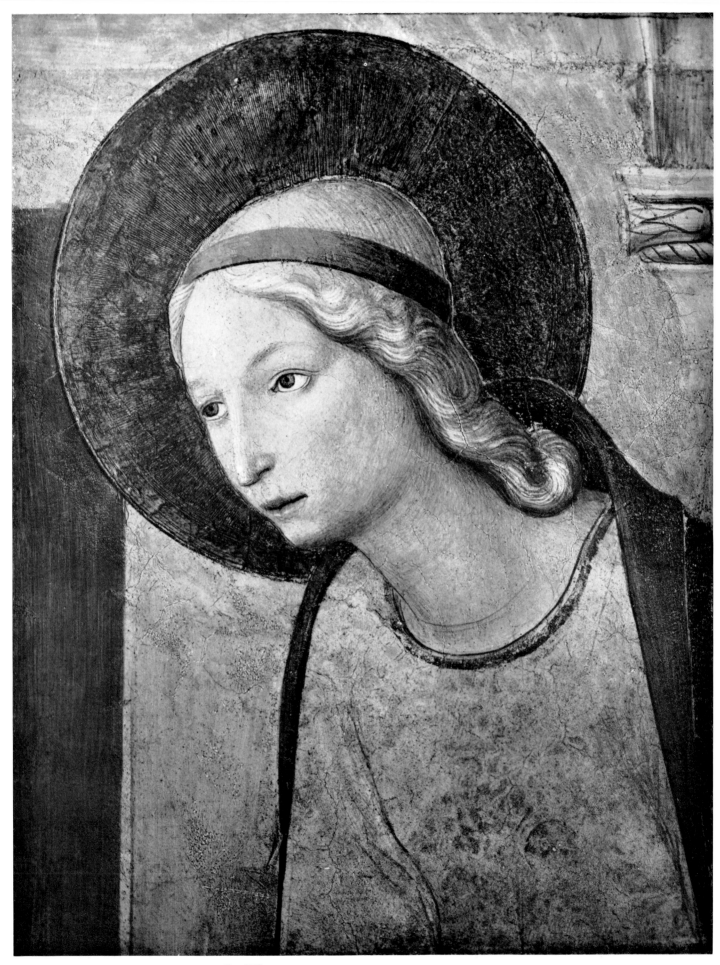

95. THE VIRGIN ANNUNCIATE. Detail of Plate 91.

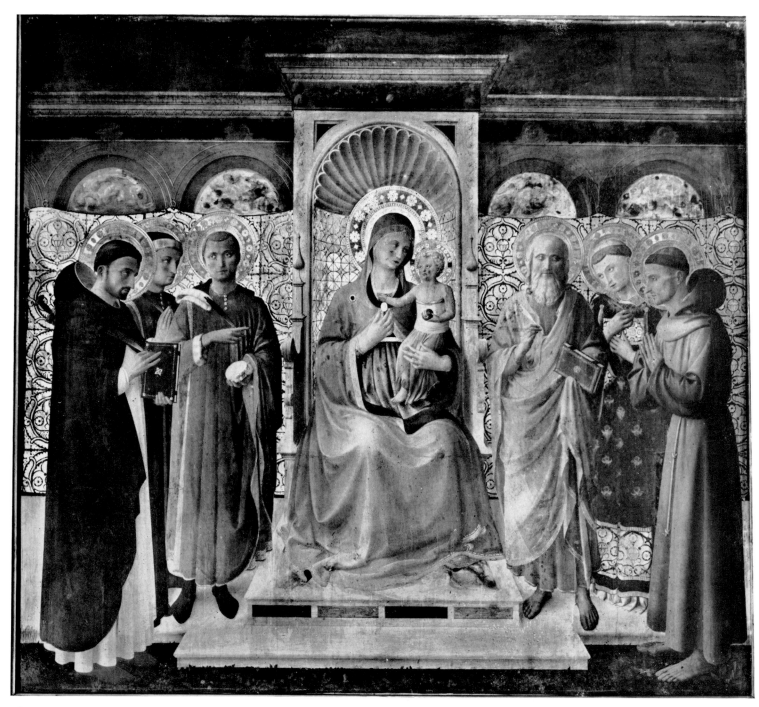

96. THE ANNALENA ALTARPIECE: THE VIRGIN AND CHILD ENTHRONED WITH SAINTS PETER MARTYR, COSMAS, DAMIAN, JOHN THE EVANGELIST, LAWRENCE AND FRANCIS. Museo di San Marco, Florence.

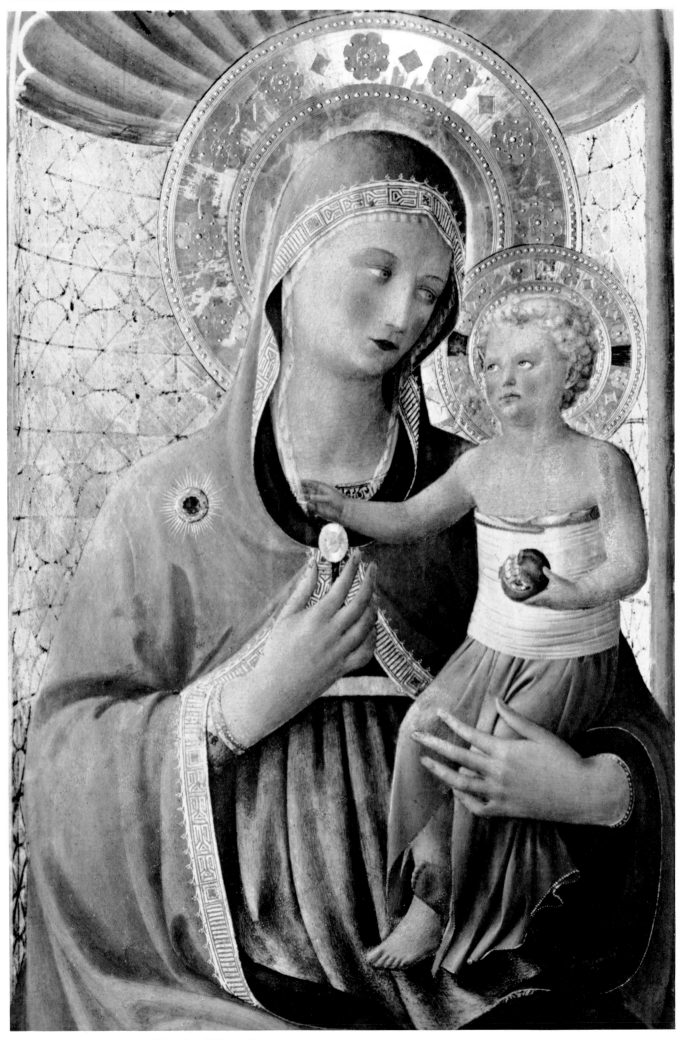

97. VIRGIN AND CHILD. Detail of Plate 96.

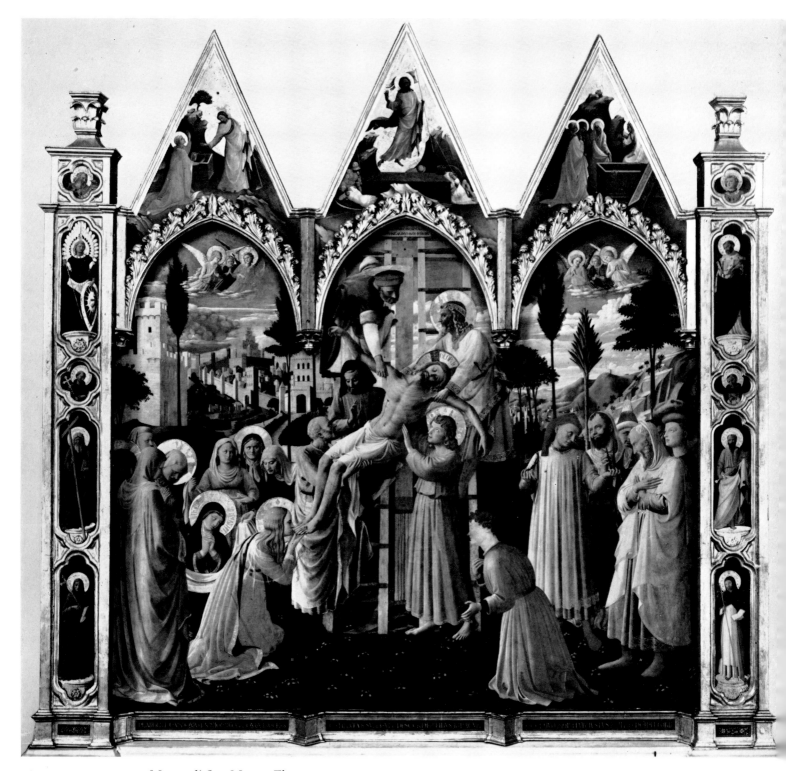

98. THE DEPOSITION. Museo di San Marco, Florence.

99. HEAD OF CHRIST. Detail of Plate 98.

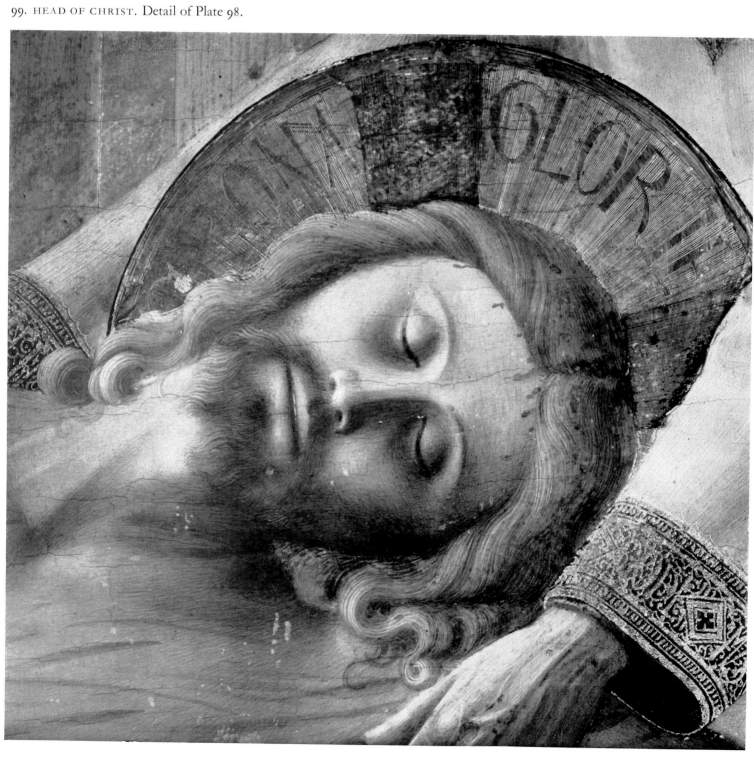

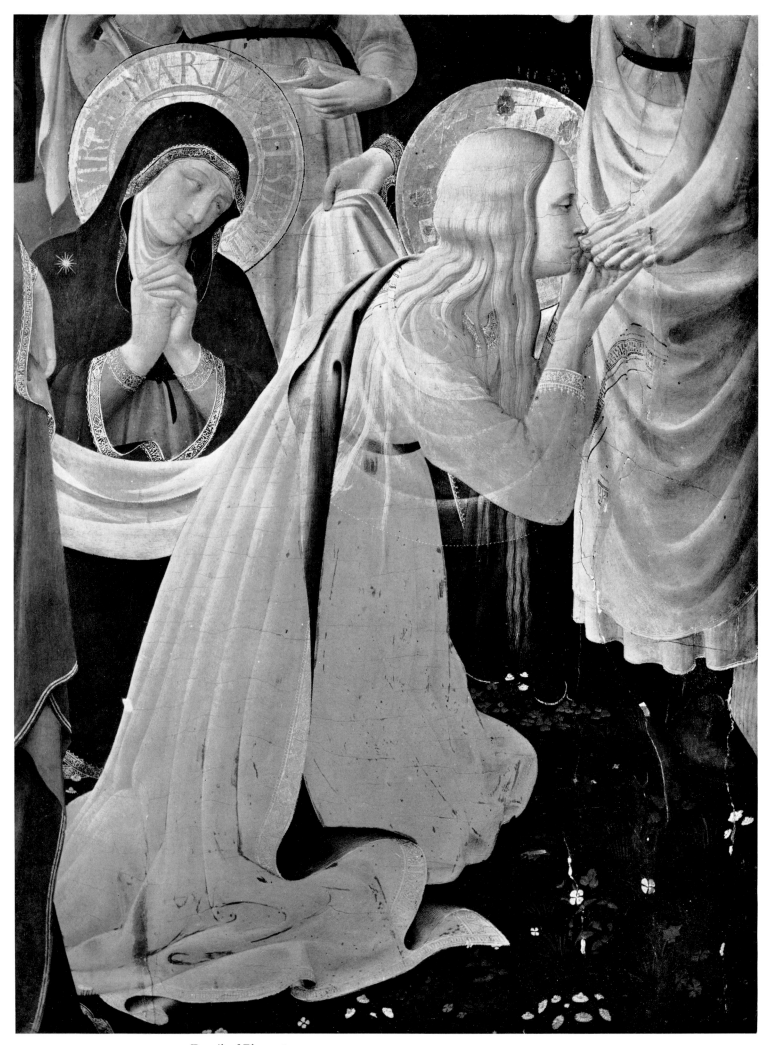

100. SAINT MARY MAGDALEN. Detail of Plate 98.

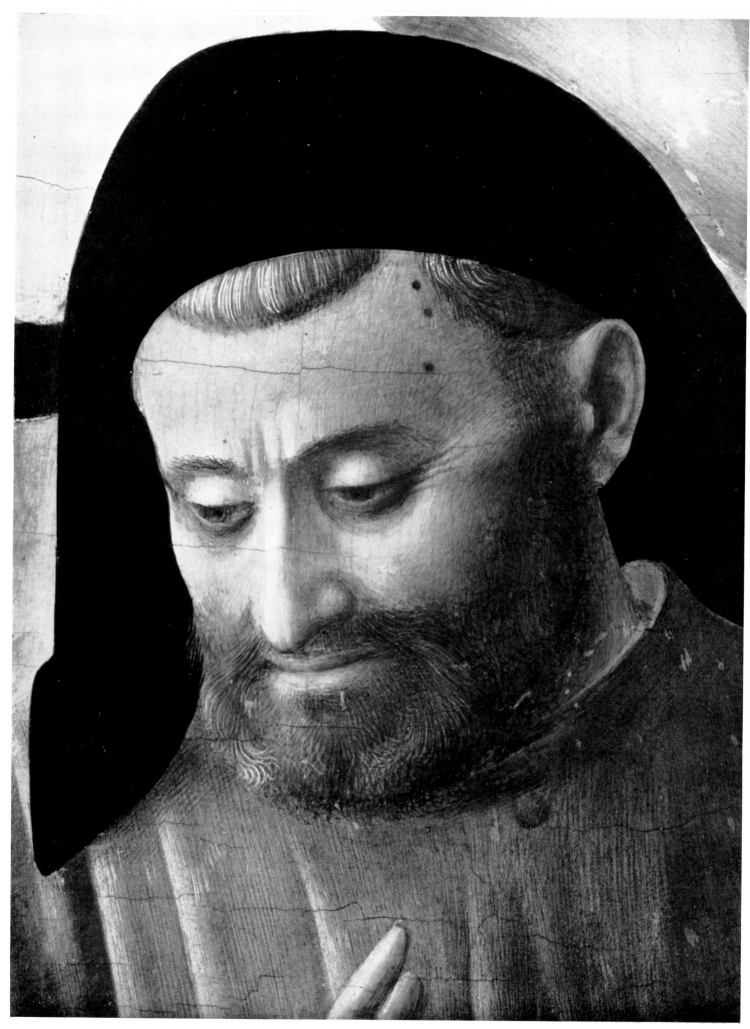

101. A MALE HEAD. Detail of Plate 98.

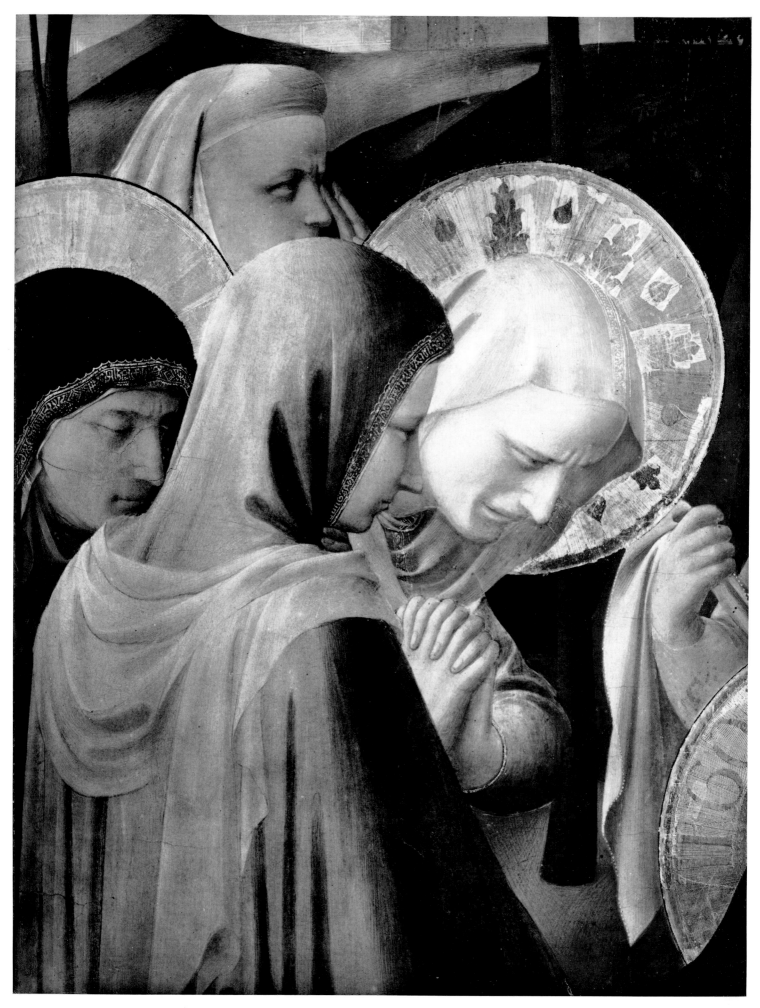

102. THE HOLY WOMEN. Detail of Plate 98.

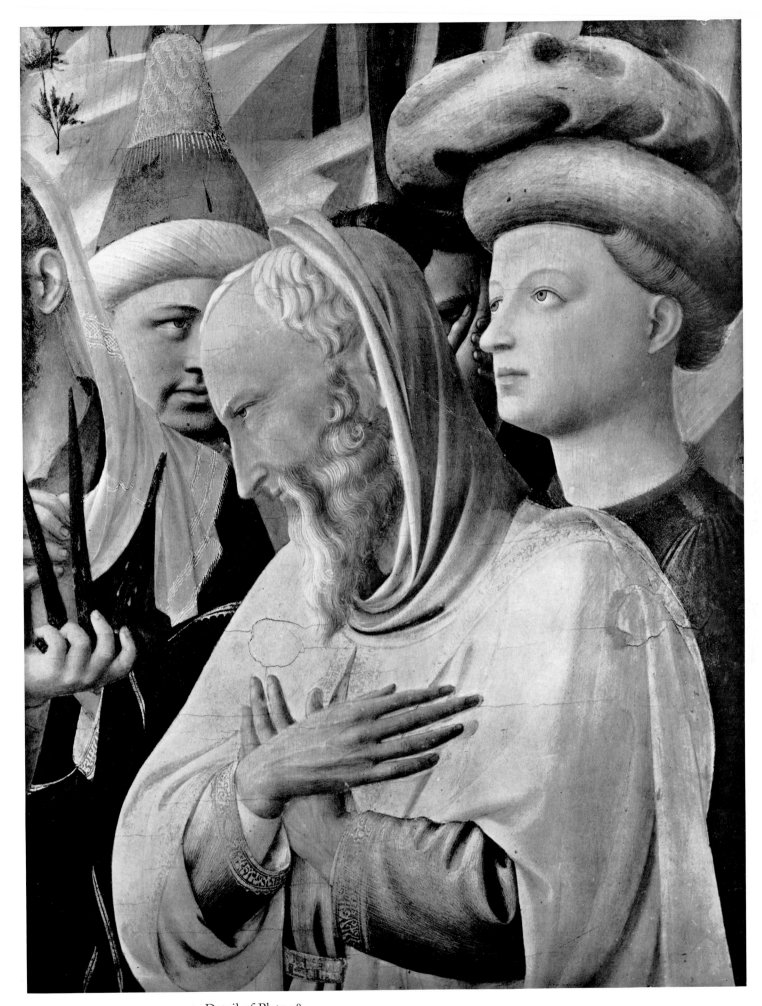

103. A GROUP OF ONLOOKERS. Detail of Plate 98.

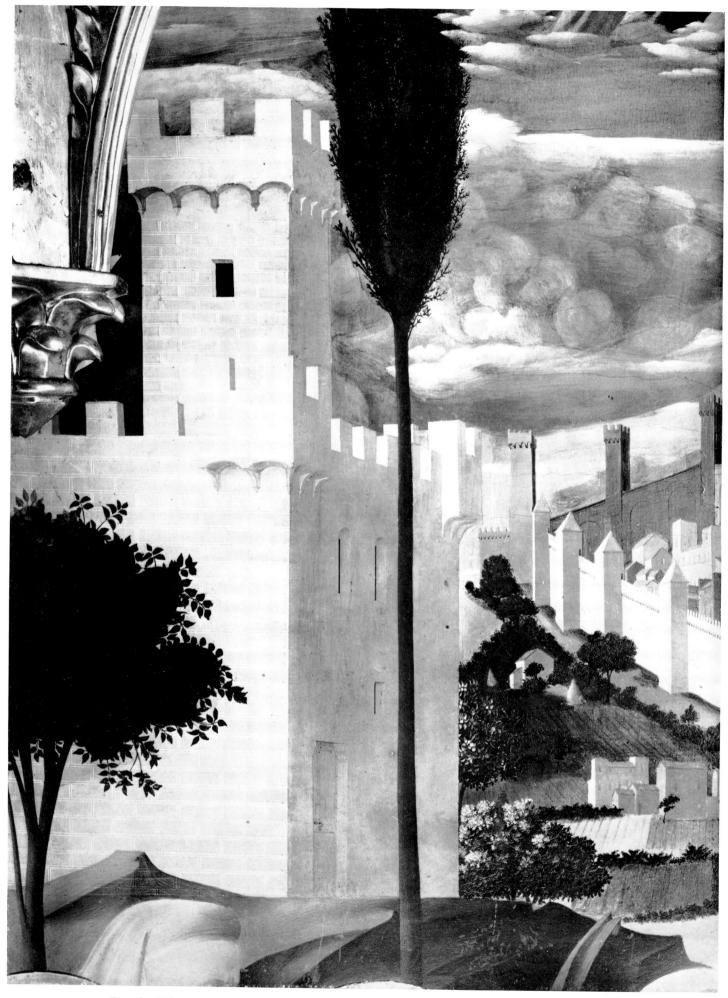

104. LANDSCAPE. Detail of Plate 98.

105. LANDSCAPE. Detail of Plate 98.

106. LANDSCAPE. Detail of Plate 98.

107 LANDSCAPE. Detail of Plate 98.

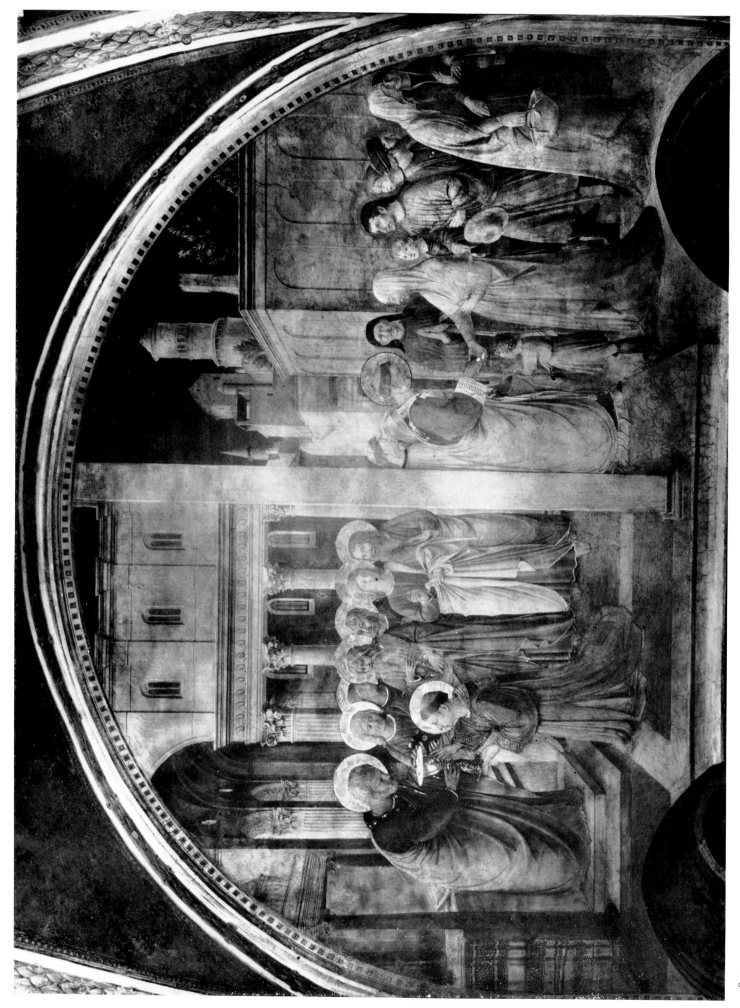

108. THE ORDINATION OF SAINT STEPHEN: SAINT STEPHEN DISTRIBUTING ALMS. Chapel of Nicholas V, Vatican.

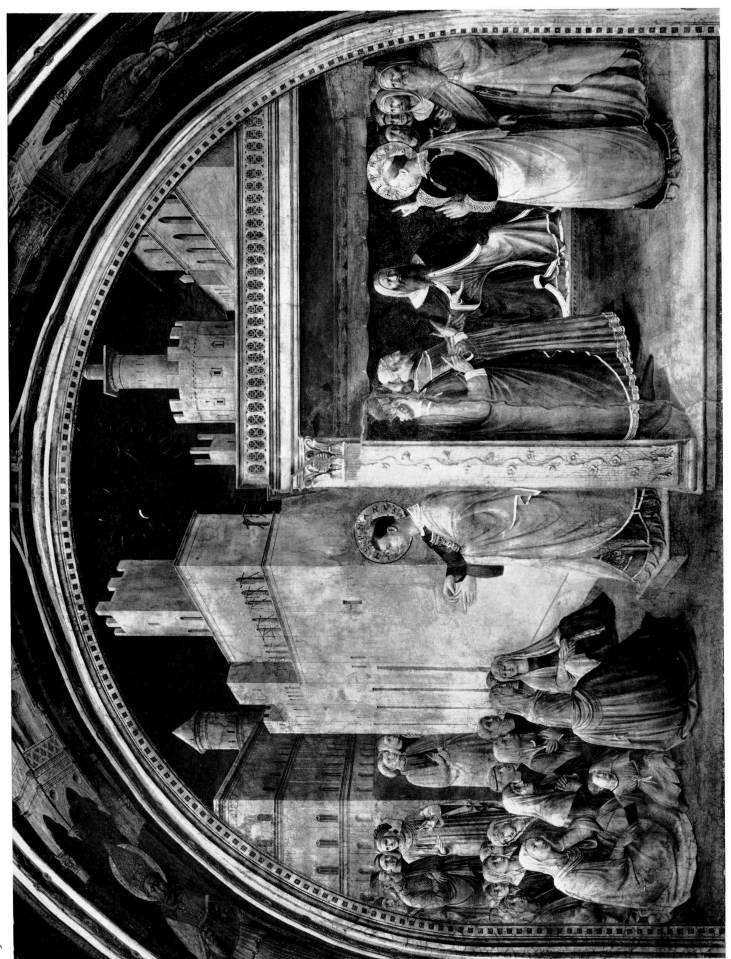

109. SAINT STEPHEN PREACHING: SAINT STEPHEN ADDRESSING THE COUNCIL. Chapel of Nicholas V, Vatican.

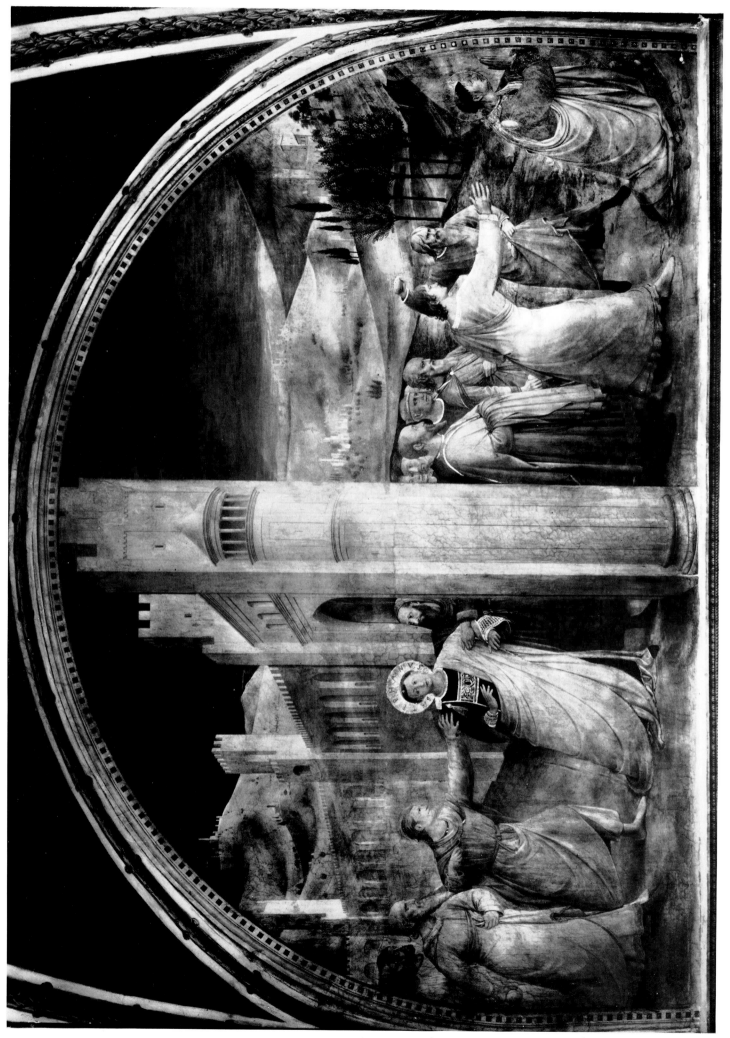

110. THE EXPULSION OF SAINT STEPHEN: THE STONING OF SAINT STEPHEN. Chapel of Nicholas V, Vatican.

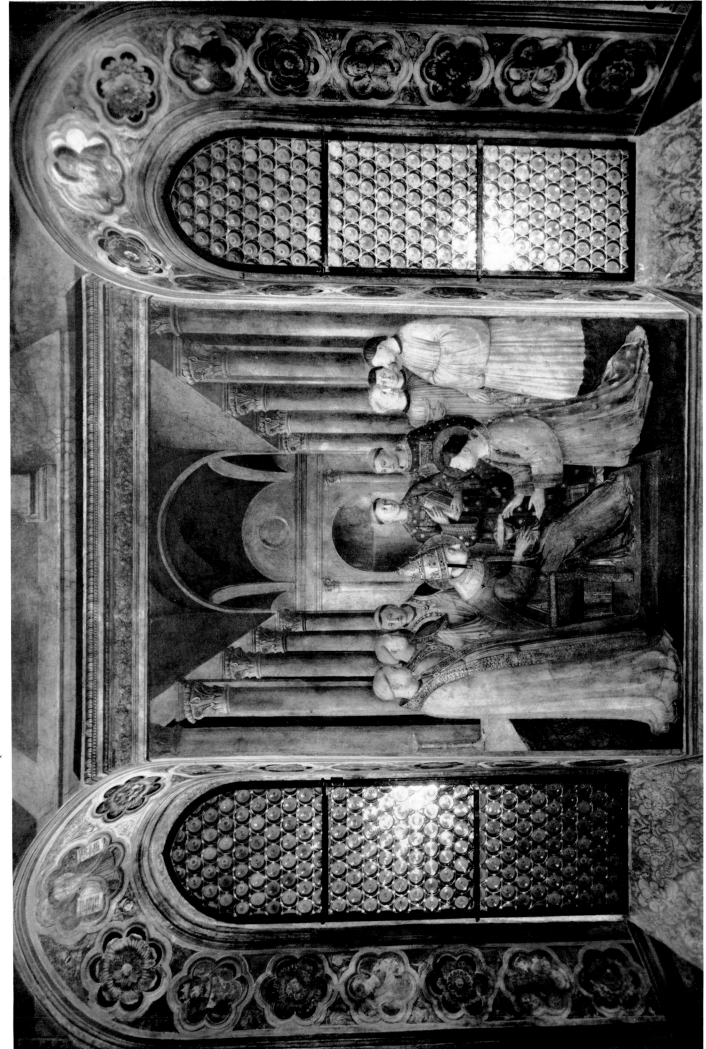

III. THE ORDINATION OF SAINT LAWRENCE. Chapel of Nicholas V, Vatican.

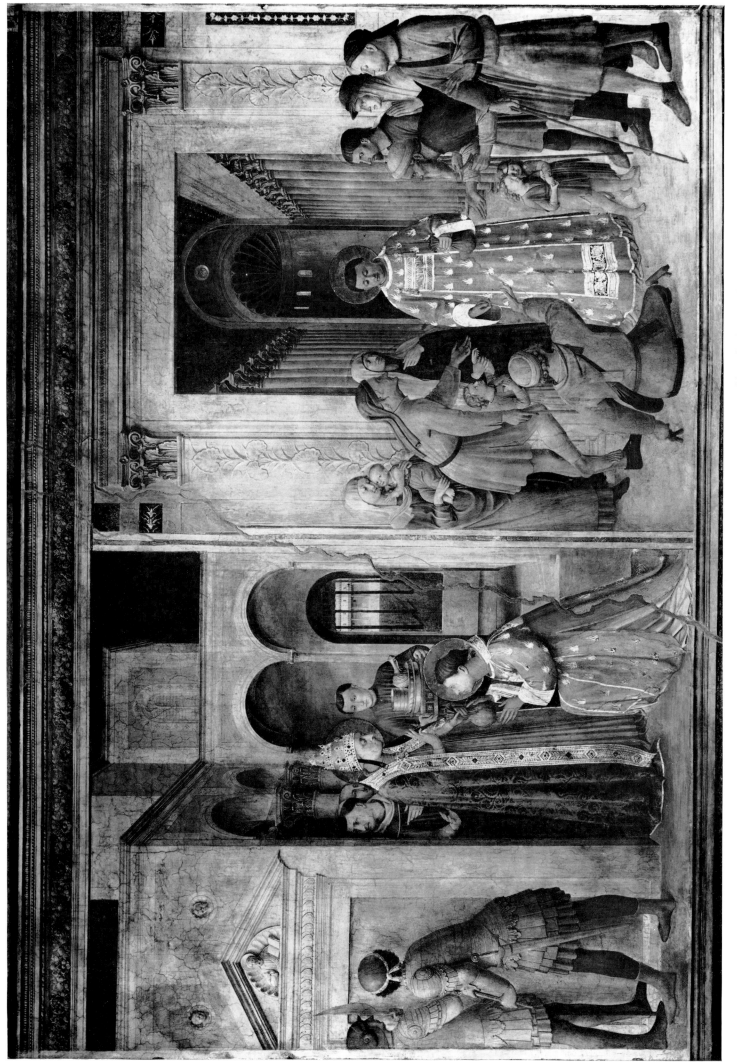

112. SAINT LAWRENCE RECEIVING THE TREASURES OF THE CHURCH: SAINT LAWRENCE DISTRIBUTING ALMS. Chapel of Nicholas V, Vatican.

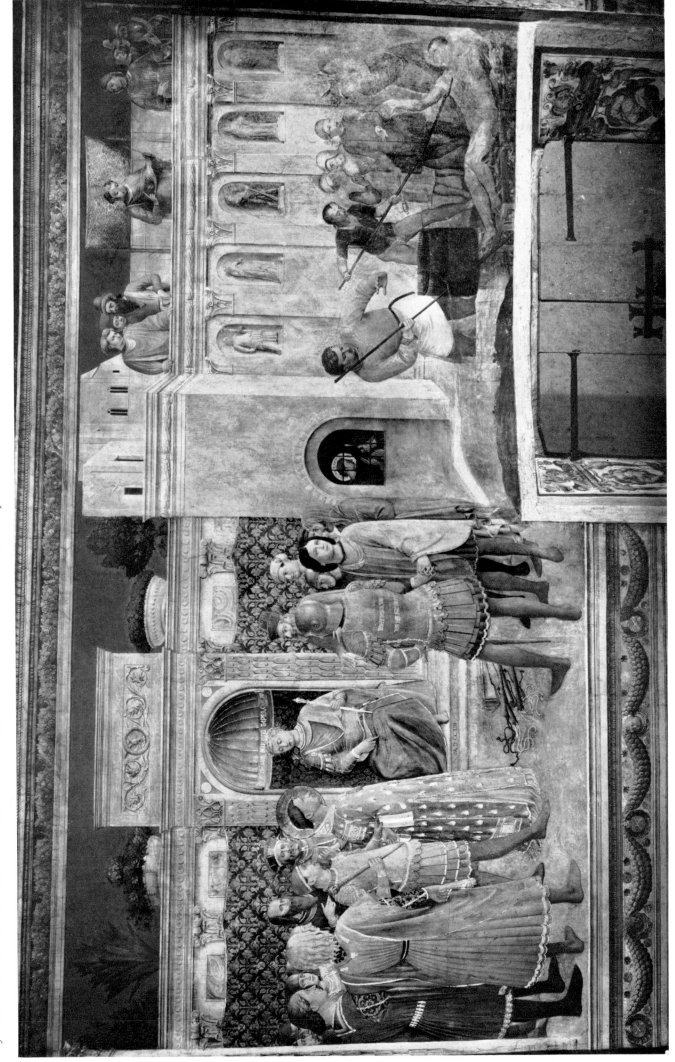

113. SAINT LAWRENCE BEFORE VALERIANUS: THE MARTYRDOM OF SAINT LAWRENCE. Chapel of Nicholas V, Vatican.

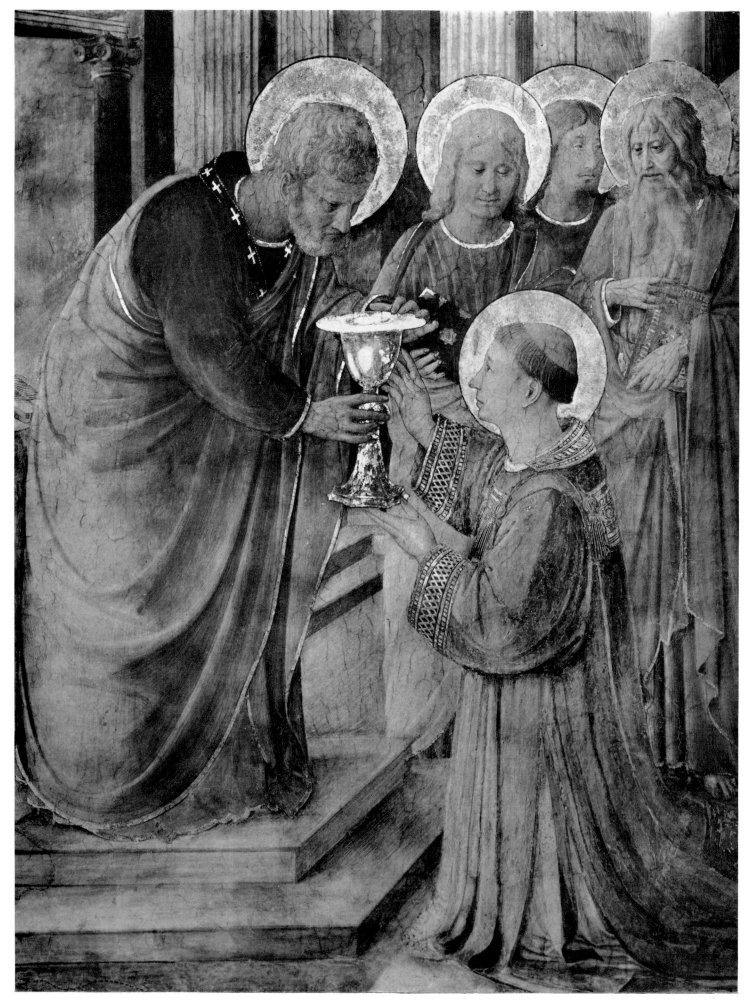

114. SAINT STEPHEN AND SAINT PETER. Detail of Plate 108.

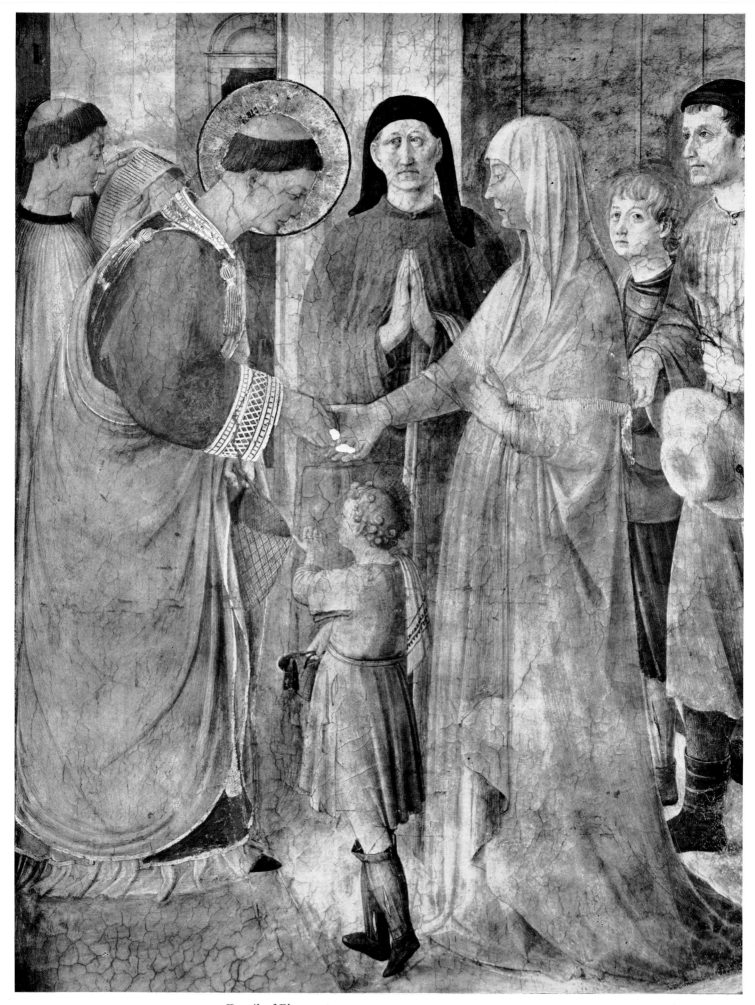

115. SAINT STEPHEN GIVING ALMS. Detail of Plate 108.

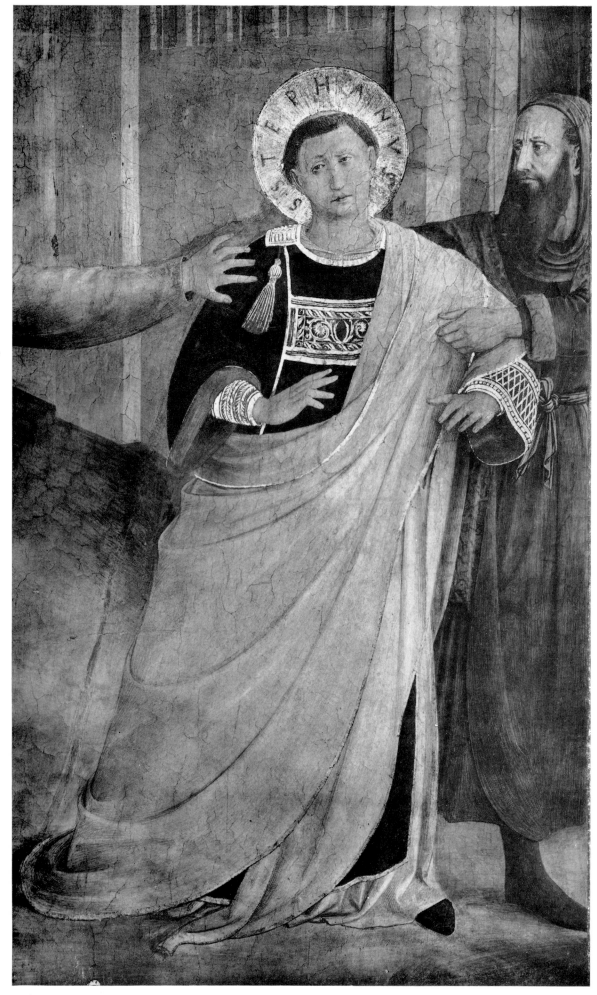

116. SAINT STEPHEN EXPELLED. Detail of Plate 110.

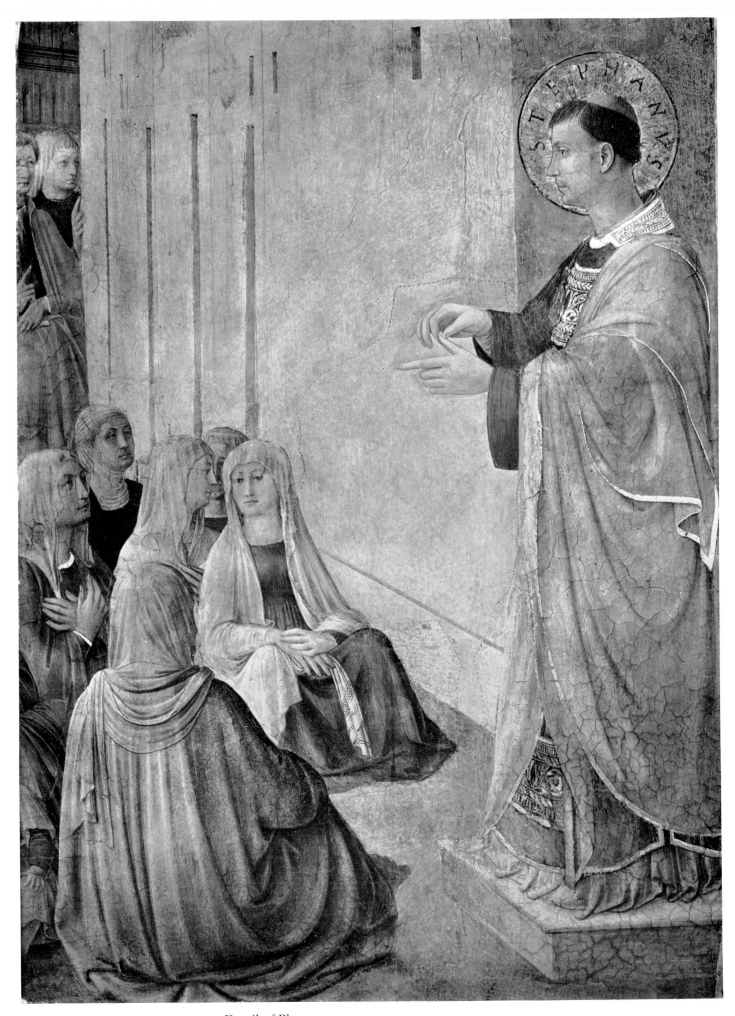

117. SAINT STEPHEN PREACHING. Detail of Plate 109.

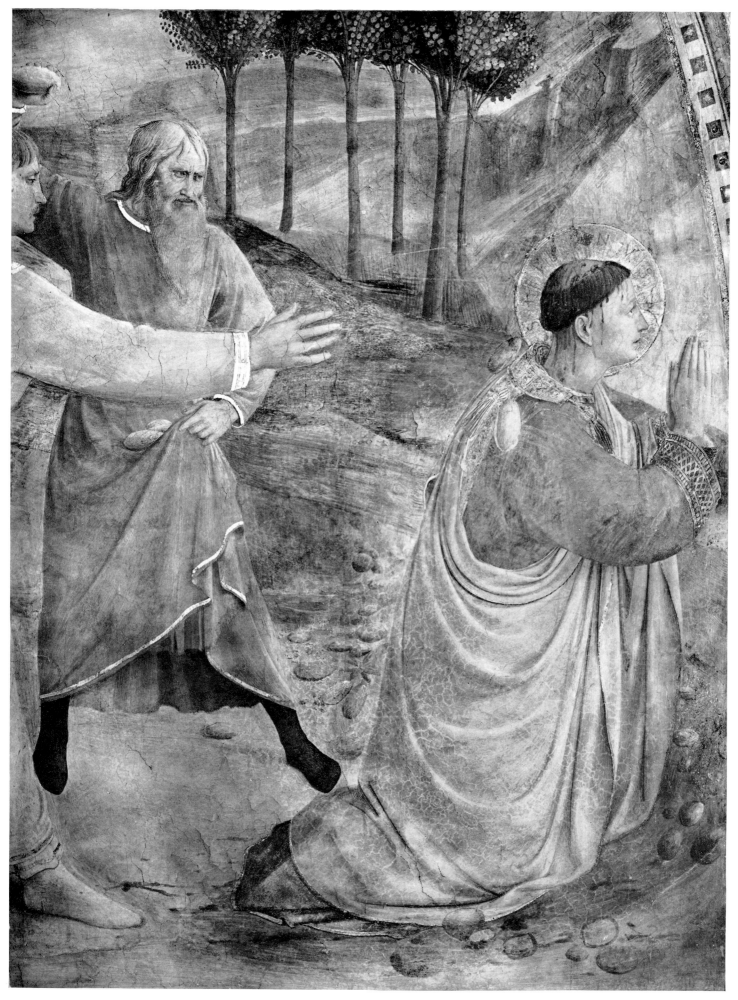

118. THE STONING OF SAINT STEPHEN. Detail of Plate 110.

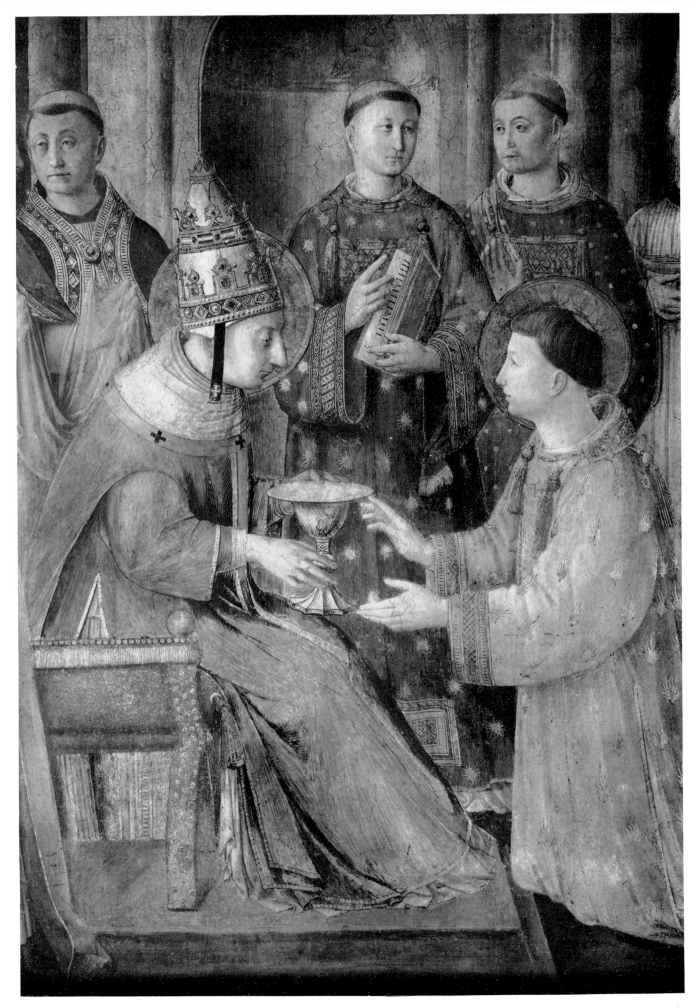

119. SAINT LAWRENCE AND THE POPE. Detail of Plate III.

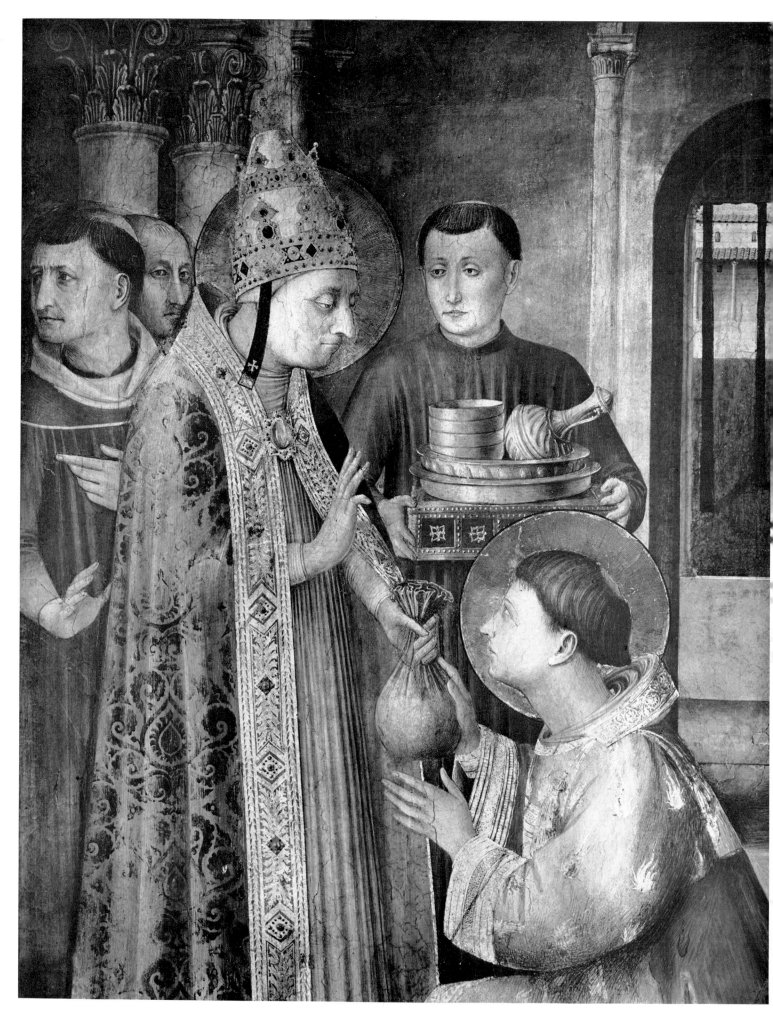

120. SAINT LAWRENCE AND THE POPE. Detail of Plate 112.

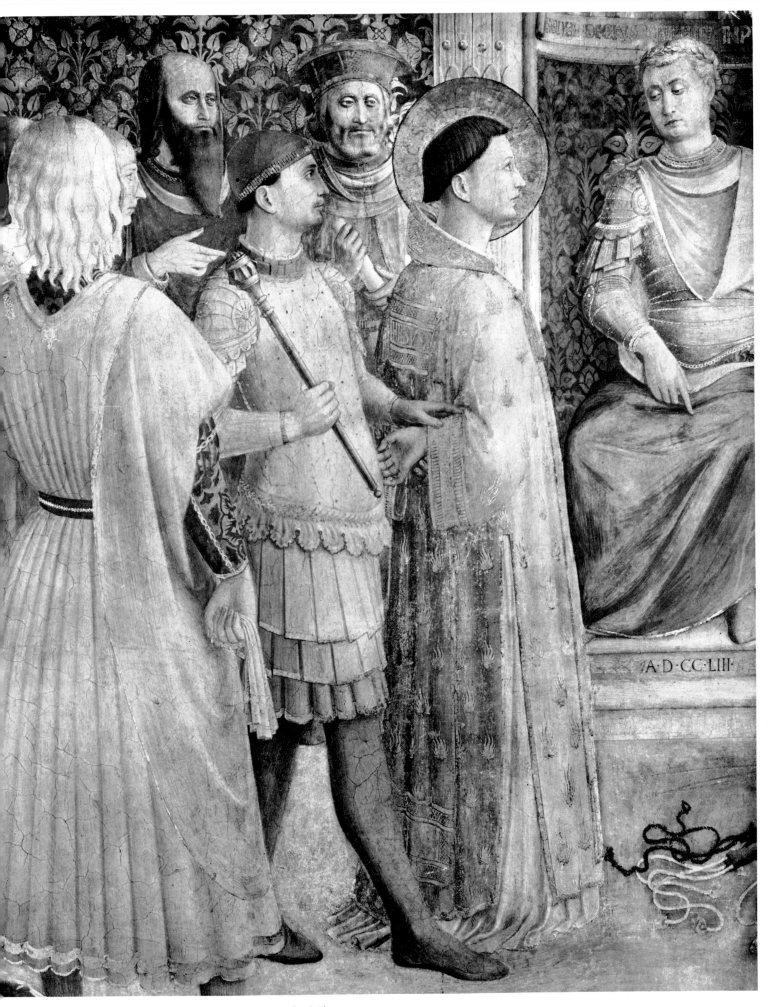

I. SAINT LAWRENCE BEFORE VALERIANUS. Detail of Plate 113.

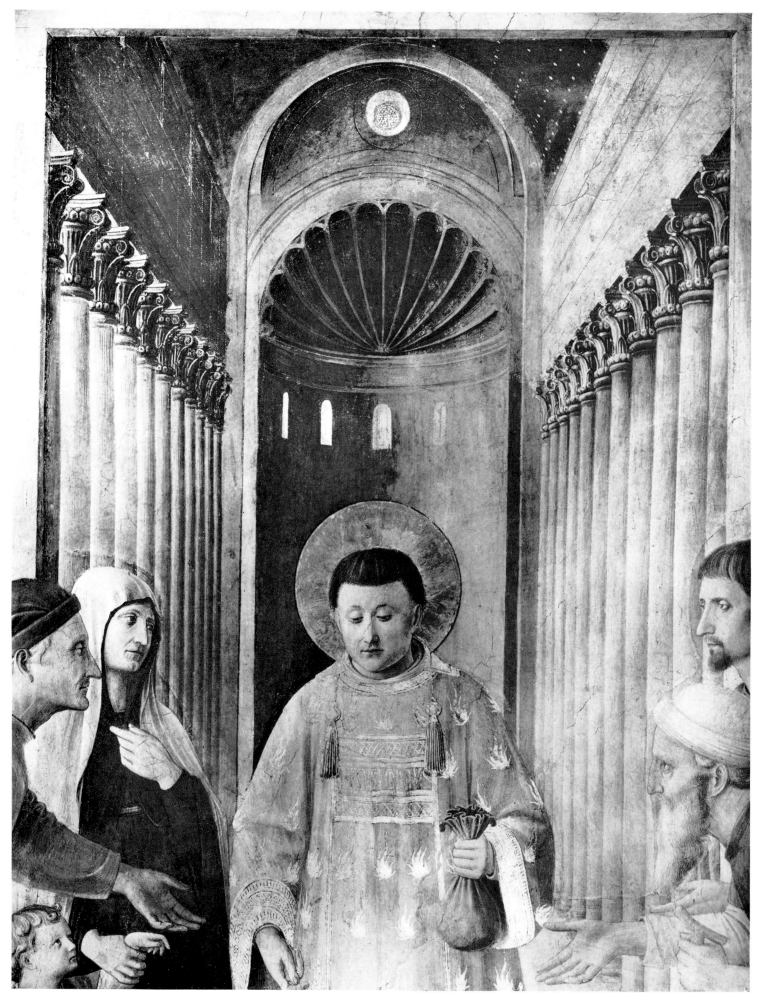

122. SAINT LAWRENCE GIVING ALMS. Detail of Plate 112.

123. SAINT LAWRENCE AND THE GAOLER HIPPOLYTUS. Detail of Plate 113.

124. CHRIST IN GLORY. Duomo, Orvieto.

PROPHETARVMLAVDABILISNVMERVS

125. PROPHETS. Duomo, Orvieto.

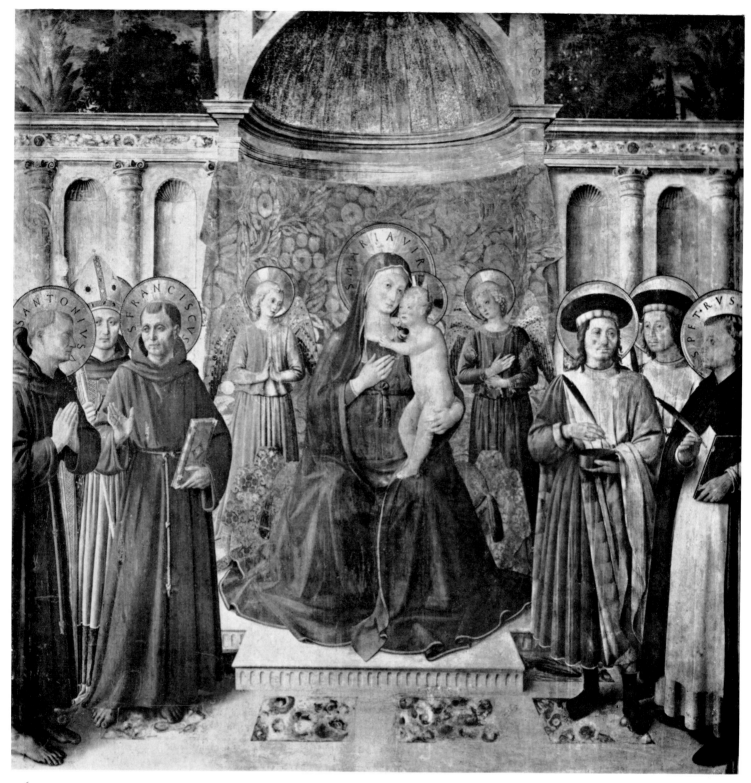

126. THE BOSCO AI FRATI ALTARPIECE: THE VIRGIN AND CHILD ENTHRONED WITH TWO ANGELS AND SAINTS ANTHONY OF PADUA, LOUIS OF TOULOUSE, FRANCIS, COSMAS, DAMIAN AND PETER MARTYR. Museo di San Marco, Florence.

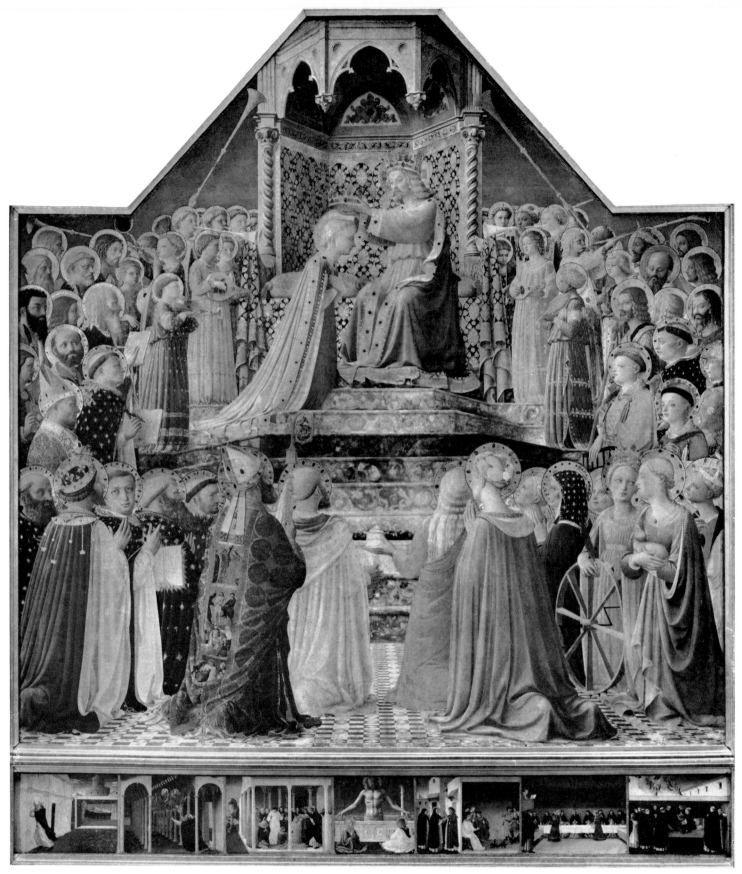

127. THE CORONATION OF THE VIRGIN. Louvre, Paris.

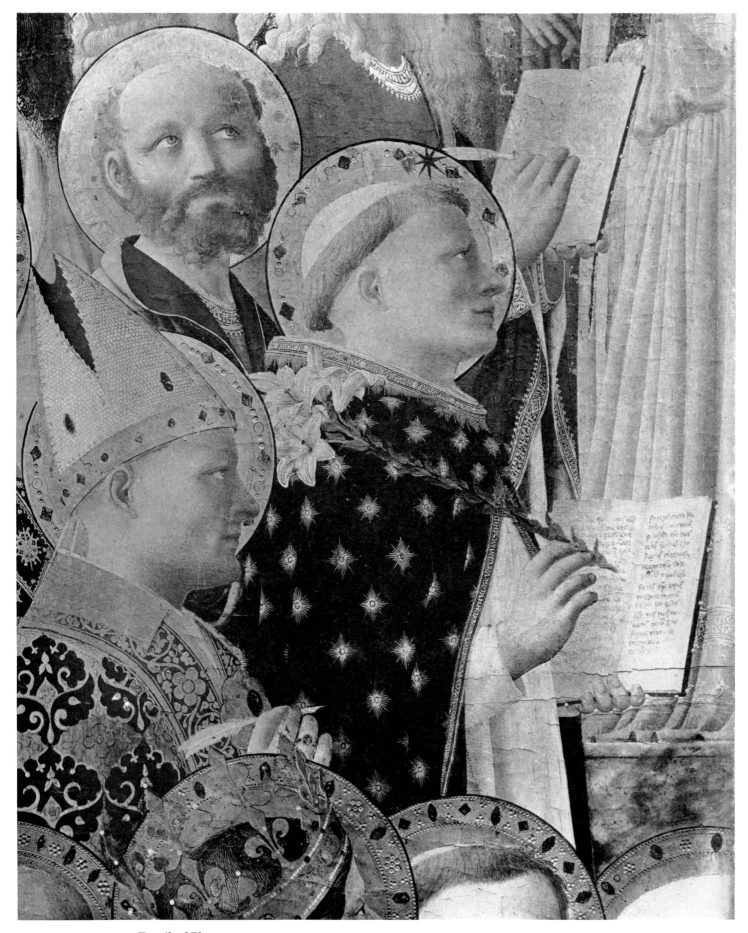

128. THREE SAINTS. Detail of Plate 127.

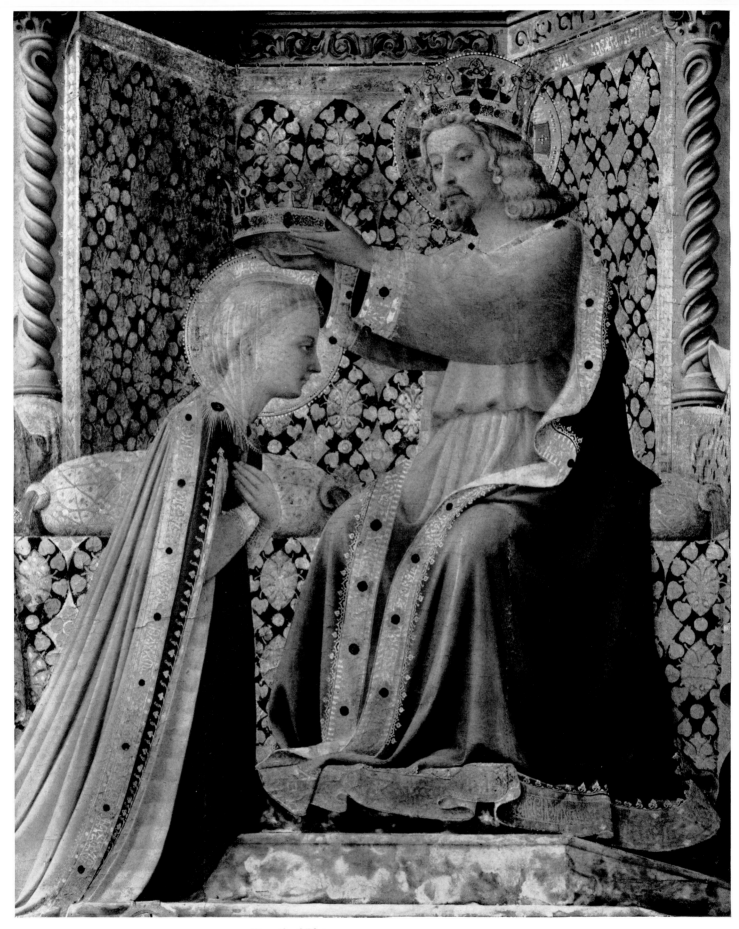

129. THE CORONATION OF THE VIRGIN. Detail of Plate 127.

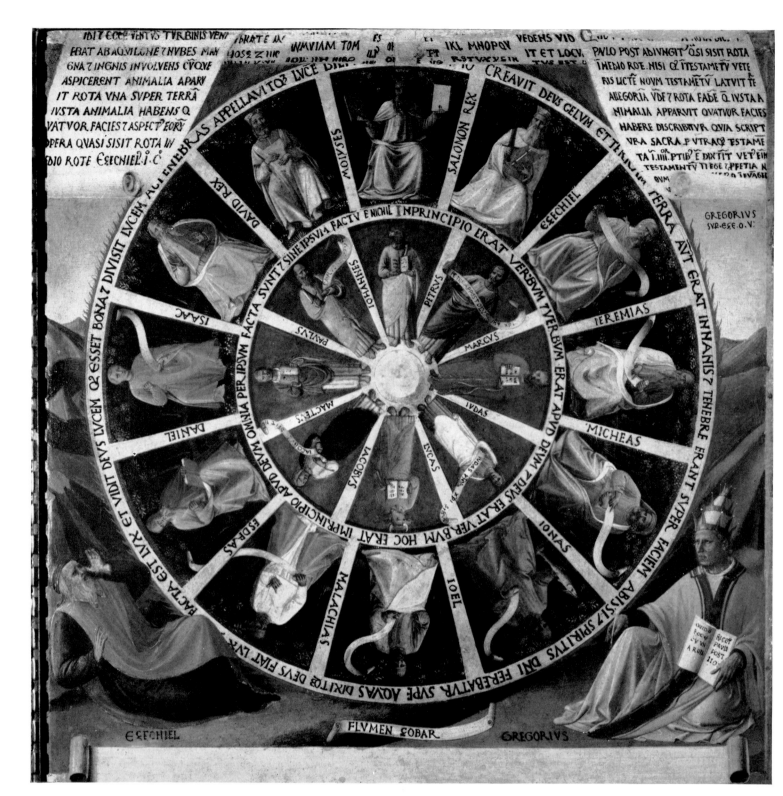

130. THE VISION OF EZEKIEL. Museo di San Marco, Florence.

ECCE VIRGO CONCIPIET 7 PARIET FILIVM 7 VOCABIT NOMEN EIVS EMANVL. YSA. VI. C

ECCE CONCIPIES INVTERO 7 PARIES FILIVM 7 VOCABIS NOMEN EI° IHESVM. LVCE. I. C.

131. THE ANNUNCIATION (before restoration). Museo di San Marco, Florence.

PARVVLVS NAT’ E NOB’ 7 FILI’ DAT’ E NOBIS 7 FACT’ E PRINCIPAT’ SVP HVMERV EI’. YSA. IX. C.

MPLETI SVNT DIES VT PARERET 7 PEPERIT FILIVM SVVM PRIMOGENITVM. LVCE. II. C.

132. THE NATIVITY. Museo di San Marco, Florence.

133. THE FLIGHT INTO EGYPT. Museo di San Marco, Florence.

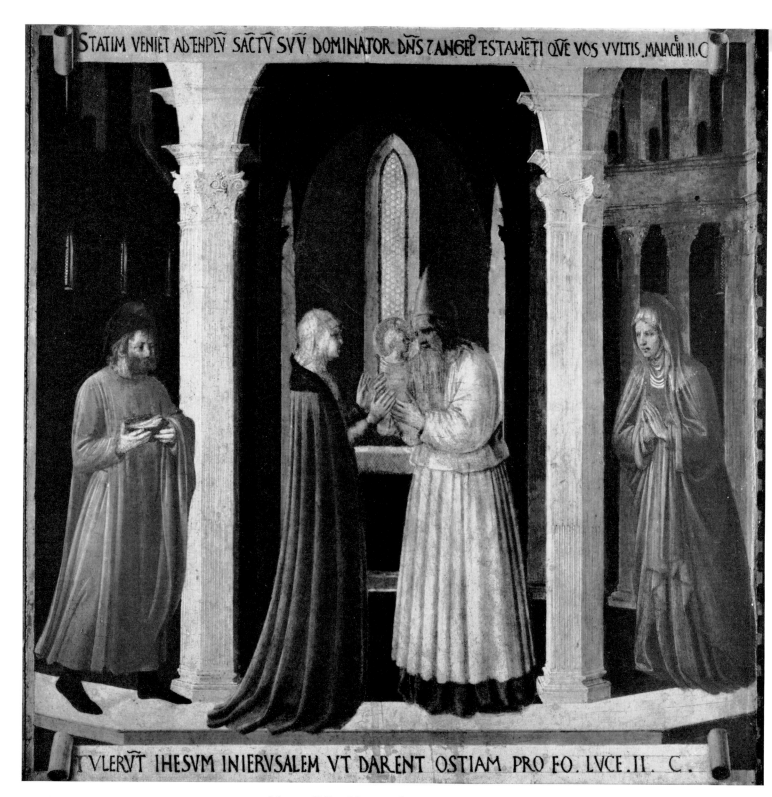

134. THE PRESENTATION IN THE TEMPLE. Museo di San Marco, Florence.

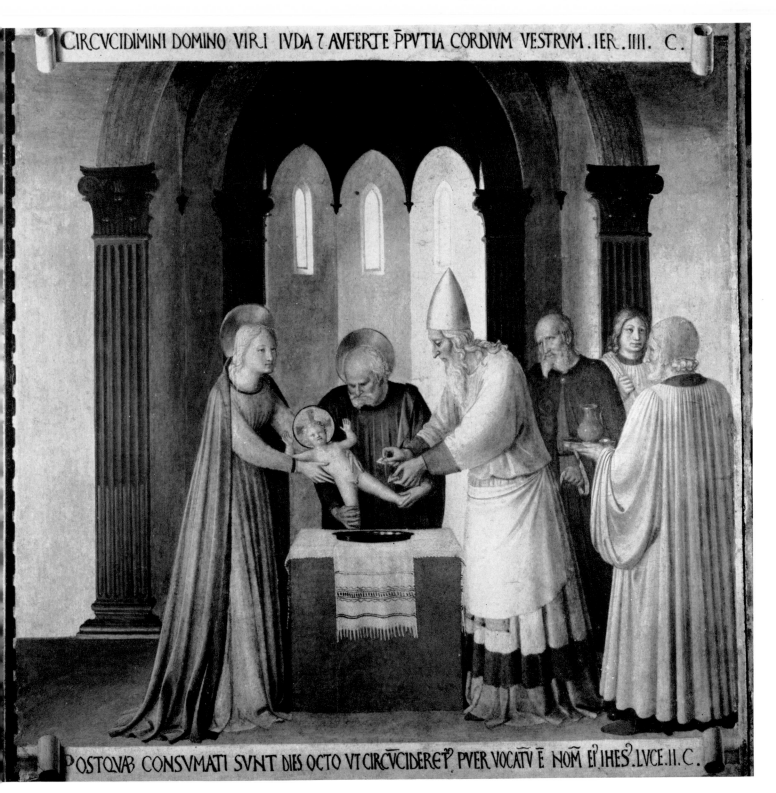

CIRCVCIDIMINI DOMINO VIR.I IVDA 7 AVFERTE PPVTIA CORDIVM VESTRVM .IER .IIII . C .

POSTQVAB CONSVMATI SVNT DIES OCTO VT CIRCVCIDERET PVER VOCATV E NOM EI IHES .LVCE.II.C.

35. THE CIRCUMCISION. Museo di San Marco, Florence.

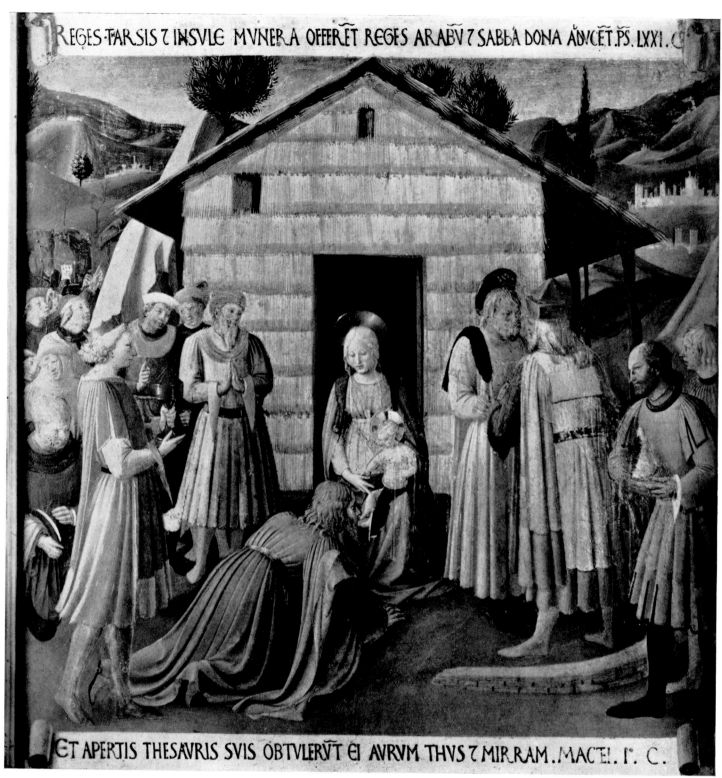

REGES·TARSIS ⁊ INSVLE MVNERA OFFERĒT REGES ARABV ⁊ SABBA DONA ADVCĒT·PS·LXXI·C

ET APERTIS THESAVRIS SVIS OBTVLERVT EI AVRVM THVS ⁊ MIRRAM·MACEI·I°·C

136. THE ADORATION OF THE MAGI (before restoration). Museo di San Marco, Florence.

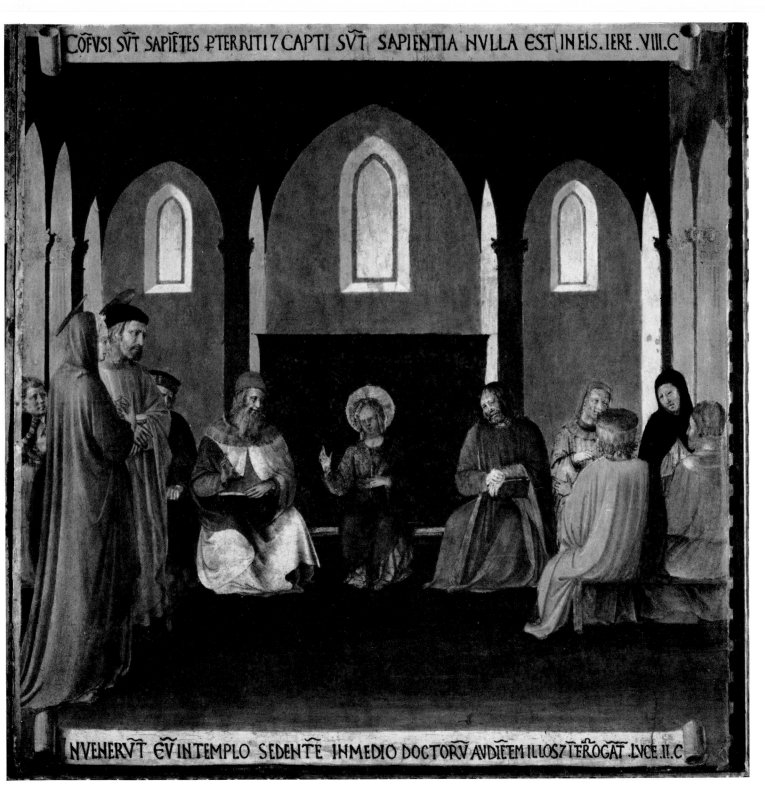

137. CHRIST TEACHING IN THE TEMPLE. Museo di San Marco, Florence.

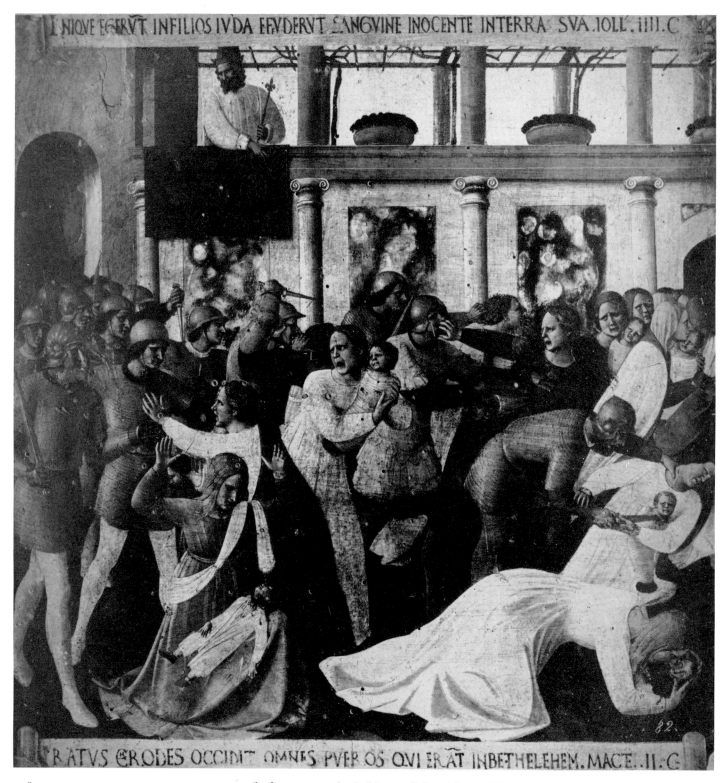

138. THE MASSACRE OF THE INNOCENTS (before restoration). Museo di San Marco, Florence.

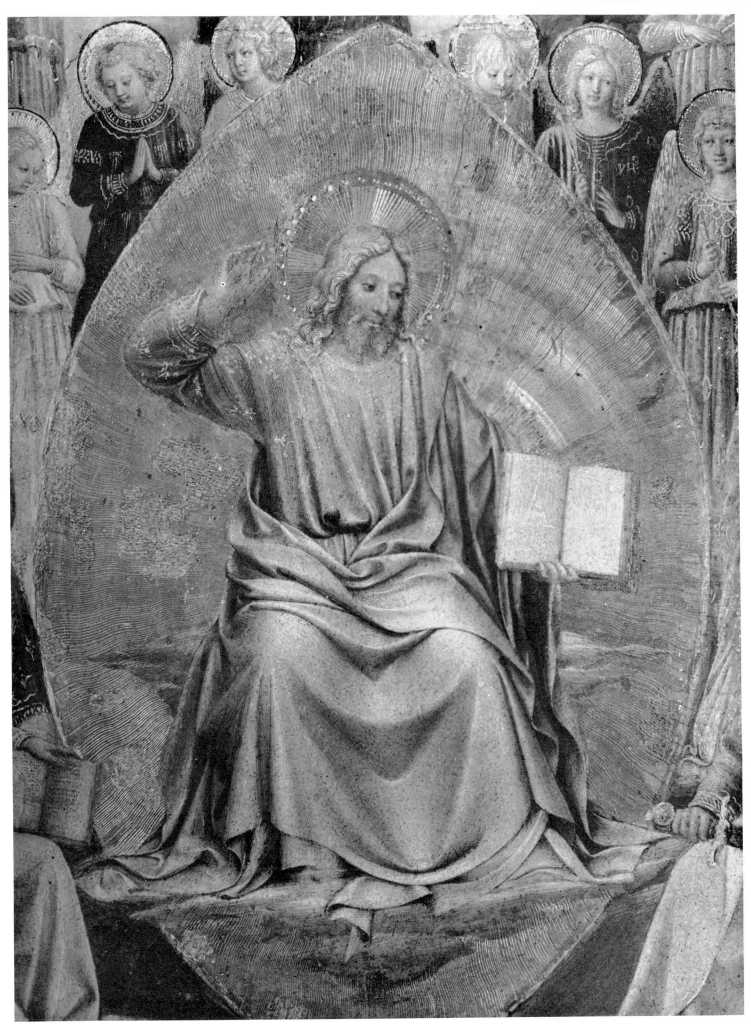

139. CHRIST AS JUDGE. Detail of Figure 45. Galleria Nazionale, Rome.

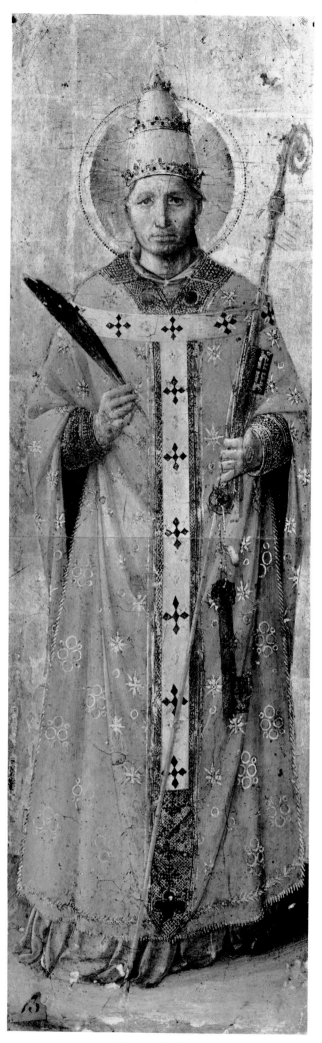

140. SAINT PETER. Private Collection.

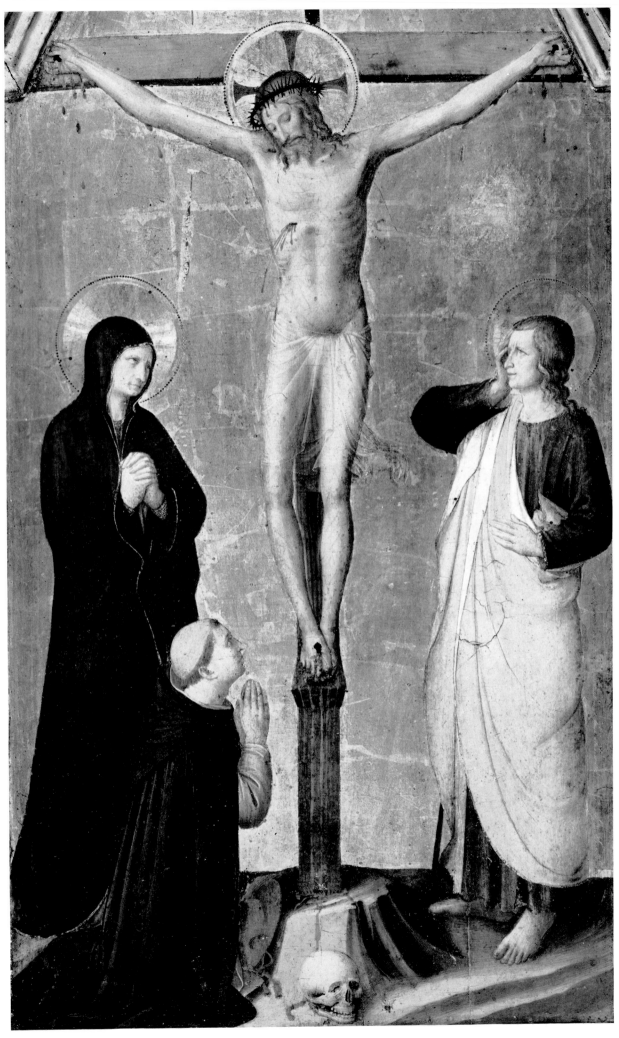

141. CHRIST ON THE CROSS WITH THE VIRGIN AND SAINT JOHN THE EVANGELIST ADORED BY
A DOMINICAN CARDINAL. Detail of Figure 41. Fogg Museum of Art, Cambridge (Mass.).

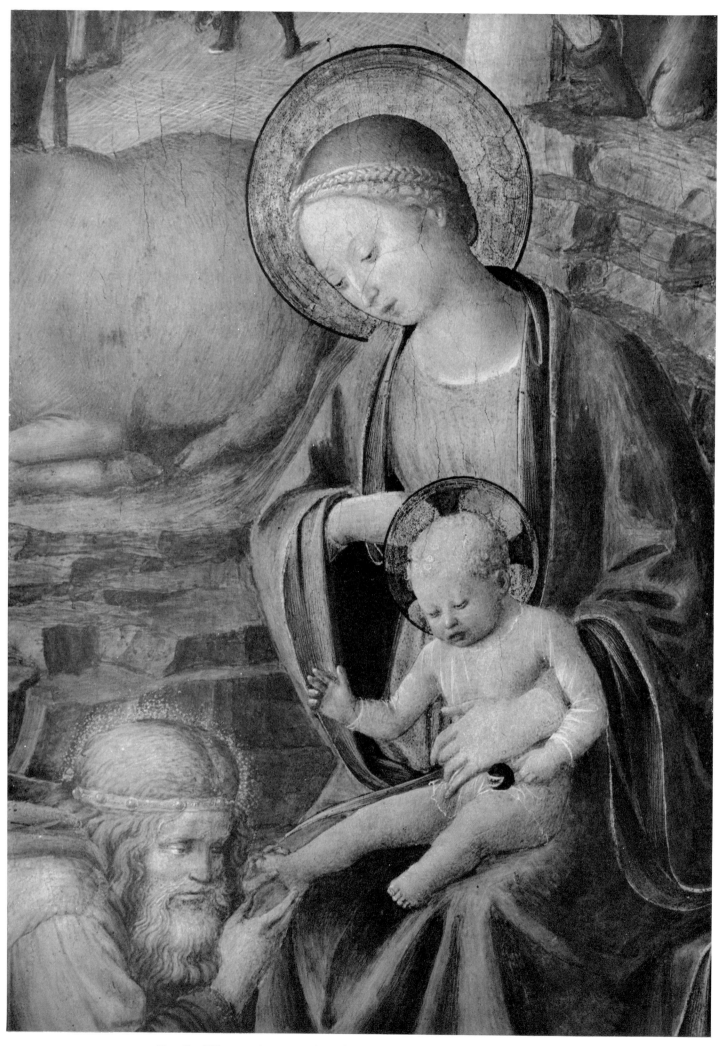

142. VIRGIN AND CHILD. Detail of Figure 46. National Gallery of Art, Washington.

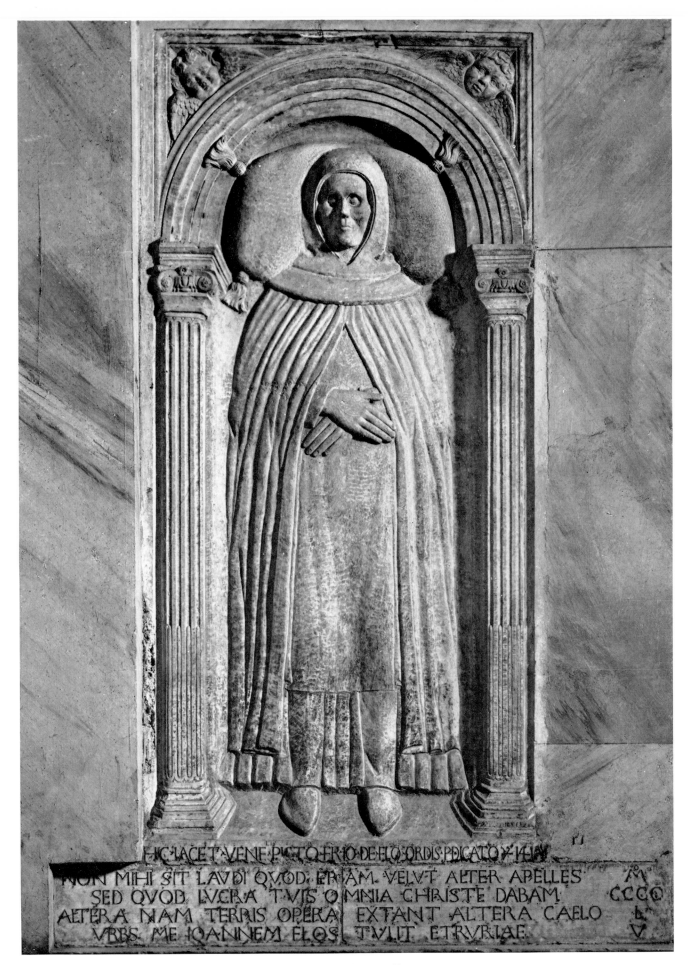

143. TOMB-SLAB OF FRA ANGELICO. Santa Maria sopra Minerva, Rome.

CATALOGUE

ABBREVIATIONS

The following bibliographical abbreviations are employed throughout the notes:

BALDINI: U. Baldini, *L'opera completa dell'Angelico*, Milan, 1970.

BEISSEL: Stephan Beissel, S.J., *Fra Giovanni Angelico da Fiesole, sein Leben und seine Werke*, Freiburg-im-Breisgau, 1905.

BERENSON 1896: Bernhard Berenson, *The Florentine Painters of the Renaissance*, New York, 1896.

BERENSON 1909: Bernhard Berenson, *The Florentine Painters of the Renaissance*, New York, 1909.

BERENSON 1932: Bernard Berenson, *Italian Pictures of the Renaissance*, Oxford, 1932.

BERENSON 1936: Bernard Berenson, *Pitture Italiane del Rinascimento*, Milan, 1936.

BERENSON 1963: Bernard Berenson, *Italian Pictures of the Renaissance: Florentine School*, London, 1963.

BERTI 1962: L. Berti, 'Miniature dell'Angelico e altro', in *Acropoli*, ii, 1962, pp. 277-98, iii, 1963, pp. 1-38.

CODICE MAGLIABECHIANO: *Il Codice Magliabechiano*, herausgegeben von Carl Frey, 1892.

CROWE AND CAVALCASELLE: J. A. Crowe and G. B. Cavalcaselle, *A History of Painting in Italy*, edited by Langton Douglas and G. de Nicola, iv, London, 1911.

D'ANCONA: Paolo d'Ancona, 'Un ignoto collaboratore del Beato Angelico: Zanobi Strozzi', in *L'Arte*, xi, 1908.

DOUGLAS: Langton Douglas, *Fra Angelico*, London, 1900.

GAYE: Giovanni Gaye, *Carteggio inedito d'Artisti dei Secoli XIV, XV, XVI*, 3 vols., Florence, 1839-40.

GENGARO: Maria Luisa Gengaro, *Il Beato Angelico a San Marco*, Bergamo, 1944.

JAHN-RUSCONI: Arturo Jahn-Rusconi, *Il Museo di San Marco a Firenze*, Milan, 1950.

KAFTAL: George Kaftal, *Iconography of the Saints in Tuscan Painting*, Florence, 1952.

LIBRO DI ANTONIO BILLI: *Il Libro di Antonio Billi*, herausgegeben von Carl Frey, 1892.

LONGHI: Roberto Longhi, 'Fatti di Masolino e di Masaccio', in *La Critica d'Arte*, xxv-vi, 1940.

LONGHI 1928-9: Roberto Longhi, 'Un dipinto dell'Angelico a Livorno', in *Pinacoteca*, i, 1928-9.

MANETTI: 'Uomini singolari in Firenze del MCCCC inanzi', in *Operette istoriche . . . di Antonio Manetti*, ed. Milanesi, Florence, 1887.

MARCHESE: P. Vincenzo Marchese, *Memorie dei più insigni Pittori, Scultori ed Architetti Domenicani*, 2nd ed., 2 vols., Florence, 1854.

MARCHESE 1853: P. Vincenzo Marchese, *San Marco Convento dei Padri Predicatori in Firenze, illustrato e inciso principalmente nei dipinti del B. Giovanni Angelico, con la vita dello stesso pittore e un sunto storico del Convento medesimo*, Florence, 1853.

VAN MARLE: Raimond van Marle, *The Development of the Italian Schools of Painting*, The Hague, x, 1928.

MOSTRA 1955: *Mostra delle opere del Beato Angelico*, Florence, 1955.

MURATOFF: Paul Muratoff, *Frate Angelico*, Italian ed., Rome, 1930.

ORLANDI 1955: Stefano Orlandi, O.P., *Beato Angelico: note cronologiche*, 1955.

ORLANDI 1964: Stefano Orlandi, O.P., *Beato Angelico*, Florence, 1964.

PAATZ: Walter und Elizabeth Paatz, *Die Kirchen von Florenz*, Frankfurt-am-Main, i, 1940; ii, 1941; iii, 1952.

PAPINI: Roberto Papini, *Fra Giovanni Angelico*, Bologna, 1925.

RICHA: Giuseppe Richa, *Notizie Istoriche delle Chiese Fiorentine*, 10 vols., Florence, 1754-62.

SALMI 1950: Mario Salmi, 'Problemi dell'Angelico', in *Commentari*, i, 1950.

SALMI 1958: Mario Salmi, *Il Beato Angelico*, 1958.

SCHOTTMÜLLER: Frieda Schottmüller, *Fra Angelico: des Meisters Gemälde*, Stuttgart, 1911.

SCHOTTMÜLLER 1924: Frieda Schottmüller, *Fra Angelico: des Meisters Gemälde*, 2nd ed., Stuttgart, 1924.

VASARI: *Le Vite de' più eccellenti Pittori, Scultori ed Architettori scritte da Giorgio Vasari pittore aretino*, con nuove annotazioni e commenti di Gaetano Milanesi, ii, Florence, 1906.

VENTURI: Adolfo Venturi, *Storia dell'Arte Italiana*, VII, *La Pittura del Quattrocento:* i, Milan, 1911.

WINGENROTH: Max Wingenroth, *Angelico da Fiesole*, Leipzig, 1905.

WURM: Alois Wurm, *Meister- und Schülerarbeit in Fra Angelicos Werk*, Strassburg, 1907.

CATALOGUE

The Virgin and Child enthroned with eight Angels between Saints Thomas Aquinas, Barnabas, Dominic and Peter Martyr. San Domenico, Fiesole. Plates 1–7; Fig. 1
Panel: 212 × 237 cm.

The altarpiece is described by Vasari (ii, pp. 509–10): 'Dipinse, similmente, a San Domenico di Fiesole la tavola dell'altar maggiore: la qual, perchè forse pareva che si guastasse, è stata ritoccata da altri maestri e peggiorata. Ma la predella e il ciborio del Sacramento sonosi meglio mantenuti; ed infinite figurine che in una gloria celeste vi si veggiono, sono tanto belle, che paiono veramente di paradiso, nè può chi vi si accosta saziarsi di vederle.' A passage from the *Chronaca Sancti Dominici de Fesulis* (f. 5 t.), transcribed by Marchese (i, p. 229 n.) and Giglioli (*Catalogo delle cose d'arte e di antichità d'Italia: Fiesole*, 1933, pp. 24–5) shows that the restoration of the painting was undertaken about 1501 by Lorenzo di Credi: 'Circa anno Domini 1501, tempore prioratus Fra Dominici de Mugello … renovata est tribune capellae majoris in duobus arcubus, et remotum est altare majus, et positum iuxta murum … et tabula altaris majoris renovata est et reducta in quadrum et additae picturae, aer super picturas superius et ornamenta tabulae per singularem pictorem Laurentium de Credis.'
The figure beside St. Thomas Aquinas has been variously identified as St. John Evangelist (Milanesi, in Vasari, ii, p. 510 n.) and St. Peter (Marchese, loc. cit.), and seems to represent St. Barnabas (Schottmüller 1924, p. 256; Van Marle, x, p. 42), to whom the high altar of the church was dedicated. In its original form the altarpiece consisted of three panels of approximately equal width, of which that in the centre showed the Virgin and Child enthroned with angels beneath a pointed arch, and those at the sides contained two saints beneath two narrower pointed arches. The form of the pointed arch above the central group and of the small arches above the lateral figures can still be seen on the surface of the painting. As at Cortona, the figures were originally set on a gold ground. The arms of the throne, the step and the tiled pavement are original, while the baldacchino, the architectural setting and the landscape are due to Credi.
The church and convent of San Domenico were re-endowed under the will of Bernabò degli Agli (d. July, 1418), and it is assumed by Muratoff that the altarpiece was executed in the bracket 1418–20. A *terminus post quem* is supplied by the cession of the premises to the heirs of the testator early in 1419, and a *terminus ante quem* by the dedication of the high altar in 1435. It has been suggested (*Mostra*, pp. 12–15) that work on the altarpiece began about 1430 and continued till 1435, and (Orlandi, p. 25) that it was executed between 1428 and 1434. Salmi (1958, p. 98) dates it before 1438. In the first edition of this book it was tentatively assigned to the years 1428–30. It has since been established that the altarpiece from San Pietro Martire, now in the Museo di San Marco, was completed by the early months

of 1429, and there can be little doubt that the Fiesole altarpiece is earlier than this work. This inference rests (i) on the more enterprising spatial treatment of the four lateral Saints in the painting from San Pietro Martire, and (ii) on the Masacciesque influence apparent in the Virgin and Child in that altarpiece, in contradistinction to the generically Gothic style of the Fiesole high altar. The present altarpiece perhaps dates from 1424–5. A parallel for the pavement occurs in an anonymous altarpiece of 1419, of which the central panel is in the Cleveland Museum of Art.
Venturi (p. 40) points out that the present pilasters of the altarpiece derive from another painting. Moreni (*Notizie istoriche dei contorni di Firenze*, iii, 1742, p. 90) and other writers ascribe the pilaster panels to Lorenzo di Credi. It is not clear whether the reference is to the original pilaster panels of Angelico (see below), to the present pilasters, or to some intermediate figures by Credi, nor is it certain at what date the substitution was made. Two panels of Saints Mark and Matthew (Plate 6) in the Musée Condé, Chantilly (Nos. 4, 5. Panel: 36 × 11 cm.) are said to have belonged to the pilasters of the altarpiece. The Saint Mark is closely related in type and style to the Saint Barnabas in the main body of the painting. These panels, regarded as shop works by Berenson (1963, p. 11), and ascribed by Van Marle (x, pp. 184–5) to Zanobi Strozzi, are autograph paintings by Angelico. Two further panels of Saints Nicholas and Michael (Panel: 36 × 14 cm.), formerly owned by the Rev. A. Hawkins-Jones, Sheffield, and subsequently in the Deane Johnson collection, Bel Air, California (Plate 7), are stated in an inscription on the back to have formed part of an altarpiece in San Domenico, Fiesole. Exhibited in Florence in 1955 (*Mostra*, p. 16, Nos. 7–8), they are regarded by Salmi as studio works, but are accepted by Berenson (1963, p. 15) as by Angelico, and are also autograph. There is no reason to question the statement, in the inscription on the reverse, that there were originally ten pilaster panels.
The predella described by Vasari (now replaced by a nineteenth-century copy) was purchased by a Florentine dealer Metzger before 1827, and was later in the hands of V. Valentini, Rome, and of A. MacBean, by whom it was sold (1860) to the National Gallery, London (No. 663). It consists of five panels, that in the centre (32 × 73 cm.) representing the Risen Christ adored by angels, those to its left and right (32 × 64 cm. each) two groups of Saints and Old Testament figures in adoration headed respectively by the Virgin and by St. John, and two narrower outer panels (32 × 22 cm. each) with Saints and Beati of the Dominican order (Plates 4–5). The predella is accepted by Douglas (p. 81), Wingenroth (p. 24), Berenson (1896, p. 100) and other critics as wholly or partly by Angelico. Van Marle (x, pp. 170–7), who gives the predella to Zanobi Strozzi, and Muratoff (p. 31) deny the panels to Angelico, and presume that they were executed a decade after the completion of the altarpiece. Against the view that the panels, like the pilasters of

the present altarpiece, were cannibalized from some other painting, may be noted the fact that the dimensions of the three larger panels correspond closely with those of the original upper panels of the altarpiece, and that the poses of the angels in the centre of the painting are connected with authentic early works of Fra Angelico and with the central group of the present altarpiece. In the three central panels there is evidence of extensive studio intervention, and it is likely that the artist employed on this part of the painting is identical with the miniaturist who assisted Angelico on the illumination of Missal No. 558 at San Marco (see p. 191). The credit for isolating this hand is due to Berti (1962), who ascribes the miniatures to Zanobi Strozzi. The central panels of the predella were tentatively given to Zanobi Strozzi in the first edition of this book. There are, however, no authenticated miniatures by Strozzi of so early a date. A later copy of six Old Testament figures from the inner right panel is in the Louvre (No. 1294D). The two outer panels, with Dominican Saints and Beati, which would have stood beneath the pilasters of the altarpiece, are of higher quality, and are likely to be largely autograph. A detailed analysis of the iconography of the predella is given by M. Davies (*National Gallery Catalogues: The Earlier Italian Schools*, 1951, pp. 12–24).

The ciborium described by Vasari is identified by Crowe and Cavalcaselle (iv, p. 88 n.) with a painted tabernacle from the Stroganoff collection (Panel: 94 × 40 cm.; ex-Bardini, Florence), now in the Hermitage at Leningrad; this is by the same hand as the central panels of the predella in the National Gallery. It is almost certainly a work of the same date as the predella, though it has also been assigned (Berti, Baldini) to the years 1434–5.

Saints Catherine of Alexandria and John Baptist. Private collection.

Plate 8; Fig. 7

Panel: 55·9 × 31·8 cm.

Saints Nicholas and Agnes. Private collection.

Panel: 54·9 × 31·8 cm.

Plate 9; Fig. 8

The panels, which are stated to come from the Esterhazy collection, Hungary, and were later on deposit in the Liechtenstein collection at Vaduz, formed the wings of a small triptych. They are cut horizontally at the top, above the cross held by St. John Baptist and the crozier of St. Nicholas, and made up. There are traces of an earlier enframing arch beside the figures. A narrow strip has been added to the right-hand panel, to the left of St. Nicholas, and there is some inpainting in the corresponding area on the left-hand panel, to the right of the Baptist. Analogies for the two female Saints are found in the angels surrounding the Virgin in the San Domenico altarpiece, for the Baptist in the Saint Peter Martyr in this painting, and for the St. Nicholas in the pilaster panels of the same altarpiece. The present panels seem, however, to be somewhat earlier in date, and may have been painted ca. 1423.

Madonna and Child with two Angels. Madrid, Alba Collection.

Plate 10; Fig. 5

Panel: 83 × 59 cm.

Bought in Florence in 1817 by D. Carlos Miguel Duque de Alba. The attribution to Angelico of this much damaged panel is accepted by Schottmüller and Berenson (1963 and earlier editions as r.), but was rejected in the first edition of this book. The panel is dated by Salmi (1958, p. 102) ca. 1430, by Berti (in *Mostra*, 1955, No. 15, p. 27) ca. 1434, and by Baldini (1970, p. 89) about 1430–5. Re-examination in the context of the Fra Angelico exhibition of 1955 seemed to show that this could only be regarded as an autograph early work, painted after the Fiesole altarpiece of ca. 1425 and before the Saint Peter Martyr triptych of 1428. The distended head of the Virgin turned almost in full face is closely related to that of Saint Thomas Aquinas in the latter painting.

The Virgin and Child with Saints Dominic, John the Baptist, Peter Martyr and Thomas Aquinas. Museo di San Marco, Florence.

Plates 11–12; Fig. 3

Panel: 137 × 168 cm.

From San Pietro Martire, Florence, where it stood on the high altar (Paatz, iv, pp. 658–9). The picture is described in San Felice by Vasari (ii, pp. 515–16): 'Alle monache di San Pietro Martire, che oggi stanno nel monastero di San Felice in piazza, il quale era dell'ordine di Camaldoli, fece in una tavola la Nostra Donna, San Giovan Battista, San Domenico, San Tommaso, e San Pietro martire, con figure piccole assai.' The transfer of the painting to San Felice took place in 1557. The altarpiece is accepted by Van Marle (x, p. 42) as an early work by Fra Angelico, but was regarded by Berenson and most other critics before 1955 as a product of Angelico's shop. It was reproduced in the first edition of this book as a probable work by Angelico of about 1425. It is ascribed by Salmi (1958) to an assistant of Angelico. After cleaning (1955) there can be no reasonable doubt that the main panels are autograph. This view is accepted by Berti (*Mostra*, No. 13) and Baldini. The terminal dates for its production are 1417, when a community of Dominican nuns was established in the convent of San Pietro Martire, and March 1429, when a note made by the Prior of San Domenico at Fiesole, Fra Pietro di Antonio, records an outstanding payment for the painting ('Monasterium Sancti Petri Martiris adhuc tenetur dare de pictura tabule sue flor. X vel circa'). The altarpiece is likely to have been painted in the preceding year. It is suggested by Baldini (p. 86) that a panel in the Courtauld Institute Gallery (formerly Gambier-Parry collection) with roundels of a Dominican nun, St. Dorothy, St. Mary Magdalen, the Dead Christ, St. John the Evangelist, St. Catherine of Alexandria and St. Agnes (Fig. 4) may have formed the predella of the altarpiece. Its dimensions (20·3 × 155 cm.), its gesso ornament, and the preponderance of female Saints depicted in it, make this highly probable. The interstices between the pinnacles of the main panels are

filled with scenes of *The Preaching and Martyrdom of St. Peter Martyr* (Plate 12). These have been regarded as later additions to the altarpiece, conjecturally executed by Benozzo Gozzoli (Salmi, Collobi-Ragghianti), but are closely related to the early miniatures by Fra Angelico in Missal No. 558 at San Marco (Berti), and appear to be autograph works contemporary with the body of the altarpiece.

Missal. Museo di San Marco, Florence, No. 558.
Parchment: 47·5 × 33·7 cm. Plates 13–14; Fig. 6

The only extant manuscript containing illuminations that can reasonably be regarded as Fra Angelico's, the volume is assumed to originate from San Domenico at Fiesole. An attribution to Angelico for the miniatures in the present volume, as well as for those in other illuminated codices at San Marco, was proposed by Wingenroth ('Beiträge zur Angelico-Forschung', in *Repertorium für Kunstwissenschaft*, xxi, 1898, pp. 343–5), but was rejected by Douglas (pp. 180–1) and D'Ancona (*La Miniatura Italiana*, ii, 1914, pp. 345–56), by whom the illuminations were given to Zanobi Strozzi. The attribution to Zanobi Strozzi was maintained in the first edition of this book. The volume was again associated with Angelico by Collobi-Ragghianti (in *Critica d'Arte*, xxxii, 1950, p. 467), and more confidently by A. M. Francini-Ciaranfi (in *Mostra*, No. 65, pp. 97–8). A careful and convincing analysis by Berti ('Miniature dell'Angelico e altro', in *Acropoli*, ii, 1962, pp. 277–98, iii, 1963, pp. 1–38) shows that the figurated illuminations in the volume are by two hands, one that of Angelico and the other that of an assistant conjecturally identified as Zanobi Strozzi. The illuminations in the volume are as follows:

c.9 *Calling of SS. Peter and Andrew*. Associate of Angelico (Berti as Angelico).
c.11v. *St. Stephen*. Angelico.
c.13v. *St. John the Evangelist*. Angelico.
c.16 *Holy Innocents*. Angelico.
c.19v. *St. Agnes*. Associate of Angelico.
c.21 *Conversion of St. Paul*. Associate of Angelico (Berti as Angelico).
c.24v. *Presentation in the Temple*. Angelico.
c.31v. *St. Thomas Aquinas*. Associate of Angelico.
c.33v. *Annunciation* (Plate 13). Angelico.
c.41v. *Death of St. Peter Martyr*. Angelico.
c.43v. *Two Saints*. Associate of Angelico.
c.45 *Christ on the Cross*. Angelico.
c.48v. *Crowning with Thorns*. Angelico.
c.55v. *St. John the Baptist*. Angelico.
c.60v. *St. Peter*. Angelico.
c.61v. *St. Paul*. Associate of Angelico.
c.64v. *Noli Me Tangere* (Fig. 6). Associate of Angelico.
c.67v. *St. Dominic in Glory* (Plate 14). Angelico.
c.68v. *St. Dominic in Prayer*. Angelico.
c.70v. *St. Lawrence*. Associate of Angelico.

c.73v. *Assumption*. Angelico.
c.80v. *St. Michael*. Associate of Angelico.
c.85v. *All Saints*. Associate of Angelico.
c.86v. *Souls in Purgatory*. Angelico.
c.93 *Christ*. Angelico.
c.100 *Christ with an Angel*. Angelico.
c.109 *Christ with three other figures*. Angelico.
c.124 *Christ blessing a kneeling Bishop*. Associate of Angelico.
c.137v. *Virgins praying before a Book*. Associate of Angelico.
c.156v. *The Virgin protecting the Dominican Order*. Angelico.

The illuminations are assigned by Ciaranfi to the half-decade 1430–5 and are dated by Berti ca. 1430. In view of the analogies between, e.g., *The Virgin protecting the Dominican Order* (c.156v.) and the Angelico *Madonna* at Frankfurt, a dating ca. 1428–30 is probable. So far as concerns the miniatures which are not attributable to Angelico, it has been suggested by Ciaranfi that these are divisible between three hands, and by Berti that they were executed by a single artist. The latter explanation appears to be correct. On the basis of the documented miniatures of Zanobi Strozzi (for these M. Levi d'Ancona, 'Zanobi Strozzi reconsidered', in *La Bibliofilia*, lxi, 1959, pp. 1–38), the identification of this hand as that of Zanobi Strozzi is not permissible.

Missal No. 558 is of cardinal importance for an understanding of Angelico's workshop before and after 1430. The associate of Angelico responsible for its secondary illuminations reappears, with other assistants, in the predella of the high altar of San Domenico at Fiesole (National Gallery, London), the *Last Judgment* in the Museo di San Marco, the reliquary panels from Santa Maria Novella, and other works.

The Virgin and Child enthroned with twelve Angels.
Staedelsches Kunstinstitut, Frankfurt-am-Main (No. 838).
Panel: 37 × 28 cm. Plate 15

Purchased 1831 from Benucci. The back of the panel has been planed down. On it are the seal of the Academy of Milan and two manuscript labels. The first of these reads:

No. 162 Del Bto. Fra Giovanni Angelico da Fiesole
 Domenicano nell'Anno 1453.

The second seems to indicate that the panel was at some time in Parma:

Nondum surgebat Parma Farnesia moles
Miris et fueram picta tabella modis.

The composition must have enjoyed some celebrity since it is known in two inferior variants. One of these is a coarse copy from the shop of Andrea di Giusto with an engaged frame terminating in a pointed finial, formerly in the oratory of Sant'Ansano at Fiesole, now in the Museo Bandini (No. 11. Panel: 38 × 28 cm.). The second is in the Pinacoteca Vaticana (No. 254. Panel: 43·5 × 38·5 cm. As School of Fra Angelico), and has wings with representations of the *Noli Me Tangere* and

the *Crucifixion* and the *Annunciation* and *Stigmatisation of St. Francis*. It is suggested by Collobi-Ragghianti and in the first edition of this book that the original form of the Frankfurt panel is recorded in the copy at Fiesole. There can, however, be no doubt that the Frankfurt panel was from the first rectangular, and that its gilding is in great part original. It is assumed by Salmi (1958, p. 99) that the painting, like that in the Vatican, was the centre of a triptych. In the planed down state of the panel this hypothesis cannot be confirmed, though the edges show, in addition to worm holes, holes that might indicate the presence of hinges.

The attribution of the panel to Angelico is accepted, among others, by Schottmüller (p. 3), Van Marle (x, pp. 46–8) and Baldini (p. 89) and, in part, by Berenson (1963, p. 14, and previous editions), and is denied by Muratoff (pp. 41–2). The composition is related to that of the central panel of the Fiesole high altarpiece, but is of rather later date, and, in the more classical drapery of the angels and the formulation of the throne and tabernacle, reveals the strong influence of Ghiberti. An attempt of Baldini to link the angels with angels by Lorenzo Monaco and the throne with that in the altarpiece ascribed to Masaccio in San Giovenale at Cascia is invalid.

The Last Judgment. Museo di San Marco, Florence.
Panel: 105 × 210 cm. Plates 16–17; Fig. 2

From Santa Maria degli Angeli, Florence, where it is described by Vasari (ii, pp. 514–15): 'e nella chiesa de' monaci degli Angeli, un Paradiso ed un Inferno di figure piccole: nel quale con bella osservanza fece i beati bellissimi e pieni di giubbilo e di celeste letizia; ed i dannati, apparecchiati alle pene dell'Inferno, in varie guise mestissime, e portanti nel volto impresso il peccato e demerito loro: i Beati si veggiono entrare celestemente ballando per la porta del paradiso; ed i dannati dai demonj all'inferno nelle eterne pene strascinati. Questa opera è in detta chiesa andando verso l'altar maggiore a man ritta, dove sta il sacerdote, quando si cantano messe a sedere.' The concluding sentence is explained by Marchese (i, p. 279) as meaning that the painting occupied a position over the seat used by the priest during the celebration of high mass. According to Orlandi, the seat of which the painting seems to have formed part was among the works commissioned in August 1431 for the Oratorio degli Scolari under a bequest of Andrea di Filippo degli Scolari, Bishop of Varadino (d. 1426), and Matteo di Stefano Scolari (d. 1426). The panel is listed by Manetti (p. 166), by Albertini (*Memoriale di molte statue e pitture della città di Firenze fatto da Francesco Albertini prete*, Florence, 1863, p. 13: 'uno iuditio di fra Iohanni') and in the *Libro di Antonio Billi* of 1516–25/30 (p. 20: 'Negli Agnolj, cioè nel munistero uno inferno et paradiso'). At the end of the seventeenth century the painting was in the Segni Chapel in the first cloister (Paatz, iii, pp. 121, 124). It was subsequently transferred to the Accademia and thence to San Marco.

The panel is regarded by Douglas (pp. 58–61) as an early work of Angelico painted immediately before the Santa Maria

Nuova *Coronation of the Virgin*. Berenson (1909, p. 105) accepts the attribution to Angelico with the proviso that the section on the right was executed by another hand. Muratoff (pp. 34–5), proposing a dating between 1420 and 1430, suggests that the panel was begun by Angelico and completed by a pupil, and Van Marle (x, p. 170) and Bazin (p. 184) presume that it was largely executed by a pupil working from Angelico's cartoon. This pupil is identified by Van Marle with Zanobi Strozzi, and by Schottmüller (p. 257) with the artist of the National Gallery predella. Wurm (p. 60) denies Angelico's authorship of the panel. The panel was given to Zanobi Strozzi in the first edition of this book, where it was suggested, wrongly, that it might depend from a lost autograph prototype.

The painting was transformed by cleaning in 1955, and an unanswerable case is stated by Berti (in *Mostra*, No. 9, pp. 17–19) for regarding it as a work by Angelico. Neither the brilliant and meticulously executed perspective of graves in the centre, the ring of angels on the left, or the arc of sky in the background, diminishing from an intense blue at the top to a lighter whitish colour on the horizon, would be explicable if the painting were designed by an assistant or were a copy from a lost original. The matter of studio intervention, however, presents considerable problems. Though the figure of Christ and the surrounding angels were almost certainly realised by Angelico, and the section on the extreme right is certainly by an assistant, the Saints and Apostles at the top and the group of the Elect to the left of centre are open to widely differing interpretations, and recall, e.g., the foreground figures in the Parma *Madonna* and the subsidiary miniatures in Missal No. 558. A dating about 1431 is very plausible.

The presence, in Giovanni di Paolo's *Paradiso* in the Metropolitan Museum, New York, and in his *Last Judgment* in the Pinacoteca at Siena, of motifs which seem to derive from Fra Angelico but cannot be referred to any of his surviving paintings, suggests that the painter may have had access to another relatively early *Last Judgment* by Angelico of which no other record survives.

The Annunciation. Museo Diocesano, Cortona.
Panel: 175 × 180 cm. Plates 18–23; Fig. 9

Painted for San Domenico, Cortona, and transferred thence in the nineteenth century to the Gesù. Beneath the main panel is a predella showing: (1) *The Marriage of the Virgin*, (ii) *The Visitation*, (iii) *The Adoration of the Magi*, (iv) *The Presentation in the Temple*, and (v) *The Death of the Virgin*; at the outer edges are *The Birth of St. Dominic* and *St. Dominic receives the Habit of the Dominican Order*.

The Cortona *Annunciation* of Angelico is one of the great masterpieces of Florentine painting. Vasari (ii, p. 290) describes an *Annunciation* by Masaccio in San Niccolò oltr'Arno 'nella quale, oltre la Nostra Donna che vi è dall'Angelo annunziata, vi è un casamento, pieno di colonne tirato in prospettiva, molto bello; perchè, oltre al disegno delle linee che è perfetto, lo fece di maniera con i colori sfuggire, che a

poco a poco abbigliatamente si perde di vista; nel che mostrò assai d'intender la prospettiva'. Longhi (pp. 168, 187) suggests that this lost painting was the source of the Cortona *Annunciation*. There is no direct evidence for the date of the Cortona altarpiece. The datings proposed range from about 1424 (Douglas, in Crowe and Cavalcaselle, iv, 1911, p. 74 n.) to the late thirties (Van Marle, x, p. 70). The painting is assigned by Muratoff (p. 37) to the bracket 1428-30, by Bazin (p. 26) to the early thirties, and by Schottmüller (p. 258) to about 1435. The handling of perspective in the main panel and in the first and fourth panels of the predella is difficult to reconcile with the very early dating proposed by Douglas, and the scheme is, as a whole, more advanced than that of the Goldman *Annunciation* of Masolino (National Gallery of Art, Washington, No. 16) of about 1426. Within Angelico's work it seems to have been painted after the San Pietro Martire triptych of 1428 and immediately before the *Madonna dei Linaiuoli* of 1433. It is known (see p. 237) that in or before 1432 Angelico was commissioned to paint an altarpiece of the *Annunciation* for the church of Sant'Alessandro at Brescia, which had been ceded to the Servite order. This altarpiece was not delivered, and the vacant altar in Sant'Alessandro was filled in 1444 by a panel by Jacopo Bellini. In view of the coincidence of dates, it must be accepted as conceivable that the *Annunciation* begun for Brescia and the *Annunciation* at Cortona are one and the same picture, which, for reasons we can no longer reconstruct, was not despatched to Brescia, but was instead diverted to a Dominican community.

With the exception of Wurm (pp. 4-5), writers on Angelico are agreed in regarding the *Annunciation* as an autograph work of the highest quality. The two outer panels of the predella are inferior in execution to the five interior panels. The latter are accepted by Van Marle (x, p. 72) as works by the artist. Schottmüller (loc. cit.) notes discrepancies in their quality, Muratoff (p. 38) limits Angelico's responsibility to the *Visitation*, *Marriage of the Virgin* and *Adoration of the Magi*, and Wurm (loc. cit.) reduces this still further to the single panel of the *Visitation*. Salmi ('Un ipotesi su Piero della Francesca', in *Arti Figurative*, iii, 1947, pp. 82-3) detects the hand of Piero della Francesca in the panel of *The Visitation*, and observes (1958, p. 108) in the main panel 'qualche eco di Paolo Uccello'. There is no substance in either view. Baldini (in *Mostra*, pp. 54-5, No. 31) concurs in Salmi's view that the altarpiece was painted ca. 1438. Orlandi (pp. 55-6) favours a dating in the middle fourteen-thirties, while Middeldorf ('L'Angelico e la scultura', in *Rinascimento*, vi, 1955, pp. 179-94) argues, almost certainly correctly, that the painting was in existence by 1433-4. All seven predella panels were certainly designed by Angelico, but the *Death of the Virgin*, and perhaps the *Presentation*, show weaknesses of execution which seem to argue the intervention of a studio hand.

The *Annunciation* at Cortona formed the basis of a number of variants executed by imitators and by members of Angelico's studio. The most important of these are:

(i) **The Annunciation.** San Francesco, Montecarlo. Fig. 11
Panel: (overall) 236 × 158 cm.; (main panels) 149 × 78 cm. each; (predella) 41 × 126 cm.

The altarpiece is wrongly supposed to have been transported to Montecarlo from the Franciscan church of Monte alle Croci outside Florence. The latter painting is recorded by Vasari (ii, p. 513): 'In San Francesco fuor della porta a San Miniato è una Nunziata,' and is almost certainly identical with an altarpiece in the National Gallery, London (see below). If painted for Montecarlo, the present altarpiece cannot have been executed before 1438, when the church of San Francesco was still incomplete. The altar on which the painting stands (for which see *Mostra*, pp. 68-9, No. 42) was consecrated in 1630 through the good offices of Pietro di Giovanni Renzi, and the *Annunciation* appears to have been restored at this time. The altarpiece is noted by Repetti (*Dizionario Geografico della Toscana*, iii, 1839, p. 334, as Sienese School), by Crowe and Cavalcaselle (iv, p. 76 n.), by whom it was incorrectly identified as a copy said to have been made of the *Annunciation* in San Domenico at Fiesole when this was removed to Spain in 1611, and by Magherini-Graziani ('Memorie e pitture di Masaccio in san Giovanni di Valdarno e nei dintorni', in the miscellaneous volume on *Masaccio*, 1904, pp. 92-4). A direct ascription to Angelico was proposed by Poggi ('L'Annunciazione del beato Angelico a San Francesco di Montecarlo', in *Rivista d'Arte*, 1909, vi, pp. 72-4), Procacci (*Mostra di opere d'arte trasportate a Firenze durante la guerra*, Florence, 1947, pp. 39-40), Salmi (*Mostra d'arte sacra*, Arezzo, 1950, p. 96; 1958, p. 111) and Collobi-Ragghianti (1955, p. 38). Salmi (1950, pp. 148-9) ascribes the predella to Battista di Biagio Sanguigni. The picture is regarded as a studio work by Berenson (1932, p. 22), Muratoff (p. 39) and Bazin (p. 181). Baldini (*Mostra*, pp. 68-9, No. 42) supports 'una collocazione nell'ambito delle opere dell'Angelico'. The Montecarlo *Annunciation* differs from that at Cortona first in that the scene is split between two panels, secondly in the illusionistic space architecture, thirdly in the poses of the two figures, which are greatly modified, and fourthly in its tonality, which is sharper and more astringent than that of the Cortona painting. The hand responsible for this altarpiece recurs again in a number of other panels, notably the predella of the Annalena altarpiece, and is possibly that of Zanobi Strozzi. Muratoff assigns the painting to the early thirties, and Poggi (more plausibly) to the period of the San Marco frescoes. Some of the changes introduced into the composition are due to the influence of altarpieces painted by Fra Filippo Lippi about 1440, and a dating about 1450 is very probable. The predella shows: (i) *The Marriage of the Virgin* (cut down), (ii) *The Visitation*, (iii) *The Adoration of the Magi*, (iv) *The Presentation in the Temple*, and (v) *The Burial of the Virgin*. These scenes are variants of the corresponding panels in the predella of the Cortona *Annunciation*. There is much local retouching in the fourth panel.

193

(ii) The Annunciation. Prado, Madrid (No. 15). Fig. 10
Panel: 194 × 194 cm.

From San Domenico at Fiesole, where it is described by Vasari (ii, p. 510): 'In una cappella della medesima chiesa è di sua mano, in una tavola, la Nostra Donna annunziata dall'Angelo Gabbriello, con un profilo di viso tanto devoto, delicato e ben fatto, che par veramente non da uomo, ma fatto in paradiso: e nel campo del paese è Adamo et Eva, che furono cagione che della Vergine incarnasse il Redentore. Nella predella ancora sono alcune storiette bellissime.' The altarpiece was sold to Duke Mario Farnese on 28 February 1611 for 1,500 ducats, and replaced in 1615 by an *Annunciation* by Jacopo da Empoli (S. de Vries, 'Jacopo Chimenti da Empoli', in *Rivista d'Arte*, xv, 1933, p. 382). It subsequently passed to the Duque de Lerma, was installed in the church of the Dominicans at Valladolid, was later moved to the Monastero de las Descalzas Reales in Madrid, and in 1861 was transferred to the Prado. The appearance of the picture was much changed by over-drastic restoration in 1933–4, and earlier comments on its quality must be read with this fact in mind. There is a vertical split through the main panel. The attribution to Angelico is admitted by Berenson (1896, p. 100), Douglas (pp. 61–2), Sanchez-Canton (*Museo del Prado: Catalogo de los Cuadros*, 1949, pp. 12–13), Salmi (1950, p. 81; 1958, p. 110) and Baldini (1970), but rejected by Schottmüller (p. 258), Van Marle (x, pp. 178–181) and Collobi-Ragghianti ('Zanobi Strozzi', in *La Critica d'Arte*, xxxii, 1950, p. 458), who ascribe it to Zanobi Strozzi, and by most other critics. The altarpiece seems to have been designed by Angelico and executed in his workshop. The relatively low quality of the main panel argues strongly against his direct intervention. The predella shows: (i) *The Marriage of the Virgin*, (ii) *The Visitation*, (iii) *The Adoration of the Magi*, (iv) *The Presentation in the Temple*, and (v) *The Burial of the Virgin*. The second and fourth scenes are loosely related to the corresponding scenes of the Montecarlo predella, while the composition of the third recalls the centralised *Adoration of the Magi* on the Annunziata silver chest. The date of the altarpiece is problematical. The structure of the room in which the scene takes place occupies an intermediate position between that in the Cortona *Annunciation* and that in the late fresco of the *Annunciation* at the head of the staircase in the convent of San Marco. For this reason a dating ca. 1430–2 proposed by Baldini is inadmissible. Salmi (1958) favours a dating after 1436. The fact that the altar of the Annunciation in San Domenico at Fiesole was dedicated (Orlandi) in October 1435 is not in itself an argument that the painting was in existence at that time, and it can hardly have been designed before about 1445. In the first edition of this book it was argued that the Prado altarpiece was somewhat later than the Montecarlo *Annunciation*. The case is contested by Berenson (*Essays in Appreciation*, 1958, p. 138), who regards the Prado painting as the earlier work. This analysis is probably correct.

(iii) The Annunciation. National Gallery, London (No. 1406).
Panel: 103 × 142 cm.
Coll.: Woodburn (imported from Italy 1818: sale, London, 9 June 1860, lot 72), Nieuwenhuys (sale, Brussels, 4 May 1883, lot 5), Bourgeois (till 1894).

This picture is traditionally identified with a painting of the *Annunciation* noted by Vasari (ii, p. 513) in San Francesco fuori della Porta San Miniato (San Salvatore in Monte) as a work of Angelico (see above). As noted by Davies (*National Gallery Catalogues: The Earlier Italian Schools*, 1951, pp. 26–7), the arms on the capitals of the two columns are those of the Lanfredini family. Since there is a Lanfredini chapel in the church of San Salvatore, the identification with the painting described by Vasari is highly probable. The altarpiece, which is loosely dependent on the Montecarlo *Annunciation* and has been cut down, is given by Berenson (1932, p. 365) and Van Marle (x, pp. 190–2) to Domenico di Michelino, and is by the Master of the Buckingham Palace Madonna. Collobi-Ragghianti ('Domenico di Michelino', in *La Critica d'Arte*, xxxi, 1950, p. 365) identifies a panel of the *Expulsion* in the Reber collection, Lausanne (80 × 56 cm.) as part of the missing left side of the altarpiece.

(iv) The Annunciation. San Martino a Mensola, near Florence.

This painting, which derives from the Cortona *Annunciation*, is assigned by Muratoff to the school of Angelico in the bracket 1430–40, but can hardly have been painted before the middle of the century. It was ascribed by Berenson first (1932, p. 348) to an early phase of the Master of San Miniato, and subsequently (*Essays in Appreciation*, 1958, p. 36) to Zanobi Machiavelli.

The Linaiuoli Triptych. Museo di San Marco, Florence.
Panel: 260 × 330 cm. Plates 24–31; Fig. 15

Commissioned in 1433 for the guild-hall of the Arte dei Linaiuoli, the triptych shows: (*centre*) *The Virgin and Child enthroned*, in the frame twelve music-making angels, (*right*) *Saint John Evangelist*, (*left*) *Saint John Baptist*. On the outer faces of the wings are (*right*) *Saint Mark*, (*left*) *Saint Peter*. Beneath is a predella representing (*centre*) *The Adoration of the Magi*, (*left*) *Saint Peter preaching*, (*right*) *The Martyrdom of Saint Mark*.
The second scene shows Saint Mark taking down the words spoken by Saint Peter, and illustrates the tradition that Saint Peter dictated the Gospel of Saint Mark. A variant, in the predella of an altarpiece of 1402 by Lorenzo di Niccolò in San Domenico at Cortona, originally in San Marco in Florence, shows Saint Peter inspired by an angel dictating Saint Mark's Gospel. For the iconography of this panel and of the scene

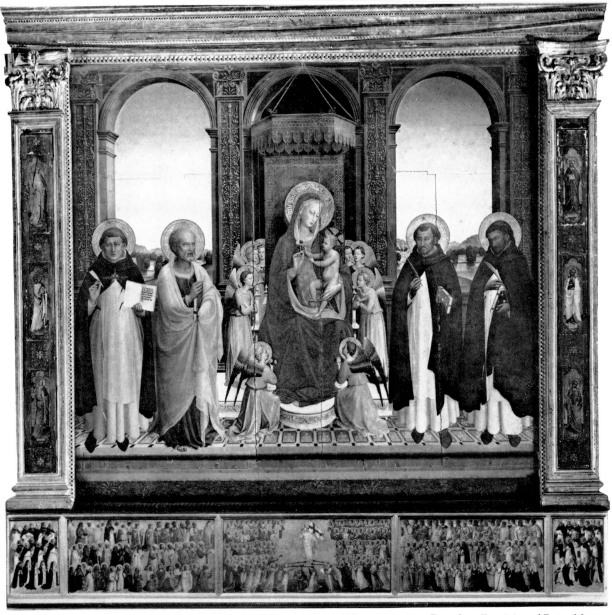

Fig. 1. *Virgin and Child Enthroned with eight Angels between Saints Thomas Aquinas, Barnabas, Dominic and Peter Martyr.* San Domenico, Fiesole. Below: *The Risen Christ Adored by Saints and angels.* National Gallery, London

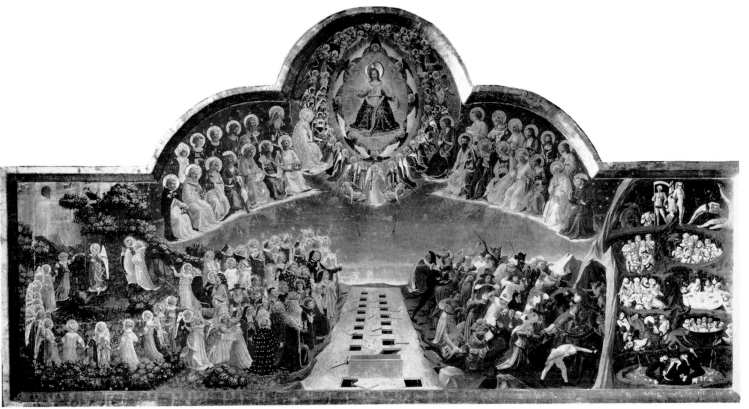

Fig. 2. *The Last Judgment.* Museo di San Marco, Florence

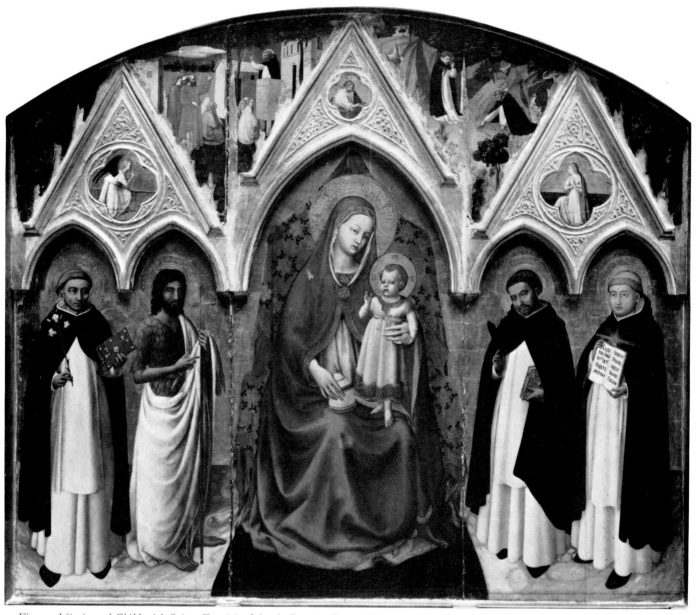

Fig. 3. *Virgin and Child with Saints Dominic, John the Baptist, Peter Martyr and Thomas Aquinas*. Museo di San Marco, Florence

Fig. 4. *Predella*. Courtauld Institute Gallery, London

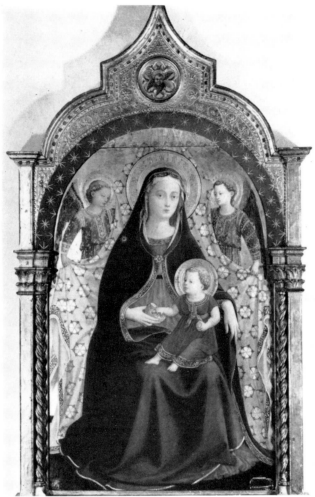

Fig. 5. *Virgin and Child Enthroned with Two Angels*.
Alba Collection, Madrid

Fig. 6. Assistant of Fra Angelico: *Noli Me tangere* (Missal No. 558, c.64v.). Museo di San Marco, Florence

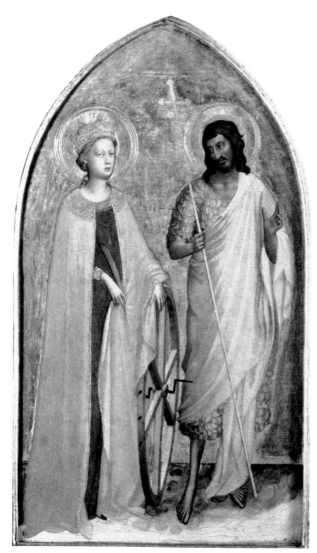

Figs. 7–8. *Saints Catherine of Alexandria and John the Baptist; Saints Nicholas and Agnes.* Private Collection

Fig. 9. *The Birth of Saint Dominic; Saint Dominic receives the Habit of the Dominican Order.* Museo Diocesano, Cortona

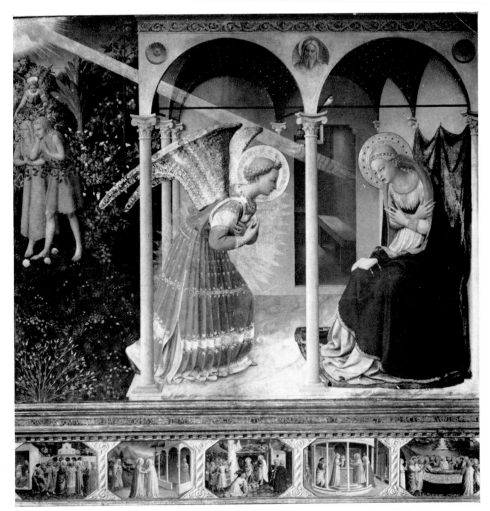

Fig. 10. Workshop of Fra Angelico: *The Annunciation*. Prado, Madrid

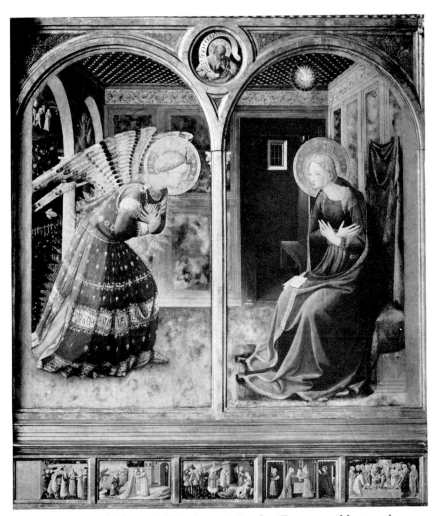

Fig. 11. Zanobi Strozzi: *The Annunciation*. San Francesco, Montecarlo

Fig. 12. *The Virgin and Child*. Sinopia beneath Plate 36. San Domenico, Cortona

Figs. 13–14. *The Marriage of the Virgin; The Burial of the Virgin*. Museo di San Marco, Florence

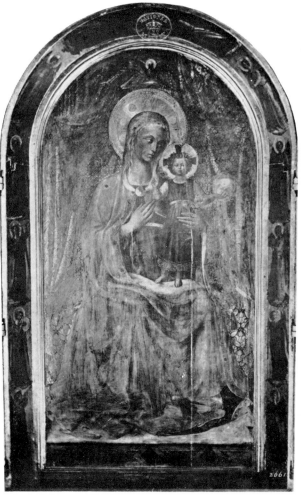

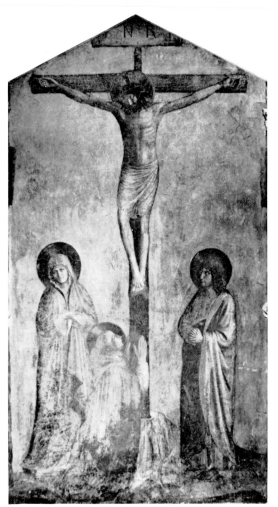

Fig. 15. *The Linaiuoli Triptych* (central panel before restoration). Museo di San Marco, Florence

Fig. 16. *Christ on the Cross adored by Saint Dominic with the Virgin and Saint John.* Louvre, Paris. (The fresco is shown prior to its removal from San Domenico, Fiesole.)

Fig. 17. *Virgin and Child with Saints Dominic and Thomas Aquinas.* Hermitage, Leningrad. (The fresco is shown prior to its removal from San Domenico, Fiesole.)

Fig. 18. Imitator of Fra Angelico: *Christ on the Cross.*
San Domenico, Fiesole

Figs. 19–20. *Saint Paul; Saint Peter.* Details of Plate 98. Museo di San Marco,
Florence

of the body of Saint Mark dragged through the streets of Alexandria during a hailstorm see Kaftal, c. 680.

A record of the commissioning of the triptych, contained in the *Libro dei Debitori e Creditori dell' Arte de' Linaiuoli* (c. 98 t.), is transcribed by Baldinucci (*Notizie de' Professori del Disegno*, iii, 1768, pp. 91–2) and more accurately by Gualandi (*Memorie originali italiane riguardanti le belle arti*, iv, 1843, p. 110): 'MCCCCXXXIII a di II di luglio
(*in margine*) Dipintura del Tabernacolo a Frate Giovanni. Richordo chome detto di e sopradetti Operaj alogharono a frate Guido, vocato fre Giovanni delordine di Sto Domenicho da fiesole adipignere uno tabernacolo di nostra donna nella detta arte dipinto di dentro e di fuori, co Colori oro et azzurro et arieto, de migliori et piu fini che si truovino, con ogni sua arte et industria per tutto et per sua faticha et manifattura per Fior. 190 doro o quello meno che parra alla sua coscientia. Et co quelle figure che sono nel disegno chome di tucto appare alibro de partiti di detta arte segnato D a c. 214 Fior. 190.'

Orlandi (pp. 43–4) explains the commission for the painting by the fact that Fra Giuliano Lapaccini, a member of the community of San Domenico at Fiesole from 1433, belonged to a family which, since 1406, had been closely associated with the Arte dei Linaiuoli. The relevant documents are printed by Orlandi (pp. 185–6).

The marble frame in which the triptych is set was designed by Ghiberti in 1432; documents of 29 October 1432 and 11 August 1433, printed by Krautheimer (*Lorenzo Ghiberti*, Princeton, 1956, p. 385, Doc. 105, 106), refer respectively to the execution of a wooden model by Jacopo di Piero detto il Papero, and to the commissioning of the tabernacle in its final form from two assistants of Ghiberti, Jacopo di Bartolommeo da Settignano and Simone di Nanni da Fiesole. There is no evidence as to what part, if any, was played by Ghiberti in the designing of the painted panels. It is suggested by Middeldorf ('L'Angelico e la scultura', in *Rinascimento*, vi, 1955, pp. 179–194) that in the Saints in the wings Angelico endeavoured to emulate contemporary monumental sculptures, and that the figures on the exterior of the wings were perhaps planned by Ghiberti.

A wide variety of view has been expressed as to the extent of studio intervention in the altarpiece. Schottmüller (pp. 257–8) regards the triptych as largely autograph, and Wurm (pp. 18–20) admits only the St. Mark as the work of Fra Angelico. The Virgin and Child, some of the angels in the frame, and the four Saints in the wings appear to have been executed largely, if not wholly, by Angelico. The predella is ascribed to a studio assistant by Muratoff (p. 43). Van Marle (x, p. 60) makes an attempt to dissociate the outer panels from that in the centre, which he accepts as Fra Angelico's; no valid qualitative distinction can be drawn between the three panels. The view of Wurm (loc. cit.) that 'die Entwürfe für die drei Predellenbilder . . . sind nicht vom Meister' can be ruled out.

Old photographs leave no doubt that the central panel (Fig. 15) has been extensively restored. The angels in the frame have been weakened by retouching, and in the *Saint Peter preaching* the heads of the figures in profile on the extreme left are much damaged by repaint. The picture (for which see *Mostra*, pp. 31–3, No. 18) was lightly cleaned in 1955.

A variant of the panel of *Saint Peter preaching*, formerly in the Beurnonville collection, Paris (Baron de Beurnonville, sale, Paris, 21 May, 1883, No. 127), the Aynard collection, Lyons (sale, Paris, 1 December 1913, No. 36), the Spiridon collection, Rome (sale, Amsterdam, 19 June 1928, No. 15) and the Nemes collection, Munich (sale, Munich, 16 June 1931, No. 11), is published by L. Venturi (in *Pantheon*, 1928, p. 20) as Angelico.

The Coronation of the Virgin. Uffizi, Florence.　　Plate 34
Panel: 112 × 114 cm.

Painted for the nuns' choir in the church of Santa Maria Nuova (Sant'Egidio). The picture is identical with a panel noted by Manetti (p. 166) and in the *Libro di Antonio Billi* (p. 18, as 'Paradiso') and described by Vasari (ii, p. 516: 'Si vede anco nel tramezzo di Santa Maria Nuova una tavola di sua mano'). The siting of the painting is discussed by Paatz (iv, p. 49 n.). As noted by Schottmüller (p. 257), the presence beside Saint Dominic of Sant'Egidio (to whom the church of the hospital of Santa Maria Nuova was dedicated) confirms this provenance.

Orlandi (1964, pp. 30–1) claims that the figure of Sant'Egidio has the features of St. Antoninus, and connects the prominence given to the figure of St. Jerome with donations to the hospital made, after 1441, by Girolamo di Bernardo de' Bardi. According to Orlandi, there is no reference to the painting in the surviving Registri di Uscita between 1423 and 1450, and it is therefore likely that it was commissioned in the period for which the registers are missing, 1442–9. Saint Antoninus, as Prior of San Marco, preached the lenten sermons at Sant'-Egidio in 1441 and 1443.

The picture is accepted as a work of Angelico by Berenson (1896, p. 98; 1963, p. 11), Douglas (pp. 56–8), and Muratoff (pp. 32–3), who dates it about 1425. A later dating, ca. 1430–40, is adopted by Schottmüller (loc. cit.) and Salmi (1955, p. 100), who accepts the panel as autograph. A dating in the early fourteen-thirties is accepted by Meiss ('Masaccio and the Early Renaissance: the Circular Plan', in *Studies in Western Art*, Princeton, ii, 1963, p. 140), who interprets the 'saints and angels . . . illuminated by the radiance of the central figures' as 'a kind of naturalistic version of the enlightenment of the apostles at Pentecost'. It is regarded as a work of Angelico and assistants by Berti (*Mostra*, 1955, pp. 20–1, No. 10) and is accepted by Baldini (p. 94). Van Marle (x, pp. 48–52) detects the hand of Zanobi Strozzi in the main figures, and Bazin (p. 181) regards it as a studio reduction after the *Coronation of the Virgin* in the Louvre. This view, with a dating about 1440, was adopted in the first edition of this book, where it was ascribed to 'the hand . . . tentatively identified as Zanobi Strozzi's'. The panel appears to be in large part autograph, and to date from soon after the Santa Maria degli Angeli *Last Judgment*, that is from about 1431–5.

Two panels of *The Marriage of the Virgin* and *The Burial of the Virgin* (Figs. 13–14) in the Museo di San Marco (Panel: 19 × 50 cm. each. Presented to Cosimo II in 1629; in the Uffizi from 1704) are assumed to have formed the predella of the *Coronation*. This view is accepted, among others, by Salmi (1955, p. 100), Berti (in *Mostra*, 1955, pp. 22–3, Nos. 11–12) and Baldini (p. 95), and is almost certainly correct. The theory is, however, contested by Orlandi (p. 30) and Collobi-Ragghianti (in *Critica d'Arte nuova*, vii, 1955, p. 40), who proposes an alternative solution whereby a panel of *The Origin of the Dominican Habit* in the National Gallery, London, and a *Scene from the Life of Saint Dominic*, formerly on the London art market, would have constituted the predella of the painting. Convincing counter-arguments are advanced by Davies (*National Gallery Catalogues: The Earlier Italian Schools*, 1961, p. 36). The two predella panels in the Museo di San Marco were evidently based on Angelico's cartoons, and are in part by a studio assistant whose hand appears in the main panel.

Saint James the Great freeing Hermogenes. Duc des Cars, Paris. Plate 32
Panel: 26 × 24 cm.

See note on the following plate. The episode is described in the *Legenda Aurea*.

The Naming of Saint John the Baptist. Museo di San Marco, Florence. Plate 33
Panel: 26 × 24 cm.

Along with two panels of *The Marriage of the Virgin* and *The Burial of the Virgin*, also in the Museo di San Marco, this panel was presumed by Crowe and Cavalcaselle (iv, p. 91) to have formed part of the predella of the Santa Maria Nuova *Coronation of the Virgin* in the Uffizi, with which it was at one time exhibited. The fact that the panels originate from two separate sources (the present painting was purchased in 1778 by Vincenzo Prati, while the supposed companion panels were presented to Cosimo II in 1629 and reached the Uffizi in 1704), and that their dimensions are incompatible (the two larger scenes measure 19 × 50 cm.) makes this conjunction improbable. Van Marle (x, pp. 181–2) ascribes *The Naming of the Baptist* (along with *The Marriage of the Virgin* and *The Burial of the Virgin*) to Zanobi Strozzi. Muratoff (p. 36) denies all three panels to Angelico. In style the present panel is related to the predella of the Linaiuoli triptych. As is pointed out by Salmi ('La giovinezza di Fra Filippo Lippi', in *Rivista d'Arte*, xviii, 1936, p. 9; and 1958, p. 103), the panel must date before 1435, since it forms the basis of a scene in the predella of a polyptych at Prato executed by Andrea di Giusto in that year. Longhi (p. 176) links the *Naming of the Baptist* with a panel of *Saint James freeing Hermogenes* (wrongly described as *Christ conferring the power to bind and loose*), in the collection of the Duc des Cars, Paris. The heights of the two panels correspond, and

their closely similar handling favours this grouping. A statement of Orlandi (p. 204) that the panels have been claimed as part of the predella of the Annalena altarpiece is fanciful. Two panels of *The Nativity* and *The Agony in the Garden* (Figs. 78–9) in the Pinacoteca at Forlì (of the same height but considerably narrower) are regarded by Longhi as further fragments of the same predella; the different scale of the figures in these panels, and their iconographical incongruity, militate against this view. There is no indication of what altarpiece the San Marco and Des Cars panels formed part. A panel with the *Meeting of Saints Dominic and Francis* at San Francisco (q.v.) may originate from the same predella.

The Virgin and Child. San Domenico, Fiesole.
Fresco and sinopia (transferred): 116 × 75 cm. Plate 35

A fresco of the Virgin and Child above the entrance to the church of San Domenico is listed in the *Codice Magliabechiano* (p. 95: 'Sono nella chiesa di San Domenicho di Fiesole piu tavole di sua mano, che molto bene per che intende sono conosciute et maximo chj visto della maniera sua. Dipinse fuori sopra l'uscio di detta chiesa una Nostra Donna'). The fresco is referred to in the plural by Vasari (ii, pp. 512–13: 'Le pitture ancora che sono nell'arco sopra la porta di San Domenico, sono del medesimo'). The *Virgin and Child* was moved, probably in 1587, and placed, with part of the wall on which it was painted, over a doorway on the ground floor of the convent, with the inscription 'B. Joannes Angelicus huius cenobii filius pinxit.' It was extensively repainted in 1858. Investigation of the fresco in 1960 (for which see Procacci, *Sinopie e affreschi*, Florence, 1960, p. 243, No. 51) revealed, beneath the ruined paint surface, a well preserved sinopia by Fra Angelico. The sinopia (for which see also Tito Centi, 'Disegno originale del B. Angelico scoperto nel suo convento', in *Memorie Domenicane*, lxxviii, 1961, pp. 3–9) is related by Orlandi (p. 42) to the *Madonna dei Linaiuoli*. The function of the lunette was closely similar to that of the lunette over the entrance to San Domenico at Cortona, and comparison of the two sinopie seems to indicate that the Fiesole fresco is somewhat the earlier of the two. It is likely to date from the first half of the fourteen-thirties. Vasari's use of the term 'pitture' suggests that in addition to the rear face the interior of the lunette may also have been frescoed. If this were so, the Fiesole lunette would have formed a close precedent for that at Cortona.
The following frescoes also originate from San Domenico:

(i) **Christ on the Cross adored by Saint Dominic with the Virgin and Saint John.** Louvre, Paris (No. 1294).
Fresco transferred to canvas: 435 × 260 cm. Fig. 16
Coll.: Bardini (1879).

The fresco was formerly in the refectory of San Domenico at Fiesole, where it is described by Marchese (i, pp. 232–3), who reports that it was then 'affatto perduto'. A passage in the

Chronaca Sancti Dominici de Fesulis (f. 10), quoted by Marchese (loc. cit.) records that it was restored by Francesco Mariani in 1566. Schottmüller (p. 267) regards the fresco as largely the work of an assistant. Light is thrown on its condition by a photograph (Fig. 16) made while it was still *in situ* at Fiesole. This shows that the upper part of the fresco above the arms and label of the Cross has been made up, that the heads of the Virgin and Saint John have been reworked, and that the cloak of the Virgin and the habit of Saint Dominic (which were both extensively abraded) have been renewed. In their original form the heads of the three main figures are hardly consistent with a dating after 1435, while the drapery forms recall those of the Cortona polyptych. The fresco is thus of interest as offering a precedent for the similar frescoes executed in San Marco in Florence.

(ii) **The Virgin and Child between Saints Dominic and Thomas Aquinas.** Hermitage, Leningrad. Fig. 17
Fresco transferred to canvas: 196 × 187 cm.
Coll.: Capponi, Archduke Sergius of Russia (1882).

The fresco is described in the refectory (former Sala Capitolare) of San Domenico by Marchese (i, pp. 233–4), but was in fact (Orlandi) on the wall of the Dormitorio at the head of the stairway. Before the convent was reacquired by the Dominicans in 1880, it was removed from the wall (1879). According to Marchese, it was already extensively restored before that time. Clumsy repainting is also noted by Milanesi (in Vasari, ii, p. 511 n.), and is confirmed by a photograph (Fig. 17) made of the fresco while it was still at Fiesole. Schottmüller (p. 261) proposes a dating about 1436. It seems likely that before restoration the types of the two lateral Saints were more evolved than those of the Fiesole high-altarpiece, which they superficially recall, and that the fresco, like that in the Louvre, dates from the first half of the fourteen-thirties.

In addition a fourth fresco is preserved at Fiesole:

(iii) **Christ on the Cross.** San Domenico, Fiesole. Fig. 18
Fresco: 363 × 212 cm.

Situated in the Sala del Capitolo of the convent, this fresco was covered with whitewash until 1882, and was not therefore removed from the wall, like the frescoes in Paris and Leningrad. It is not described by any early source. The fresco was restored in 1955. With the exception of Van Marle (x, p. 157), who regards it as a school work, the ascription to Angelico is admitted by all writers on the artist. An early dating (about 1420–30) is favoured by Schottmüller (1924, pp. 171, 265), a dating in the thirties by Douglas (pp. 82–3), and a dating about 1450 by Muratoff (p. 75). A dating about 1430 was accepted in the first edition of this book. Orlandi (pp. 41–2) connects it with a statement in the *Cronaca quadripartita* that 'essendo allora Priore Fra Pietro d'Antonio (1432) e poi Fra

Girolamo d'Antonio da Perugia, furono fatti gli armadi della sagrestia, le mense del refettorio e i sedili del Capitolo', and assigns it and the fresco in the Louvre to the years 1432–4. The treatment of the body of Christ in the two frescoes is, however, dissimilar. Whereas the figure in the Louvre fresco conforms to the norm of Angelico's representations of the Crucified Christ, that in the San Domenico fresco does not. There is no parallel elsewhere in Angelico's work for the particularised realism of the body or for the foreshortened head. These features are inconsistent with the recently cleaned Crucifix from San Niccolò del Ceppo (Fig. 62), which seems to date from the early fourteen-thirties, and with Angelico's many later paintings of the Crucified Christ. An attempt has been made to resolve this difficulty by supposing (Berti) that the fresco was painted under the strong influence of Masaccio soon after the Fiesole high-altarpiece. There is, however, no analogy in Masaccio's Naples *Crucifixion* or in the Santa Maria Novella *Trinity* for the forward-tilting head, in which the treatment recalls Castagno not Masaccio. The probability, therefore, is that the fresco was painted about the middle of the century by an artist in Angelico's following.

The Virgin and Child between Saints Dominic and Peter Martyr. San Domenico, Cortona. Plates 36–7; Fig. 12

The fresco, which must originally have shown the Virgin seated in full-length between kneeling figures of Saints Dominic and Peter Martyr, fills the lunette above the west door of San Domenico. In the interior of the pointed arch are four seated figures of the Evangelists. Despite their damaged state, both the main fresco and the subsidiary figures are clearly the work of Angelico. A bull issued by Eugenius IV in 1438, empowering the Prior of San Domenico to apply certain funds to the painting of the church, is not (as is supposed by Marchese, i, pp. 218–19) in itself evidence of the date at which the fresco was executed. There is some doubt as to the date of construction of the façade of the church, which may not have been completed in 1438, and Orlandi (p. 59) for this reason dates the fresco after 1445. The fresco was perhaps executed about 1440. It was restored in 1955, was subsequently removed from the wall, and was exhibited at the *Mostra degli affreschi staccati*, 1966, with the underlying sinopia (Fig. 12).

The Virgin and Child enthroned between Saints Mark (?), John Baptist, John Evangelist and Mary Magdalen. Museo Diocesano, Cortona. Plates 38, 40–1; Figs. 21, 23
Panel transferred: (central panel) 137 × 68 cm.; (lateral panels) 117 × 69 cm.; (overall) 218 × 240 cm.

Painted for San Domenico, Cortona. In the finials are the Annunciatory Angel, Christ on the Cross between the Virgin and St. John, and the Virgin Annunciate. The predella of the

altarpiece (Fig. 23), shows (i) *The Dream of Innocent III and the Meeting of Saints Dominic and Francis*, (ii) *Saints Peter and Paul appearing to Saint Dominic*, (iii) *The Raising of Napoleone Orsini*, (iv) *The Disputation of Saint Dominic and the Miracle of the Book*, (v) *Saint Dominic and his Companions fed by Angels*, and (vi) *The Death of Saint Dominic*.

The polyptych is identified by Douglas (pp. 66–7, 123) with a painting recorded as executed ca. 1437 on the commission of Niccolò di Angelo Cecchi for the chapel of St. Thomas Aquinas in San Domenico. It transpires, however, from a document of 1452 which alludes to this painting (Cortona, Archivio Communale, quoted by Douglas, loc. cit.) that the chapel of St. Thomas Aquinas had a secondary dedication to St. Nicholas of Bari, and in these circumstances the painting referred to is more probably the polyptych by Sassetta in the same church, in which this Saint is shown. The companion polyptych of Sassetta on the corresponding altar at the head of the left (north) aisle is related in form to the polyptych of Fra Angelico, and was perhaps executed about 1436. Venturi (pp. 40–2) favours an earlier dating, and Muratoff (pp. 40–1) regards the altarpiece as closely linked in style with the *Annunciation* in the Gesù, and on these grounds dates it about 1430. Schottmüller (p. 259) proposes a dating between 1430 and 1440. Stylistically the altarpiece forms a middle term between the Linaiuoli triptych (1433) and the Perugia polyptych (1437). This dating is accepted by Salmi (1958, p. 106) and Baldini (in *Mostra*, pp. 49–50, No. 28). Orlandi (pp. 57–8) assumes that the altarpiece postdates a bull of Eugenius IV of 13 April 1438, in which the Prior of the Convent is authorised to allocate certain sums of money to the completion of the decoration of the church ('faciendo pingi figuras huiusmodi'). Wurm (pp. 15–16) admits only the head of the Saint to the right of the Virgin as autograph. The two outer figures are somewhat weaker than those in the interior of the wings, but the underdrawing of the figures (see below) indicates clearly that all of the main figures were sketched in by a single hand.

The action of damp, precipitated by conditions of storage in 1940–4, resulted in the rotting of the panels and the disintegration of the gesso priming. In 1945–6 the film of the paint surface was removed from all five panels, and photographs of this taken from behind provide important evidence for the technical procedure which underlies Angelico's altarpieces (*Florence: Mostra di opere d'arte restaurate*, 1946, pp. 28–9, and Procacci, 'Recent Restoration in Florence, II', in *Burlington Magazine*, lxxxix, 1947, pp. 330–1).

Iconographically the predella is closely related to that of the Louvre *Coronation of the Virgin*, of which it appears to have formed the prototype. The cartoons seem to be due to Angelico, and the execution to the hand responsible for the fresco in Cell 2 and other frescoes at San Marco. The predella differs markedly in style and handling from e.g. the *Crucifixion* above the central panel, but is probably of the same date as the altarpiece. A derivative from the third scene of the predella, *The Raising of Napoleone Orsini*, was exhibited at Stuttgart in 1950 (*Frühe Italienische Tafelmalerei*, No. 80, as by the Master of the Griggs *Crucifixion*).

The Virgin and Child enthroned with Angels between Saints Dominic, Nicholas of Bari, John Baptist and Catherine of Alexandria. Galleria Nazionale dell'Umbria, Perugia (No. 91). Plates 39, 42–5; Figs. 22, 24
Panel: (central panel) 130 × 77 cm.; (lateral panels) 95 × 73 cm.

Above the lateral panels are tondi of the Annunciatory Angel and the Virgin Annunciate. The pilasters contain twelve figures of Saints, arranged in three pairs on each side, of which those below are represented in full length and those above are cut off at the knee (*left side*: Saints Peter and Paul, Saints Louis and Mary of Egypt, Saints Benedict and Peter Martyr; *right side*: Saints John the Evangelist and Stephen, Saints Catherine of Alexandria and Jerome, Saints Thomas Aquinas and Lawrence). The predella consists of three panels showing (i) *The Birth of Saint Nicholas, the Vocation of Saint Nicholas, and Saint Nicholas and the three Maidens*; (ii) *Saint Nicholas addressing an Imperial Emissary, and Saint Nicholas saving a Ship at Sea*; (iii) *Saint Nicholas saving three Men condemned to Execution, and the Death of Saint Nicholas*. Nos. (i) and (ii) are now in the Pinacoteca Vaticana (Nos. 251/2) and No. (iii) is in the Galleria Nazionale at Perugia (Panel: 33 × 63 cm. each).

Painted for the chapel of San Niccolò dei Guidalotti in San Domenico, Perugia, perhaps under the terms of the will of a former Bishop, Benedetto Guidalotti (d. 1429). A statement in the *Annali* of Padre Bottonio (MS., Bibl. Com., Perugia, ii, c.72, quoted by Bombe, *Geschichte der Peruginer Malerei bis zu Perugino und Pinturicchio*, 1912, p. 77) ascribes the altarpiece to the year 1437: '1437. La tavola dell'Altare di S. Niccolo nella Cappella de' Guidalotti fu data questo anno a dipingere a F. Gio: da Fiesole padre nostro et famosissimo pittore de l'ordine nostro, di cui è ancora l'altra tavola posta in chiesa Vecchia sopra l'altar maggiore.' There is no record of a second altarpiece painted by Angelico for San Domenico at Perugia, and it is suggested by Orlandi ('Su una tavola dipinta da Fra Filippo Lippi per Antonio del Branca', in *Rivista d'Arte*, xxix, 1954, pp. 199–201) that the reference is to a lost altarpiece commissioned from Fra Filippo Lippi in 1451 in the sacristy of San Marco in Florence in the presence of Fra Giuliano Lapaccini by Antonio del Branca of Perugia. An attempt of Middeldorf ('L'Angelico e la scultura', in *Rinascimento*, vi, 1955, pp. 188–9) to replace the conventional date of 1437 with a dating after 1450 and to assign the commission to Jacopo Vagnucci, Bishop of Perugia (1449–82), is rejected by Orlandi (p. 61). The altarpiece was transferred to the sacristy of San Domenico before 1706, and was among the pictures seized by the French in the Napoleonic wars and removed to Paris. On its return two of the predella panels were retained in the Vatican (see above). The triptych was disassembled before the middle of the nineteenth century (when the main panels were exhibited in the chapel of Santa Orsola in San Domenico and one of the predella panels hung above the door of the sacristy), and passed to the Perugia gallery in 1863. It was reconstituted in 1915 (Cecchini, *La Galleria Nazionale dell'Umbria in Perugia*, 1932, pp. 13–16) in a modern frame; in this recon-

struction the arrangement of the pilasters (which must originally have conformed to the double-sided pilasters of the *Deposition* in the Museo di San Marco) was incorrect. An accurate reconstruction appears in Bombe (op. cit., p. 79). A cleaning undertaken in 1918 appears to have involved much restoration, especially to the pilaster panels, and was rectified by a further cleaning in 1953 (for this see Rome, Istituto Centrale di Restauro: C. Brandi, *Mostra di dipinti restaurati*, 1953, pp. 13–15), which revealed extensive damage to the Virgin's face. The execution is unequal in quality. Whereas the central panel and the two Saints on the left appear to be substantially autograph, the figures of Saint John the Baptist and Saint Catherine of Alexandria are by an assistant working from Angelico's cartoon. The figures of the Annunciatory Angel and Virgin Annunciate are by this hand, which reappears in subsidiary parts of the Croce al Tempio *Lamentation over the dead Christ* and of the *Deposition* in the Museo di San Marco. The two predella panels in the Pinacoteca Vaticana were cleaned in 1955. The three predella panels are ascribed by Weisbach (*Pesellino und die Romantik der Renaissance*, 1901, p. 38) to Pesellino, a view in which Schottmüller (p. 259) and Van Marle (x, pp. 66–8) seem to concur. Fra Angelico's responsibility for the predella panels is accepted by Berenson (1896, p. 100) and by Venturi (p. 56). Baldini (in *Mostra*, p. 61, No. 35), following Salmi, tentatively ascribes the soldiers to the right of the left-hand scene in the Perugia panel to Zanobi Strozzi, and the Saint in this scene and the Saint and clerics in the right-hand scene to Domenico di Michelino. The validity of these observations is debatable. Berti (in *The Great Age of Fresco*, New York, 1968, p. 150) relates the central panel, where the romantic rock forms have no parallel in Angelico's work, to the frescoed *Scenes from the Life of St. Benedict* in the Chiostro degli Aranci of the Badia, and this scene and the frescoes may be due to Giovanni Gonsalvi da Portogallo, who was associated with Angelico at San Domenico di Fiesole.

The Lamentation over the Dead Christ. Museo di San Marco, Florence (No. 58). Plates 46–7; Fig. 25
Panel: 105 × 164 cm.

Painted for the Confraternità di S. Maria della Croce al Tempio, and originally over an altar on the left side of the church (Paatz, iii, p. 308). The panel passed to the Accademia on the suppression of the Confraternity in 1786. The painting is described in the *Libro di Antonio Billi* of 1516–25/30 (p. 18: 'Una tauola nel Tempio, doue e Giesu morto et intorno uno coro delle Marie'), by Vasari (ii, p. 514: 'Per la Compagnia del Tempio di Firenze fece, in una tavola, un Cristo morto'), and by Richa (ii, p. 132). In addition to the figures present at the Deposition the panel includes (*left*) Saint Dominic and (*right*) Saint Catherine of Alexandria and the Beata Villana.
The panel was commissioned by Fra Sebastiano di Jacopo di Rosso Benintendi on 13 April 1436 and was completed by 2 December of the same year. The relevant document (discovered and transcribed by Orlandi, *Beato Angelico: note*

cronologiche, 1955, p. 31, and 1964, pp. 187–8) reads as follows: 'Sia manifesto a chiunque legera la presente scritta. Come io frate Cipriano di ser Antonio priore di Fiesole e di sancto Marcho one comperato da don Bastiano di iacopo monaco dello ordine (di) sancto benedetto uno messale secondo l'ordine di frati predicatori per preço et pregio di ducati quindici di camera stimato da frate bartolomeo da monte rapoli priore di sancta maria novella di firenze. Detta quantita di ducati quindici de' quali ane recevuto ducati otto e quali ebbe per noi dallo vescovo di racanati di limosina per llo papa et irresto che sono ducati sette ci lascia per parte di pagamento d'una tavola la quale debba dipignere frate Giovanni dipintore et per chiareça di cio io frate Cipriano sopradetto one fatta la sopra detta scritta di mia propria mano a di XIII d'aprile MCCCCXXXVI. Item io frate giovanni dipintore o ricevuto staia sessanta di grano per soldi diciassepte la staio ad di 2 di dicembre 1436, monta l. XXXXXI. Item die decto o ricevuto fiorini quatro d'oro per lire quatro l'una e soldi dodici. Montono L. 18 et s. 8.' Fra Sebastiano Benintendi had been a Dominican friar prior to his entry into the Benedictine order (hence the appearance of St. Dominic on the left of the painting), and according to Orlandi (loc. cit.) had a special devotion to St. Catherine of Alexandria. He was a nephew of the Beata Villana delle Botti.
Milanesi (in Vasari, ii, p. 512 n.) notes that the inclusion of the Beata Villana in this painting is due to the fact that the Compagnia del Tempio exercised certain rights over the relics of this Saint in Santa Maria Novella. The date MIIIIXXXXI, which appears on the edge of the Virgin's veil, is noted by Middeldorf ('L'Angelico e la scultura', in *Rinascimento*, vi, 1955, p. 190) as an indication of the date of the painting, and is tentatively connected by Orlandi (loc. cit.) with the dedication of the altar in 1440 by Fra Tommaso Tommasini Paruta. The painting is damaged, and was reduced in height in the course of cleaning at the Istituto Centrale del Restauro, Rome, in 1955, when part of the repaint in the background and elsewhere was removed.
A trecento *Lamentation* by Niccolò di Tommaso (Fig. 26), now in the Congregazione della Carità at Parma, for which it was acquired in Florence, presents close similarities to, and is likely to have been the model for, this painting.

The Virgin and Child enthroned with Angels and Saints Cosmas and Damian, Lawrence, John Evangelist, Mark, Dominic, Francis and Peter Martyr. Museo di San Marco, Florence. Plates 48–65; Fig. 36
Panel: 220 × 227 cm.

Painted for the high altar of San Marco, Florence. The altarpiece is described by Vasari (ii, pp. 508–9): 'Ma particolarmente è bella a maraviglia la tavola dell'altar maggiore di quella chiesa; perchè, oltre che la Madonna muove a divozione chi la guarda per la semplicità sua, e che i Santi che le sono intorno, sono simili a lei; la predella, nella quale sono storie del martirio di San Cosimo e Damiano e degli altri, è tanto ben fatta, che non è possibile immaginarsi di poter veder mai cosa

fatta con più diligenza, nè le più delicate o meglio intese figurine di quelle'. The altarpiece was removed from the church in the seventeenth century, and is described by Cinelli (1677) as in the convent. In 1745 it was noted by Richa (vii, p. 143) in a passage leading to the sacristy of the church. It was transferred to the Accademia in Florence in 1884, and thence (1919) to the Museo di San Marco. The surface of the panel (for the condition of which see Baldini, in *Mostra*, 1955, pp. 73–4, No. 43) is much abraded from an old cleaning with soda; a number of restorations were removed in the course of cleaning in 1955. In its present state it provides no more than a general indication of its original quality.

There is no record of the commissioning of the altarpiece. The convent of San Marco was handed over to the Dominicans in 1436. In 1437 work was begun on the rebuilding of the convent proper and of the church, the roof of which was unsound. Structural work in the Cappella Maggiore of the church was completed in 1439, and its decoration is presumed to have been finished by Epiphany 1443, when it was dedicated, in the presence of Eugenius IV, by the Archbishop of Capua. In 1438 Cosimo de' Medici agreed to present to the convent of San Domenico at Cortona an altarpiece which had previously stood on the high altar of San Marco in Florence (Gaye, i, p. 140), and in 1440 this altarpiece (by Lorenzo di Niccolò) was installed at Cortona. A passage from the *Cronaca di San Marco* transcribed by Milanesi (in Vasari, ii, p. 534) confirms the details of this transaction. This reads in full (Raoul Morçay, *La cronaca del convento di San Marco*, 1913, p. 14): 'Tempore illo, fratre Cypriano existente adhuc Priore, tabula altaris majoris quae magna et pulchra erat, ornata multis figuris ac valoris ducatorum ducentorum vel circa, donata fuit a fratribus conventui Cortonii ordinis nostri, operante ad hoc praecipue fratre Cypriano antedicto; cui fecit apponere arma seu insignia Medicea et dictorum Medicorum nomina; necdum perfecta erat tabula quae nunc est super dictum altare majus.' There is thus a high degree of probability that the altarpiece painted by Angelico for the high altar of the church was commissioned in 1438 and completed soon after 1440. This view is accepted by Salmi (1958, pp. 112–13) and Orlandi (1964, pp. 70–2).

The iconography of the main panel is studied by Orlandi (loc. cit.). Round the edge of the Virgin's robe is a passage from Sir. (Ecclesiasticus) xxiv, 24, 23: 'Ego mater pulchrae dilectionis et timoris et agnitionis et sanctae spei. Ego quasi vitis fructificavi suavitatem odoris et flores mei fructus honoris et honestatis'. The garlands of roses and the palm and cypress trees seen at the back of the painting refer to Sir. xxiv, 17–18, where the Virgin is compared to the cedar of Lebanon, the cypress of Mount Sion, the palm of Cades and the rose of Jericho. The book held by St. Mark is open at Mark, vi, 2–8, which describes Christ teaching in the synagogue. Orlandi regards the kneeling Saint to the left (Cosmas) as a portrait of Cosimo il Vecchio de' Medici and the kneeling Saint to the right (Damian) as a portrait of Lorenzo de' Medici (d. 25 September 1440).

Eight narrative panels with scenes from the legend of Saints Cosmas and Damian formed part of the altarpiece. These are:

(i) **The Healing of Palladia by Saints Cosmas and Damian, and Saint Damian receiving a Gift from Palladia.** National Gallery of Art (Kress Collection), Washington (No. 790). Fig. 36
Panel: 36·5 × 47·5 cm.

Coll.: Keller, New York. The panel shows on the left the miraculous cure of Palladia by the two Saints, and on the right Saint Damian receiving a gift pressed on him by the grateful woman in the name of Christ.

(ii) **Saints Cosmas and Damian and their Brothers before Lycias.** Alte Pinakothek, Munich (No. H.G.36). Plate 60
Panel: 38 × 45 cm.

Purchased in 1822 from Weiss, Berlin, for the Bavarian Royal Collection. The panel shows the two Saints and their three brothers before the proconsul Lycias, who orders them to sacrifice to the pagan gods.

(iii) **Lycias possessed by Devils: Saints Cosmas and Damian thrown into the Sea.** Alte Pinakothek, Munich (No. H.G. 37). Plates 56b, 57
Panel: 38 × 45 cm.

Provenance as (ii). The panel shows in the background (*right*) the five brothers thrown into the sea, and (*left*) rescued by an angel. In the foreground is Lycias assailed by devils, who leave him in response to the Saints' prayers.

(iv) **The attempted Martyrdom of Saints Cosmas and Damian by Fire.** National Gallery of Ireland, Dublin (No. 242). Plate 61
Panel: 37 × 46 cm.

Coll.: Lombardi-Baldi; Graham; purchased for the National Gallery of Ireland, 1886. The five brothers are seen unscathed in the centre of a pyre or furnace, while the flames destroy their executioners.

(v) **The Crucifixion of Saints Cosmas and Damian.** Alte Pinakothek, Munich (No. H.G. 38). Plates 56a, 58, 59
Panel: 38 × 46 cm.

Provenance as (ii). The two Saints, crucified, are assailed (*centre*) with stones and (*right and left*) with arrows, which return to strike the executioners.

(vi) **The Decapitation of Saints Cosmas and Damian.** Louvre, Paris (No. 1293). Plate 62
Panel: 36 × 46 cm.

Coll.: Niccolò Tachinardi; Valentini, Rome; Palazzo Imperiali, Rome; Timbal (purchased 1868); acquired by the Louvre, 1882. The panel shows the execution of the five brothers.

(vii) The Burial of Saints Cosmas and Damian. Museo di San Marco, Florence. Plate 63
Panel: 37 × 45 cm.

The panel shows a camel enjoining that the bodies of Saints Cosmas and Damian (which were to be separated on account of a supposed disagreement between the brothers) should be buried side by side.

(viii) The Dream of the Deacon Justinian. Museo di San Marco, Florence. Plate 64
Panel: 37 × 45 cm.

The panel shows the two Saints replacing the cancerous leg of Justinian the Deacon with the healthy leg of an Ethiopian buried in the cemetery of S. Pietro in Vincoli.

A *Lamentation over the dead Christ* in the Alte Pinakothek at Munich (No. H.G. 38a.; Plate 65) also formed part of the predella. The connection of this scene (which measures 38 × 46 cm., and was acquired in 1818 independently of the three other panels in the Pinakothek) with the predella is denied by Schottmüller (p. 260). It is, however, reasonably certain that this panel is identical with a 'Deposizione di Croce' listed along with seven scenes from the legend of Saints Cosmas and Damian in the Farmacia of the convent of San Marco at the time of the suppression, and likely that it also formed one of the 'quattro quadretti dell'Angelico . . . ch'erano in San Marco, ora in Germania', restored in 1817 in Florence by Luigi Scotti (Marchese, i, p. 249). Bazin (p. 183) dismisses the supposed connection between the predella panels and the upper panel, which he assigns to different phases of the artist's evolution; this view is untenable. Physical examination of the panels (for which see Baldini) reveals that the original sequence (*left to right*) was *The Healing of Palladia, Saints Cosmas and Damian before Lycias, Lycias possessed by Devils, The attempted Martyrdom of Saints Cosmas and Damian by Fire, The Lamentation over the Dead Christ, The Crucifixion of Saints Cosmas and Damian, The Decapitation of Saints Cosmas and Damian, The Burial of Saints Cosmas and Damian,* and *The Dream of the Deacon Justinian.* The aggregate width of the narrative panels (412 cm.) is greatly in excess of the width of the upper panel (227 cm.). It has been variously claimed that the predella consisted of eight scenes (Muratoff and Van Marle), seven (Douglas), six (Bodkin) and five (Crowe and Cavalcaselle and Collobi-Ragghianti). The balance of probability is against the view that the predella exceeded the width of the upper panel, and its width can thus hardly have been greater than the overall length of five of the narrative scenes. Bodkin ('A Fra Angelico Predella', in *Burlington Magazine*, lviii, 1931, pp. 183–94) concludes that it was composed (from left to right) of the scenes numbered (ii), (iii), (iv), (v), (vi) and (vii) above. Collobi-Ragghianti ('Zanobi Strozzi', in *La Critica d'Arte*, xxxii, 1950, pp. 468–73), arguing from the presence of gilt Ionic columns at the edges of certain of the panels, believes it to have consisted of scenes (ii), (i), (iv), (vi) and (vii). Both reconstructions presuppose that the

panels not included were omitted from the altarpiece. This thesis is unacceptable, and no reconstruction is admissible which does not explain the siting of the entire cycle. It was mistakenly suggested in the first edition of this book that the nine surviving panels and a missing tenth panel were arranged in two tiers of five panels each. The correct reconstruction (for which see Salmi, 1955, p. 147, and 1958, pp. 112–13, Baldini, in *Mostra*, pp. 72–3 No. 43, and in *Commentari*, vii, 1956, pp. 78–83) provides for panels on the front and side of each of the pilasters of the altarpiece and a sequence of five panels between them. The basis of this reconstruction is the altarpiece by Lorenzo di Niccolò at Cortona, for which Fra Angelico's altarpiece was substituted. Weisbach (*Pesellino und die Romantik der Renaissance*, 1901, pp. 37–43) presumes that Pesellino intervened in the execution of the predella; there is no evidence of this. An attempt is made by Salmi (1955, 1958) to trace the intervention of Benozzo Gozzoli in the two soldiers on the right of *Saints Cosmas and Damian before Lycias*, in the subordinate figures of *Lycias possessed by Devils*, and in the whole of *The Crucifixion of Saints Cosmas and Damian*, and to ascribe parts of *The Decapitation of Saints Cosmas and Damian* to Zanobi Strozzi. The name of Piero della Francesca has also been mentioned in connection with the panels. Like the upper section of the altarpiece, the nine scenes in the predella are autograph paintings by Fra Angelico. The predella is dated by Salmi after 1440 and by Bazin ca. 1445–50. It is unlikely that work on any part of the painting continued after 1443.

Six panels with single figures of Saints (Figs. 27a–d) seem to have formed part of the pilasters of the altarpiece. These comprise:

(i–iii) *Saints Jerome, Bernard* and (?) *Roch* (Lindenau Museum, Altenburg, No. 92). Panel: 39 × 14 cm. each. These panels, which were purchased in Rome in 1844 and according to a statement in the catalogue of 1898 'nach der Mitteilung des Dr. Braun verbürgt aus S. Marco in Florenz stammend', are associated by Salmi (1958, pp. 22, 104) followed by Oertel (*Frühe Italienische Malerei in Altenburg*, 1961, pp. 145–6) with the Annalena altarpiece.

(iv) *Saint Thomas Aquinas* (Private collection, Lake Bluff, Illinois). Panel: 39 × 14 cm. Published in the first edition of this book (1952, pp. 175–6, fig. xi) as in an Italian private collection.

(v) *Saint Benedict* (Minneapolis Institute of Arts, 62.9). Panel: 39 × 13 cm. The panel is inscribed on the reverse in a late eighteenth-century hand: *di Fra Giovanni da Fiesole/figuri che esistono S. Marco di Firenze*. It is stated to have belonged to the first Duke of Wellington and to have been given by him to his physician Dr. Thomas Peregrine. It was later in the collections of E. F. Peregrine (sale Sotheby, 22 June 1960, No. 10) and Richard H. Zinzer, Forest Hills, New York, and was purchased for the Minneapolis Institute of Arts in 1962. Published, as an autograph work by Fra Angelico, by Antony M. Clark (*Minneapolis Institute of Arts Bulletin*, li, March 1962, pp. 18–19; *Art Quarterly*, xxv, Summer, 1962, pp. 166–7; *Apollo*, lxxvi, August 1962, pp. 493–4; *European Paintings in the Minneapolis Institute of Arts*, 1963, No. 203, p. 383).

(vi) *Saint Anthony the Abbot* (Private collection). Panel.
Each of the two pilasters is likely to have consisted of five panels. Of the total of ten pilaster panels four, therefore, are untraced. So far as can be judged from the surviving panels, the pilasters portrayed representatives of religious orders and Dominican Saints who were not included in the main panel of the altarpiece. It is possible that the first of the panels at Altenburg represents San Giovanni Gualberto not Saint Jerome, and unlikely that the third of the Altenburg panels portrays Saint Roch.

Frescoes. San Marco Florence.

Plates 66–95; Figs. 28–35

The fifteenth-century frescoes in the convent of San Marco (most of which have at one time or another passed under the name of Fra Angelico) fall into four main groups:
(i) a *Christ on the Cross adored by Saint Dominic* and five lunettes of *Saint Dominic, Saint Peter Martyr, Saint Thomas Aquinas,* the *Pietà* and *Christ as Pilgrim received by two Dominicans* in the cloister.
(ii) a *Crucifixion with attendant Saints* in the Sala del Capitolo opening off the cloister.
(iii) a *Christ on the Cross adored by Saint Dominic,* an *Annunciation* and a *Virgin and Child with eight Saints* in the corridor on the upper floor.
(iv) forty-three frescoes in the forty-five cells on the upper floor.
The earliest reference to the frescoes at San Marco occurs in the *Cronaca di San Marco* of Fra Giuliano Lapaccini (d. 1458). This reads: 'Tertium insigne apparet in picturis. Nam tabula altaris majoris et figurae capituli et ipsius primi claustri et omnium cellarum superiorum et Crucifixi refectorii omnes pictae sunt per quendam fratrem ordinis Praedicatorum et conventus Fesulani qui habebatur pro summo magistro in arte pictoria in Italia, qui frater Johannes Petri de Mugello dicebatur, homo totius modestiae et vitae religiosae' (Raoul Morçay, *La cronaca del convento di San Marco*, 1913, p. 16). The frescoes are also mentioned in the *Memoriale* of Albertini of 1510 (*Memoriale di molte statue e pitture della citta di Firenze fatto da Francesco Albertini prete*, Florence, 1863, p. 12: 'Nel magno convento et chiesa di Sancto Marcho, facto la maior parte dalla casa de' Medici, vi sono assai cose buone. La tavola maiore et il capitulo et le figure del primo claustro, per mano di frate Iohanni Ord. Pred.'), in the *Libro di Antonio Billi* of 1516–25/30 (p. 19: 'et il capitulo di Santo Marcho di Firenze et la tauola dello altare maggiore con piu altre fiure nella decta chiesa'), in the *Codice Magliabechiano* (p. 94: 'In Firenze nel monasterio de fratj di San Marcho dipinse il capitulo. E di sua mano nella chiesa de dettj fratj la tauola dell'altare maggiore con piu pitture di suo nel couento de dettj fratj'), and by Manetti (p. 166).
The extent of Angelico's responsibility for these frescoes, and particularly for the frescoes in the cells has been widely discussed. The views of the principal students of the artist are

shown in the table on p. 203. There is no documentary evidence of the names or number of assistants employed in Angelico's studio in the years in which the frescoes were produced. The following notes refer to individual frescoes:

Cloister
Christ on the Cross adored by Saint Dominic.
Dimensions: 340×155 cm. Plate 66

Described by Vasari (ii, p. 508): 'Fece poi nel primo chiostro, sopra certi mezzi tondi, molte figure a fresco bellissime, ed un Crucifisso con san Domenico a'piedi, molto lodato.' This formerly much repainted fresco, which confronts the visitor as he enters the cloister of the convent, was designed and executed by Angelico. Its visual effect was greatly impaired by a marble border of irregular shape added in 1628 (Paatz, iii, p. 32), after the cloister walls had been decorated by Poccetti and other artists. A weak variant of the composition in the upper corridor is framed in a painted rectangle. The background, the haloes and the black habit of St. Dominic were described in the first edition of this book as extensively retouched, but have since been cleaned. The fresco is certainly later in date than the *Crucifixion* in the Sala del Capitolo, and must therefore date from after 1442.

Saint Dominic.

The fresco occupies the lunette above the entrance to the Sala del Capitolo on the north side of the cloister. The surface is much abraded, but the placing of the figure on its ground leaves little doubt that it was executed by Angelico. This and the remaining lunettes in the cloister have been restored since the issue of the first edition of this book.

Saint Peter Martyr enjoining Silence. Plate 69

The fresco occupies the lunette above the entrance to the sacristy on the west wall of the cloister. The figure, though abraded, is less gravely damaged than the *St. Dominic*, and was certainly executed by Angelico. This is confirmed by the sinopia revealed when the fresco was removed from the wall. A notable feature is the illusionistic frame, covered with foliated decoration and penetrated at three points by pierced rectangles, which are already present in the sinopia.

Saint Thomas Aquinas. Plate 68

The fresco occupies the lunette above a door to the right of the entrance on the south wall of the cloister. Like the *St. Peter Martyr*, to which its condition approximates, the figure was certainly painted by Angelico.

FRESCOES AT SAN MARCO: ANALYSIS OF ATTRIBUTIONS

	Subject	Berenson (1963)	Douglas	Schottmüller	Venturi	Van Marle	Muratoff	Bazin	Salmi (1958)
Ground Floor Cloister:	CHRIST ON CROSS	A.	A.	A.	A.	A.	A.	A.	A.
	ST. DOMINIC	A.	A.	A.	—	A.	A. (?)	—	A.
	ST. PETER MARTYR	A.	A.	A.	—	A.	A. (?)	—	A.
	ST. THOMAS AQUINAS	A.	A.	A.	—	A. (r.)	A. (?)	—	A.
	PIETA	A.	A.	A.	—	A.	A. (?)	—	A.
	CHRIST AS PILGRIM	A.	A.	A.	—	A. (r.)	A. (?)	—	A.
Sala del Capitolo:	CRUCIFIXION	A.	A.	A.	A.	A.	A. (p.)	A. (Ass. Master of *Nativity*)	A.
Upper Floor Corridor:	CHRIST ON CROSS	A.	A.	Ass. (cartoon by A.)	—	A. (r.)	A. (r.)	A. (p.)	—
	ANNUNCIATION	A.	A.	A.	A.	A.	Ass.	Master of *Annunciation* A. (p.)	A.
	VIRGIN AND CHILD WITH SAINTS	A.	A.	A. (p.)	A.	A. (p.)	A.	(Ass. Master of *Annunciation*)	A.
Cell No. 1.	NOLI ME TANGERE	A.	A.	A.	—	Ass.	Ass.	Master of *Annunciation*	A.
2.	LAMENTATION	A.	A.	A. (p.)	Ass. No. 1	Ass. (?)	Ass.	Master of *Nativity*	A. assisted
3.	ANNUNCIATION	A.	A.	A.	A.	A.	A.	A.	A.
4.	CHRIST ON CROSS	A.	A. (r.)	Ass.	—	Ass.	Ass.	—	A. assisted
5.	NATIVITY	A.	A.	Ass.	Ass. No. 1	Ass.	Ass.	Master of *Nativity*	A. assisted
6.	TRANSFIGURATION	A.	A.	A.	A.	A.	A.	A.	A.
7.	MOCKING OF CHRIST	A.	A.	A.	Ass. No. 1	A. (?)	A.	A.	A.
8.	MARIES AT SEPULCHRE	A.	A.	A. (g.p.)	—	Ass.	Ass.	Masters of *Nativity* and *Annunciation*	A. assisted (Strozzi?)
9.	CORONATION	A.	A.	A.	A.	A. (p.)	A.	A.	A.
10.	PRESENTATION	A.	A.	A. (?r.)	—	A. (r.)	A. (r.)	A.	A. assisted
11.	VIRGIN AND CHILD	A.	Ass.	Ass.	—	Ass.	Ass.	Master of *Nativity*	A. assisted
15–23.	CHRIST ON CROSS	A. (r.)	—	—	—	—	—	—	—
24.	BAPTISM OF CHRIST	A.	Ass. (cartoon by A.)	Ass.	Ass. No. 2	Ass.	Ass.	—	A. assisted
25.	CHRIST ON CROSS	A.	Ass.	Ass.	Ass. No. 2	A. (p.)	Ass.	—	A. assisted
26.	MAN OF SORROWS	A.	Ass. (cartoon by A.)	Ass.	Ass. No. 2	A. (p.)	Ass.	—	A. assisted
27.	FLAGELLATION	—	Ass.	—	—	Ass.	Ass.	—	—
28.	CHRIST CARRYING CROSS	A.	Ass. (cartoon by A.)	—	—	A.	Ass.	—	Umbrian assistant of A.
31.	CHRIST IN LIMBO	A.	A. (g.p.)	? Strozzi	—	Ass.	Ass.	—	A. and Strozzi
32.	SERMON ON MOUNT	A.	A. (g.p.)	? Strozzi	—	A. (g.p.)	Ass.	—	A., Strozzi and Gozzoli
33.	ARREST OF CHRIST	A.	A. (g.p.)	? Strozzi	—	Ass.	Ass.	—	A. assisted
33A.	TEMPTATION	A.	A. (g.p.)	? Strozzi	—	Ass.	Ass.	—	A. and Strozzi
34.	AGONY IN GARDEN	A.	A. (g.p.)	? Strozzi	A.	A.	Ass.	Master of *Nativity*	A., Strozzi and Gozzoli
35.	INSTITUTION OF EUCHARIST	A.	A. (g.p.)	? Strozzi	—	Ass.	Ass.	Master of *Nativity*	A., Strozzi and Gozzoli
36.	CHRIST NAILED TO CROSS	A.	A. (g.p.)	A.	—	A.	Ass.	—	A., Strozzi and Gozzoli
37.	CRUCIFIXION	A.	A.	Ass.	—	A.	Ass.	—	A. assisted
38.	CHRIST ON CROSS	—	—	—	Gozzoli	—	—	—	A. assisted
39.	ADORATION OF MAGI	A.	A. (g.p.)	A. (r.)	—	A. (?)	A. (p., r.)	—	A. assisted
42.	CHRIST ON CROSS	A.	—	—	—	A. (p.)	Ass.	—	—
43.	CHRIST ON CROSS	A.	—	—	—	—	—	—	—

Abbreviations: A. Fra Angelico Ass. Assistant of Fra Angelico (p.) in part (g.p.) in greater part (r.) restored

PLAN OF THE CONVENT OF SAN MARCO
UPPER FLOOR

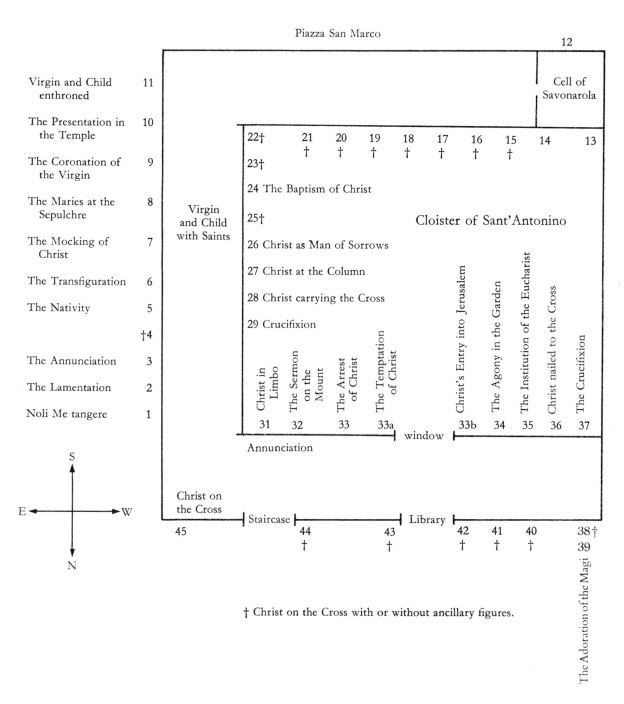

Piazza San Marco

12

Virgin and Child enthroned — 11

Cell of Savonarola

The Presentation in the Temple — 10

22† 21 20 19 18 17 16 15 14 13
 † † † † † † †

The Coronation of the Virgin — 9

23†

The Maries at the Sepulchre — 8

24 The Baptism of Christ

Virgin and Child with Saints

25†

Cloister of Sant'Antonino

The Mocking of Christ — 7

26 Christ as Man of Sorrows

The Transfiguration — 6

27 Christ at the Column

The Nativity — 5

28 Christ carrying the Cross

†4

29 Crucifixion

The Annunciation — 3

The Lamentation — 2

Noli Me tangere — 1

Christ in Limbo — 31
The Sermon on the Mount — 32
The Arrest of Christ — 33
The Temptation of Christ — 33a
Christ's Entry into Jerusalem — 33b
The Agony in the Garden — 34
The Institution of the Eucharist — 35
Christ nailed to the Cross — 36
The Crucifixion — 37

window

Annunciation

S ↑
E ←→ W
N ↓

Christ on the Cross

Staircase | Library

45 44 43 42 41 40 38†
 † † † † † 39

The Adoration of the Magi

† Christ on the Cross with or without ancillary figures.

PLAN OF THE CELLS IN THE CONVENT OF SAN MARCO

Pieta.

Plate 67

The fresco occupies the lunette above the entrance to the antechamber of the refectory. Despite surface damage, this noble figure, with its bold triangular design, is one of the finest of the cloister lunettes.

Christ as Pilgrim received by two Dominicans.

Plate 70

The fresco occupies the lunette above the entrance to the hospice on the south side of the cloister. Though much damaged, the lunette, like the *Pieta*, was executed by Angelico. Beissel (p. 22) interprets the scene as an injunction to the friars that they should welcome guests with the same solicitude with which the pilgrims at Emmaus welcomed Christ. It is suggested by Orlandi (p. 77) that the subject of the fresco was selected by St. Antoninus, whose *Trialogus super Evangelio de duobus discipulis euntibus in Emmaus* was prepared about this time.

Sala del Capitolo.

The Crucifixion with attendant Saints.

Plates 72–5

Dimensions: 550 × 950 cm.

The *Crucifixion* occupies the north wall of the chapter house. The only fresco at San Marco which is approximately datable, it can be assigned to the months between August 22, 1441 (when the Sala del Capitolo was still unfinished, and the conventual chapter was held elsewhere) and August 1442, when the room was ready for use. It is described by Vasari (ii, pp. 507–8): 'Fu questo Padre per i meriti suoi in modo amato da Cosimo de' Medici, che avendo egli fatto murare la chiesa e convento di San Marco, gli fece dipingere in una faccia del capitolo tutta la passione di Gesù Cristo; e dall'un de' lati tutti i Santi che sono stati capi e fondatori di religioni, mesti e piangenti a piè della croce; e dall'altro un San Marco Evangelista intorno alla Madre del figliuol di Dio venutasi meno nel vedere il Salvatore del mondo crucifisso; intorno alla quale sono le Marie che tutte dolenti la sostengono, e i Santi Cosimo e Damiano. Dicesi che nella figura di San Cosimo, Fra Giovanni retrasse di naturale Nanni d'antonio di Banco, scultore ed amico suo. Di sotto a questa opera fece, in un fregio sopra la spalliera, un albero che ha San Domencio a' piedi; ed in certi tondi che circondano i rami, tutti i papi, cardinali, vescovi, santi e maestri di teologia, che aveva avuto insino allora la religione sua de' Frati Predicatori. Nella quale opera, aiutandolo i Frati con mandare per essi in diversi luoghi, fece molti ritratti di naturale, che furono questi: San Domenico in mezzo, che tiene i rami dell'albero; papa Innocenzio V francese; il beato Ugone, primo cardinale di quell'ordine; il beato Paulo fiorentino, patriarca; Sant'Antonino, arcivescovo fiorentino; il beato Giordano tedesco, secondo generale di quell'ordine; il beato Niccolò; il beato Remigio fiorentino; Boninsegno fiorentino, martire; a tutti questi sono a man destra; a sinistra poi Benedetto XI, trivisano; Giandomenico, cardinale fiorentino; Pietro da Palude, patriarca ierosolimitano; Alberto Magno, tedesco; il beato Raimondo di Catalogna, terzo generale dell'ordine; il beato Chiaro fiorentino, provinciale romano; san Vincenzio di Valenza, e il beato Bernardo fiorentino; le quali tutte teste sono veramente graziose e molto belle.' There is no reason to doubt Vasari's assurance that many of the heads of Dominicans beneath the main scene derive from portrait types, like those of Tommaso da Modena preserved in the Sala Capitolare of San Niccolò at Treviso. In the border of the fresco are eleven medallions, that in the centre above containing the pelican with the inscription: SIMILIS FACTVS SVM PELLICANO SOLITVDINIS. The remaining ten medallions show (*left to right*) an unidentified figure with the inscription: DEVS NATVRE PATITVR; Daniel with the inscription: POST EDOMADES VII ET LXII OCCIDET(VR) CHR(ISTV)S; Zacharias with the inscription: HIS PLAGATVS SVM; Jacob with the inscription: AD PRAEDAM DESCENDISTI FILI MI DORMIENS ACCVBVISTI VT LEO; David with the inscription: IN SITI MEA POTAVERVT ME ACETO; Isaiah with the inscription: VERE LANGORES NOSTROS IPSE TVLIT ET DOLORES MEOS; Jeremiah with the inscription: O VOS OMNES QVI TRANSITE PER VIAM ATTENDITE ET VIDETE SI EST DOLOR SICVT DOLOR MEVS; Ezekiel with the inscription: EXALTAVI LIGNVM H(VM)ILE; Job with the inscription; QVIS DET DE CARNIBVS EIVS VT SATVREMVR; and the Erythrean Sibyl with the inscription: MORTE MORIETVR TRIBVS DIEBVS SOMNO SVBSCEPTO TRINO AB INFERIS REGRESSVS AD LVCEM VENIET PRIMVS. These texts are important for an understanding of the fresco, which shows in the centre the Crucifixion, with the Virgin, the two Maries and St. John, and to left and right Saints participating in the mystical sufferings of Christ. On the left are St. John Baptist, the patron of Florence, St. Mark, the titular saint of the convent, and Saints Lawrence, Cosmas and Damian, the patrons of the Medici. On the right are the founders of religious orders (*kneeling, left to right*) Saints Dominic, Jerome, Francis, Bernard, Giovanni Gualberto and Peter Martyr, and (*standing, left to right*) Saints Ambrose, Augustine, Benedict, Romuald and Thomas Aquinas. Some measure of studio intervention must be presumed in the sometimes flaccid execution of the figures (though not of the heads) of the Saints beneath the Cross, but old photographs suggest that many of the figures have been reworked and that their expressiveness has been impaired. The often illustrated head of St. Thomas Aquinas is, for example, so heavily retouched as to date in effect from the late nineteenth century. The figure of the good thief is perhaps by Gozzoli. The hand responsible for the half-length prophets in the medallions round the fresco recurs in the *Adoration of the Magi* in Cell 39 (q.v.). The red ground of the fresco is regarded by Douglas (pp. 99–100) and Muratoff (p. 54) as evidence that the fresco was left incomplete. Current restoration (1972) has shown that the red ground is in large part repainted to the colour of the priming for the original blue ground, part of which has been

205

recovered under red overpainting. The disappearance of the blue background is (as Marchese, i, p. 255 remarks) accountable for the silhouette-like character of the figures in the frontal plane.

Refectory.

Christ on the Cross with the Virgin and Saint John.

A fresco of this subject described in the chronicle of the convent of San Marco (*Annal. Sancti Marci*, f. 6 t.) is assumed by Marchese (i, pp. 257–8) to have been destroyed in 1534 in favour of Sogliani's fresco of *Saint Dominic and his Brethren fed by Angels*, now in the refectory.

Upper Corridor.

Christ on the Cross adored by Saint Dominic.
Dimensions: 237 × 125 cm.

The fresco, situated at the end of the corridor, is a weak variant of the fresco of the same subject in the cloister beneath. Under it is the inscription: SALVE MVNDI SALVTARE. SALVE SALVE IESV CHARE. CRVCI TVAE ME APTARE. VELLEM VERE TV SCIS QVARE. PRESTA MIHI COPIAM. The full text of this hymn appears in Migne (*Patr. Lat.*, clxxxiv, 1319).

The Annunciation. Plates 91, 94, 95
Dimensions: 216 × 321 cm.

Situated on the inner wall of the corridor facing the staircase. Beneath the fresco is the painted inscription: VIRGINIS INTACTE CVM VENERIS ANTE FIGVRAM PRETEREVNDO CAVE NE SILEATVR AVE. Above this is an incised inscription of uncertain date: SALVE MATER PIETATIS ET TOTIVS TRINITATIS NOBILE TRICLINIVM. In composition the fresco is more closely related to the *Annunciation* at Madrid than to the other *Annunciation* altarpieces. The design (one of the richest and most satisfying in Angelico's work) and the greater part of the execution are by the master, and the discrepancies between this fresco and the fresco of the same subject in Cell 3 are a matter of date and not of quality (see below). The two types of capital shown in the loggia derive from capitals employed by Michelozzo in the cloisters of the Annunziata and of San Marco.

The Virgin and Child enthroned with eight Saints.
Dimensions: 205 × 276 cm. Plates 90, 92, 93

The fresco, situated on the inner wall of the east corridor, shows (*left*) Saints Dominic, Cosmas, Damian and Mark, and (*right*) John the Evangelist, Thomas Aquinas, Lawrence and Peter Martyr. The composition is consistent with that of the

Bosco ai Frati altarpiece, and the fresco (along with the *Annunciation*) is likely to have been executed after Angelico's return from Rome. The extent of studio intervention has been exaggerated.

Cells.

1. Noli Me Tangere. Plates 77–8
Dimensions: 177 × 139 cm.

Assigned to an assistant of Angelico by Van Marle (x, p. 77) and Muratoff (p. 57), and by Bazin to the so-called Master of the *Annunciation*. There is no reason to doubt that the cartoon of this fresco is by Angelico, and that the two figures are wholly by his hand. Noteworthy is the practice of silhouetting the two heads, one against a rock, the other against a wooden fence, and the colour, which has the luminosity typical of the autograph frescoes.

2. The Lamentation. Fig. 28
Dimensions: 104 × 162 cm.

The group of four kneeling figures surrounding the dead Christ was perhaps adapted in reverse from the corresponding group in the Croce al Tempio *Lamentation* in the Museo di San Marco. Neither the cartoon of the fresco nor its execution is by Angelico. The artist responsible for painting it is characterised by thin types with pointed noses and furrows between the eyes, flat forms and constricted drapery. Throughout the present book this hand is denominated the Master of Cell 2.

3. The Annunciation. Plates 76, 79
Dimensions: 187 × 157 cm.

Wholly by Angelico.

4. Christ on the Cross with Saint John the Evangelist, the Virgin, and Saints Dominic and Jerome.
Dimensions: 189 × 157 cm.

Design and execution are by the Master of Cell 2. The Christ on the Cross depends from the corresponding figure in the fresco in the cloister beneath.

5. The Nativity. Fig. 29
Dimensions: 189 × 150 cm.

Executed by the Master of Cell 2. The design is, however, more coherent than that of the frescoes in Cells 2 and 4, and it is possible that the figures of the Virgin, St. Joseph and the Child, and the rectangular stable depend from a drawing by Angelico.

6. The Transfiguration. Plates 86–9
Dimensions: 189 × 159 cm.

This splendid scheme was designed and executed by Angelico. Marchese (1853, p. 39) reports the foreground figures as much damaged.

7. The Mocking of Christ. Plates 80–1
Dimensions: 195 × 159 cm.

The composition, and the execution of the figure of Christ and of the head to his left, are due to Angelico. The seated figures of the Virgin and of St. Dominic in the foreground were perhaps executed by the Master of Cell 2 after the master's cartoon. There is a strip of repaint round three sides of the fresco, and a large made-up area above; the fresco may originally have been rectangular.

8. The Maries at the Sepulchre. Fig. 30
Dimensions: 182 × 155 cm.

Designed and executed by the Master of Cell 2. The figure of the angel and of the Virgin peering down into the tomb probably depend from drawings by Angelico, who may also have been responsible for the execution of the angel's head. The Christ is restored. There is much local retouching in the background and elsewhere.

9. The Coronation of the Virgin. Plates 84–5
Dimensions: 189 × 159 cm.

Designed and executed by Angelico. Below are the kneeling figures of (*left to right*) Saints Thomas Aquinas, Benedict, Dominic, Francis, Peter Martyr and (?) Mark. A variant of the two main figures is found on one of two circular panels with *Christ on the Cross between the Virgin and Saint John Evangelist* and *The Coronation of the Virgin* (diameter: 19 cm.) in the Museo di San Marco, painted in the workshop of Angelico. These panels were at one time in the Cappella di Santa Lucia in the SS. Annunziata, and seem originally to have come from Santa Maria della Croce al Tempio (Paatz, i, pp. 135, 196).

10. The Presentation in the Temple. Plates 82–3
Dimensions: 151 × 131 cm.

The central figures seem to have been executed by Angelico. The subsidiary figures of Saint Peter Martyr and the Beata Villana were repainted before the middle of the nineteenth century (Marchese, 1853, p. 36). The fresco was originally rectangular.

11. The Virgin and Child enthroned with Saints Zenobius and Thomas Aquinas.
Dimensions: 189 × 159 cm.

Designed and executed by the Master of Cell 2. The spatial scheme depends from that of *The Mocking of Christ*. Old photographs show that this fresco was extensively damaged and has been heavily retouched. The fresco was perhaps originally rectangular.

15–22. These cells contain frescoes of *Christ on the Cross*, most of which appear to be the work of a single hand, perhaps that responsible for the execution of the *Christ on the Cross adored by Saint Dominic* in the corridor. The level of execution is below that of the frescoes associable with the Master of Cell 2, and in no case can the compositions be ascribed to Angelico. The somewhat superior fresco in Cell 22 is given by A. Padoa Rizzo (*Benozzo Gozzoli Pittore Fiorentino*, 1972, p. 101) to Gozzoli.

23. Christ on the Cross with the Virgin and Saint Peter Martyr.

Designed and executed by the Master of Cell 2.

24. The Baptism of Christ. Fig. 31
Dimensions: 187 × 156 cm.

The scene differs in style from the preceding frescoes, but probably represents a later phase in the evolution of the Master of Cell 2. This and the following frescoes are less closely related to Angelico than the frescoes on the opposite side of the corridor.

25. Christ on the Cross with the Virgin, Saint Mary Magdalen and Saint Dominic.
Dimensions: 189 × 145 cm.

This scene is by the same hand as the preceding fresco. The confused design and uncertain space relationships militate against the view of Salmi (1958) that the fresco was planned and in part executed by Angelico.

26. Christ as Man of Sorrows with the Virgin and Saint Thomas Aquinas.

By the same hand as the fresco in Cell 24. The blindfold head of Christ in the upper right corner of the fresco and the seated Virgin in the left foreground are loosely dependent on *The Mocking of Christ* in Cell 7.

27. Christ at the Column with the Virgin and Saint Dominic.

Probably by the same hand as the fresco in Cell 24.

28. Christ carrying the Cross with the Virgin and Saint Dominic.
Fig. 32
Dimensions: 158 × 140 cm.

Probably by the same hand as the fresco in Cell 24. The fresco is tentatively regarded by Salmi (1958) as an early work by Bonfigli.

29. The Crucifixion.

This fresco is rightly regarded by A. Padoa ('Benozzo ante 1450', in *Commentari*, xx, 1969, pp. 52–62) as a work by Benozzo Gozzoli of ca. 1442–4.

31 Christ in Limbo.
Fig. 33
Dimensions: 195 × 177 cm.

The fresco is by a new hand, which was responsible for decorating the following five cells. In each case the composition is more elaborate than those of the preceding frescoes, with a tendency towards circular construction and a cursive handling of the drapery which are reminiscent of miniature illumination. None of the scenes was designed by Angelico. The artist responsible for these frescoes is tentatively identified by D'Ancona (pp. 92–4) and Van Marle (x, pp. 88–9) with the miniaturist Zanobi Strozzi, and with the artist responsible for the concluding panels of the Annunziata silver chest (see pp. 216–18). In the few cases where direct comparison is possible, and particularly in the two scenes of *Christ in Limbo*, the version on panel is more closely related to Angelico than the version in fresco, and in no case can the two works be by a single hand. In the present volume the author of the frescoes is denominated the Master of Cell 31. The identification of this artist with Zanobi Strozzi is doubtful.

32. The Sermon on the Mount.
Fig. 34
Dimensions: 193 × 200 cm.

Designed and executed by the Master of Cell 31.

33. The Arrest of Christ.
Dimensions: 189 × 188 cm.

Designed and executed by the Master of Cell 31.

34. The Agony in the Garden.
Dimensions: 189 × 157 cm.

Designed and executed by the Master of Cell 31. As noted by Beissel (p. 36), the watching figures of the Virgin and Martha (an unusual feature in the iconography of this scene) are contrasted with the sleeping apostles opposite. The figures of the two women are given by Salmi (1950, p. 154) to Gozzoli.

35. The Institution of the Eucharist.
Dimensions: 196 × 244 cm.

Designed and executed by the Master of Cell 31. The illusionistic treatment of the windows, with their fictive view across the cloister of the convent, is a notable feature of the composition. This rare scene is also included in the cycle of panels on the silver chest, where it replaces the more usual *Last Supper*, and is accompanied by the words (*John*, vi, 54): QVI MANDVCAT MEAM CARNEM ET BIBIT MEVM SANGVINEM HABET VITAM AETERNAM. An altarpiece of the same subject, painted by Justus of Ghent in 1473 for the Compagnia di Corpus Domini at Urbino, is in the Galleria Nazionale delle Marche at Urbino.

36. Christ nailed to the Cross.
Fig. 35
Dimensions: 181 × 144 cm.

Designed and executed by an assistant. The hand responsible for this fresco is more closely connected with Angelico than the Master of Cell 31, and stands in the same relation to the master as the Master of Cell 2, from whom he is distinguished by thick-set figures and heavier forms. This artist, denominated in this volume the Master of Cell 36, is identical with one of the assistants employed by Angelico on the frescoes in the Vatican. Salmi (1950, p. 154) detects the intervention of Gozzoli. From the mouth of Christ run the words: PR DIMICTE ILLIS QVIA NES (CIVNT QVID FACIVNT). Beissel (p. 40) refers the unusual iconography of this scene to a passage in the *Vitae Christi* of St. Bonaventure (c. 78, in *Opera S. Bonventurae*, Lugdini, vi, 1668, p. 388), from which details of the representation (including the three ladders supporting Christ and the executioners) are drawn.

37. The Crucifixion with Saint John the Evangelist, the Virgin, and Saints Dominic and (?) Thomas Aquinas.
Dimensions: 290 × 179 cm.

Designed and executed by the Master of Cell 36. The representation of the bad thief depends from that in the *Crucifixion* in the Sala del Capitolo.

38. Christ on the Cross with the Virgin and Saints John the Evangelist, Cosmas and Peter Martyr.

Like the frescoes in Cells 40, 41 and 44, this scene, with the *Pieta* beneath, has escaped a direct ascription to Angelico. It is regarded by Venturi (pp. 70–2) as an early work of Gozzoli. The hand recurs in the damaged *Adoration of the Magi* in Cell 39.

39. The Adoration of the Magi. Plate 71
Dimensions: 180 × 360 cm.

Probably designed by Angelico. The fresco was restored in the middle of the nineteenth century by Professor Antonio Marini, and no verdict is now possible as to the part played by Angelico in its execution. The forms on the left side in particular have been materially changed. In style it is most closely connected with the *Crucifixion* in the Sala del Capitolo, and at least on the right reveals the intervention of Benozzo Gozzoli. The fresco has been assigned to the years 1439 (on account of the presence of oriental costumes, presumed to have been inspired by the Council held in Florence in this year), 1441 (for no evident reason) and 1442–3 (in preparation for or in commemoration of the occupation of the cell by Pope Eugenius IV at the time of the consecration of San Marco). The cell was occupied by Cosimo de' Medici (for whom it was constructed). Paatz (iii, p. 74) relates the subject to the Compagnia dei tre Magi, which was directed from San Marco and with which the Medici were associated.

40, 41, 44. Christ on the Cross.

These works are of low quality, and have never received a direct ascription to Angelico.

42. Christ on the Cross with (?) Saint Mark, Longinus, Saint Dominic, the Virgin and Saint Mary Magdalen.
Dimensions: 208 × 205 cm.

Designed and executed by the Master of Cell 36.

43. Christ on the Cross with the Virgin and Saints John the Evangelist, Mary Magdalen and Dominic.

Designed and executed by the Master of Cell 36. The fresco was originally painted on an external wall of the corridor, and later enclosed in a cell.

In so far as condition is concerned, it must be noted that in a number of cases the shape or size of the cell frescoes has been modified. Thus in *The Mocking of Christ* in Cell 7 there are additions to right and left and the upper part of the fresco

(which must originally have been rectangular) has been made up. The fictive frames of the frescoes seem in practically every case to be of comparatively recent date. In the aggregate these changes and the addition of areas of modern paint serve to weaken the impact of the frescoes.

There is no firm evidence for the date at which the frescoes were begun. A bull giving the Silvestrine convent of San Marco Nuovo to the Dominicans was promulgated in January 1436, and shortly thereafter the community took possession of the premises. According to the generally reliable analysis of Orlandi (pp. 66–84), based on the *Cronaca di San Marco*, the friars lived for almost two years in the derelict convent before repairs were undertaken or rebuilding was begun. The rebuilding of the church and convent was initiated by Michelozzo (on the commission of Cosimo and Lorenzo de' Medici, who had been instrumental in securing the premises for the Dominicans) in 1438, and not, as implied by Vasari, in the preceding year. The *cappella maggiore* of the church was completed in 1439, and the church was dedicated at Epiphany 1443. The *dormitorio di mezzo* (that is Cells 1–11 built over the old refectory) was in course of construction in 1438, and was followed by the *dormitorio settentrionale* (that is the cells in the area of the Library) and the *dormitorio del Noviziato* (that is the cells towards the Piazza San Marco). The chronicle of Fra Giuliano Lapaccini, cited by Marchese (i, p. 77), confirms that forty-four cells were completed by 1443. These dates throw little or no light on the chronology of the frescoes, and there is no way of establishing whether the frescoes in each group of cells were executed after the completion of the appropriate dormitory or after the completion of the whole upper floor. In the former case the frescoes in Cells 1–11 could date from as early as 1439, and in the latter case all the cell frescoes would date from after 1443. It is inferred by Salmi and Orlandi that the *Crucifixion* fresco in the chapter house was still unfinished on 22 August 1441, when the chapter met in the sacristy, but was probably completed by 25 August 1442. A *terminus ante quem* for those frescoes in the cells that were executed personally by Angelico is provided by the artist's departure for Rome in 1445.

The frescoes on the ground floor are wholly by Angelico and members of his studio. In style and handling the *Crucifixion* in the Sala del Capitolo is closely linked with the *Adoration of the Magi* in Cell 39. Both of these scenes were probably painted on the commission of Cosimo de' Medici. The scenes on the upper floor for which Angelico was directly responsible are limited to six cells on the outer side of one corridor and to two frescoes on the corridor walls. There is a marked discrepancy of style between these two groups of scenes, and it is very probable that the second of them (comprising the *Annunciation* and the *Virgin and Child with eight Saints*) was painted after Angelico's return from Rome in 1449. Of the frescoes in the cells the foreground figures in *The Transfiguration* most clearly anticipate the style of the upper cycle of frescoes in the Vatican. In work in these and the contiguous cells (1–11) Angelico was assisted by an artist, the Master of Cell 2, whose hand appears for the first time in the predella of the Cortona polyptych. The

hand of this painter is sometimes evident in frescoes substantially executed by Angelico, and is sometimes found in isolation. Though strongly influenced by Angelico, his role was not limited to reproducing the master's cartoons, and certain of his frescoes must be regarded as independent inventions within the framework of Angelico's style. There is no trace of the hand of this artist in the frescoes in the Vatican, and this lends support to the view that he may also have executed the frescoes in Cells 24–8 after 1445 when Angelico left Florence. The indebtedness of these scenes to Angelico is considerably less marked than in the frescoes in Cells 2, 4, 5, 8, 11 and 23. Four frescoes in cells to the right of the staircase (36, 37, 42 and 43) again reflect Angelico's style. Like the Master of Cell 2, the Master of Cell 36 must have been a member of Angelico's studio, and seems to have worked under the general guidance, but without the active intervention, of the master. It is possible that this artist was responsible for painting (from Angelico's cartoon) the drapery of certain figures in the *Crucifixion* in the Sala del Capitolo, and served as an assistant of Angelico in the *Scenes from the Life of Saint Stephen* in the Vatican. The third hand apparent in the frescoes in the cells, the Master of Cell 31, is less intimately related to Angelico. The frescoes in Cells 15–21, 40, 41 and 44 are of low quality; the hand or hands responsible for these frescoes presumably served in a subordinate capacity in Angelico's shop.

The Deposition from the Cross. Museo di San Marco, Florence. Plates 98–107; Figs. 19, 20
Panel: 176 × 185 cm.

Painted for Santa Trinita, Florence. The painting (which was set on a wall, not over an altar) is described in the Strozzi Chapel (Sacristy) of the church by Manetti (p. 166) and in the *Libro di Antonio Billi* (p. 18: 'Et nella sagrestia di Santa Trinita la tauola, doue e disposto Christo di croce') and by Vasari (ii, p. 513: 'e in Santa Trinita, una tavola della Sagrestia, dove è un Deporto di Croce, nella quale mise tanta diligenza, che si può fra le migliori cose che mai facesse annoverare'). The figure of Nicodemus is stated by Vasari (ii, p. 450) to be a portrait of the architect Michelozzo: 'Il suo ritratto è di mano di Fra Giovanni nella sagrestia di Santa Trinita, nella figura d'un Nicodemo vecchio con un cappuccio in capo, che scende Cristo di croce'. Crowe and Cavalcaselle (iv, p. 89) suggests that Michelozzo is represented not in the Nicodemus, but in the male figure with a black headdress to the left of the Cross (Plate 101), on the ground that this is more readily consistent with Michelozzo's age at the time when the altarpiece is presumed to have been executed.
Beneath the three sections of the principal scene are the inscriptions: (*left*) PLANGENT EVM QVASI VNIGENITVM QVIA INOCENS, (*centre*) ESTIMATVS SVM CVM DESCENDENTIBVS IN LACVM, and (*right*) ECCE QVOMODO MORITVR IVSTVS ET NEMO PERCIPIT CORDE. These passages come respectively from Zacharias, xii, 10; Psalm 87, 5; and Resp.

III, Noct. II, Sabb. Sanct. The iconography of the panel is discussed by Beissel (pp. 54–7). The three pinnacles of the altarpiece, representing the *Noli Me tangere*, *The Resurrection* and *The three Maries at the Sepulchre*, are by Lorenzo Monaco, and were therefore executed before 1424–5. The pilasters, which are painted on two sides, show, reading from top to bottom, figures of: (i) *outside left*, Saints John Baptist, Lawrence and Augustine; (ii) *inside left*, Saints Michael, Andrew and Francis; (iii) *inside right*, Saints Peter, Paul and Dominic, and (iv) *outside right*, Saints Stephen, Ambrose and Jerome. In addition each pilaster contains two medallions with heads of Saints and angels.
The altarpiece has been dated about 1425 (Van Marle, x, p. 53), on account of the three pinnacles by Lorenzo Monaco, about 1435 (Muratoff, pp. 48–9, and Schottmüller, p. xxii), between 1435 and 1440 (Perkins, *La Deposizione: Beato Angelico*, 1948, p. 4), and between 1441 and 1446 (Douglas, pp. 91–3). Salmi (1958, pp. 96–7) dates it ca. 1436. It is suggested by Orlandi (1964, pp. 45–53) that financial transactions between Palla Strozzi and the Dominicans at Fiesole recorded in the *Giornale e levate di messer Palla di Noferi Strozzi* in 1431–2 prove work on the painting to have been in progress in that year and that it was completed ca. 1434–5. This argument is not convincing. A dating about 1443, after the completion of the San Marco altarpiece, is probable. Douglas (loc. cit.) regards the pinnacles as accretions to the altarpiece. This view is incorrect, and the fact that Lorenzo Monaco was closely associated with Santa Trinita suggests that the altarpiece was left unfinished at his death in 1425, and was resumed by Fra Angelico at a later date.
The contrary case is stated by M. Cammerer-George (*Die Rahmung der Toskanischen Altarbilder im Trecento*, Strasbourg, 1966, pp. 187–8), who supposes that the painting was completed by Lorenzo Monaco for Palla Strozzi, that it was mutilated after the banishment of Palla Strozzi in 1434, perhaps on account of the presence of portraits of Strozzi and his sons, and that it was later (ca. 1440) painted afresh by Fra Angelico. Middeldorf (in *Rinascimento*, vi, 1955, pp. 171–4) identifies the kneeling figure in the foreground as the Beato Alessio degli Strozzi. The standing Beato with a red headdress is explained by Orlandi (loc. cit.) as a portrait of Palla Strozzi as the Beato Giovanni da Vespignano teaching his sons to accept the troubles that beset them in the spirit of the sufferings of Christ.
Some measure of studio intervention is presumed by Muratoff (loc. cit.), who attempts to connect it with an assistant supposedly employed on the predella of the San Marco altarpiece, by Bazin (p. 182), who ascribes the figures on the left to the author of the *Nativity* fresco in San Marco (Cell 5), and by Wurm (pp. 44–5), who limits Angelico's responsibility to the figure of Christ. The left side of the altarpiece (and particularly the figures of the kneeling women) is somewhat weaker than the centre and right, and was probably executed, under Angelico's supervision and from his cartoon, by the studio assistant responsible for the two Saints on the right of the Perugia altarpiece.

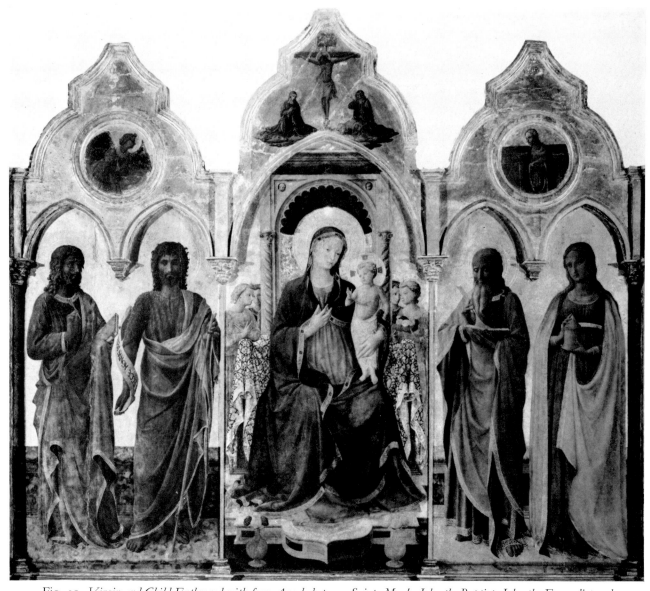

Fig. 21. *Virgin and Child Enthroned with four Angels between Saints Mark, John the Baptist, John the Evangelist and Mary Magdalen.* Museo Diocesano, Cortona

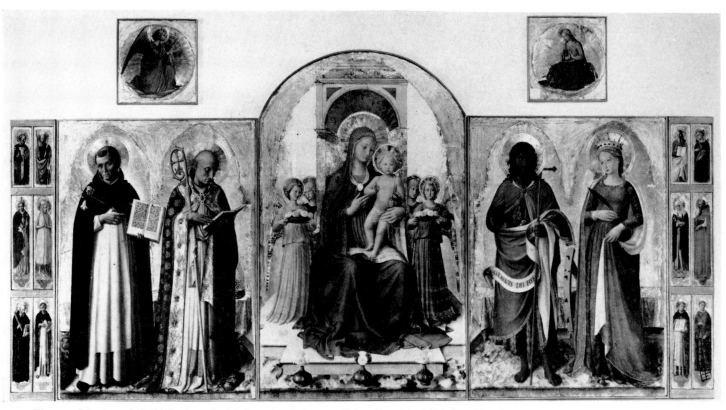

Fig. 22. *Virgin and Child Enthroned with four Angels between Saints Dominic, Nicholas, John the Baptist and Catherine of Alexandria.* Galleria Nazionale dell' Umbria, Perugia

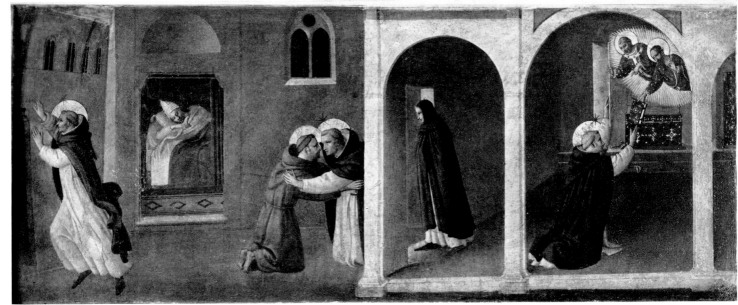

Fig. 23a. *The Dream of Pope Innocent III and The Meeting of Saints Dominic and Francis; Saints Peter and Paul appearing to Saint Dominic.*
Museo Diocesano, Cortona

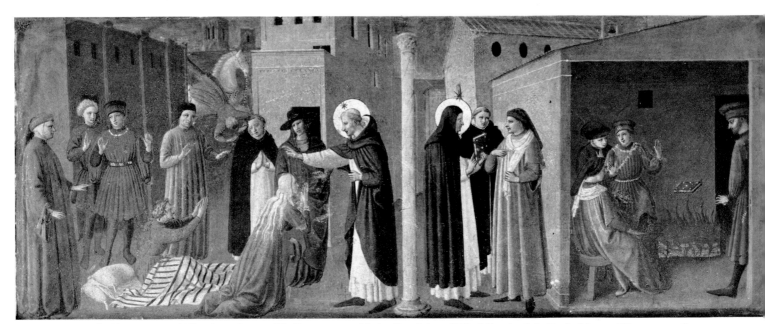

Fig. 23b. *The Raising of Napoleone Orsini; The Disputation of Saint Dominic and The Miracle of the Book.* Museo Diocesano, Cortona

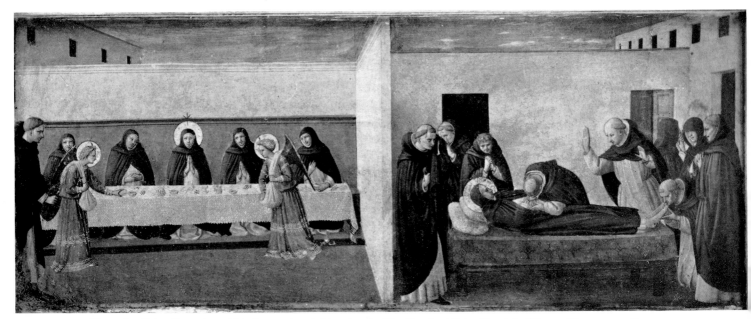

Fig. 23c. *Saint Dominic and his Companions fed by Angels; The Death of Saint Dominic.* Museo Diocesano, Cortona

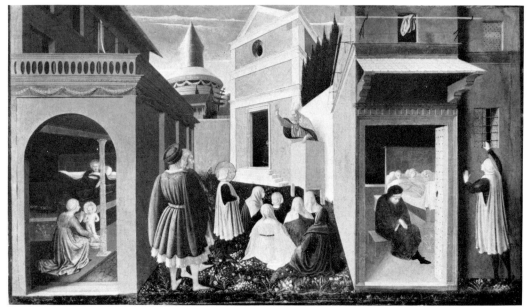

Fig. 24a. *The Birth of Saint Nicholas, The Vocation of Saint Nicholas, and Saint Nicholas and the three Maidens.* Pinacoteca Vaticana

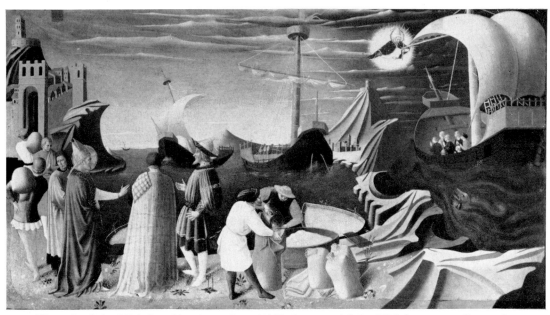

Fig. 24b. *Saint Nicholas addressing an Imperial Emissary, and Saint Nicholas saving a Ship at Sea.* Pinacoteca Vaticana

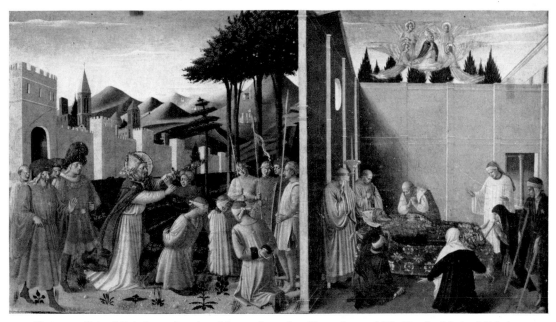

Fig. 24c. *Saint Nicholas saving three Men condemned to Execution, and The Death of Saint Nicholas.* Galleria Nazionale dell'Umbria, Perugia

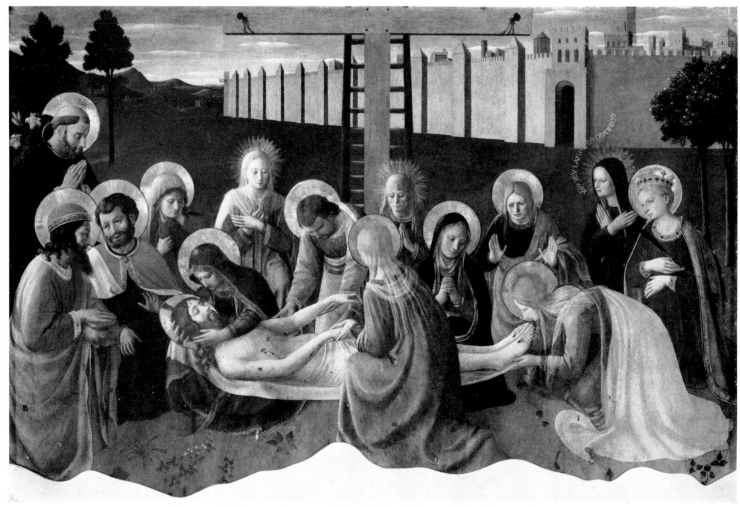

Fig. 25. *The Lamentation over the Dead Christ*. Museo di San Marco, Florence

Fig. 26. Niccolò di Tommaso: *The Lamentation over the Dead Christ*. Congregazione della Carità, Parma

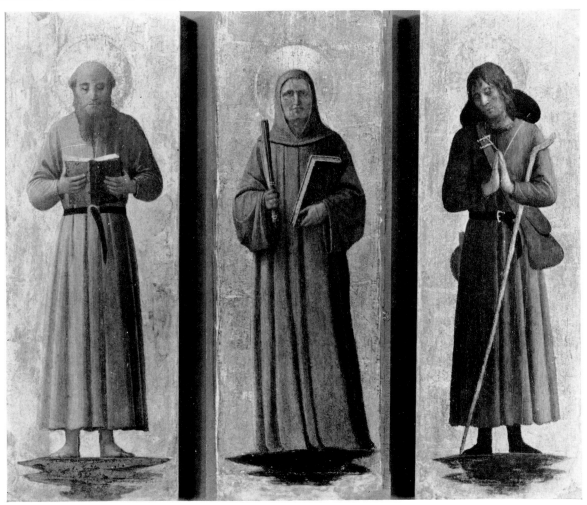

Fig. 27a. *Saints Jerome, Bernard and Roch*. Lindenau Museum, Altenburg

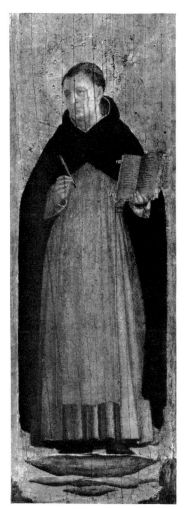

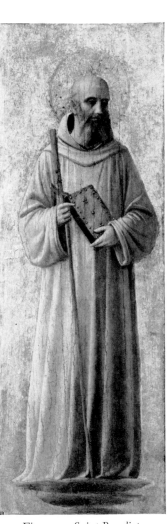

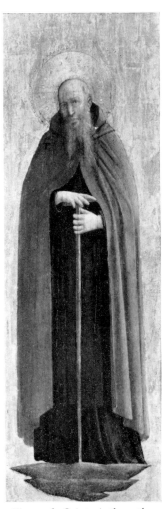

Fig. 27b. *Saint Thomas Aquinas*.
Private Collection

Fig. 27c. *Saint Benedict*.
Minneapolis Institute of Arts

Fig. 27d. *Saint Anthony the
Abbot*. Private Collection

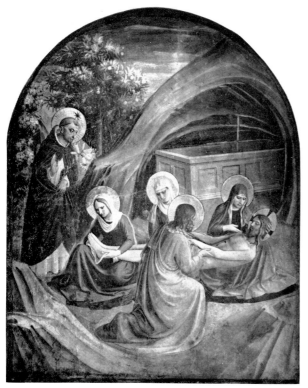

Fig. 28. Master of Cell 2: *The Lamentation over the Dead Christ*. San Marco, Florence (Cell 2)

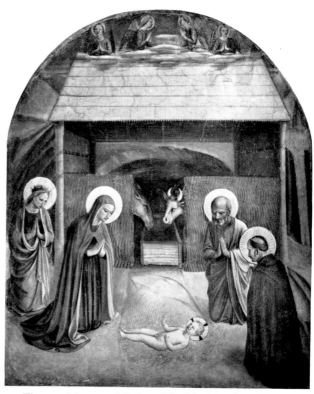

Fig. 29. Master of Cell 2: *The Nativity*. San Marco, Florence (Cell 5)

Fig. 30. Master of Cell 2: *The Maries at the Sepulchre*. San Marco, Florence (Cell 8)

Fig. 31. Master of Cell 2(?): *The Baptism of Christ*. San Marco, Florence (Cell 24)

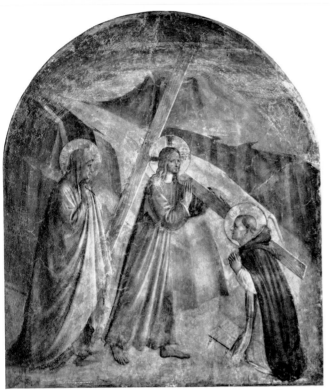

Fig. 32. Master of Cell 2(?): *Christ carrying the Cross*.
San Marco, Florence (Cell 28)

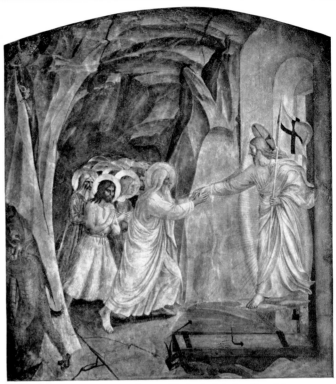

Fig. 33. Master of Cell 31: *Christ in Limbo*. San Marco,
Florence (Cell 31)

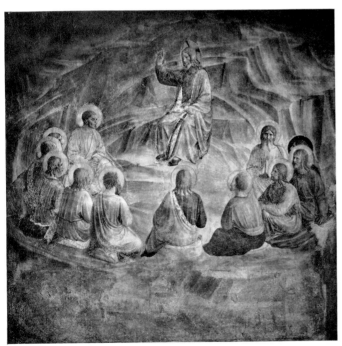

Fig. 34. Master of Cell 31: *The Sermon on the Mount*. San Marco,
Florence (Cell 32)

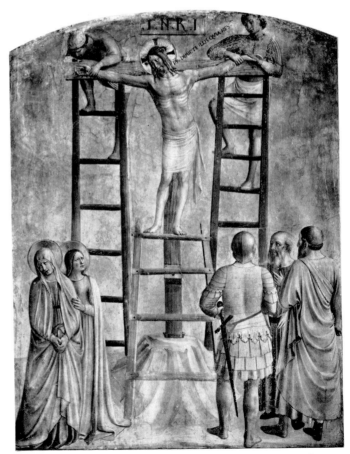

Fig. 35. Master of Cell 36: *Christ nailed to the Cross*. San Marco,
Florence (Cell 36)

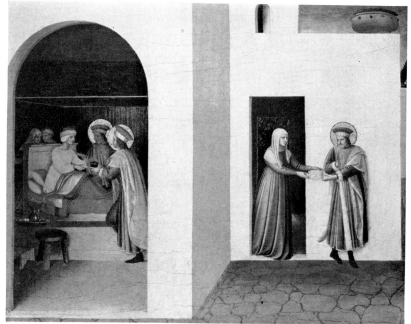

Fig. 36. *The Healing of Palladia by Saints Cosmas and Damian, and Saint Damian receiving a Gift from Palladia.* National Gallery of Art, Washington (Kress Collection)

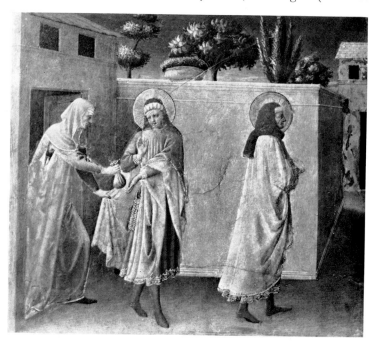

Fig. 37 a–b. Zanobi Strozzi: *Saint Damian receiving a Gift from Palladia;
The Attempted Martyrdom of Saints Cosmas and Damian by Drowning.*
Museo di San Marco, Florence

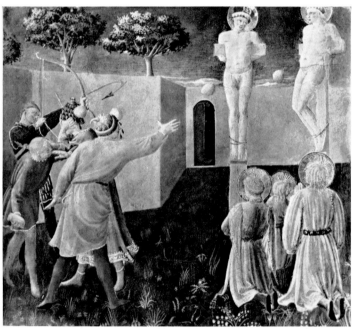

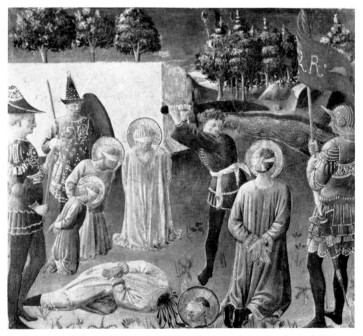

Fig. 37 c–e. Zanobi Strozzi: *The Attempted Martyrdom of Saints Cosmas and Damian by Fire; The Crucifixion of Saints Cosmas and Damian; The Decapitation of Saints Cosmas and Damian.* Museo di San Marco, Florence

Fig. 38. The Ceiling of the Chapel of Nicholas V, Vatican

Fig. 39. *Saint Bonaventure*. Chapel of Nicholas V, Vatican

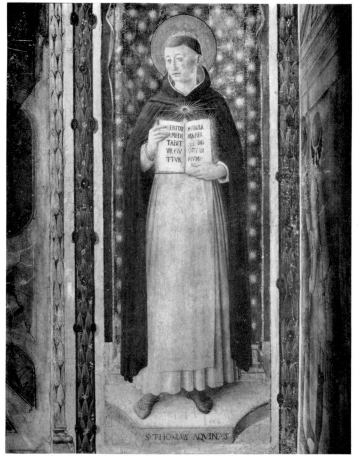

Fig. 40. *Saint Thomas Aquinas*. Chapel of Nicholas V, Vatican

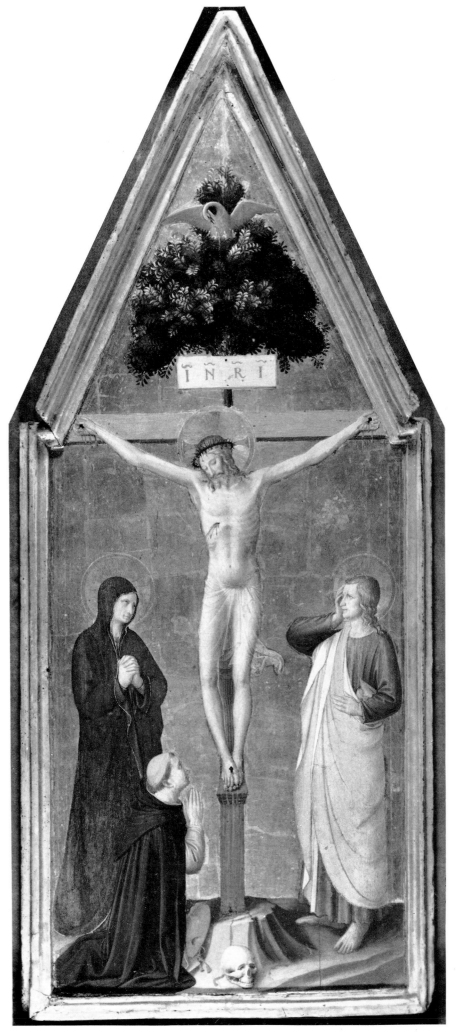

Fig. 41. *Christ on the Cross with the Virgin and Saint John the Evangelist adored by a Dominican Cardinal.* Fogg Museum of Art, Cambridge (Mass.)

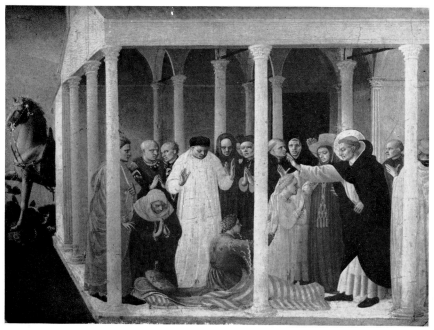

Fig. 42 a–c. *The Dream of Pope Innocent III; Saints Peter and Paul appearing to Saint Dominic; The Raising of Napoleone Orsini*. Louvre, Paris

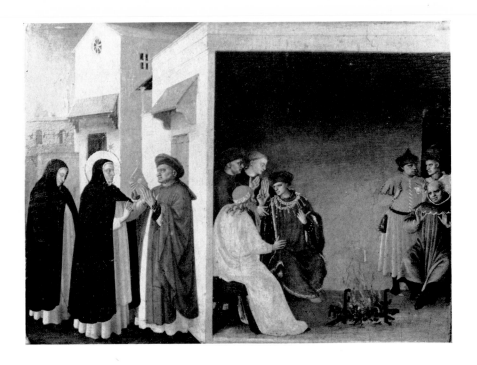

Fig. 42 d–f. *The Disputation of Saint Dominic and the Miracle of the Book;
Saint Dominic and his Companions fed by Angels; The Death of Saint Dominic.*
Louvre, Paris

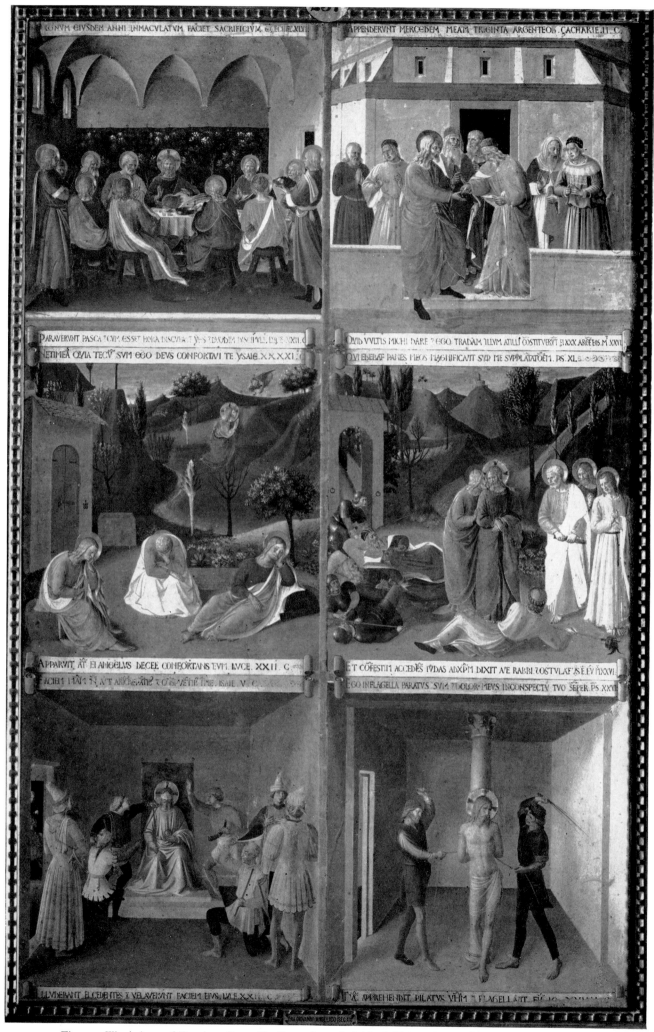

Fig. 43. Workshop of Fra Angelico: *Six Scenes from the Life of Christ*. Museo di San Marco, Florence

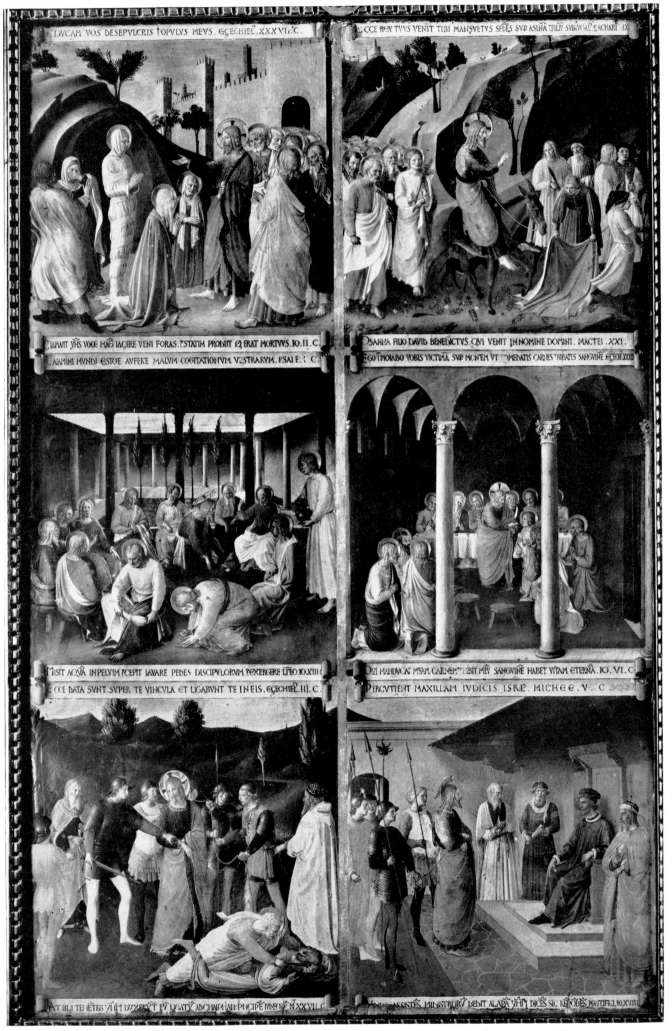

Fig. 44. Workshop of Fra Angelico: *Six Scenes from the Life of Christ*. Museo di San Marco, Florence

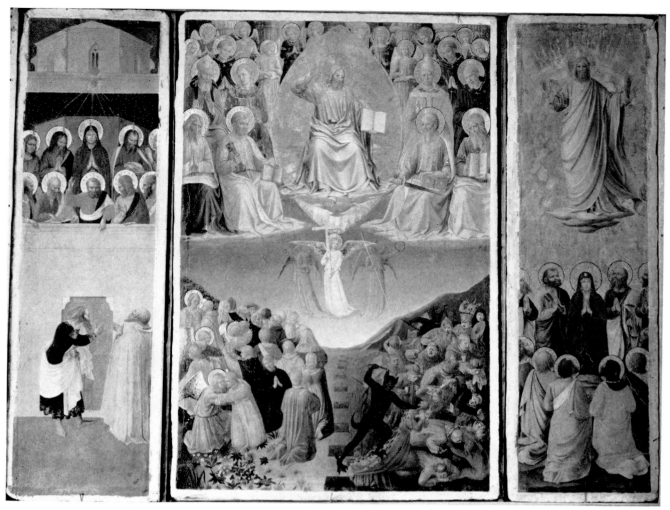

Fig. 45. *The Last Judgment, the Ascension and Pentecost.* Galleria Nazionale, Rome

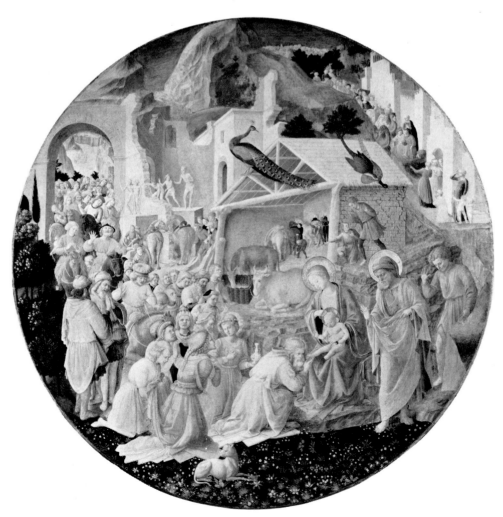

Fig. 46. Fra Angelico and Fra Filippo Lippi: *The Adoration of the Magi.*
National Gallery of Art, Washington (Kress Collection)

Throughout the panel there is much retouching of a local character, and the cloud forms appear in some cases to have been modified.

Three panels with scenes from the lives of SS. Onophrius and Nicholas in the Accademia in Florence are regarded by Pudelko (in *Burlington Magazine*, lxxiv, 1939, p. 78) as part of the original altarpiece by Lorenzo Monaco. There is no record of a predella painted by Fra Angelico.

The Virgin and Child enthroned with Saints Peter Martyr, Cosmas, Damian, John the Evangelist, Lawrence and Francis. Museo di San Marco, Florence.
Panel: 180 × 202 cm. Plates 96–7

From the Dominican convent of San Vincenzo d'Annalena, Florence. Removed after the suppression (1810). Transferred (1846) to the Accademia and subsequently to the Museo di San Marco. According to Paatz (*Die Kirchen von Florenz*, v, 1953, pp. 407–16), permission for the founding of the convent was given by Pope Nicholas V in 1450. Building was begun in 1453, and the erection of an oratory was authorised in 1455. If, therefore, the altarpiece was painted for the convent, it can scarcely have been commissioned before 1453. There is, however, general agreement with the view of Schottmüller that Angelico's altarpiece was painted before this time, perhaps on the commission of the Medici, to whose family the foundress of the convent, Annalena Malatesta, was closely linked. Crowe and Cavalcaselle (iv, 1911, p. 105 n.), followed by Van Marle (x, pp. 62–3), Muratoff (p. 45) and Jahn-Rusconi (Pl. 28), propose a dating in the fourteen-thirties. A dating in the mid-thirties is accepted by Baldini (in *Mostra*, pp. 38–9, No. 22) and Salmi (1958, pp. 104–5).

The problem of the dating of the altarpiece is in practice more complex than this analysis suggests. Three alternative solutions have been advanced: (i) that the altarpiece was commissioned in the mid-thirties for 'qualche cappella di fondazione o di patronato mediceo', and was transferred thence to the Annalena convent (Salmi, loc. cit.), (ii) that the altarpiece was painted in about 1453, (iii) that the present painting is not the Annalena altarpiece. The third case is argued by Parronchi ('Due pale dell'Angelico per due conventi', in *Commentari*, xii 1961, pp. 31–7), who suggests that on their removal to Paris in 1810 the Annalena and Bosco ai Frati altarpieces (for the latter see below) were transposed. This contention is disproved by Orlandi (1964, pp. 44–5). The first case rests on the difficulty of reconciling the style of the altarpiece with the dating indicated by the building history of the convent. In the first edition of this book it was argued that the painting was later than the Linaiuoli triptych and the Cortona polyptych, and somewhat less evolved in style than the San Marco altarpiece, and must therefore have been produced about 1437–8. It now seems probable that the Annalena altarpiece follows and does not precede the San Marco altarpiece, though it cannot be assigned to a date as late as that of the foundation of the convent. It may be noted that the Annalena altarpiece does not

include the figures of Saints Vincent Ferrer and Stephen, to whom the convent church was dedicated.

The fact that the predella (see below) was neither designed nor executed by Angelico suggests that the altarpiece may have been begun about 1443–4, and was still unfinished in 1445, when he was summoned to Rome. The surface of the main panel has suffered from abrasion, but is otherwise relatively well preserved; it was cleaned in 1955.

It was first suggested by Beissel (p. 51) that six scenes from the legend of Saints Cosmas and Damian, formerly in the Cappella di San Luca in the Santissima Annunziata, now in the Museo di San Marco (Fig. 37), formed the predella of this altarpiece. These scenes (each of which measures 20 × 22 cm.) show (i) *Saint Damian receiving a Gift from Palladia*, (ii) *Saints Cosmas and Damian and their Companions before Lycias*, (iii) *Saints Cosmas and Damian thrown into the Sea*, (iv) *The attempted Martyrdom of Saints Cosmas and Damian by Fire*, (v) *The Crucifixion of Saints Cosmas and Damian*, and (vi) *The Decapitation of Saints Cosmas and Damian*. On the analogy of the San Marco predella, the series should also have included the scenes of *The Burial of Saints Cosmas and Damian* and *The Dream of the Deacon Justinian*. The former is lost, while the latter is identical with a panel formerly in the Spencer-Churchill collection, Northwick (Dimensions: 19·5 × 22 cm. Coll: Duke of Lucca, sale, London, 1840, 25 July, lot 1; sale, Christie's, London, 1965, 28 May, lot 14, bt. Weitzner). The attribution to Angelico of the six scenes at San Marco is accepted by Muratoff (p. 45) and, with reserve, by Berenson (1963, p. 12), and is rejected by Schottmüller (p. 237), Van Marle (x, p. 182), who ascribes the cycle to Zanobi Strozzi, and Salmi (1950, p. 144), who assigns the execution of the first panel to Battista di Biagio Sanguigni and that of the remainder to Zanobi Strozzi. Paatz (i, p. 132) identifies them incorrectly as part of the San Marco altarpiece. The ascription to Angelico of the Spencer-Churchill panel is questioned by Phillips (in *Burlington Magazine*, xxxiv, 1919, p. 4) and Longhi (p. 175), who dates the panel before 1430 and detects the intervention of Andrea di Giusto. There is no evident discrepancy between the handling of the first panel and that of the remaining scenes, and the whole series conforms closely to documented miniatures by Zanobi Strozzi such as the *Conversion of Saint Paul* in Gradual A, Inv. 515, in the Museo di San Marco, which is documented to the month of September 1448 (for this see M. Levi d'Ancona, *Miniatura e miniatori a Firenze dal XIV al XVI secolo*, 1962, pp. 261–8). Salmi (1955, p. 104) assumes that the predella included a ninth panel with the *Pieta*; this is very probable, since the aggregate width of the panels would then be 198 cm.

The predella is of cardinal importance for the dating of the altarpiece, since certain of the scenes (e.g. *The attempted Martyrdom by Fire*) depend directly from the corresponding scenes in the San Marco predella, and others (e.g. *Saint Damian receiving a Gift from Palladia* and *The Decapitation of Saints Cosmas and Damian*) include motifs from that work. In these circumstances a date before 1443 can be ruled out.

It is claimed by Salmi (loc. cit.) and Baldini (1970, p. 101) that three panels of Saints at Altenburg originate from the pilasters

of this altarpiece. The balance of probability is that they belong to the San Marco altarpiece (q.v.).

Scenes from the Lives of Saints Stephen and Lawrence.
Chapel of Nicholas V, Vatican.

Plates 108–23; Figs. 38–40

There is no proof of Angelico's presence in Rome before March 1447, when he was engaged in painting 'la chapella di santo Pietro'. It is, however, generally assumed that he had been summoned to Rome considerably earlier. Pacchioni ('Gli ultimi anni del Beato Angelico', in *L'Arte*, xii, 1909, pp. 2–3), working from statements of Razzi (*Vite dei Santi e Beati Toscani*, i, 1593, p. 746) and Castiglioni (in *Acta Sanctorum*, ad loc.) that Angelico's arrival in Rome preceded the appointment of Sant'Antonino as Archbishop of Florence in January 1446, supposes that Angelico reached Rome before that time. Orlandi (pp. 86–9) records a substantial body of near contemporary evidence which supports this view. Since Angelico was certainly at work in Rome seven days after the election of Nicholas V as Pope (6 March 1447), the statement of Vasari (ii, p. 516) that 'papa Niccola V mandò per lui' can hardly be correct, and his employment in the Vatican must be ascribed to the intervention of Eugenius IV (d. 23 February 1447), who was familiar with his work in Florence. The balance of probability is that Angelico left Florence for Rome in the second half of 1445. A cycle of frescoes by Angelico in the Chapel of Nicholas V in the Vatican survives, and a further fresco cycle of *Scenes from the Life of Christ* in the demolished Chapel of St. Nicholas (Capella del SS. Sacramento) is described by Vasari (see pp. 238–9).

The documentary references to Angelico's activity in Rome relate to two separate commissions, the first the painting of 'la chapella di santo Pietro' and the second to 'dipinture de lo studio di N.S.'. It is argued by Orlandi that the term 'chapella di canto Pietro' signifies the tribune of St. Peter's. According to this thesis, Angelico would have been engaged initially in 1446–7 on frescoes in the tribune, and after 1447 would have divided his time between this work and the decoration of the Chapel of Nicholas V.

This explanation is demonstrably incorrect, since Manetti in his account of the tribune makes no reference to frescoes, and has been disregarded by all subsequent students of Angelico. The entry referring to the painting of the studio of Nicholas V is transcribed by Müntz (*Les Arts à la Cour des Papes*, i, 1878, p. 112): '1449. A spese fatte questo anno nela fabrica di palazzo . . . da di primo di Genaro . . . di 31 di Dicembre . . . d'ogni sorta duc. 182, bol. 62, den. 8 in dipinture de lo studio di N.S. cioe per salario di Fra Giovanni di Fi(renze) e suoi gharzoni, e altre chosette. . . .' A later payment of 16 March 1451 to the glass painter Fra Giovanni da Roma 'per due finestre di vetro biancho a fatte nelo studio di N.S., una con santo Lorenzo e santo Stefano, e nel altra la nostra donna' (Müntz, op. cit., p. 128) was regarded by Müntz as proof that the 'studio di N.S.' was identical with the Chapel of Nicholas

V. This inference is accepted by most students of Fra Angelico. Biagetti, however ('Una nuova ipotesi intorno allo studio e alla cappella di Niccolo V nel Palazzo Vaticano', in *Atti della Pontificia Accademia Romana di Archeologia*, iv, 1933, pp. 205–14) proves conclusively that the payment of 1451 to Fra Giovanni da Roma cannot, on account of the dimensions of the windows, refer, as Müntz assumed, to the windows of the Chapel of Nicholas V, and that the design of the pavement of the supposed studio, for which payment was made to Verrone di Agnolo da Firenze in 1451, from the first presupposed the presence of an altar. There were thus two separate commissions, one for the Chapel of Nicholas V, which is referred to throughout the documents as the 'capella segreta del papa', 'cappelletta piccola della sala prima', and 'cappelletta piccola di palazzo', and the other for the studio. According to Magnusson (*Roman Quattrocento Architecture*, Stockholm, 1958, pp. 107–8), the studio was in the eastern wing of the palace, close to the private chapel of the Pope. D. Redig de Campos (*I Palazzi Vaticani*, Bologna, 1967, pp. 50–2) distinguishes the studio of Pope Nicholas V from the chapel and dates work on both to 1447–50. The studio is probably identical with the 'stanza di lavoro', of which an inventory was made after the death of Nicholas V in 1455. Work in the studio was under way in 1449. Papini ('Riguardo al soggiorno dell'Angelico in Roma', in *L'Arte*, xiii, 1910, pp. 138–9) infers from the recorded payments that Angelico worked in the studio for little more than half of this year, and that the frescoed decoration was in all probability completed when Gozzoli, Angelico's principal assistant in Rome, arrived at Orvieto in July 1449. The frescoes were certainly completed before March 1450, when provision was made for the gilding of the frieze.

The frescoes in the Chapel of Nicholas V have been assigned alternatively to the brackets 1447–9 and 1453–5. Schottmüller (p. 236) and Wingenroth (pp. 114 f.) believe the frescoes to have been executed in part before 1449 and in part after 1453. Van Marle (x, pp. 120–1) and Muratoff (p. 66) refer the entire decoration of the chapel to the later date. A document of 15 February 1448, recording a payment 'pro duabus libris azuri ultramarini pro pictura capelae secretae D. N. Papae' (Müntz, op. cit., ii, p. 316), though it makes no mention of Fra Angelico, certainly refers to the decoration of the chapel; and it is assumed by Biagetti that this was begun early in 1448 and was completed before 1451, when the pavement of the chapel was renewed. Van Marle (x, p. 121) wrongly refers the date A.D. CCLIII on the *Saint Lawrence before Valerianus* to the year 1453.

This speculation is superfluous, in that three documents published by Müntz (op. cit., i, 1878, pp. 126–7) offer a precise date for the execution of the frescoes. These documents read as follows:

1447. 9 May. A Pietro Jachoo da Furli dipintore a lavorato chon frate Giovanni a la chapella di santo Pietro adi detto fl. 3, b. 15, e quali ebbe di suo salario di qo. mexe e XVIII di e stato a lavorare, cioe s'e partito dadi XIII di Marzo perinfino adi die di Maggio e fo al bast. I a fo. 809(?) . . . a sua rag.—T.S. 1447, fol. 37.

1447. 23 May. A frate Giovanni di Pietro dipintore a la chapella di sto. Pietro dell'ordine di san Domenicho adi XXIII di Maggio. d. quarante tre, b. vinti sette, sono per la provisione di d. 200 l'anno dadi 13 di Marzo perinfino adi ultimo di Maggio prossimo a venire: f. XLIII, b. XXVII.— A Benozo da Leso dipintore da Firenze a la sopradetta chapella adi detto f. diciotto, b. dodici, e quali sono per sua provisione di f. VII il mexe dadi XIII di Marzo sino adi ultimo di Maggio prossimo: fl. XVIII, b. XII.—A Giovanni d'Antonio della Checha dipintore a la detta chapella adi detto b. due, b. quaranta due, sono per la provisione di mexi 2 2/5 a f. uno il mexe e finira(?) a di ultimo di Maggio prossimo: fl. II, d. XLII.—A Jachomo d'Antonio da Poli dipintore ala detta chapella adi XXIII di Maggio fl. tre, sono per la sua provisione di 3 mexe e quali debano finire a di ultimo di Maggio prossimo a f. I il mexe: f. III, b. O.—T.S. 1447, ff. 38 v. et 39.

1447. 1 June. A frate Giovanni da Firenze che dipigne nela chapella di sº Pietro adi detto f. due, b. trenta nove, sono per choxe assgº avere spexi per bisogni di detta chapella: fl. II, b. XXXVIIII.—Ibid., 1.39v.

It is assumed by Beissel (p. 89) and other writers on Fra Angelico that the 'chapella di santo Pietro' to which these documents refer is identical with the Cappella del Sacramento or Cappella di San Niccolò, which contained the *Scenes from the Life of Christ* by Fra Angelico described by Vasari. An analysis by Egger ('Capella Sancti Nicolai (Cappella del SS. Sacramento)' in Ehrle and Egger, *Der Vatikanische Palast in seiner Entwicklung bis zur Mitte des XV. Jahrhunderts*, 1935, p. 133) leaves no doubt that this identification is incorrect. The sense of the documents is elucidated by a passage in the record of a meeting held at Orvieto on 11 May of the same year (quoted in full on p. 214), in which it is stated that 'ad presens in Urbe sit quidam frater observantie sancti Dominici, qui pinsit et pingit *capellam Smi. D.N. in palatio apostolico sancti Petri de Urbe*.' In view of the coincidence of date, this passage cannot apply to any other work than that to which the payments of 9 and 23 May 1447 relate. Equally the term 'cappellam Smi. D.N.' can refer only to the secret chapel of the Pope, that is the Chapel of Nicholas V, and we must therefore conclude that the payments noted by Müntz are connected with work not in the basilica of St. Peter's but in the Vatican Palace (the words 'chapella di sto. Pietro' being a contraction of the more detailed description given in the Orvieto document), and that this work was the painting of the private chapel of the Pope. Having regard to the number of assistants employed by Angelico in Rome and to the fact that the two completed sections of the ceiling of the Cappella di San Brizio at Orvieto were executed in less than four months, we may suppose that work in the studio and the chapel of Nicholas V was concluded by the summer of 1449.

The Chapel of Nicholas V is described by Vasari (loc. cit.): 'Per quanti tanti lavori essendo chiara per tutta Italia la fama di Fra Giovanni, papa Niccola V mandò per lui, ed in Roma gli fece fare la capella del palazzo, dove il papa ode la messa, con un Deposto di Croce ed alcune storie di San Lorenzo, bellissime.' The *Deposition*, which presumably served as an altarpiece, has disappeared. The narrative frescoes are arranged in two tiers, and comprise six *Scenes from the Life of Saint Stephen* (above) and five *Scenes from the Life of Saint Lawrence* (below). These show: (i) on the wall to the right of the entrance (above) *The Ordination of Saint Stephen* and *Saint Stephen distributing Alms*, (below) *The Ordination of Saint Lawrence*; (ii) on the entrance wall (above) *Saint Stephen preaching* and *Saint Stephen addressing the Council*, (below) *Saint Lawrence receiving the Treasures of the Church from Pope Sixtus II* and *Saint Lawrence distributing Alms*; and (iii) on the wall to the left of the entrance (above) *The Expulsion of Saint Stephen* and *The Stoning of Saint Stephen*, (below) *Saint Lawrence before Valerianus* and *The Martyrdom of Saint Lawrence*. Flanking the frescoes on the lateral walls are eight full-length Saints: (below) Saints Jerome (transformed into a figure of Saint Bonaventure) (Fig. 39), Thomas Aquinas (Fig. 40), Athanasius and John Chrysostom, (above) Saints Augustine, Ambrose, Leo and Gregory the Great. On the roof of the chapel are the four Evangelists. Below the lower frescoes are traces of a polychrome textile pattern which originally completed the scheme (for this see *Ecclesia*, 1951).

The entire fresco cycle is extensively restored. Inscriptions in the chapel record restorations in the last quarter of the sixteenth century by Pope Gregory XIII, in 1712 by Pope Clement XI and in 1815 by Pope Pius VII. An account of local restoration of the frescoes on the roof and walls, made necessary by lesions in the ground, as a result of which traces were revealed of the naturalistic blue sky in the lateral frescoes and of the painted drapery with the stemma of Nicholas V on the lower part of the wall, is given by Biagetti (in *Atti della Pontificia Accademia Romana*, serie iii, *Rendiconti*, iii, 1925, pp. 485–92). General restoration of the frescoes was undertaken in 1947–51, and the reproductions in the present volume show them in their cleaned state. The narrative frescoes fall into two classes, those which are much abraded (of which *The Martyrdom of Saint Lawrence* on the left wall is the most seriously damaged), and those which have been much repainted and restored (*The Preaching of Saint Stephen* and *Saint Lawrence receiving the Treasures of the Church* are salient examples of this). Of the full-length figures the *Saint Athanasius* and *Saint John Chrysostom* have been transferred to canvas and are gravely damaged. A clear account of the results of the cleaning of 1947–51 is given by Redig de Campos (in *Atti della Pontificia Accademia Romana di Archeologia*, xxiii–iv, 1950, pp. 385–8). It is established that in 1447 Angelico's studio comprised Benozzo Gozzoli, who received a relatively high remuneration, his nephew Giovanni di Antonio della Cecha (probably identical with a Giovanni di Antonio da Firenze, who later in the year was killed on the scaffolding at Orvieto), Carlo di ser Lazaro da Narni, and Giacomo d'Antonio da Poli. All of these artists may have been employed in the Chapel of Nicholas V. The part played by Gozzoli in the execution of the frescoes has been analysed by Pacchioni ('Gli inizi artistici di Benozzo Gozzoli', in *L'Arte*, xiii, 1910, pp. 423–42), Wingenroth (*Die Jugendwerke des Benozzo Gozzoli*, 1897, pp. 69–80), and A. Padoa Rizzo (*Benozzo Gozzoli Pittore Fiorentino*, 1972, pp. 107–11).

In the narrative scenes the execution of the figures may be tentatively distributed as follows:

The Ordination of Saint Stephen. The two foremost figures and the third apostle from the left by Angelico; the first, second, fifth and (?) sixth apostles from the left by Gozzoli.

Saint Stephen distributing Alms. The Saint, the acolyte in the left background and the woman in the centre by Angelico; two women on the right and the male figure advancing with a hat possibly but not certainly by Gozzoli.

Saint Stephen preaching. The much damaged Saint and at least four seated women in the foreground by Angelico; the woman in full-face, other women in middle ground and two standing men on right of background by Gozzoli.

Saint Stephen addressing the Council. Largely by Angelico; heads in background on right and two standing figures on left possibly by Gozzoli.

The Expulsion of Saint Stephen. The Saint and the bearded man holding a stone by Angelico; two men on extreme left by Gozzoli.

The Stoning of Saint Stephen. Largely by Angelico; two male heads on left by Gozzoli.

The Ordination of Saint Lawrence. Largely by Angelico; three acolytes and deacon on right by Gozzoli.

Saint Lawrence receiving the Treasures of the Church. Saint and attendant behind much repainted. Pope and soldiers on left by Angelico.

Saint Lawrence distributing Alms. Saint by Angelico. Woman with child on left and woman in left centre by Gozzoli.

Saint Lawrence before Valerianus. Probably largely by Angelico. Soldier in helmet, male figure behind Saint and five heads on extreme right by Gozzoli.

The Martyrdom of Saint Lawrence. Figures in window, Saint and executioner on left by Angelico; figures above by Gozzoli.

The hands of at least two other assistants are apparent in the frescoes. Muratoff (pp. 68–70) denies Angelico's responsibility for the cartoons of the Saint Stephen frescoes, and greatly restricts the scale of his intervention in the lower scenes. There can, however, be little doubt that Angelico was responsible for all of the cartoons of the narrative frescoes. Van Marle (x, pp. 122–32) correctly notes that the part executed by Angelico is greater in the lower (and more visible) than in the upper (and less visible) scenes. Examination suggests that each of the frescoes was, in a loose sense, collaborative, and that two or more artists worked on each field. Van Marle's attempt to attribute the whole of the second, fifth and sixth scenes of the legend of Saint Stephen to an unnamed assistant of Angelico is inadmissible.

Two sheets of drawings at Cambridge and Windsor (for which see pp. 235–6) contain what have sometimes been claimed as preliminary studies for the Vatican frescoes.

Christ in Glory: Prophets. Duomo, Orvieto. Plates 124-5

The documents which enable us to trace the story of Angelico's frescoes at Orvieto have been published by Luzzi (*Il Duomo d'Orvieto descritto ed illustrato,* 1866, p. 433) and Fumi (*Il Duomo di Orvieto,* 1891, pp. 393–5) and are reprinted by Douglas (pp. 184–7). They comprise:

(i) A letter from a Benedictine monk, Don Francesco di Barone da Perugia, to the Camarlingo of the Fabbrica of the Duomo at Orvieto notifying the latter that Angelico, who was then in Rome, had expressed his willingness to come to Orvieto for the following summer (1447).

(ii) The record of a meeting at Orvieto on 11 May of the same year, in which the *operai* of the Duomo take note of the fact that the Chapel of the Corporal (or the Cappella della Madonna di San Brizio) in the south transept of the cathedral has not yet been painted, 'et pro honore dicte Ecclesie est dipingenda per aliquem bonum et famosum magistrum pictorem, et ad presens in Urbe sit quidam frater observantie sancti Dominici, qui pinsit et pingit cappellam Smi. D.N. in palatio apostolico sancti Petri de Urbe, qui forte veniret ad pingendam dictam cappellam, et est famosus ultra omnes alios pictores ytalicos et staret ad pingendum in dicta cappella tantum tribus in anno mensibus, vid: junio, julio et augusto, quia aliis mensibus opportet eum servire Smo. D.N. et in dictis tribus mensibus non vult stare Rome, et petit salarium pro se ad rationem ducentorum ducatorum auri in anno et cum expensis ciborum, et quod sibi dentur colores expensis Fabrice, et fiant pontes expensis Fabrice, item vult pro uno suo consortio ducatos septem auri de auro et pro duobus aliis famulis tres ducatos auri, vid: in mense pro quolibet ipsorum et cum expensis ipsorum; habitis inter eos pluribus collocutionibus, delib: quod dictus Enrigus miles possit conducere pro dicta Fabrica et etiam dictus Camerarius dictum magistrum pictorem cum dictis consortio et famulo cum dictis salariis et expensis et aliis petitis, dummodo promictat servire laborerium totius picture dicte cappelle vel saltem servire in dicta pictura dictis tribus mensibus quolibet anno quousque finiverit totum laborerium. Et vocatur dictus magister pictor frater Johannes.' (Orvieto, Archivio dell'Opera del Duomo. Rif. 1443–8, c. 284 t.)

(iii) A payment of 26 August 1447 to 'Giovanni compagno overo garzone di m. frate Giovanni dipentore' covering the expense of journeys to Florence to buy ultramarine and to Rome to purchase other colours. (Orvieto, Archivio dell'Opera del Duomo. Cam. 1445–50.)

(iv) An entry of 28 September 1447, noting that the sum due to Angelico for three months' work at Orvieto had been paid. (Orvieto, Archivio dell'Opera del Duomo. Rif. 1443–8, c. 287 t.)

(v) A more detailed document of the same date, in which Angelico (on his own behalf and on that of his three assistants 'Benozzo Lesi de Florentia, Johannis Antonii de Florentia, et Jacobus de Poli') acknowledges the settlement of the sum due. (Orvieto, Archivio dell'Opera del Duomo. Rif. 1443–8, c. 298.)

(vi) A final payment of 30 September 1447 'ad frate m. Giovanni pentore per la provisione sua et di compagni, cioe per tre mesi et mezo che anno servito ad depegnere nella capella nuova—ducati d'ore cento tre e mezo. Item ad Benozzo per le

spese che fecero nell'albergo prima che essi fussero condutti.' (Orvieto, Archivio dell'Opera del Duomo. Cam. 1445–50.) Angelico did not return to Orvieto after 1447, and the contract for the frescoes was broken in 1449. Document (ii) appears to provide for the complete painting of the chapel (later undertaken by Signorelli). As was usual, work began on the roof, where two of the four triangular spaces were finished when Angelico left Orvieto. These show a *Christ in Majesty with Angels* and *Sixteen Prophets*; below the latter are the words PROPHETARVM LAVDABILIS NVMERVS. Muratoff (p. 65) assumes that the execution of the frescoes was entrusted entirely to assistants. This can hardly have been the case, and, as noted by Van Marle (x, pp. 106–7), a number of the heads in the upper part of the second fresco were probably painted by Angelico. Schottmüller (p. 265) and Douglas (p. 140) rightly deny that the figure of Christ in the first fresco is due to an assistant; owing to damage to the ground, this figure is extensively restored. Pacchioni ('Gli inizi artistici di Benozzo Gozzoli', in *L'Arte*, xiii, 1910, p. 426) ascribes the angels to the left of the *Christ in Majesty* to Gozzoli, and three of those to the right (which are much damaged) to Angelico. In the second fresco three of the prophets (the first and third in the central row reading from the top and a figure to their right) are related in type to Gozzoli, who was also perhaps responsible for the drapery of the foreground figures and for many of the heads in the borders of the two frescoes. Salmi (1950, pp. 155–6) endorses the ascription to Gozzoli of the bulk of the angels in the *Christ in Glory*, and tentatively distributes the heads in the borders of the two fields between Giacomo da Poli and Giovanni d'Antonio. A. Padoa Rizzo (*Benozzo Gozzoli Pittore Florentino*, 1972, pp. 103–5) accepts the Christ as substantially by Angelico, and regards the angels to the left as in the main by Gozzoli and those to the right as in the main by Angelico. Among the Prophets Gozzoli would have been responsible for six figures, including the youthful prophet at the apex of the pyramid and, doubtfully, the Baptist at the bottom on the left.

The Virgin and Child enthroned with two Angels between Saints Anthony of Padua, Louis of Toulouse, and Francis, and Saints Cosmas, Damian and Peter Martyr. Museo di San Marco, Florence. Plate 126
Panel: 174 × 174 cm.

Painted for the high altar of the Franciscan Observant church of San Buonaventura at Bosco ai Frati, on the commission of Cosimo de' Medici, whose villa at Cafaggiolo was not far distant from the convent and who was responsible for the rebuilding of the church (completed by Michelozzo in 1438). The *Chronaca del Chiostro di San Francesco in Mugello* of Fra Giuliano Ughi (Florence, Archivio di Stato, Storie e Relazioni miscellanee, vol. 167 nuovo, published by Fabriczy, 'Michelozzo di Bartolommeo', in *Jahrbuch der Preussischen Kunstsammlungen*, xxv, 1904, pp. 70–1), after describing the chalices, missals and vestments presented to the community by Cosimo

de' Medici, adds: 'La bella tavola dell'altar maggiore, la quale dipinse un frate di S. Domenico'. Apparently removed from the high altar at the time of the installation of a new high altar under the Grand Duke Ferdinand III. Transferred to the Gallerie Fiorentine before 1810.

An analysis by Baldini (in *Mostra*, 1955, No. 61, pp. 88–90) shows that the altarpiece has been reduced by approximately 12 cm. at each side. The predella now associated with the altarpiece (which shows the Pieta with half-length figures of SS. Peter, Paul, Bernardino and three other Saints) has been cut similarly at the sides, and there can thus be no doubt that the main panel and the predella formed part of one and the same altarpiece. Since San Bernardino was canonised only in 1450, a dating in the years 1450–2 (proposed initially by Venturi and supported by Salmi and Baldini) is therefore mandatory, and the earlier dating (ca. 1440–5) proposed in the first edition of this book is incorrect. This late dating is confirmed by the scheme of the altarpiece, and especially by the screen behind, whose niches recall those in the *Martyrdom of Saint Lawrence* in the Vatican, as well as by a cleaning undertaken in 1955.

Some measure of studio intervention in the execution of the main panel must be presumed. Bazin (p. 184) attempts to identify Angelico's assistant in this altarpiece as Benozzo Gozzoli. There is, however, nothing in it that corresponds with Gozzoli's authenticated works about 1450. Apart from some abrasion, the panel is well preserved.

It was mistakenly suggested by Schottmüller (p. 265) that the present predella was an accretion to the altarpiece, and that this was originally completed by a cycle of scenes from the life of Saint Francis in the Lindenau Museum, Altenburg, the Staatliche Museen, Berlin/Dahlem, and the Pinacoteca Vaticana (for these see under 'Other Works ascribed to Fra Angelico').

The Coronation of the Virgin. Louvre. Paris (No. 1290).
Panel: 213 × 211 cm. Plates 127–9; Fig. 42

The altarpiece was painted for San Domenico at Fiesole, where it was seen by Vasari (ii, pp. 510–11) on an altar to the left of the church. Vasari's account reads: 'Ma sopra tutte le cose fece Fra Giovanni, avanzò se stesso e mostrò la somma virtù sua e l'intelligenza dell'arte, in una tavola che è nella medesima chiesa allato alla porta entrando a man manca; nella quale Gesù Cristo incorona la Nostra Donna in mezzo a un coro d'Angeli, e in fra una moltitudine infinita di Santi e Sante, tanti in numero, tanto ben fatti, e con sì varie attitudini e diverse arie di teste, che incredibile piacere e dolcezza si sente in guardarle: anzi pare che que' spiriti beati non possino essere in cielo altrimenti, o per meglio dire, se avessero corpi, non potrebbono; perciocchè tutti i Santi e le Sante che vi sono, non solo sono vivi e con arie delicate e dolci, ma tutto il colorito di quell'opera par che sia di mano di un Santo, o d'un Angelo, come sono: onde a gran ragione fu sempre chiamato questo dabben religioso, Frate Giovanni Angelico. Nella

predella poi, le storie che vi sono della Nostra Donna e di San Domenico, sono in quel genere divine; e io per me posso con verità affermare, che non veggio mai questa opera che non mi paja cosa nuova, nè me ne parto mai sazio.'

Beneath is a predella in seven compartments (Fig. 42 a–f) representing: (i) *The Dream of Pope Innocent III*, (ii) *Saints Peter and Paul appearing to Saint Dominic*, (iii) *The Raising of Napoleone Orsini*, (iv) *Pietà*, (v) *The Disputation of Saint Dominic and the Miracle of the Book*, (vi) *Saint Dominic and his Companions fed by Angels*, and (vii) *The Death of Saint Dominic*.

The altarpiece was transported to Paris by Napoleon I in 1812, and the predella, which had been separated from the upper panel, was purchased in Florence in 1830. The pilasters and pinnacles have disappeared. The six narrative scenes in the predella depend from those in the predella of the Cortona polyptych. Orlandi (1964, p. 25) transcribes a passage from a later chronicle of the convent, which refers to the dedication in October 1435 of the high altar and of the nearby altars of the Virgin Annunciate and of the Coronation of the Virgin 'in cui è la tavola dell'Incoronazione della Beata Vergine con molti Angeli e Santi. Le tavole dei detti altari, tutte, furono dipinte per mano di Fra Giovanni de Piero del Mugello, figlio di detto convento, più anni avanti che la chiesa fosse consecrata.' It is wrongly inferred from this that all three altarpieces date from ca. 1428–34. *The Coronation of the Virgin* is presumed by Douglas (p. 55) to have been executed before 1430 on account of the Gothic form of the throne. A dating about 1430 is proposed by Muratoff (pp. 41–2), a dating after 1430 by Bazin (p. 26), and a dating between 1430 and 1440 by Schottmüller (p. 258). Salmi (1955, p. 109) suggests that the altarpiece was planned before 1430 and elaborated slowly after 1435. A measure of studio intervention is presumed by Papini (p. 39) and Muratoff (p. xcix), while Wurm (p. 10) regards the entire painting as a studio work, and Salmi (1950, pp. 148–9) ascribes the kneeling Bishop in the main panel to Battista di Biagio Sanguigni (b. 1392; d. after 1451).

In the first edition of this book it was claimed that the main problem of the altarpiece arose from the employment in it of two different methods of space representation, one used for the throne, tabernacle and steps, and the other employed for the pavement and foreground. It was inferred from this that the altarpiece was by two different hands, and was begun by Angelico and completed by a younger artist, who would have been responsible for the predella. An attempt was made to identify the second artist as Domenico Veneziano (Pope-Hennessy, 'The Early Style of Domenico Veneziano', in *Burlington Magazine*, xciii, 1951, pp. 216–23). White (1957, pp. 170–1, 187 n.) relates the inward-turned figures in the foreground to the early *Madonna and Child with Angels* at Frankfurt-am-Main, and notes that the canopy and floor recede to a single vanishing point; he concludes from this that 'in general and in detail it seems most likely that Fra Angelico remained in control of the work that he designed but did not wholly execute himself'. Angelico's authorship of the main panel and of the predella is accepted by Berenson (1963, p. 14).

The earlier analysis of the altarpiece was based on the widely entertained belief that it preceded the San Marco altarpiece, and was therefore painted before 1438, the parts ascribed to Domenico Veneziano dating from 1438 or 1439. This dating is incorrect, and the balance of probability is that the altarpiece was not begun until after 1450, when Angelico returned to Florence after completing the Chapel of Pope Nicholas V. Among the arguments in favour of this view may be noted (i) the form of the tabernacle over the throne, which finds its closest analogy in the tabernacles over the Fathers of the Church in the chapel in the Vatican, and is projected in the same way; (ii) the angels beside the throne, which are related not to the angels in earlier paintings by Angelico, but to those in the Cappella di San Brizio at Orvieto; (iii) the low viewing point used in the pavement in the foreground, which differs from that in the San Marco altarpiece and the paintings which precede it, and makes use of a system explored in Domenico Veneziano's antecedent Santa Lucia altarpiece. It is observed by Meiss ('Masaccio and the Early Renaissance: the Circular Plan', in *Studies in Western Art*, Princeton, ii, 1963, p. 140) that the altarpiece is 'one of the few works in which Fra Angelico was thrown off his stride in strenuous efforts to keep up with the innovations around him'. The painting is the single altarpiece by Fra Angelico in which vanishing point and the focus of narrative interest do not coincide. This, and the use in the foreground of a low viewing point, are inherent in the artistic problem presented by the altarpiece, and do not imply any change of plan or the intervention of a second designing mind. A number of the foreground figures, especially on the right, are weakly executed; particularly notable in this respect are Saints Catherine of Alexandria and Agnes, the female Saint behind them to the right, and the tonsured figures above.

If the altarpiece was executed in the fourteen-fifties and not in the mid-fourteen-thirties, the ascription to Domenico Veneziano (which was at best conjectural) falls to the ground. There is, however, no doubt that the predella was executed by a second hand. While the scenes shown in it depend from those in the predella of the Cortona altarpiece, the compositions are revised in a manner which is untypical of Fra Angelico and is inconsistent with such late works as the autograph panels of the Annunziata silver chest. An example of this is the diagonal structure of *Saints Peter and Paul appearing to Saint Dominic*. The strongly realistic treatment of the heads in, e.g. *The Raising of Napoleone Orsini* and *The Miracle of the Book* is also difficult to reconcile with the practice of Angelico at this or any other time. Particularly striking are the discrepancies between the central *Pietà* and the more serious and more firmly constructed *Entombment* from the San Marco altarpiece.

Scenes from the Life of Christ. Museo di San Marco, Florence. Plates 130–8; Figs. 43–4
Panel: each scene approximately 39 × 39 cm.

The thirty-five scenes were designed to decorate the doors of the silver chest in the church of the Santissima Annunziata.

The earliest reference to the silver chest occurs about 1460 in the *Theotocon* of Fra Domenico da Corella (publ. Lami, *Deliciae Eruditorium*, xii, pp. 49-116):

> Sunt ubi cum variis argentea vasa figuris
> Quae tegit interius picta tabella foris,
> Angelicus pictor quam finxerat, ante Iohannes
> Nomine, non Iotto, non Cimabove minor,
> Quorum fama fuit Tyrrhenas clara per urbes,
> Ut dulci Dantes ore poeta canit.

The panels are also ascribed to Angelico in the *Memoriale* of Albertini of 1510 (*Memoriale di molte statue e pittura della citta di Firenza fatto da Francesco Albertini prete*, Florence, 1863, p. 12: 'Li ornamenti della argenteria per mano di fra Iohanni'), in the *Libro di Antonio Billi* of 1516-25/30 (p. 18: 'Nell' ornamento doue stanno gli arienti, alla Nunziata de Seruj figure picole') and, between 1482 and 1497, by Manetti (p. 166: 'quasi tutto il tabernacolo degli arienti della Nunziata de' Servi').

The work is noted by Vasari (ii, pp. 511-12): 'Nella cappella similmente della Nunziata di Firenze, che fece fare Piero di Cosimo de' Medici, dipinse gli sportelli dell'armario, dove stanno l'argenterie, di figure piccole, condotte con molta diligenza'. The cupboard originally stood in the small oratory beside the chapel built by Michelozzo to the left of the main entrance of the church. Later the panels were shown in the Chiostro dell'Antiporto; in 1687 they were replaced in the Cappella Feroni inside the church, and were subsequently moved to the Cappella dei Galli (1691). Details of their movements are given by Baldinucci (*Notizie de' Professori del Disegno*, 1768, pp. 90-1): 'Dipinse egli per la Capella della santissima Nunziata di Firenze, che fece fare Cosimo de' Medici, i portelli di un grande Armario nella facciata a man dritta entrando in essa Capella, dove stavano anticamente le argenterie, che agli anni addietro fu levato, e posto in quel luogo un molto devoto Crocifisso di legno. . . . I detti portelli tutti storiati di piccole figure della Vita, Morte e Resurrezione del Salvatore, furono da' Frati di quel Convento posti nel Chiostro piccolo, che e avanti alla Chiesa, credo io affine di esporlo a maggior venerazione dei' popoli, e renderlo anche a' medesimi più godibile; ma non so già con quanta speranza di maggior durata, per esser quel luogo assai sottoposto all'ingiurie del tempo. Il che avendo osservato il Serenissimo Granduca Cosimo III mio Signore, operò che fossero tolti via, e collocata in più venerabile e più durevol posto, che fù per entro la chiesa medesima, da uno de' lati della Cappella de' cinque Santi, dico dalla parte di verso il maggiore Altare.'

In 1785 the panels were moved to the Library, and thence to the Accademia (Paatz, i, p. 185). The subjects of the panels are scenes from the life of Christ (each accompanied by parallel quotations from the Old and New Testament), to which are added scenes of Pentecost, the Coronation of the Virgin and Last Judgment. The series is prefaced by a panel of *The Vision of Ezekiel* and concluded by the so-called *Lex Amoris*; a brief account of the iconography of these scenes is given in the Introduction of the present book.

The panels are generally assumed to have been commissioned by Piero de' Medici (*Cronaca di Firenze di Benedetto Dei*, Bibl· Naz., Florence, Cog. Magl. xxi, f. 96t.) as part of a project for developing an oratory for the donor's use between the Chapel of the Annunziata and the convent library. The commission was commonly assigned to the year 1448. It is, however, argued by Casalini ('L'Angelico e la cateratta per l'Armadio degli Argenti alla SS. Annunziata di Firenze', in *Commentari*, xiv, 1963, pp. 104-24) that it was placed in or after 1450, since the ceiling of the chapel was not roofed over till 1451. The last payment relating to this phase in the history of the silver chest dates from 1453. It is likely that at this time the panels (which seem to have been restricted to the three rows of three panels from *The Vision of Ezekiel* to *Christ teaching in the Temple*, to the three panels painted by Baldovinetti in 1452-3, and to six missing panels by or from the workshop of Angelico, with which they may have been completed) were planned as two doors opening outwards. It cannot, however, be ruled out that an installation with four doors, comprising all the extant panels, was planned at this time. Subsequent payments in 1461-3 relate to a new installation, in which, in place of doors, the silver cupboard was closed by a single massive shutter operating on pulleys, in which all the panels were incorporated. The purpose of this change was to ensure greater security for the ex votos contained in the cupboard. The dimensions of the shutter into which the panels were built was of the order of 300 × 355 cm. The reason for postulating six missing panels is that the first nine scenes, like the two groups of twelve scenes which were set beneath them, read horizontally, whereas Baldovinetti's three panels read vertically, and should therefore have been completed with other scenes from the life of Christ. Though the panels were sawn up into smaller units in 1814, technical examination and the continuity of certain of the backgrounds leave little doubt that the present sequence of the scenes is that originally planned. The attrition of the paint surface on the left of the *Raising of Lazarus* and on the right of the *Lamentation over the dead Christ* suggests that these areas must have been in contact with the stone frame of the shutter. The Libro di Fabbrica records payments for the completion of the shutter between January 1461 and June 1463, in which Baldovinetti appears again to have been involved. The most important of these payments is that on January 30, 1461, to the painter Pietro del Massaio for 'insegnare dipingere l'armario'. The far from complete documentation of the commission would be consistent with the view that when Fra Angelico left Florence for Rome only the panels of the upper register were complete.

All the panels have been weakened by retouching. The extent of restoration can be gauged from comparison with photographs made prior to 1858. These show that in *The Annunciation* panel the angel's head, the lower part of the angel's hair, and his left upper arm, forearm and left hand are, in their present form, due to restoration. The expression of the Virgin's face has also been modified. There is some local restoration elsewhere on the panel. In the case of *The Adoration of the Magi* a large number of worm holes have been stippled in, and the heads of the figures on the left and of the

kneeling King have been weakend by retouching, while the head of the Virgin has been rounded and softened. The most seriously damaged panel is *The Massacre of the Innocents* (Plate 138), in which retouching has gravely impaired the figures of Herod and of the women and soldiers beneath.

From the time of Rio (*De l'art chrétien*, ii, p. 374) it has been observed that the panels of the chest are unequal in conception and execution. Views on the authorship of the chest vary between the poles of Berenson (1932, p. 20), who accepts all of the panels save *The Marriage at Cana, The Baptism, The Transfiguration*, the *Vision of Ezekiel* and the *Lex Amoris* as substantially by Fra Angelico, and Muratoff (pp. 62-3), who discounts the possibility of Fra Angelico's intervention in or general responsibility for any of the scenes. The *Nativity* has been given tentatively and in part by Salmi (1958, p. 55) and positively by A. Padoa Rizzo (*Benozzo Gozzoli*, 1972, p. 113) to Gozzoli. In considering the authorship of the panels it is essential to remember first that they have been much restored, and secondly that those parts executed by Angelico are late works. With these points in mind it may be noted:

(i) The first nine scenes are so distinguished in conception and in such close conformity with the compositional methods of the San Marco predella as almost certainly to have been designed by the master. Angelico himself was certainly responsible for the execution, in whole or in part, of *The Nativity, The Circumcision, The Adoration of the Magi, The Massacre of the Innocents*, the whole of *The Flight into Egypt* and *The Annunciation* and the figures in the much abraded *Christ teaching in the Temple*, and perhaps for all of the nine panels.

(ii) *The Marriage at Cana, The Baptism of Christ* and *The Transfiguration* are by Baldovinetti. The style of these three scenes depends from Domenico Veneziano rather than Angelico.

(iii) The remaining scenes are by a single hand wrongly identified by D'Ancona (p. 92) as that of the artist responsible for the frescoes of *Christ in Limbo, The Sermon on the Mount, The Arrest of Christ, The Agony in the Garden* and *The Institution of the Eucharist* in Cells 31-5 in the convent of San Marco. Four of the scenes (*The Raising of Lazarus, Christ's Entry into Jerusalem, The Last Supper* and *Judas receiving Payment*) may be generally dependent on cartoons by Angelico. The compositional schemes used in the remainder are unlike those used by Angelico, save where they incorporate motifs from the San Marco frescoes or other works. Examples of this are *The Mocking of Christ* (which derives from the corresponding fresco), *Christ carrying the Cross* (where the Virgin is based on the Virgin in the fresco), and *The Coronation of the Virgin* (where the central group is a reduced variant of that in Cell 9).

It is a reasonable hypothesis that the panels in group (i) were painted by Angelico in or soon after 1451, and that those in group (iii) were produced by a member of Angelico's shop, between 1455 and 1461.

The Last Judgment, the Ascension and Pentecost.
Galleria Nazionale (Barberini), Rome (No. 723).

Plate 139; Fig. 45

Panel: 55 × 38 cm. (centre), 56 × 18 cm (wings).

Perhaps from the Monte di Pieta. Doubt has been cast on the form of this painting, which is regarded by Crowe and Calvalcaselle (iv. 1911, p. 92) as 'altered in shape'. Schottmüller (p. 264) denies that the wings were originally part of the same complex as the central panel. The balance of evidence is that the painting was designed as a triptych in approximately its present form; the height of the central panel has, however, been reduced. The central panel is given by Muratoff (pl. cxi) to an assistant of Angelico, and is dismissed by Schottmüller (loc. cit.) as an inferior variant of the *Last Judgment* in Berlin (see below). When allowance is made for the condition of the painting, it is likely that all three panels were designed by the master, and that the central panel, at least, is substantially autograph. The attribution of the central panel to Angelico is admitted, among others, by Van Marle (x, pp. 133-4), who notes that it is superior in quality to the corresponding panel in Berlin, and by Berenson (1963, p. 15). The panel is certainly late in date, and Beissel (p. 120) assumes that it was executed at Santa Maria sopra Minerva. The Christ of the central panel is related to that of the *Last Judgment* in Berlin and repeats the pose utilised in the Orvieto fresco (q.v.), while the Christ of the right wing recalls the *Transfiguration* fresco at San Marco.

Saint Peter. Mr. and Mrs. Deane Johnson (formerly), Bel Air (California).
Plate 140

Panel: 46 × 16 cm.

Coll.: Artaud de Montor, Paris (*Peintres Primitifs: Collection de Tableaux rapportée d'Italie*, 1808, No. 62; 1811, No. 85; 1843, No. 82, as Giottino); Chalandon, Lyons and Paris; Mr. and Mrs. Deane Johnson, Bel Air (Cal.); sold Sotheby, London, December 6th, 1972, No. 7 (as Fra Angelico).

At the base of the panel is the partly effaced inscription: SC.... TRV. The inscription is not visible in the reproduction in the Artaud de Montor catalogue, where it is noted 'on ne sait pas le nom de ce souverain pontife'. A dating by Longhi ca. 1430-5 cannot be sustained. The tooling of the halo is closely similar to that of the haloes in the *Crucifixion* in the Fogg Art Museum, Cambridge, and the panel is likewise a late work. Tooling along its edge and in the spandrels of the lightly indicated arch above suggests that it is not a pilaster panel, but perhaps formed the wing of a small triptych. It is likely that it was originally part of the same complex as the Cambridge *Crucifixion*, where the edges of the gold ground are also tooled and which is likewise illuminated from the left. If the tooled arch above were completed, the height would be approximately that of the rectangular lower section of the *Crucifixion*, and the ratio of the figure to the gold ground would be comparable to that of the Virgin and Saint John in the Fogg painting.

Christ on the Cross between the Virgin and Saint John adored by a Dominican Cardinal. Fogg Art Museum, Cambridge (Mass.). Plate 141; Fig. 41
Dimensions: 88 × 36 cm.

Coll.: Timbal (bt. Bologna 1860); Prof. Noel Valois; Hervey E. Wetzel (till 1921). Valois ('Fra Angelico et le Cardinal Jean de Torquemada', in *Société Nationale des Antiquaires de France, Centenaire 1804–1904: Recueil de Mémorires*, 1904, pp. 461–70) identifies the donor's portrait as that of the Spanish Dominican Juan de Torquemada, who was born in 1388, was created cardinal in 1439 and died in 1468. This identification is supported by the presence of a cardinal's hat in front of the kneeling figure, and by comparison with a later portrait of Juan de Torquemada included in the *Annunciation* by Antoniazzo Romano in Santa Maria sopra Minerva. The panel is accepted as a work of Angelico by Berenson (1963, p. 11), Muratoff (p. 65) and most other students of Angelico, and is ascribed by Borenius ('A Fra Angelico for Harvard', in *Burlington Magazine*, xxxix, 1921, pp. 209–10) to the years 1449–53. It finds a point of reference in the autograph panels of the Annunziata silver chest. Arguing from the fact that Torquemada was Maestro del Palazzo Apostolico in 1435–9, and supported the cause of the Dominicans of Fiesole against the Silvestrine monks of San Marco in Florence, Orlandi (pp. 62–3) suggests that the panel was presented to Torquemada during his residence in Florence in 1439. The style of the panel does not admit of so early a dating.

The panel appears originally to have been the centre of a triptych. It is likely that one of the two missing wings comprised a figure of Saint Peter formerly in the Artaud de Montor collection (for this see previous note).

The Adoration of the Magi. National Gallery of Art, Washington (Kress Collection, No. 1085). Plate 142; Fig. 46
Panel: 137·4 cm. (diameter).
Coll.: Palazzo Guicciardini, Florence (inventory of 1807, as Botticelli; sold July 1810); Dubois, Florence (?); William Coningham, London (till 1849, as Filippo Lippi); Alexander Barker, London (1854–74); Cook Collection, Richmond; Paul Drey, New York; Kress Collection (1947).

An analysis of the complex literature of this panel is supplied by Shapley (pp. 95–7). The tondo is plausibly identified with a painting listed in the 1492 Medici inventory (Müntz, *Les Collections des Médicis au XVe siècle*, 1888, p. 60: 'Uno tondo grande cholle chornicie atorno messe d'oro dipintovi la nostra Donna e el nostro Signori e e' Magi che vanno a offerire, di mano di fra Giovanni, f. 100'). It was generally ascribed to Fra Filippo Lippi until, in 1932, the thesis was advanced by Berenson ('Fra Angelico, Fra Filippo e la cronologia', in *Bollettino d'Arte*, xxvi, 1932–3, pp. 1 and 49 ff.) that the panel was begun by Fra Angelico, and completed, about 1445, by Lippi. This case is sustained by Suida (in *Paintings and Drawings from the Kress Collection*, 1951, p. 42). Lippi's authorship of the tondo is reaffirmed by Pudelko ('Per la datazione delle opere di Fra Filippo Lippi', in *Rivista d'Arte*, 1936, xviii, p. 68) and Oertel (*Fra Filippo Lippi*, 1942, p. 70), the latter with a dating ca. 1455–7. In the first edition of this book the tondo was stated to be substantially by Fra Filippo Lippi. The attribution to Angelico was subsequently withdrawn by Berenson ('Postscript, 1949: The Cook Tondo Revisited', in *Homeless Paintings of the Renaissance*, 1969, pp. 235–42), who concluded that the picture 'is entirely Fra Filippo's handiwork', though with the rider that it might depend from a *modello* by Angelico. This conclusion is unacceptable on two separate grounds. The first is that the figures are not wholly by Fra Filippo Lippi and members of his studio. Those on the right beside the city wall and a number of those in the archway on the left are more closely related to the work of Angelico than to that of Lippi, as is the Virgin in the foreground of the scene. This incongruity seems to have led Toesca (in *Enciclopedia Italiana*, xxi, 1934, p. 238) to argue that the tondo was designed and in large part painted by Lippi, but was completed by an assistant of Angelico. The second ground is that the architectural setting incorporates two separate schemes. The ascending city wall on the extreme right makes use of formulae frequently encountered in the work of Fra Angelico, but never met with in Filippo Lippi, whereas the ruined architecture in the centre distance and on the left makes use of a system of projection peculiar to Lippi but alien to Angelico. In the insecurely rendered stable in the centre the two schemes are reconciled. This would imply that work on the tondo was begun by Fra Angelico, but that at an early stage it was handed over for completion to Fra Filippo Lippi. The parallels for those parts of the altarpiece associable with Angelico are found in the panels of the Annunziata silver chest rather than in any earlier work. Certain of the heads in the background on the left seem to be by the hand responsible for the *Crucifixion* on the silver chest, and the dressing of the Virgin's hair, with braided plaits worn round the head, recurs in the silver chest panel of the *Maries at the Sepulchre*. The mistake in Berenson's initial article is therefore one of dating not of attribution. It is likely that work was started on the tondo in the early fourteen-fifties under the supervision of Angelico, to whom the upper part of the figure of the Virgin could well be due, and that the body of the tondo was painted by Fra Filippo Lippi at the date presumed by Oertel, about 1455. If this were so, it would account for the fact that the panel was regarded, thirty-seven years after the artist's death, as 'di mano di fra Giovanni'.

OTHER WORKS BY OR ASCRIBED TO FRA ANGELICO

Altenburg, Lindenau Museum (No. 91). *Saint Francis before the Sultan.* Fig. 47
Panel: 27·8 × 31·4 cm.
Purchased in Rome, 1845.

The panel forms part of a predella with scenes from the life of Saint Francis, to which three panels (Figs. 49–51) in the Staatliche Museen, Berlin/Dahlem (*The Meeting of Saints Francis and Dominic,* 26 × 31 cm.; *The Apparition of Saint Francis at Arles,* 26 × 31 cm.; and *The Death of Saint Francis,* 29 × 70·3 cm.) and a panel (Fig. 48) in the Vatican Gallery (*The Stigmatisation of Saint Francis,* 28 × 33 cm.) also belonged. The total width of the five panels is 196 cm. It was for long mistakenly supposed that they constituted the predella of the Bosco ai Frati altarpiece. Collobi-Ragghianti (in *Critica d'Arte,* ix, 1950, p. 467) suggests that the predella originates from the same altarpiece as the Pontassieve *Madonna,* now in the Uffizi; this is possible, though the central panel of the predella is 10 cm. wider than the *Madonna.* Baldini (in *Mostra,* 1955, p. 65, No. 39) supports a theory of Salmi (1955), based on the landscape and iconography of *The Meeting of Saints Francis and Dominic,* that the predella was executed for a church in Umbria. The assumption of Salmi and Baldini that the scene of the Virgin kneeling before Christ in the upper left corner of this panel is connected with intercession against plague is corrected by Orlandi (1964, p. 204). It was subsequently suggested by Salmi (1958, p. 35) that the predella belonged to an altarpiece in San Salvatore al Monte recorded as a work by Fra Angelico; this is improbable, since the main panel of the San Salvatore altarpiece represented the *Annunciation* (for this see p. 194). A dating ca. 1435–1440, that is before the predella of the San Marco altarpiece, proposed by Salmi and Oertel, is untenable, and Collobi-Ragghianti's dating ca. 1450 is to be preferred. Most critics are agreed that the execution of the panels is to a greater or lesser degree due to an assistant. A photograph of the Altenburg panel before restoration suggests that it is a damaged autograph painting by Fra Angelico. The cartoon of the panel in the Vatican, and perhaps also the execution, is Angelico's. Angelico is probably also to be credited with the cartoons of scenes (i), (ii) and (iii), the latter of which is based on the fresco of the same subject by Giotto in the Bardi Chapel. Scene (i) forms the basis of a fresco by Benozzo Gozzoli at Montefalco (1452), and provides a *terminus ante quem* for the entire predella.

Amsterdam, Rijkmuseum (No. 17A). *Madonna and Child.*
Panel: 74 × 61 cm. Fig. 53
Coll.: Quadt (till 1869); Augusteum, Oldenburg (till 1923).

Ascribed to Angelico by Bode (in *Catalogus van den Jubileum Tentoonstelling in der Rijksmuseum te Amsterdam,* 1923, No. 156), Schottmüller (1924, pp. 102, 261), A. Venturi (*Studi dal Vero,* 1927, p. 11), Berenson (1963, p. 11, and earlier), Van Marle (x, p. 138), Baldini (in *Mostra,* 1955, p. 48, No. LXII, and 1970, p. 103), and Salmi (1958, pp. 106–7). The panel is less than perfectly preserved. The arched form of the upper part is not original, and the halo of the Virgin has been cut at the top. It has been shown by C. Gomez-Moreno ('A reconstructed panel by Fra Angelico, and some new evidence for the chronology of his work,' in *Art Bulletin,* xxxix, 1957, pp. 183–93) that there were originally two angels above the curtain, one of which, from the left side, is in the Wadsworth Atheneum, Hartford (Fig. 52). A variant of the complete composition ascribed to Andrea di Giusto is in the Accademia, Florence (for this see *Mostra,* No. 97, pl. xciii). The panel is dated by Gomez-Moreno ca. 1438–40, and is related by Salmi (*loc. cit.*) to the Cortona polyptych. The handling throughout is too weak to admit of a direct ascription to Angelico, and is possibly due to the same hand as the tondo of the Virgin Annunciate above the Perugia polyptych.

Antwerp, Musée Royal des Beaux-Arts (No. 3). *Saint Romuald appearing to the Emperor Otto III.* Fig. 66
Panel: 22·3 × 27·3 cm.
Coll.: Comtesse de Looz, Florence; Van Ertborn (purchased 1825).

The panel (for which see Kaftal, c. 897–8) represents Saint Romuald forbidding the Emperor Otto to enter the church until he had done public penance for having taken the wife of the senator Crescentius as his mistress. The panel is regarded by Berenson (1963, p. 11) as a ruined work from Angelico's studio. It is, however, relatively well preserved. It is given by Salmi (1958, p. 65) to Angelico assisted by the miniaturist Sanguigni, and is listed by Baldini (1970, p. 116) among works attributed to Fra Angelico. The authorship of the painting cannot be discussed without reference to a second panel from the same predella, at Cherbourg (q.v.). The fact that these two panels originate from one predella is confirmed not only by their style and size and by the tooling of the haloes, but by the presence of a common horizontal split equidistant from the upper edge of both. A third panel from the same predella is at Chantilly (q.v.). In the present panel the asymmetrical structure, the arbitrary rendering of the architectural forms and the inconsistency of scale in the figures preclude an ascription to Angelico. There is no firm connection with Sanguigni's authenticated miniatures.

Basel, Private Collection. *Madonna and Child with Saint Catherine of Alexandria and four Angels.* Fig. 54
Canvas (transferred from panel): 91 × 46 cm.
Coll.: Barker; Earl of Dudley (sale 1892, 25 June, No. 39); Sedelmeyer, Paris; Schaeffer, Frankfurt-am-Main; Henckell, Wiesbaden; Schniewind, Neviges.

Noted by Waagen (*Treasures of Art in Great Britain*, ii, 1854, p. 231), and accepted as a work of Angelico by Crowe and Cavalcaselle (iv, p. 93), Berenson (1909, p. 22) and Schottmüller (1924, p. 260). Presumed by Van Marle (pp. 138–40) to have been executed in large part by Gozzoli. Salmi (1958, pp. 17, 100–1) regards the painting as 'una libera e meno monumentale variante di bottega' of the Thyssen *Madonna* at Lugano, and expresses some reserve on its condition, while Baldini (1970, p. 90) regards it as 'opera di altissima qualità, anchorchè in qualche parte assai consunta'. The assumption that the painting depends from the Thyssen *Madonna* is not necessarily correct, and it is likely to date from a rather earlier time. The types of the Virgin and of the Child recall the *Madonna* at Parma, and the painting may have been produced in Angelico's shop about 1435.

Berlin, Staatliche Museen (No. 60). *Madonna and Child with Saints Dominic and Peter Martyr.* Fig. 55
Panel: 70 × 51 cm.
Coll.: Solly (1821).

Ascribed to Angelico by Crowe and Cavalcaselle (iv, p. 93), Berenson (1896, p. 98; 1963, p. 11), Schottmüller (1924, p. 260) and Muratoff (p. 36). A direct ascription to Angelico is accepted by Salmi (1958, p. 102), Berti (in *Mostra*, p. 30, No. XVII) and Baldini (p. 90). The attribution is questioned by Van Marle (x, p. 140). The matter of attribution is complicated by the physical condition of the painting, especially by damage in the area of the Virgin's head. The type and pose of the Child suggest a dating between the Saint Peter Martyr triptych of 1428 and the Linaiuoli tabernacle of 1433, and the heads of the two Saints find a point of reference in the two *Scenes from the life of Saint Dominic* in the predella of the Cortona *Annunciation*. Certain features of the painting (e.g. the left hand of the Virgin and the left hand of the Child holding the orb) are inexplicably weak, and suggest that we have here to do with a damaged work designed by Fra Angelico and executed in his studio.

Berlin, Staatliche Museen (No. 60A). *The Last Judgment.*
Panel: (centre) 101 × 63 cm., (wings) 101 × 27 cm. Fig. 56
Coll.: a baker in Rome (1811); Cardinal Fesch (soon after 1816); Fesch sale (1845); Prince Musignano; Lord Ward (Earl of Dudley); purchased for Kaiser Friedrich Museum, 1884.

Originally painted on a single panel, probably of the same dimensions (116 × 148 cm.) and certainly of the same propor-

tions as a copy made by Spranger in 1567 for Pope Pius V, now in Turin. The panel is given to Angelico by Douglas (p. 132), Schottmüller (p. 264) and Berenson (1896, p. 98). Except by Muratoff (p. 36), who links it with the Santa Maria degli Angeli *Last Judgment*, it is generally regarded as a late work, dating from Angelico's first Roman period and therefore roughly contemporary with the Orvieto frescoes. The cartoon of Christ is closely related to that of the corresponding figure at Orvieto. The panel may have been produced about 1448–50. The handling throughout is strongly reminiscent of that of the Montecarlo *Annunciation*, and is perhaps by Zanobi Strozzi. This attribution is supported by Collobi-Ragghianti (in *Critica d'Arte nuova*, ii, 1955, pp. 43, 44), though with an earlier dating. An attribution to Angelico after 1446 is accepted by Salmi (1958, p. 50). According to the catalogue of the Kaiser Friedrich Museum (*Beschreibendes Verzeichnis der Gemälde im Kaiser-Friedrich-Museum und Deutschen Museum*, 1931, p. 18), a weak and overpainted copy of the Berlin *Last Judgment* appeared for sale in Rome in 1914. This was stated to have come from the church of the Cappuccini at Leonforte (near Catania) and was owned by Baron Lidestri di Artesinella. This painting (also described by Douglas, p. 199) is apparently identical with a painting in the Museo Civico di Castello Ursino, Catania. A variant, depending either from the present painting or from a related prototype, appeared in the Emile Gavet sale (Paris, Galerie Georges Petit, 1897, May 31–June 9, No. 728) as Fra Angelico. This panel, which is untraced, is of approximately the same size as the Berlin *Last Judgment* (Panel: 102 × 127 cm.), and is given by Fahy to the Master of Marradi.

Berlin, Staatliche Museen.
The Meeting of Saints Francis and Dominic (No. 61) Fig. 49.
Panel: 26 × 31 cm. Bought 1823.
The Apparition of Saint Francis at Arles (No. 62) Fig. 50.
Panel: 26 × 31 cm. Bought 1823.
The Death of Saint Francis (No. 61A) Fig. 51.
Panel: 29 × 70·3 cm.
Coll.: Farrer; Fuller-Maitland. Presented 1909 by W. von Bode.

For these three predella panels (Figs. 49–51) see under Altenburg, above.

Berne, Kunstmuseum (No. 874). *Madonna and Child.*
Panel: 46 × 35 cm. Fig. 57
Coll.: Von Stürler.

The panel was exhibited at Stuttgart (*Frühe Italienische Tafelmalerei*, 1950, No. 3) as a work of Fra Angelico ('eigenhändige Ausführung ... nicht ausgeschlossen'). It is given by Berenson (1963, p. 11) to the studio of Angelico, and is listed by Baldini (1970, p. 116) among other works ascribed to the master. By a follower of Angelico.

Boston, Museum of Fine Arts (No. 14–416). *Madonna and Child enthroned with Saints Peter, Paul and George, four Angels and a Donor.* Fig. 64
Panel: 25 × 25 cm.
Coll.: Aynard, Lyons (sale 1913, No. 33).

Berenson (1932, p. 20, and later) as Angelico; Van Marle (x, p. 156) and Muratoff (pl. cclviii) as workshop of Angelico. Orlandi (p. 64) relates the figure of St. George, which occupies a prominent place on the right of the panel, to the fact that the Dominican community of Fiesole in 1435 took over for one year the church and convent of San Giorgio sulla Costa. If this association is valid, the kneeling figure to the left of the throne may, as Orlandi claims, be a portrait of Tonnero de' Castellani, the incumbent of San Giorgio and of Sant'Andrea at Mosciano, whose renunciation of the former church paved the way to its occupation by the Dominicans. In the first edition of this book it was mistakenly suggested that the panel might be an early work by the author of a number of *Madonnas* published by Berenson ('Quadri senza casa', in *Dedalo*, xii, 1932, pp. 523–9) as Domenico di Michelino. Angelico's authorship of the panel is accepted by Salmi (1958, p. 105) and Baldini (1970). The open pose of the Child is unique in works from Angelico's shop, and recalls the Child in the San Pierino lunette of Luca della Robbia. Crowe and Cavalcaselle, as noted by Salmi, observe that the back of the panel, when in the Triqueti collection, Paris, contained a head of Christ; this was transferred, and has since disappeared. The closest point of reference for the style of the attenuated figures occurs in the *Sposalizio* in the predella of the Montecarlo *Annunciation*.

Boston, Isabella Stewart Gardner Museum. *The Burial and Assumption of the Virgin.* Fig. 72
Panel: 58 × 36 cm.

See under FLORENCE, Museo di San Marco: *Madonna della Stella.*

Cambridge (Mass.), Fogg Art Museum (1962–277). *Virgin and Child.* Fig. 61
Panel (transferred to masonite): 40·4 × 30·8 cm.
Coll.: Professor Elia Volpi (sale New York, American Art Association, 1916, 27 November, No. 991, as Masolino); A. Kingsley Porter; bequeathed to the Fogg Art Museum by Lucy Wallace Porter.

There is substantial damage in the Virgin's mantle, and her hands are rubbed, but the heads of the two figures and the gold background and haloes are well preserved. The panel is published by Collobi-Ragghianti (in *Critica d'Arte nuova*, ii. 1955, p. 43) as a work of Zanobi Strozzi of ca. 1436, and is given by Berenson (1963, p. 217) to an unidentified Florentine artist close to Masolino. The attribution to Fra Angelico is due to Everett Fahy. The principal stylistic influence in the paint-

ing is that of Gentile da Fabriano, which is reflected, e.g., in the floriated punching of the background, in the types of the two figures and in the flower held by the Child. The panel is evidently earlier in date than the Fiesole altarpiece, and is likely to have been painted about 1423.

Chantilly, Musée Condé (No. 6). *Saint Benedict in Ecstasy.*
Panel: 17 × 26 cm. Fig. 67

At one time explained as *Saint Jerome in Prayer*, the scene is now commonly regarded (Salmi, 1958, p. 105; Berenson, 1963, p. 11; Baldini, 1970, p. 116) as *Saint Benedict in Ecstasy*. It appears to have formed part of the same predella as the Antwerp *Saint Romuald appearing to the Emperor Otto III*, which is likely to have been painted for a Camaldolese or Benedictine church. The present panel is regarded by Berenson (1963, p. 11, and earlier editions) as a product of Angelico's studio, and is identified by Salmi (1958, pp. 89, 105) as part of the predella of a lost altarpiece by Fra Angelico in the Certosa di Galluzzo described by Vasari (see under Lost Works). This identification is impossible, since the Certosa altarpiece showed Saints Lawrence, Mary Magdalen, Zenobius and Benedict, and the surviving parts of the predella depict scenes from the lives of Saints Julian (?), Romuald and Benedict. Salmi appears to give this 'così nobile composizione' to Angelico. The structure is incompatible with that of Angelico's known works, and the attribution is rightly rejected by Baldini (1970, p. 116). Collobi-Ragghianti gives the panel first to Zanobi Strozzi (in *Critica d'Arte*, xxxii, 1950, pp. 454, 457) and subsequently to Angelico (in *Critica d'Arte nuova*, ii, 1955, p. 47).

Cherbourg, Musée (No. 8). *The Penitence of Saint Julian* (?)
Panel: 20 × 32 cm. Fig. 68
Coll.: Thomas Henry (presented to the Musée de Cherbourg, 1835).

The subject is traditionally identified as the *Conversion of Saint Augustine*. According to Kaftal (c. 104), it represents Saint Augustine 'meditating in the garden under a tree with his young son and Alypius near by, the Epistles of Saint Paul in his hand. Christ speaks to him: *Tolle, tolle, et lege*.' The standard iconography of this scene is that employed by Benozzo Gozzoli in Sant'Agostino at San Gimignano. In the present panel the son of Saint Augustine does not appear, and the volume of Epistles is also omitted. It is, therefore, likely that the panel represents some other scene. The subject is described by Longhi (in *Critica d'Arte*, xxv, 1940, p. 175) as the *Penitence of Saint Julian*. Another panel from this predella, at Antwerp (q.v.), shows a scene from the life of Saint Romuald. Ascribed to the circle of Angelico by Reinach ('La Vision de Saint Augustin', in *Gazette des Beaux-Arts*, 1929, i, p. 257), it is regarded as an early work by Fra Angelico by Longhi (loc. cit.) and was exhibited under Angelico's name in Paris in 1956 (Orangerie, *De Giotto à Bellini*, No. 44, pp. 30–1). It is tenta-

tively looked upon by Berenson (1963, p. 142) as an early work by the Master of the Castello Nativity, and is given by Salmi (1958, p. 92) to Zanobi Strozzi. The panel is by the same hand as the companion panels at Antwerp and Chantilly, which were originally part of the same predella.

Cincinnati, Cincinnati Art Museum (1966.267). *Madonna and Child.* Fig. 58
Panel. Diameter: 19·3 cm. (painted surface).

This much damaged panel is published in the *Bulletin of the Cincinnati Art Museum*, 1968, p. 43, as a work by Fra Angelico. It is given by Fredericksen and Zeri (*Census of Pre-Nineteenth Century Italian Paintings in North American Public Collections*, 1972, p. 9) to a follower of Fra Angelico. The dominant influence in this modest painting is that of Masolino.

Cleveland, Museum of Art. *The Coronation of the Virgin.*
Panel: 27 × 37 cm. Fig. 65
Coll.: Contini-Bonacossi; Elisabeth Severance Prentiss.

Published by H. S. Francis (*Catalogue of the Elisabeth Severance Prentiss Collection*, Cleveland Museum of Art, 1944, p. 21, No. 1) as 'certainly contemporary with, or directly from the workshop of, the master himself'. Stated to have been ascribed to Angelico by Swarzenski, Mather, Mayer and Longhi, the latter with a dating ca. 1425–30. Close in style to Arcangelo di Cola da Camerino.

Detroit, Institute of Arts. *The Virgin and Child with four Angels.* Fig. 76
Panel: 16·2 × 9·7 cm.
Coll.: Baron Maurice de Rothschild, Paris.

The panel is published by Richardson (in *Bulletin of the Detroit Institute of Arts*, xxxv, 1956, pp. 87–8, and *Art Quarterly*, 1956, pp. 319–20) as a work painted by Angelico 'approximately in the 1420s'. The attribution is accepted by Salmi (1958, p. 85), Berenson (1963, p. 11), Longhi, Berti and Baldini (1970, p. 86), either with a generic reference to Angelico's early style (Berenson) or with specific reference to the Saint Peter Martyr triptych 'e le altre prime cose dell'Angelico' (Baldini). Though less than perfectly preserved, the panel is indubitably autograph. The handling is more fluid than that of the Saint Peter Martyr triptych, and recalls the *Last Judgment* in the Museo di San Marco and the predella of the Cortona *Annunciation*; this would be consistent with a dating ca. 1430–2.

Detroit, Mrs. Edsel Ford. *Annunciatory Angel; Virgin Annunciate.* Fig. 75
Panel: 36 × 26 cm. each.
Coll.: Duke of Hamilton; J. E. Taylor; Sedelmeyer; Carl Hamilton.

Ascribed to Angelico by Berenson (1932, p. 20 and later), Van Marle (x, p. 143), L. Venturi (*Italian Paintings in America*, 1933, Nos. 176, 177) and most other critics. In the first edition of this book it was suggested that the panels formed the lateral pinnacles of an altarpiece, perhaps the *Coronation of the Virgin* in the Louvre, where the tooled haloes of a number of the angels in the upper part of the panel are closely similar. This hypothesis is supported by Salmi (1958, p. 110) and Baldini (1970, p. 94). According to Crowe and Cavalcaselle (iv, 1911, p. 76 n.), who saw the panels at Hamilton Palace, the gold ground of both panels was then overpainted in blue. Salmi (1958, p. 33) suggests that the figures were originally represented in full length. They are identified by Orlandi (p. 60) with 'duas parvas icones depictas a Beato fratre Johanne angelico . . . videlicet B. Mariae Annuntiatae et Angeli annuntiantis,' which were presented by the convent of San Domenico at Fiesole to Cardinal Scaglia in 1622.

Florence, Biblioteca Laurenziana. *Diurno Domenicale* No. 3.

The miniatures in this volume from Santa Maria degli Angeli fall into two groups, one of which is correctly given by Ciaranfi ('Lorenzo Monaco miniatore', in *L'Arte*, n.s. iii, 1932, pp. 302–17) to Lorenzo Monaco, while the other is assigned to a 'tendenza dell'Angelico' with the tentative suggestion that it might comprise the earliest known works of the artist. Salmi (1950, pp. 75–7) accepted the following illuminations as works by Fra Angelico of ca. 1409:

c. 1v.	*Resurrection.*
c. 6v.	*Christ with two Apostles on the road to Emmaus.*
c. 11r.	*Christ and the Apostles.*
c. 15r.	*The Elect contemplating the Redeemer.*
c. 23v.	*Christ and the Apostles.*
c. 41v.	*Choir of Monks.*
c. 57v.	*David dancing.*
c. 80v.	*Pentecost.*

When the researches of Orlandi had shown that an ascription to Angelico ca. 1409 could not be sustained, the eight miniatures were once more ascribed to Angelico by Salmi (1958, pp. 95–6) with a dating ca. 1420. The attribution to Angelico was contested in the first edition of this book, and is rejected by Berti (1963, p. 34). Longhi (p. 163) assigns the illuminations not to the year inscribed on the volume (1409) but to ca. 1420, and regards them as the work of an unknown imitator of Angelico, perhaps Battista di Biagio Sanguigni. M. Levi d'Ancona ('Some new Attributions to Lorenzo Monaco', in *Art Bulletin*, xl. 1958, pp. 180, 188–9) refers all the illuminations in the book to the years 1422–3, and suggests that two of

the narrative scenes were begun by Lorenzo Monaco, one of them (*Dance of David* f. 55v.) being completed by Zanobi Strozzi, who would also, after 1450, have been responsible for f. 22v, 15 and 39v.

The eight miniatures listed above are tentatively given by Berenson (1963, p. 6, and earlier editions) to Andrea di Giusto.

Florence, Museo di San Marco. *Madonna and Child enthroned.* Fig. 60
Panel: 189 × 81 cm.
Provenance unknown.

In the left hand of the Child is a cartellino with the words:

·DISCITE A ME QVIA MITIS SVM Z. VMILIS CORDE Z.INVENIETIS REQVIEM ANIMABVS VESTRIS.

The painting formed the central panel of a triptych or polyptych. As pointed out by Schottmüller (p. 227), its scheme is generically related to that of the Monte Oliveto altarpiece of Lorenzo Monaco of 1406–10, now in the Uffizi, and on this account it has been regarded as Angelico's earliest surviving work, Muratoff (p. 27) and Salmi (1958, pp. 8, 95) proposing a dating about 1420 and Schottmüller (p. 1) placing it in the bracket 1425–30. Longhi (1928–9, p. 155) alone advances a dating after 1430. The treatment is conspicuously less Gothic than that of the central panel of the altarpiece in San Domenico at Fiesole, and the earliest admissible date is about 1430. Berti (in *Mostra*, No. 2, p. 5) concurs in this dating. An unconvincing attempt is made by Berti ('Un foglio miniato dell'Angelico', in *Bollettino d'Arte*, xlvii, 1962, p. 214) to identify the lateral panels of the altarpiece in paintings of *SS. John Baptist and Jerome* and *SS. Francis and Onophrius* from the Certosa di Galluzzo. A derivative from Lorenzo Monaco's polyptych is found in the Prato altarpiece of Andrea di Giusto as late as 1435. Berenson (1909, p. 105) notes that the *Trinity* in the upper part of the frame is not by Angelico; the ascription of this part of the painting to Angelico is accepted by Salmi (1950, p. 78). After cleaning (1955) the figures of the Virgin and Child seem to be wholly by Angelico. The spatial treatment of the throne is one of several features which are wholly irreconcilable with the Certosa panels.

Florence, Museo di San Marco. *Madonna della Stella.*
Panel: 60 × 30 cm. Fig. 69

The painting is one of four reliquary panels formerly preserved in Santa Maria Novella. The attribution of these panels to Angelico goes back to a passage in the *Chronaca* of Biliotti of 1570–1600 (xix, p. 24, quoted by Marchese, i, p. 270): 'Habemus et multas plurimorum Sanctorum reliquias, quas quidem fr. Joannes Masius fiorentinus, multae devotionis et taciturnitatis vir, in quatuor inclusit tabellas, quae fr. Joannes fesolanus pictor, cognomento Angelicus, pulcherrimis beatissimae Mariae Virginis et Sanctorum Angelorum ornavit

figuris. Obiit fr. Joannes Masius anno 1430.' The latter date is qualified by Marchese with the gloss: 'Nel manoscritto si legge veramente 1333, ma deb' essere un errore di penna.' An entry in the *Necrologio* of Santa Maria Novella (f. 58 n.) reveals that Fra Giovanni Masi in fact died in 1434: 'N. 603. Fr. Johannes Masi obiit florentie die 27 junij 1434. hic fuit maxime devotionis vir ad unguem regularem vitam servavit quoad omnia sed potissime quoad silentium fuit enim supra modum taciturnus et tam magnus et assiduus confessor quod ex assiduitate maxima plures intraret egritudines . . . hic plurima de suis patrimonialibus paramenta faciens in sacristia et plures reliquias sanctorum adornavit.' The reliquary panels are also mentioned by Vasari (ii, p. 513): 'e in Santa Maria Novella, oltre alle cose dette, dipinse di storie piccole il cereo pasquale, ed alcuni reliquieri che nelle maggiori solennità si pongono in sull'altare.' The other three reliquary panels are presumed to be:

(i) *The Annunciation and the Adoration of the Magi.* Museo di San Marco, Florence. Fig. 70
Panel: 42 × 25 cm.
(ii) *The Coronation of the Virgin.* Museo di San Marco, Florence.
Panel: 42 × 25 cm. Fig. 71
(iii) *The Burial and Assumption of the Virgin.* Isabella Stewart Gardner Museum, Boston. Fig. 72
Panel: 58 × 36 cm.

The four panels are noted by Richa (iii, 1754, p. 49) in the sacristy of Santa Maria Novella. By 1847, however, when they were described by Kugler (*Handbuch der Geschichte der Malerei*, 1847, i, p. 358), one of the four reliquaries had disappeared (for this see also Paatz, iii, pp. 834–5). The three remaining panels (the *Madonna della Stella* and those listed as (i) and (ii) above) were seen by Milanesi (in Vasari, ii, p. 514 n.) in a reliquary cupboard in Santa Maria Novella, and were transferred in 1868 to San Marco. The Boston panel was purchased in the first half of the nineteenth century by the Rev. John Sanford, and bequeathed by him in 1857 to Lord Methuen; it was sold through Colnaghi to Mrs. Gardner in 1899. Waagen (*Galleries and Cabinets of Art in Great Britain*, 1857, p. 397) states that the panel was 'formerly the altarpiece of a chapel near Leghorn'. This pedigree is mistranscribed by Salmi (1958, p. 101): 'Poi ricompare in una cappella presso Leghorn (Inghilterra), dove l'aveva posto il Rev. John Sanford; quindi a Lorsham (Wiltshire) nella collezione di Lord Methuen.' There is a high degree of probability that this is the reliquary panel removed from Santa Maria Novella before 1847.

The statement of Biliotti that the four reliquaries were commissioned by Fra Giovanni Masi led earlier writers on Angelico to date them before Masi's presumed death in 1430. If Biliotti's statement is accepted at its face value, the *terminus ante quem* for all four panels would be 1434. Internal evidence suggests that a dating ca. 1430–4 is very probable. Thus the angels in the frame of the *Madonna della Stella* anticipate those in the frame of the Linaiuoli Tabernacle; the *Adoration of the Magi* at the bottom of the second reliquary panel recalls, in the treatment of the ground and the posing of the figures, the

Naming of the Baptist in the Museo di San Marco; the *Annunciation* seems to depend from the Cortona *Annunciation*; the *Adoration of the Child* in the predella of the *Coronation of the Virgin* recalls the panel of the *Nativity* at Forlì; and the *Burial of the Virgin* under the Boston *Assumption* is related to the comparable panel from the predella of the *Coronation of the Virgin* in the Uffizi. Irrespective of the issue of authorship, the claim of Salmi (1958, p. 97) that the *Madonna della Stella* was painted about 1425 is logically untenable. More persuasive is a dating shortly before 1434 proposed by Berti (in *Mostra*, 1955, pp. 7–8, No. 3) and Baldini (p. 93). The four reliquaries were regarded by Richa (loc. cit.) as a cycle of scenes from the life of the Virgin ('i misteri della vita di Maria Vergine'), and may have been so commissioned, but they vary in structure and size, and it cannot necessarily be assumed that they were ordered as a group and not commissioned sequentially. It is argued by Salmi (1958, p. 101) that the *Madonna della Stella* is the earliest and the *Assumption* the latest of the panels.

All four panels are accepted as works of Angelico by Berenson (1909, pp. 104–5, and subsequent editions). Some measure of studio intervention is presumed by other students. The *Madonna della Stella* is given to Angelico by all critics save Wurm (p. 7), and the *Annunciation and Adoration of the Magi* is accepted by Douglas (p. 35), Schottmüller (p. 257), Van Marle (x, p. 46), Papini (p. 15), Muratoff (pp. 29–30), Bazin (p. 181), Berti (in *Mostra*, 1955, pp. 7–8, No. 3), Salmi (1958, p. 98) and Baldini (1970, p. 93). The Boston panel is accepted by Douglas (pp. 37–8), Schottmüller (p. 256), Hendy (*The Isabella Stewart Gardner Museum: Catalogue of the Exhibited Paintings and Drawings*, 1931, pp. 10–13), Salmi (1958, p. 101), and Baldini (p. 93), and rejected by Wurm (pp. 6–7), Van Marle (x, pp. 46, 148), Muratoff (Pls. xlii, xliii) and Bazin (p. 181). Van Marle advances a tentative ascription for this panel to Zanobi Strozzi, and Wurm and Muratoff ascribe it to the artist responsible for the predella panels of *The Marriage and Burial of the Virgin* in the Museo di San Marco. Studio intervention is presumed by Salmi, Baldini and Meiss (in *Studies in Western Art*, 1963, ii, p. 140). The *Coronation of the Virgin* is denied to Angelico by Douglas (pp. 38–43), Schottmüller (pp. 267–8), Van Marle (x, p. 46), Muratoff (pls. xli, xlii) and Bazin (p. 181). In the first edition of this book all four panels were given, wrongly, to Zanobi Strozzi.

In discussing the authorship of the paintings, account must naturally be taken of their condition. Muratoff suggests that discrepancies between the type of the Virgin in the *Madonna della Stella* and comparable figures in the autograph paintings of Angelico are due to restoration. Examination of the surface of the panel does not substantiate this view. As noted by Salmi, however, the Saints in the foreground of the *Coronation of the Virgin* are extensively restored. There is no reason to doubt that all four panels were commissioned from Angelico's workshop at Fiesole, and were planned under his supervision. It is, however, difficult to believe that he had any share in the execution of the *Madonna della Stella*, or in the main panel of the *Annunciation and Adoration of the Magi*; in the latter the Virgin and Child reveal the same mannerisms as the *Madonna della Stella*, and the formulation of St. Joseph and of the King kneeling in the centre is markedly inferior to those of figures in autograph paintings of the time. The damaged predella of the *Coronation of the Virgin* was possibly painted by Angelico. The Boston *Burial and Assumption of the Virgin* is by two different hands, neither of which is Fra Angelico's. The four panels enjoy a prominence in the Angelico literature which is justified neither by their historical significance nor by their quality. They seem to have been carried out by two or more miniaturists in Angelico's shop who may also have been employed on subsidiary parts of the *Last Judgment* in the Museo di San Marco and of the *Coronation of the Virgin* in the Uffizi.

Florence, Museo di San Marco. *Christ on the Cross with the Virgin and Saint John the Evangelist. The Coronation of the Virgin.* Figs. 73–4
Panel: 19 cm. diameter (each).

The two panels are recorded in the church of Santa Maria della Croce al Tempio (Paatz, iii, pp. 308–10). After the church was secularised, they were transferred (1786) to the Confraternity of Santa Lucia in the Annunziata, whence they were removed first to the Accademia and then to the Museo di San Marco. Though widely accepted as autograph works (e.g. by Berenson, 1963, p. 12, and previous editions; Salmi, 1958, pp. 117–18; Baldini, 1970, p. 117, doubtfully), the tight and mannered handling is uncharacteristic of Angelico. There can be no reasonable doubt (Schneider, Schottmüller, Pope-Hennessy) that the tondo with the *Coronation of the Virgin* depends from the fresco of the same subject in Cell 9 at San Marco, and the proportions of the Christ in the *Crucifixion* tondo repeat those of, e.g., the *Crucifixion* in the Sala del Capitolo at San Marco. For this reason the panels are unlikely to have been painted before the mid-forties. They are ascribed in the first edition of this book, possibly correctly, to the Master of Cell 2 at San Marco.

Florence, Museo di San Marco. *Crucified Christ.*
Panel: 164 × 100 cm.
From the depot of the Florentine Soprintendenza (inv. 1890, No. 6084).

Previously assigned to the school of Lorenzo Monaco, the Crucifix was cleaned in 1959 and exhibited (*Catalogo della X Mostra d'opere d'arte restaurate*) as an early work of Fra Angelico. The attribution is accepted by Berti (in *Acropoli*, iii, 1963, p. 11) with a dating soon after the Saint Peter Martyr triptych, and by Baldini (1970, p. 87). The drawing and lighting of the features recall the head of Saint Peter Martyr in the Fiesole high altar more closely than that of the same Saint in the Saint Peter Martyr triptych, and the panel appears to date from about 1425. There is no means of establishing whether or not it is identical with the lost Crucifix painted for Santa Maria Nuova in 1423 (see p. 238).

Florence, Uffizi. *The Virgin and Child.* Fig. 59
Panel: 134 × 59 cm.

From the Prepositura di San Michele Arcangelo, Pontassieve. On the frame at the base of the panel is an incomplete inscription which reads: TONIO DI LVCA E PIERO DI NICHOLAIO E SER PIERO (presumably with reference to the donors or the operaii of the church). The panel, which evidently formed the centrepiece of a dismembered polyptych, was published for the first time in 1930, when it was shown at the exhibition of Italian Art at the Royal Academy in London (No. 82). It is listed by Berenson (1963, p. 12) as a studio work. Collobi-Ragghianti ('Zanobi Strozzi' in *Critica d'Arte*, xxxii, 1950, p. 467) wrongly identifies a fragmentary *Saint Francis* in the Johnson Collection, Philadelphia Museum of Art, as one of the missing lateral panels of the altarpiece, which she assigns to the bracket 1447–53. A dating about 1440–5 was proposed in the first edition of this book. The cartoon of the Child is, however, all but identical with that of the Bosco ai Frati altarpiece, which must date from after 1450.

Florence, San Niccolò del Ceppo. *Christ on the Cross adored by Saints Nicholas of Bari and Francis.* Fig. 62
Panel: 210 × 186 cm.

The history of the Crucifix and the two kneeling Saints goes back to 1677, when they are described by Bocchi-Cinelli as on the high altar of the church. They were subsequently (Paatz, iv, pp. 394, 397–8) moved to the Sacristy. The present church of San Niccolò del Ceppo was built in 1561–3, and there is a high degree of probability that the painting was transferred there from the church of Santi Filippo e Jacopo del Ceppo, which was constructed after 1414 as the seat of the Compagnia di San Niccolò (delle Sette Opere della Misericordia). The church was dedicated in 1417, and was served initially by Franciscan tertiaries from Doccia. As noted by Salmi (1958, p. 101), the Christ on the Cross and the two Saints were from the first silhouetted, and did not form part of a polyptych; in this they recall models by Lorenzo Monaco.
The upper part of the figure of Saint Francis is a modern substitution for the original panel (now in the Philadelphia Museum of Art, Johnson Collection, q.v.). The Crucifix is associated with Angelico by Poggi (in *Rivista d'Arte*, vi, 1909, p. 132). It is ascribed by Berti (in *Mostra*, 1955, No. 25, pp. 45–6) and Salmi (1958, p. 101) to the workshop of Angelico, with a tentative dating ca. 1433–4, but is rightly accepted by Baldini (1970, p. 96) as an autograph work. The balance of probability is that it dates from about 1430.

Florence, Convento di Santa Trinita. *Christ on the Cross with the Virgin and Saint John the Evangelist.* Fig. 77
Parchment: 34 × 22 cm.

The miniature, which is rectangular in form, is surrounded by a decorative border. At the corners of the border are roundels of the Evangelists and at the base is a roundel of St. Dominic. Beneath is the inscription PROPTER NOS/ET PROPTER NOS/HOMINES/TRA(HVNT) SALVTE(M). Unrecorded prior to its appearance in 1961 at the Mostra di Arte Sacra Antica, Florence (No. 190), it is regarded by Berti ('Un foglio miniato dell'Angelico', in *Bollettino d'Arte*, xlvii, 1962, pp. 207–15, and 'Miniature dell'Angelico (e altro)—ii', in *Acropoli*, iii, 1963, p. 34) as an autograph work by Angelico of ca. 1435–40. The attribution is warranted by the exceptionally high quality of the illumination, and the dating by its style, which anticipates that of the *Crucifixion* on the main panel of the San Marco altarpiece. The half-length figures in the roundels are closely related to the autograph miniatures in Missal No. 558.

Florence, Private Collection. *Madonna and Child.*
Panel.

Published by Berti (in *Acropoli*, iii, 1963, ii, p. 16, fig. 12) as a work of Angelico assisted by Zanobi Strozzi of ca. 1428–30. This dating rests on a supposed connection with the Fiesole high altarpiece. The ascription is accepted by Baldini (1970, p. 89), who detects Masaccesque influences in the panel. In photograph the relationship to the San Domenico *Madonna* appears superficial. The type of the Virgin recalls that in the Sant'Andrea a Ripalta triptych of 1436 by Andrea di Giusto, and it is possible that the panel is an earlier work by this artist.

Forlì, Pinacoteca. *The Nativity* and *The Agony in the Garden.*
Panel: 26 × 16 cm. each. Figs. 78–9

Presented to the gallery by Missirini, the panels were published by Santarelli (in *Le Gallerie Nazionali Italiane*, iii, 1897, p. 154) as works of Angelico. They were later associated with the workshop of Angelico by Schottmüller (1924, p. 241) and other critics, and were republished by Longhi (p. 176) as autograph early works datable before 1430. In the first edition of this book the panels were assigned to the workshop of Angelico, with a conjectural late dating; they are given by Salmi (1958, pp. 35, 110–11) to 'la piena maturità dell'Angelico non senza il parziale intervento di un aiuto'. Baldini (in *Mostra*, Nos. 37, 38, p. 64; and 1970, pp. 107–8) regards them as autograph works of about 1440, and Collobi-Ragghianti (in *Critica d'arte nuova*, ii, 1955, p. 47) places them in the bracket 1446–8. The panels are sometimes described as a diptych, but probably formed the wings of a small triptych, and seem originally to have been completed with engaged framing, since removed. The suggestion of Longhi that they formed part of the same predella as the *Naming of the Baptist* in the Museo di San Marco and the related panel in the Des Cars collection cannot be sustained. The four panels must, however, have been painted at almost the same time, and the two paintings at Forlì are, as was emphasised by Longhi, strongly Masaccesque, the seated figure of Saint Peter depending

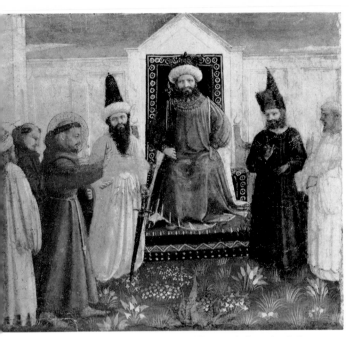

Fig. 47. Fra Angelico (?): *Saint Francis before the Sultan*.
Lindenau Museum, Altenburg

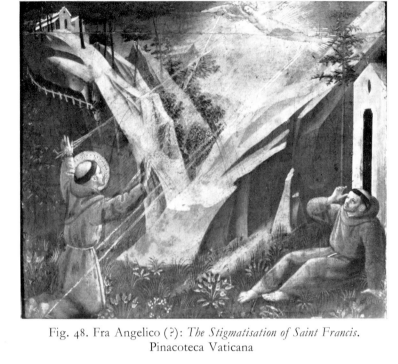

Fig. 48. Fra Angelico (?): *The Stigmatisation of Saint Francis*.
Pinacoteca Vaticana

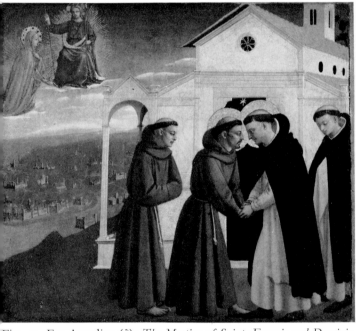

Fig. 49. Fra Angelico (?): *The Meeting of Saints Francis and Dominic*.
Staatliche Museen, Berlin

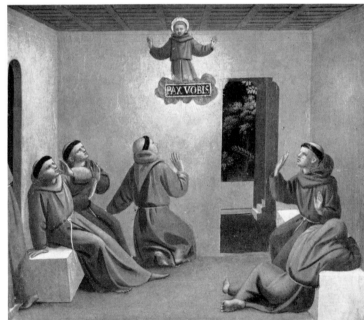

Fig. 50. Fra Angelico (?): *The Apparition of Saint Francis at Arles*.
Staatliche Museen, Berlin

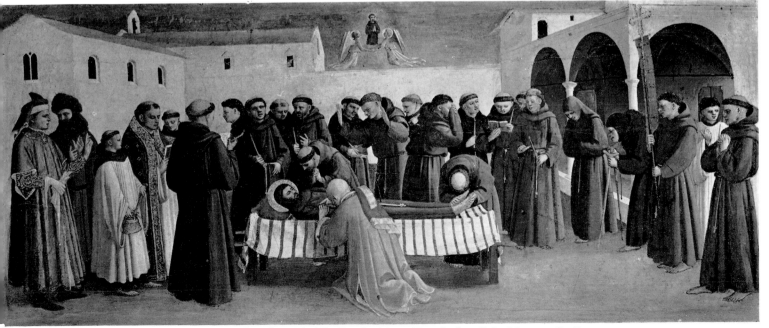

Fig. 51. Fra Angelico (?): *The Death of Saint Francis*. Staatliche Museen, Berlin

Fig. 52. Workshop of Fra Angelico:
Angel, from upper left corner of
Amsterdam *Madonna.* Wadsworth
Atheneum, Hartford, Conn.

Fig. 53. Workshop of Fra Angelico: *Madonna and Child.*
Rijksmuseum, Amsterdam

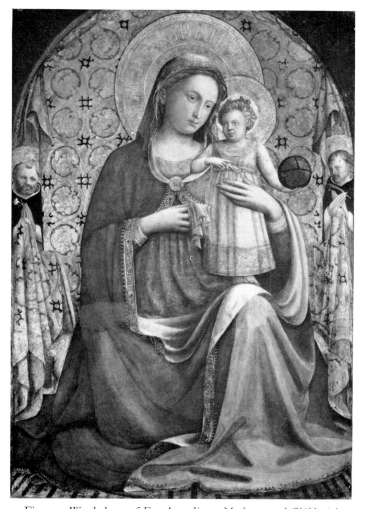

Fig. 54. Workshop of Fra Angelico: *Madonna and Child with
Saints Catherine of Alexandria and four Angels.* Private Collection,
Basel

Fig. 55. Workshop of Fra Angelico: *Madonna and Child with
Saints Dominic and Peter Martyr.* Staatliche Museen, Berlin

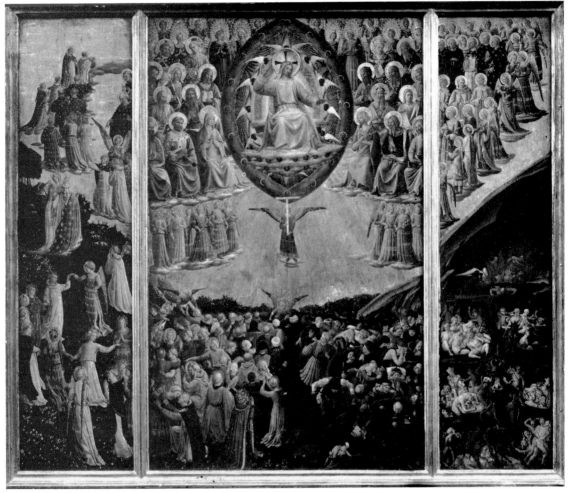

Fig. 56. Zanobi Strozzi (?): *The Last Judgment*. Staatliche Museen, Berlin

Fig. 57. Imitator of Fra Angelico: *Madonna and Child*.
Kunstmuseum, Berne

Fig. 58. Florentine School: *Madonna and Child*.
Cincinnati Art Museum

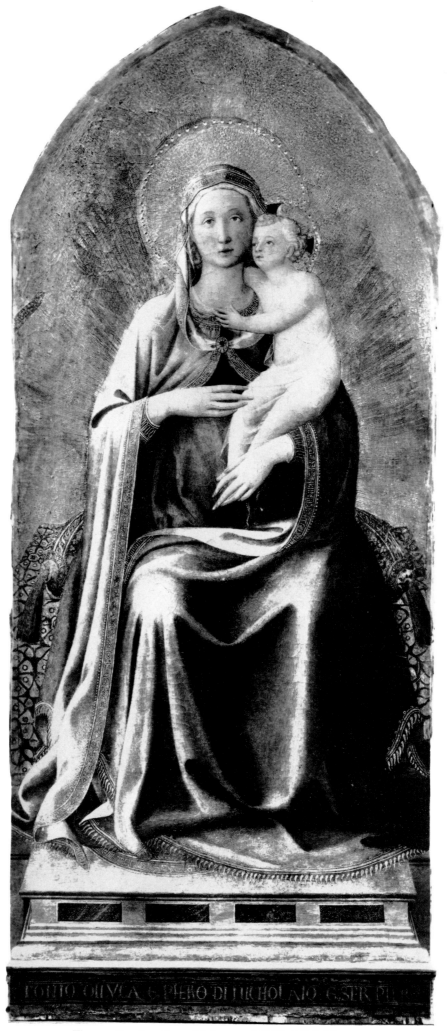

Fig. 59. Fra Angelico: *Madonna and Child*. Uffizi, Florence

Fig. 60. Fra Angelico: *Madonna and Child*.
Museo di San Marco, Florence

Fig. 61. Fra Angelico: *Madonna and Child*.
Fogg Museum of Art, Cambridge (Mass.)

Fig. 62. Fra Angelico: *Christ on the Cross adored by Saints Nicholas and Francis*.
San Niccolò del Ceppo, Florence

Fig. 63. Fra Angelico: *Saint Francis*. Philadelphia
Museum of Art (Johnson Collection)

Fig. 64. Zanobi Strozzi (?): *Madonna and Child Enthroned with Saints Peter, Paul and George, four Angels and a Donor*. Museum of Fine Arts, Boston

Fig. 65. Style of Arcangelo di Cola: *The Coronation of the Virgin*. Cleveland Museum of Art

Fig. 66. Imitator of Fra Angelico: *Saint Romuald appearing to the Emperor Otto III*. Musée Royal des Beaux-Arts, Antwerp

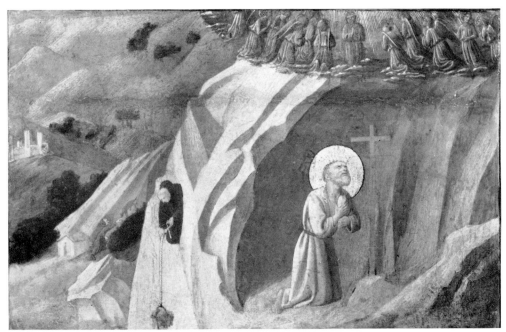

Fig. 67. Imitator of Fra Angelico: *Saint Benedict in Ecstasy*. Musée Condé, Chantilly

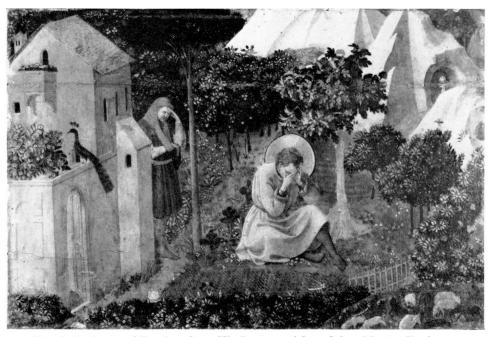

Fig. 68. Imitator of Fra Angelico: *The Penitence of Saint Julian*. Musée, Cherbourg

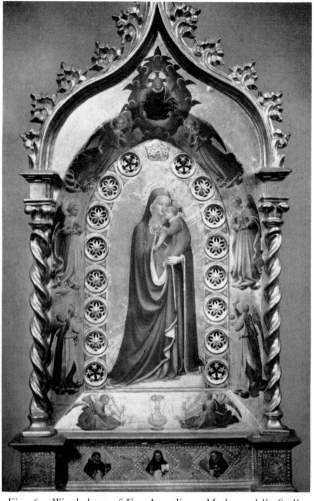

Fig. 69. Workshop of Fra Angelico: *Madonna della Stella*. Museo di San Marco, Florence

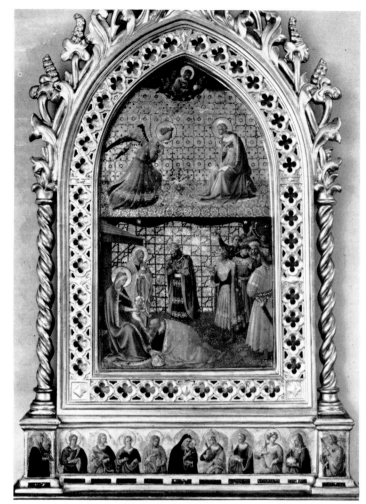

Fig. 70. Workshop of Fra Angelico: *The Annunciation and The Adoration of the Magi*. Museo di San Marco, Florence

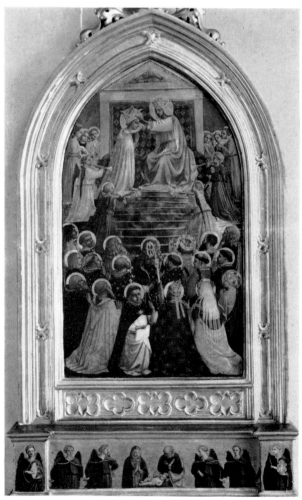

Fig. 71. Workshop of Fra Angelico: *The Coronation of the Virgin*. Museo di San Marco, Florence

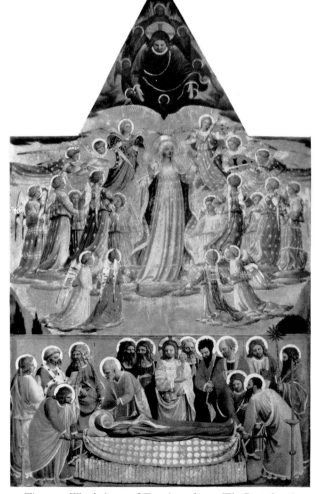

Fig. 72. Workshop of Fra Angelico: *The Burial and The Assumption of the Virgin*. Gardner Museum, Boston

Figs. 73–74. Master of Cell 2 (?): *Christ on the Cross with the Virgin and Saint John; The Coronation of the Virgin.*
Museo di San Marco, Florence

Fig. 75. Fra Angelico: *Annunciatory Angel; Virgin Annunciate.* Mrs. Edsel Ford, Detroit

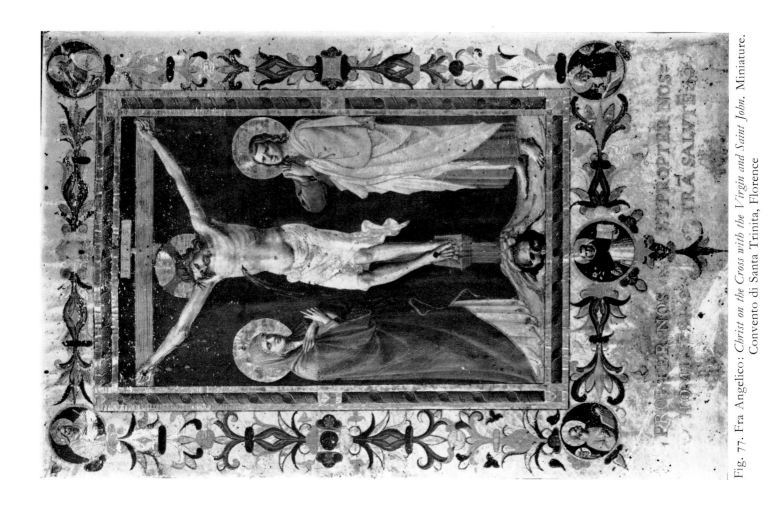

Fig. 77. Fra Angelico: *Christ on the Cross with the Virgin and Saint John.* Miniature.
Convento di Santa Trinita, Florence

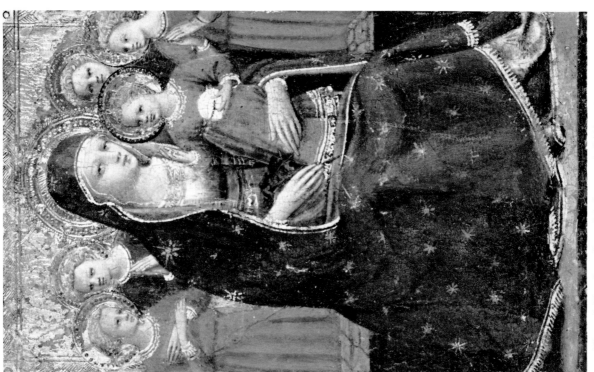

Fig. 76. Fra Angelico: *Madonna and Child with four Angels.*
Institute of Arts, Detroit

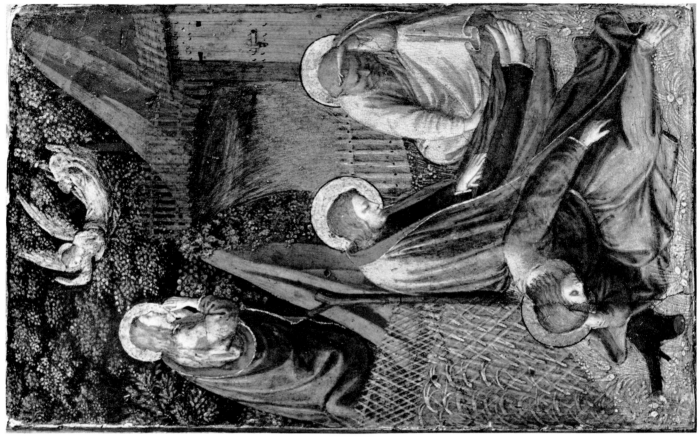

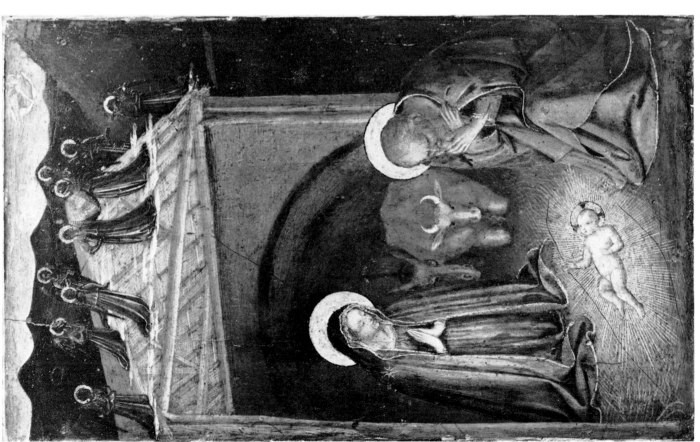

Figs. 78–79. Fra Angelico: *The Nativity; The Agony in the Garden*. Pinacoteca, Forlì

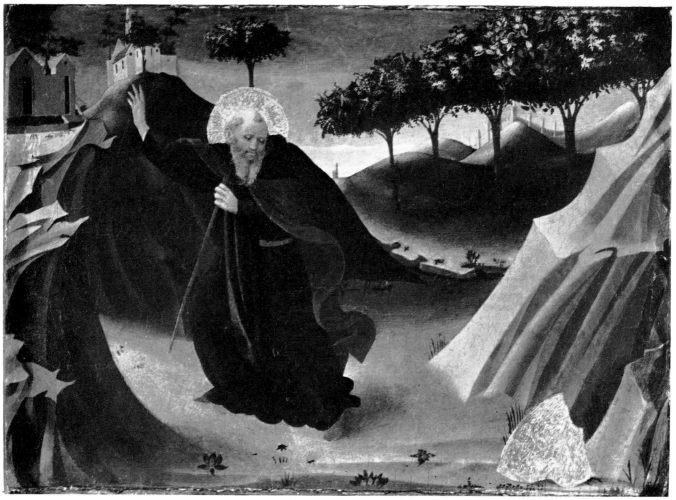

Fig. 80. Imitator of Fra Angelico: *The Temptation of Saint Anthony the Abbot*. Museum of Art, Houston

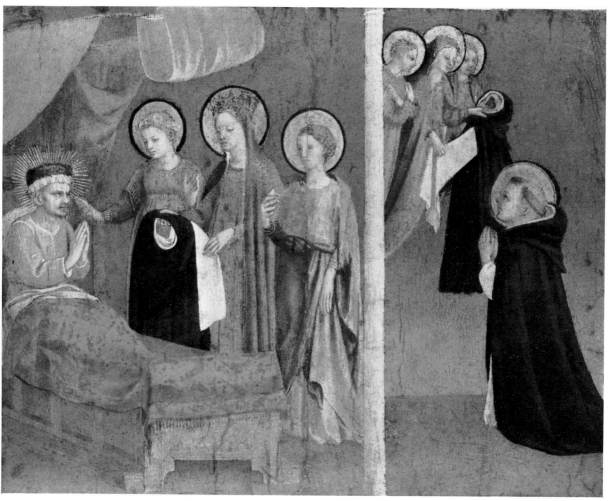

Fig. 81. Workshop of Fra Angelico: *Scenes from the Life of Saint Dominic*. National Gallery, London

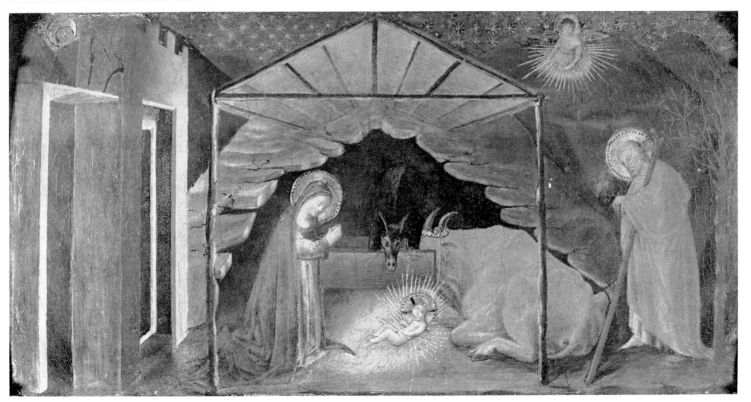

Fig. 82. Imitator of Fra Angelico: *The Nativity*. Clowes Foundation, Indianapolis

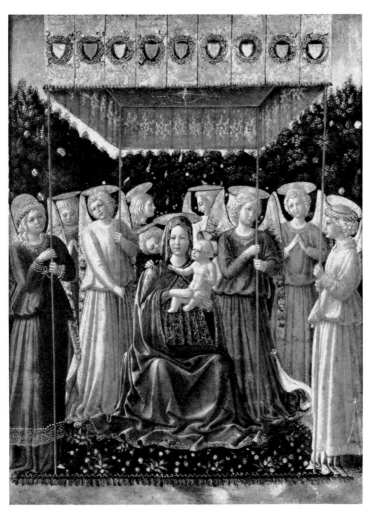

Fig. 83. Florentine School: *Madonna and Child with nine Angels*.
National Gallery, London

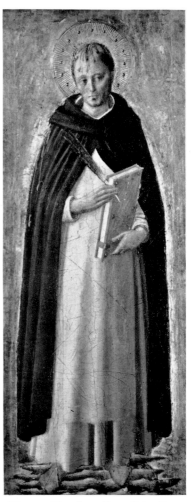

Fig. 84. Fra Angelico: *Saint Peter Martyr*. Royal Collection, London

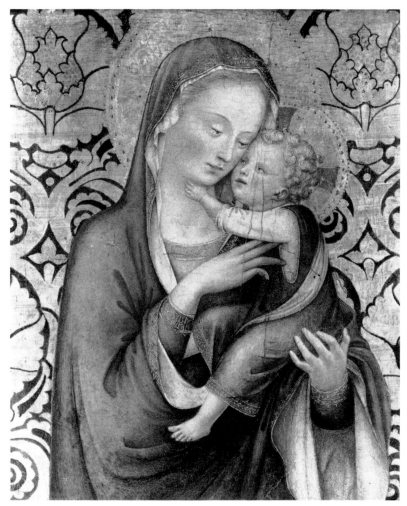

Fig. 85. Imitator of Fra Angelico: *Madonna and Child*. Norton Simon
Foundation, Los Angeles

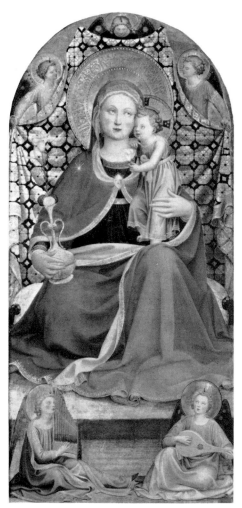

Fig. 86. Workshop of Fra Angelico:
Madonna and Child with five Angels.
Thyssen-Bornemisza Collection, Lugano

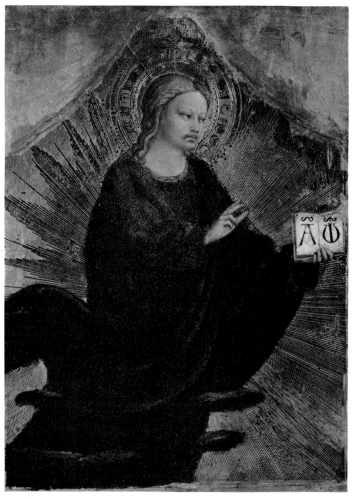

Fig. 87. Fra Angelico: *Christ blessing*. Royal Collection, London

Fig. 88. Florentine School: *The Dream of Pope Innocent III and
Saints Peter and Paul appearing to Saint Dominic*.
Yale University Art Gallery, New Haven

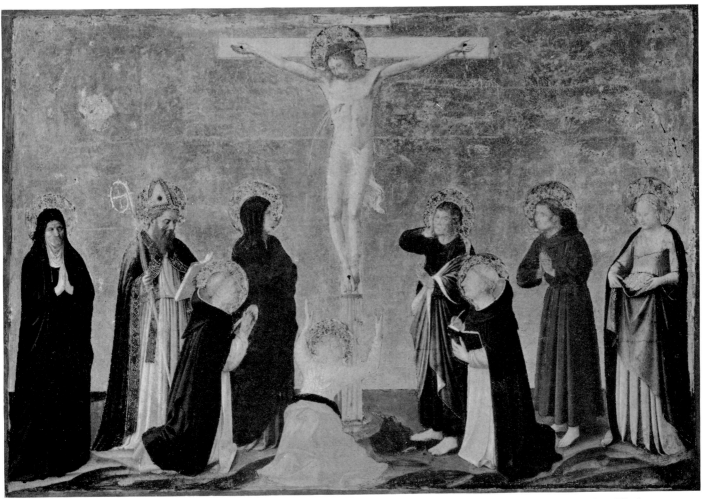

Fig. 89. Fra Angelico (?): *Christ on the Cross with the Virgin and eight Saints*. Metropolitan Museum, New York

Fig. 90. Fra Angelico: *Christ crowned with Thorns*.
Santa Maria del Soccorso, Leghorn

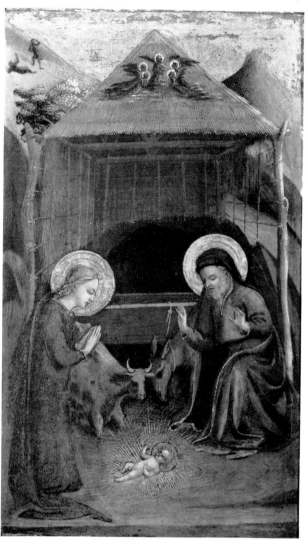

Fig. 91. Imitator of Fra Angelico: *The Nativity*.
Metropolitan Museum of Art, New York

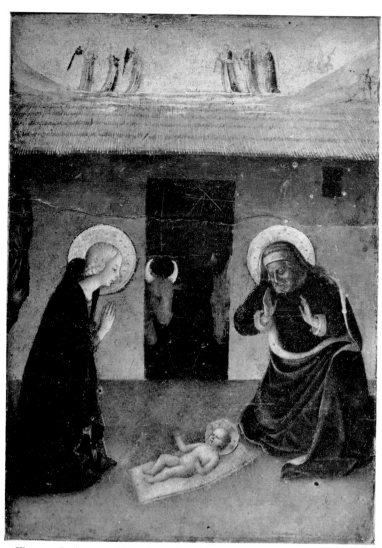

Fig. 92. Imitator of Fra Angelico: *The Nativity*. Institute of Arts,
Minneapolis

Fig. 93. Fra Angelico (?): *A Martyr Bishop*. National Gallery,
London

Fig. 94. Fra Angelico (?): *A Bishop Saint*.
Mr. and Mrs. Henry L. Moses, New York (formerly)

Fig. 95. Master of Cell 31: *Madonna and Child Enthroned with Angels between Saints Peter and Paul.*
Ashmolean Museum, Oxford

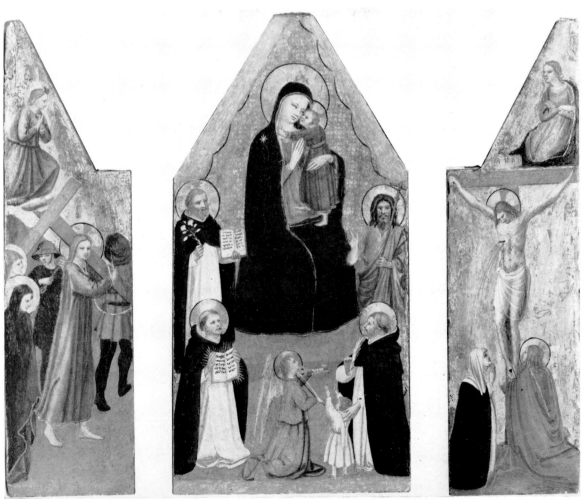

Fig. 96. Tuscan School: *Madonna and Child with Saints; Christ Carrying the Cross; Christ on the Cross;
the Annunciation.* Christ Church, Oxford

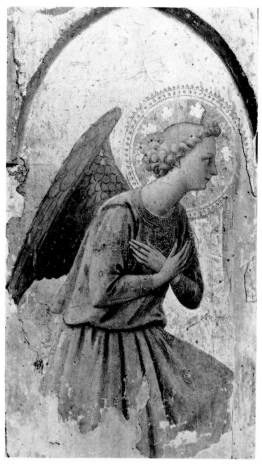

Fig. 97. Workshop of Fra Angelico: *Angel*.
Louvre, Paris

Fig. 98. Florentine School: *St. Jerome*. Art Museum,
Princeton University

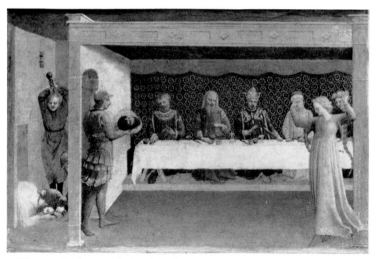

Fig. 99. Imitator of Fra Angelico: *The Presentation of the Baptist's
Head to Herod*. Louvre, Paris

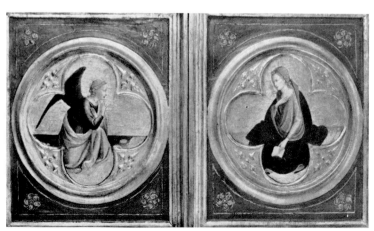

Fig. 100. Fra Angelico: *Annunciatory Angel; Virgin Annunciate*.
Tucher Collection, Vienna (formerly)

Fig. 101. Florentine School: *Madonna and Child
with two Angels*. Boymans-Van Beuningen
Museum, Rotterdam

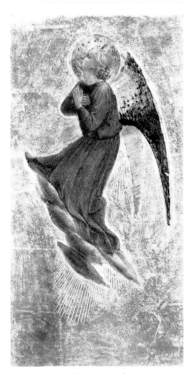

Fig. 103. Workshop of Fra Angelico: *Two Angels*.
Pinacoteca Sabauda, Turin

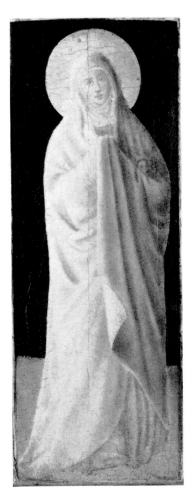

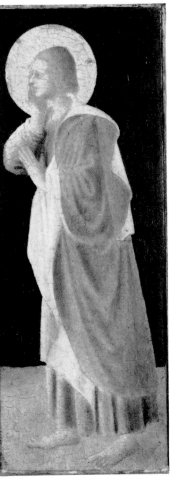

Fig. 102. Fra Angelico: *The Redeemer*. Museo di San Matteo, Pisa

Fig. 104. Sanguigni (?): *Mourning Virgin; Saint John the Evangelist*.
Art Museum, Princeton University

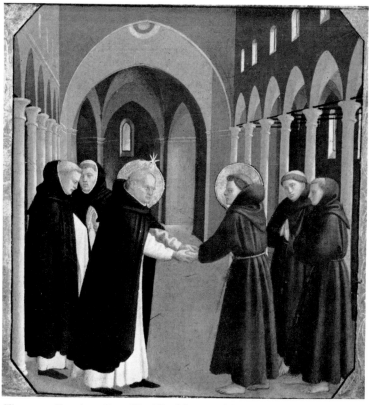

Fig. 105. Fra Angelico (?): *The Meeting of Saints Dominic and Francis.*
M. H. de Young Memorial Museum, San Francisco

Fig. 105a. Fra Angelico: *Madonna and Child.* Turin,
Pinacoteca Sabauda

Fig. 106. Zanobi Strozzi: *Madonna and Child with nine Angels and
Saints Dominic and Catherine of Alexandria.* Vatican, Pinacoteca

Fig. 107. Zanobi Strozzi: *Madonna and Child with two Angels.*
National Gallery of Art, Washington (Mellon Collection)

Fig. 108. Fra Angelico: *Madonna and Child with four Saints*. Pinacoteca, Parma

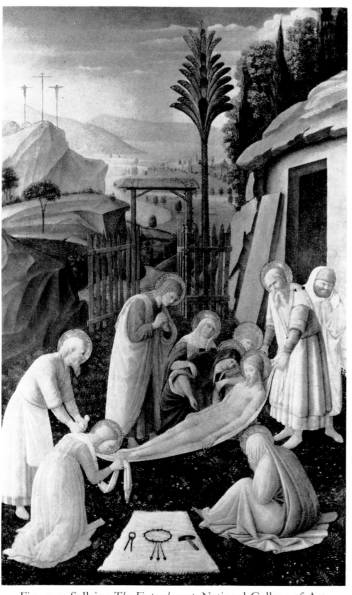

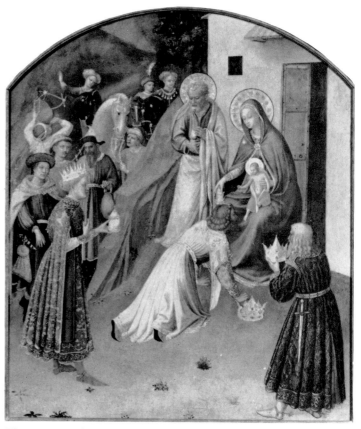

Fig. 109. Sellajo: *The Entombment*. National Gallery of Art, Washington (Kress Collection)

Fig. 110. Workshop of Fra Angelico: *The Adoration of the Magi*. Abegg-Stiftung, Riggisberg

Fig. 111. Gozzoli (?): *The Stigmatisation of Saint Francis and the Death of Saint Peter Martyr*. Strossmayer Gallery, Zagreb

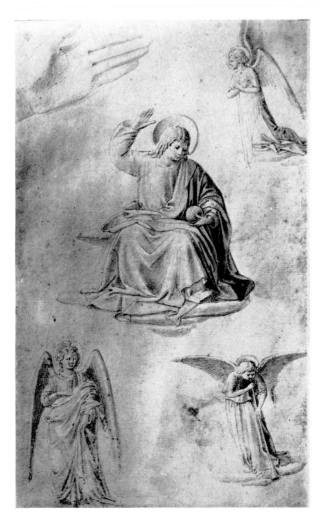

Fig. 112. Master of 1417: *Two Scenes from the Legend of a Holy Hermit*. Albright-Knox Art Gallery, Buffalo

Fig. 113. Gozzoli: *Christ as Judge and two Angels; Kneeling Angel*. Musée Condé, Chantilly

PROPHAETA. DAVID

Fig. 114. Fra Angelico: *King David*. British Museum, London

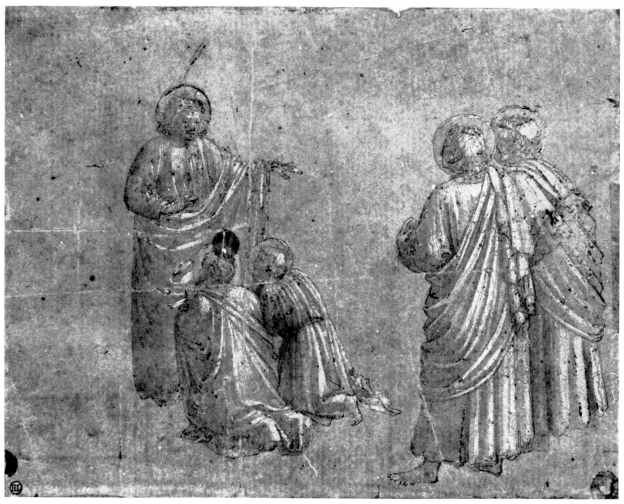

Fig. 115. Fra Angelico (?): *Christ despatching the Apostles*. Louvre, Paris

Fig. 116. After Fra Angelico: *Christ on the Cross*.
Albertina, Vienna

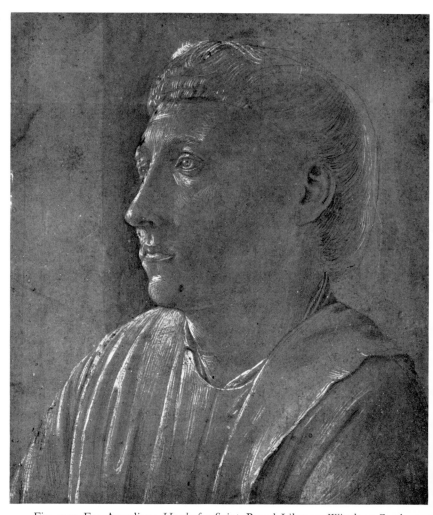

Fig. 117. Fra Angelico: *Head of a Saint*. Royal Library, Windsor Castle

(Salmi) from the figure of the Saint in the background of Masaccio's *Tribute Money*. A suggestive analogy for the *Agony in the Garden* occurs on a panel at Altenburg variously given to Masaccio and to Paolo Schiavo and seemingly dating from about 1430. The present panels are later in date than the predella of the Cortona *Annunciation*, and may well be contemporary with the Linaiuoli predella of 1433–4.

Houston, Museum of Fine Arts, No. 44–550 (Edith A. and Percy S. Straus Collection). *The Temptation of Saint Anthony the Abbot.*　　　　　　　　Fig. 80
Panel: 19 × 28 cm.
Coll.: William IV of Prussia; Count von Ingenheim; A. S. Drey; K. W. Bachstitz; Percy S. Straus, New York.

The panel is given by Berenson (1963, p. 14 and earlier editions) and L. Venturi (*Italian Pictures in America*, 1933, pl. 178) to Angelico, and by Offner ('The Straus Collection goes to Texas', in *Art News*, 1945, 15–31 May, pp. 22–3) to the workshop of Angelico. Offner notes that 'this ingenious conception emerges from the fancy of Fra Angelico, but the execution is as certainly due to a follower. For, although the forms derive from the master's stock, they want in the intimate signs of his own hand.' The attribution to Angelico is accepted by Baldini (1970, pp. 97–8).
In the first edition of this book it was stated that 'judging from photographs alone, it is difficult to believe that the execution of the panel as well as its cartoon is not due to Angelico'. Examination of the work in the original suggests that this analysis was incorrect. Its lighting and structure, and especially the buildings in the upper left corner and the rock forms in the foreground, recall the panel of the *Penitence of Saint Julian* at Cherbourg, and it is possible that the scene originates from the same predella.

Indianapolis, The Clowes Foundation. *The Nativity.*
Panel: 26 × 52 cm.　　　　　　　　　　　　Fig. 82
Coll.: Kilenyi, Hungary.
Exh.: Indianapolis, 1959 (No. 1); Notre Dame, 1962 (No. 1).

The panel is conjecturally identified with one of the missing panels ascribed to Angelico in the Casa Gondi, Florence, and is stated previously to have been owned by the Compagnia del Tempio. It is by an imitator of Angelico.

Leghorn, Santa Maria del Soccorso. *Christ crowned with Thorns.*　　　　　　　　　　　　　　　　Fig. 90
Panel: 55 × 39 cm.

According to Berti (in *Mostra*, 1955, p. 34, No. 19), the panel was owned in the mid-nineteenth century by Silvestro Silvestri in Leghorn and was regarded as Giottesque. It was ascribed by

Longhi (1928–9, pp. 153–9) to Angelico about 1430–5. It is accepted by Berti (loc. cit.), Baldini (1970, p. 96) and Salmi (in *Rivista di Livorno*, 1957; and 1958, pp. 20–1, 103–4), the latter with a dating between 1433 and 1438, and is ignored by Berenson (1963 and previous editions). The attribution was wrongly rejected in the first edition of this book. Re-examination of the painting after cleaning (1955) suggests that it must date from about 1436.

Leningrad, Hermitage. *Madonna and Child with four Angels.*
Panel: 80 × 51 cm.

When in the Stroganoff collection, the panel was ascribed by A. Venturi ('Quadri di Gentile da Fabriano a Milano e a Pietroburgo', in *L'Arte*, i, 1908, p. 495) to Gentile da Fabriano. It was later reattributed by Colasanti ('Nuovi dipinti di Arcangelo di Cola da Camerino', in *Bollettino d'Arte*, ser. ii, 1, 1921–2, pp. 544–5) to Arcangelo di Cola. Longhi (1928–9, p. 154, and 1940, p. 186) and Salmi (1950, p. 78; 1958, pp. 8–9, 95, with question mark) ascribe it to Angelico. The attribution to Arcangelo di Cola is contested by Zeri (in *Antichità Viva*, viii, 1969, p. 15) who gives it tentatively to Angelico, and it is reproduced as a work of Fra Angelico of about 1425 by Levinson-Lessing (*The Hermitage, Leningrad: Mediaeval and Renaissance Masters*, 1967, No. 5). The connection with Angelico is superficial, and is warranted neither by the types of the Virgin and Child nor by the decorative treatment of the Virgin's cloak. The robes of the angels in the foreground have no close parallel in early paintings by Angelico. The panel is, however, as is rightly argued by Zeri, by a different hand from the *Madonna* at Rotterdam, with which it is frequently associated and was connected in the first edition of this book.

London, National Gallery (No. 2908). *A Martyr Bishop or Abbot.*　　　　　　　　　　　　　　　　　Fig. 93
Panel: 16 × 15·5 cm. (diameter of painted area 14 cm.).
Coll.: Lady Lindsay (prior to 1893); Lady Lindsay Bequest (1912).

From a frame or predella. A companion panel (Fig. 94) of a Bishop Saint (Coll.: Mr. and Mrs. Henry L. Moses, New York, formerly) is stated to have come from an altarpiece in San Domenico at Fiesole. Both panels are given by Berenson (1963, p. 14) to Angelico in part, and originate in the master's workshop. Salmi (1958, p. 87) ascribes the execution of the present panel to Zanobi Strozzi, and suggests that it formed part of the predella of the Croce al Tempio *Lamentation*. The names of the Saints were originally inscribed on the right sides of the panels. The remains of the inscription on that in London is transcribed by Davies (p. 31) as . . . MEVS (?); that on the Moses panel is indecipherable in photograph. The identification by Salmi of the Saint in the London panel as Louis of Toulouse is unconvincing.

227

London, National Gallery (No. 3417). *The Blessed Reginald of Orleans receives a vision of the Dominican Habit, and the Virgin presenting the Habit to Saint Dominic.* Fig. 81
Panel: 23·8 × 29·8 cm.
Coll.: Richard Claygate (before 1885); Sir Charles Cook (1891); presented by Sir Charles Cook 1919.

It is inferred by Davies (1961, pp. 35–6) from marbling on the back of the panel that it was originally part of a cupboard door. It has been cut considerably at the top, and the door may originally have included a second scene. The argument of Collobi-Ragghianti (in *Critica d'Arte nuova*, ii, 1954–5, p. 40) that the panel formed part of the same predella as the *Marriage* and *Burial of the Virgin* in the Museo di San Marco, and originally stood beneath the Santa Maria Nuova *Coronation of the Virgin*, is dismissed by Berti (in *Mostra*, pp. 20–1) and Davies (loc. cit.), and is inadmissible. According to Salmi (1958, p. 110), the panel was executed in the studio from Angelico's design, and may have formed part of the predella of the Croce al Tempio *Lamentation*. The second part of this thesis is untenable. Berenson (1963, p. 14) ascribes it to the workshop of Angelico, while Davies gives it to 'some fairly close follower'.

London, National Gallery (No. 5581). *Madonna and Child with nine Angels.* Fig. 83
Panel: 29·2 × 21·6 cm.
Coll.: Miss Rogers (prior to 1844); Samuel Rogers (sale 1856, 2 May, lot 614); C. S. Bale (sale 1881, 14 May, lot 290); Cook (till 1945).

Variously regarded as an early work by Boccatis (Douglas, in *L'Arte*, 1903, p. 108), a putative early work by Domenico Veneziano (Berenson, 1932, p. 172), a putative early work by Piero della Francesca (Salmi, in *Arti Figurative*, 1947, pp. 8off.), an early work by Benozzo Gozzoli (Cook catalogue, 1932, and earlier; Berenson, 1963, p. 95), and an early work by Fra Angelico (Longhi, pp. 174–5). A careful analysis of the literature of the panel is provided by Davies (1961, pp. 36–7). The composition, in which the figures are disposed beneath a receding rectangular canopy supported by four angels, has no equivalent in the work of Angelico or of the young Gozzoli.

London, H.M. the Queen. *Saint Peter Martyr.* Fig. 84
Panel: 26 × 8·5 cm.
Coll.: Metzger (1845).

Berenson (1932, p. 22, and subsequent editions) as Angelico; Longhi (*Catalogue of the Exhibition of the King's Pictures*, Royal Academy, 1946–7, p. 73, No. 186) as early Gozzoli. Tentatively regarded as one of the missing pilaster panels of the Louvre *Coronation of the Virgin* by Salmi (1958, p. 86), who wrongly associates it with a panel of *Saint Thomas Aquinas* reproduced in the first edition of this book. The latter panel is considerably larger (39 × 14 cm.), and forms part of a series of pilaster panels

which seem to originate from the San Marco altarpiece. The present panel is superior to, e.g., the workshop pilasters of the Perugia polyptych, and is perhaps autograph.

London, H.M. the Queen. *Christ blessing.* Fig. 87
Panel: 28 × 22·5 cm.
Coll.: Spence (1854).

Vertical split through centre. Much abraded on robe and sleeve and in upper part of cloud. Berenson (1932, p. 22, and subsequent editions) and Salmi (1958, p. 109) as Angelico. As noted by Salmi (p. 33), the panel 'avrebbe potuto bellamente culminare, con la cornice mistilinea, una pala, o meglio, un trittico come quello di Perugia, quale completamento proprio di un "Annunciazione"'. The connection with Angelico is doubted by Nicolson (in *Burlington Magazine*, xcl, 1949, p. 137) and Shearman (in *Italian Art in the Royal Collection, The Queen's Gallery*, London, 1964, No. 4, pp. 7–8, with a wrong attribution to Gentile da Fabriano). The panel was mistakenly ascribed, in the first edition of this book and by Collobi-Ragghianti (in *Critica d'Arte nuova*, ii, 1955, p. 43), to Zanobi Strozzi. The closest points of reference in Angelico's work occur in the *Last Judgment* in the Museo di San Marco and the *Coronation of the Virgin* in the Uffizi, and the panel is likely to date from about 1430–1.

London, Sir Thomas Barlow (formerly). *The Disputation of Saint Dominic and the Miracle of the Book.*
Panel: 24 × 33·5 cm.
Coll.: R. C. Witt; Hon. Robert Bruce; Lord Rothermere (exh. Burlington Fine Arts Club, London, 1919, as Masolino).

This much damaged and abraded panel does not depend directly from the two representations of the scene in the predella of Cortona triptych and in that of the *Coronation of the Virgin* in the Louvre. It is published by Berenson (in Dedalo, x, 1932, p. 524, and 1963, p. 14) as a ruined work by Fra Angelico of about 1440, and is listed by Baldini (1970, pp. 98–99). In the present state of the paint surface any attribution must be highly conjectural, but there are no *prima facie* grounds, other than the clarity of the composition, for postulating the intervention of Angelico.

Los Angeles, Norton Simon Foundation. *Madonna and Child.* Fig. 85
Panel: 45 × 37·5 cm.

Coll.: Stated to have come from the Oratorio dei Crociferi, Messina; Lazzeri, Messina; Marchese Palermo, Messina; Benjamin, Paris (Féral, *Catalogue des tableaux anciens comprenant la Collection de Mme. Benjamin*, Georges Petit, 1922); Duveen, New York.

The panel is accepted by Salmi (1958, pp. 63, 123) as a late work datable after the Vatican frescoes and painted in the

vicinity of the Bosco ai Frati altarpiece. A considerably earlier dating ca. 1435 is advanced by Baldini (1970, p. 96) on the strength of resemblances to the fresco fragment formerly over the entrance to San Domenico, Fiesole. It is difficult to believe that this much damaged painting was designed by Angelico or executed in his studio.

Lugano, Thyssen-Bornemisza Collection. *Madonna and Child with five Angels.* Fig. 86
Panel: 100 × 49 cm.
Coll.: Conjecturally Palazzo Gondi, Florence; King of the Belgians; Kleinberger, Paris (1909); Pierpont Morgan.

A direct ascription to Angelico is advanced by A. Venturi (in *L'Arte*, xii, 1909, pp. 319–20), Schottmüller (p. 234), Muratoff (pl. cxxviii), Berenson (1932, p. 22, and subsequently), Berti (in *Mostra*, No. 21 bis., p. 138), Salmi (1958, p. 102), Heinemann (*The Thyssen-Bornemisza Collection*, 1969, pp. 12–13), Salmi (1958, p. 102) and Baldini (1970, p. 90). Van Marle (x, pp. 139–40), who questions the attribution to Angelico, proposes an ascription to Benozzo Gozzoli. The panel was given in the first edition of this book to the workshop of Angelico. The two angels in the foreground recur in a *Madonna and Child with four Angels* in the Accademia Carrara at Bergamo. It has been argued (Collobi-Ragghianti, in *Critica d'Arte*, xxxiii, 1950, p. 25) that the present painting depends from that at Bergamo, and, conversely, that the painting at Bergamo is a weak derivative from the present composition. The painting is dated by A. Venturi before the Linaiuoli tabernacle, and by Berti ca. 1435. An early dating is also accepted by Salmi and Baldini. The closest analogies for its style, and especially for, e.g., the cursive edge of the Virgin's cloak, the resolution of the hanging drapery, and the types of the two Angels beside the throne, occur in the *Coronation of the Virgin* in the Louvre, and it is likely that the Thyssen *Madonna* was also painted about 1450.

Minneapolis, Institute of Arts (68.41.8). *The Nativity.*
Panel: 28·3 × 17·5 cm. Fig. 92
Coll.: Conjecturally Borghese, Rome; Nemes, Munich; Herschel V. Jones, Minneapolis (from 1930); Miss Tessie Jones (bequeathed to Institute of Arts 1968).

According to an entry in *European Paintings in the Minneapolis Institute of Arts*, 1971, p. 385, No. 204, 'the *verso* of the panel bears several nineteenth-century paper stamps of an undecipherable princely collection, the inventory number 2252, and a French sales catalogue extract with the lot number 215 and the Borghese source.' The panel is published by Anthony M. Clark (*Minneapolis Institute of Arts Bulletin*, lvii, 1968, p. 63; *Art Quarterly*, xxxiii, Spring, 1969, p. 69) as Workshop of Fra Angelico. The composition is closely related to that of the *Nativity* in the Metropolitan Museum of Art, New York, and the panel, though influenced by Angelico, likewise originates outside the master's shop.

New Haven, Yale University Art Gallery. *The Dream of Pope Innocent III and Saints Peter and Paul appearing to Saint Dominic.* Fig. 88
Panel: 33·2 × 41·9 cm.
Coll.: Edwin A. Abbey Memorial Collection (1937. 343).

Published by C. Seymour (*Early Italian Paintings in the Yale University Art Gallery*, 1970, No. 78, p. 115) as by a close follower or associate of Fra Angelico, with the comment that 'the possibility of Angelico's own hand is conceivable, but at present far from provable'. This much abraded panel is of good quality, and in so far as it is dependent on Fra Angelico recalls, in the scene on the right side, the related panel of the predella at Cortona, not that in the Louvre. There is no parallel in Angelico for the scene on the left, where the Saint faces to the right not to the left and the figure of the sleeping Pope is rendered in reverse. In its present state the panel is unattributable, but seems to date from the sixth decade of the century.

New York, Metropolitan Museum (No. 14.40.628). *Christ on the Cross with the Virgin and Saints Monica, Augustine, Dominic, Mary Magdalen, John the Evangelist, Thomas Aquinas, Francis and Elisabeth of Hungary.* Fig. 89
Panel: 33·9 × 50·1 cm.
Coll.: Gouvello de Kériaval, Paris: Benjamin Altman, New York.

Douglas (in Crowe and Cavalcaselle, iv, 1911, p. 97 n.) and Berenson (1932, p. 22, and subsequent editions) as a ruined work by Fra Angelico. Van Marle (x, p. 160) as a shop piece. In 1951 the panel was cleaned, a modern background with blue sky and two palm trees being removed. Comment on the painting made before this time should be read with this point in mind. Zeri (*Italian Paintings. A Catalogue of the Collection of the Metropolitan Museum of Art, Florentine School*, New York, 1971, pp. 78–9) regards it as 'surely by Fra Angelico and . . . executed as an independent work and not as part of the predella of an altarpiece'. An attempt is made by Salmi (1958, p. 89) to identify it with a picture by Angelico which in 1492 hung in the Anticamera di Piero di Lorenzo in the Palazzo Medici (E. Müntz, *Les Collections des Médicis au XVe. siècle*, 1888, p. 86: 'una tavoletta quadra dipintovi . . . uno Christo in croce con 9 figure d'attorno,' valued at fiorini 12). This identification may well be correct. The panel is a work of considerable delicacy, and despite its inorganic, widely spaced composition (which recalls the practice of the later frescoes at San Marco, and especially of those by the Master of Cell 36), it is not impossible that it was painted about 1440–5 by Fra Angelico.

New York, Metropolitan Museum (No. 24.22). *The Nativity.* Fig. 91
Panel: 38·7 × 29·1 (with engaged frame).
Coll.: Antonio Nardi (until about 1923); Ugo Jandolo, Rome; Agnew, London (1924).

The panel formed the left wing of a triptych or diptych; its back is painted to imitate porphyry. Inscribed in the centre at the top, above the two groups of angels: (TER)RA PAX HO(MIN)IB(US) BON(A)E (VOLUNTATI)S. Though purchased as a work of Fra Angelico, with supporting statements from De Nicola, Perkins, Borenius and L. Venturi, and briefly listed as a work of Angelico by Berenson (1932, p. 22; 1963, p. 14, as workshop of Angelico), this little panel has never been accepted as an autograph work. It is argued by Zeri (*Italian Paintings, The Metropolitan Museum of Art. Florentine School,* 1971, pp. 79–81) that it may have been designed by Angelico in his middle period, but was carried out by an assistant. In Zeri's view, 'in the figure of the Madonna and especially in that of the Child there is a close similarity to the work of the so-called Pseudo-Domenico di Michelino, sometimes identified with Zanobi Strozzi'. Salmi (1958, p. 94) also claims that 'lo schema deriva da un pensiero o da un disegno del maestro', which was executed by an assistant, probably Domenico di Michelino. The connection with Angelico is less close than these accounts suggest. Though the feature of the centralised doorway recurs in a number of Angelico's works, neither the simplified profile pose of the Virgin, nor the awkwardly set Saint Joseph, nor the naïve detail of the group of shepherds on the left is likely to originate in a cartoon by the master. The attributions to Domenico di Michelino and Zanobi Strozzi are incorrect. A version of the composition, lacking the shepherds, and showing a manger based on that of the silver chest *Nativity,* is in the Minneapolis Institute of Arts (q.v.).

New York, Mr. and Mrs. Henry L. Moses (formerly).
A Bishop Saint. Fig. 94
Panel.
Coll.: Samuel Rogers; Sutton.

See under LONDON, National Gallery (No. 2908).

Oxford, Ashmolean Museum (No. 42). *Triptych: Virgin and Child with Saint Dominic and six Angels,* between (left wing) *Saint Peter* and (right wing) *Saint Paul.* Fig. 95
Panel: 42 × 27 cm. (centre), 45 × 15 cm. (each wing).
Coll.: Fox-Strangways (till 1850).

The triptych is given by Berenson (1963, p. 14, and earlier editions) to the studio of Angelico, and by Van Marle (x, p. 161) to 'an artist directly inspired by Fra Angelico but more evolved'. A point of departure for the style of the two lateral panels is provided by the later cell frescoes at San Marco, and

Collobi-Ragghianti (in *Critica d'Arte nuova,* ii, 1955, p. 47) associates the whole work with the hand here identified as the Master of Cell 36. An alternative attribution to the Master of Cell 31 (C. Lloyd) is likely to be correct.

Oxford, Christ Church. *Triptych: Virgin and Child with Saint John the Baptist and three Dominican Saints,* between (left wing) *Christ carrying the Cross* and (right wing) *Crucified Christ with Saint Mary Magdalen and a Dominican Beata.* Fig. 96
Panel: (central panel) 38·3 × 20 cm.; (left wing) 38·3 × 10·9 cm.; (right wing) 38·3 × 11·4 cm.
Coll.: Fox-Strangways Gift (probably 1834).

The three panels, then laid down on a later panel, are dismissed by Borenius (*Pictures by the Old Masters in the Library of Christ Church, Oxford,* 1916, No. 47) as a late imitation of a Florentine fifteenth-century painting. The technical and other arguments in favour of their authenticity are reviewed by Byam-Shaw (*Paintings by Old Masters at Christ Church, Oxford,* 1967, No. 20, pp. 39–40), who gives the triptych to the studio of Fra Angelico, relating it to the reliquary panels from Santa Maria Novella in the Museo di San Marco and the Gardner Museum, Boston. The possibility that the triptych was produced by a painter working in the immediate vicinity of Angelico can be ruled out, and the naïve compositions suggest that we have here to do with a pastiche of Angelico's work painted about 1450 by a provincial artist for some local Dominican community.

Paris, Louvre (No. 1291). *The Presentation of the Baptist's Head to Herod.* Fig. 99
Panel: 20 × 30 cm.
Coll.: Samuel Rogers; His de la Salle (until 1878).

The panel is given by Berenson (1963, p. 15, and earlier editions) to the studio of Angelico, by Van Marle (x, p. 182) to Zanobi Strozzi, and by Salmi (1958, p. 126) to Angelico and Strozzi in collaboration, with a dating ca. 1435. Related in style to the panels at Antwerp and Chantilly, it is, like them, a relatively early work of notably good quality by a miniaturist in the circle of Angelico, perhaps Sanguigni.

Paris, Louvre (Np. 1294B). *Angel.* Fig. 97
Panel: 37 × 25 cm.
Coll.: Gay (till 1909).

Damaged by paint losses and local retouching. According to Migeon (in *Gazette des Beaux-Arts,* 4e pér., i, 1909, p. 412) and Seymour de Ricci (*Description des Peintures du Louvre,* i, 1913, p. 58), this panel and a second Angel formerly in the Thierry de la Loue collection, Paris, were traditionally supposed to have formed part of the tabernacle of the high altar of San Domenico at Fiesole. This hypothesis can be discounted on stylistic and other grounds, and, irrespective of authorship, a very early dating is improbable. Accepted as Angelico by

Schottmüller (p. 240), Berenson (1932, p. 22, and subsequent editions), Van Marle (x, p. 58), and Baldini (1970, p. 95), 'questo nobile dipinto' (Salmi, 1958, p. 115) is an attractive workshop product of good quality. The much damaged companion panel appeared at auction at the Palais Galliéra, Paris, on 14 June 1974.

Parma, Pinacoteca (No. 429). *Madonna and Child with Saints John the Baptist, Dominic, Francis and Paul.* Fig. 108
Panel: 101 × 56 cm.
Coll.: Rosini, Pisa (as Gozzoli); Marchese Tacoli-Canacci (acquired in Florence 1786); bought for the Parma Gallery from the heirs of Dr. Giuseppe Campanini (1842).

A direct ascription to Angelico is sustained by Berenson (1896, p. 100), Van Marle (x, p. 58) and Schottmüller (p. 230). The autograph status of the panel is questioned by Crowe and Cavalcaselle (iv, p. 93), Douglas (p. 197) and Muratoff (pp. 32–3). In the first edition of this book it was argued that the kneeling figures in the foreground were by Zanobi Strozzi, but that the group of the Virgin and Child was based on a cartoon by Angelico of about 1430, and was probably executed by the master. Save that the foreground figures are not by Strozzi but by another assistant of Angelico, whose hand recurs in the predella panels of the *Marriage* and *Dormition of the Virgin* in the Museo di San Marco, this analysis appears to be correct. According to Salmi (1958, p. 102) the work was designed by Angelico ca. 1428–30, but was finished later by a heavier brush, perhaps that of Gozzoli. Baldini (1970, p. 90) regards it as partly autograph. A predella with figures of Saints Nicholas, Lawrence and Peter Martyr in the Kunstmuseum, Berne (No. 874. Dimensions: 11·3 × 56·4 cm.), is doubtfully connected by Collobi-Ragghianti (in *Critica d'Arte,* xxxii, 1950, p. 468) with this painting.

Philadelphia, Museum of Art (Johnson Collection). *Saint Francis.* Fig. 63
Panel: 59 × 41 cm.
Acquired in 1912.

The background is added and the right hand is modern. The panel is accepted as a work of Angelico by Schottmüller (p. 267, dated 1440–5) and Berenson (*Catalogue of the John G. Johnson Collection, Philadelphia,* i, 1913, pp. 10–11, No. 64, dated 1445–1450). It was suggested in the first edition of this book that the panel did not form part of a polyptych, but perhaps originated from a lost *Crucifixion* of the type of the *Crucified Christ between Saints Nicholas and Francis* in San Niccolò del Ceppo, Florence. It has since been demonstrated by Berti (*Mostra,* No. 25, pp. 45–6) that the Philadelphia panel was originally part of the San Niccolò del Ceppo painting. The original right hand of Saint Francis, which is still attached to the Crucifix, was shown extended towards Christ. The attribution is inseparable from that of the main panel (see under Florence, San Niccolò del Ceppo).

Pisa, Museo di San Matteo (No. 118). *The Redeemer.*
Linen: 193 × 78 cm. Fig. 102

Given by Berenson (1896, p. 100, and subsequent editions) to Angelico, and by Schottmüller (p. 219), Van Marle (x, p. 162), Salmi (1958), Baldini (1970, p. 117) and in the first edition of this book to the artist's workshop, this processional banner, though much worn, is of good quality, and is perhaps an in part autograph late work.

Princeton, University Art Museum. *Saint Jerome.* Fig. 98
Panel: 22·5 × 16·5 cm.
Coll.: Mather, Washington Crossing.

As demonstrated by Offner (in *Art in America,* viii, 19–20, pp. 68–76), the panel carries the arms of the Ridolfi and Gaddi families, and is likely to commemorate a marriage in 1424. It is attributed to Masolino by A. Venturi (*L'Arte e San Girolamo,* 1924, pp. 132–4), Offner (loc. cit.), and Pope-Hennessy (*Sassetta,* 1939, pp. 183–4). The ascription to Angelico is due to Longhi (in *Critica d'Arte,* xxvi, 1940, p. 174), Salmi (*Masaccio,* 2nd ed., 1948, p. 234 and 1958, p. 97), and Collobi-Ragghianti (in *Critica d'arte nuova,* ii, 1955, pp. 23–4), and is rejected by Berti (in *Acropoli,* iii, 1963, p. 38), who regards the panel as later in date. Baldini (1970, p. 86) argues that if the panel dates from ca. 1424 it is likely to be by Angelico, while if it is later the attribution is untenable. There is no reason to doubt that it was produced in the mid-twenties, but the connection with Angelico is nebulous. Points of reference for the pose are found in the work of the Master of the Griggs *Crucifixion* and for the setting in that of the Master of the Sherman Predella.

Princeton, University Art Museum. *Mourning Virgin; Saint John the Evangelist.* Fig. 104
Panel: 29 × 13 cm. each.

Mather ('Two unpublished Fra Angelicos', in *Art in America,* xxii, 1934, pp. 92–5) and Berenson (1936, p. 20; 1963, p. 15, as studio of Angelico); Salmi (1950, p. 149; 1958, p. 94) as Battista di Biagio Sanguigni. The two panels, which are dated by Mather ca. 1425 and are regarded by Salmi as late studio works, seem to have formed the wings of a *Crucifixion* triptych, and though much damaged appear to correspond with Sanguigni's documented miniatures.

Riggisberg, Abegg-Stiftung. *The Adoration of the Magi.*
Panel: 63 × 54 cm. Fig. 110
Coll.: Nemes, Munich; Charles J. Abegg, Zurich.

An attempt by L. Venturi (in *L'Arte,* 1931, pp. 250–5) to identify this panel with the 'colmo per uso di tavoletta d'altare . . . dentro la storia de' magi' recorded in the Palazzo Medici

(see under Lost Works) is rejected by Salmi (1958, p. 115) on account of the incompatibility of the dimensions. A point of reference for the building on the right is supplied by the *Adoration of the Magi* in the predella of the Linaiuoli triptych. According to Collobi-Ragghianti (in *Critica d'Arte nuova*, ii, 1955, p. 47), the Abegg panel precedes that in the predella. This view is also adopted by Berti and Baldini (1970, p. 16), who date it about 1430, and is contested by Salmi, who regards it as a derivative, designed by Angelico and executed in the master's shop. So far as can be judged from photographs, the panel is a workshop product of about 1435.

Rotterdam, Boymans-Van Beuningen Museum. *Madonna and Child with two Angels.* Fig. 101
Panel: 81 × 47 cm.
Coll.: Cassirer, Berlin; Van Beuningen, Vierhouten.

Colasanti ('Nuovi dipinti di Arcangelo di Cola da Camerino', in *Bollettino d'Arte*, ser. ii, I, 1920–2, pp. 539–40) and Berenson ('Quadri senza Casa', in *Dedalo*, x, 1929, pp. 136, 140, and 1936, p. 28, and later editions) as Arcangelo di Cola; Gronau (verbally), Longhi (1928–9, pp. 154–5, and 1940, p. 186) and Salmi (1950, p. 78) as Angelico. The attribution to Angelico involves a dating in the early or mid-twenties. Salmi (1958, p. 9) in a later, more detailed analysis, concludes that the panel is not by Fra Angelico, on account of the absence of 'quella interiore elevazione che caratterizza il maestro'. The attribution is rejected by Berti (in *Acropoli*, iii, 1963, pp. 15, 36). The case for ascribing the panel to Arcangelo di Cola is argued by Vitalini Sacconi (*Pittura Marchigiana: la Scuola camerinese*, 1968) and Zampetti (*Paintings from the Marches*, 1971, p. 76). Zeri (in *Antichità viva*, viii, 1969, pp. 13–14) denies the attribution to Arcangelo di Cola, and gives the panel to an anonymous Florentine artist operating under Arcangelo di Cola's influence, who would also have been responsible for a *Madonna of Humility* in the Contini-Bonacossi collection, Florence, wrongly regarded by Longhi as a work of Masolino of 1430–5. The Contini *Madonna* is dated by Zeri ca. 1420 and the Rotterdam *Madonna* is dated ca. 1425. This conjunction and the proposed chronological relationship are very plausible.

San Francisco, M. H. De Young Memorial Museum (Kress Collection, K 289). *The Meeting of Saint Francis and Saint Dominic.* Fig. 105
Panel: 26 × 26·7 cm.
Coll.: Artaud de Montor, Paris (*Peintres Primitifs: Collection de Tableaux rapportée d'Italie*, 1843, No. 129, as Baldovinetti); Chalandon, Lyons and Paris; R. Langton-Douglas (1924); Mrs. Walter Burns, London; Contini-Bonacossi, Florence; National Gallery of Art, Washington (Kress Collection) till 1950.

Comparison with the reproduction in the Artaud de Montor catalogue could be held to show that the head of the second friar from the right was originally at a different angle, and in its present form is wholly new, and that the figure of the friar on the extreme right has been much modified, both in the area of the head and at the base. These discrepancies seem to be due, however, to inaccuracies in the Artaud de Montor reproduction, since photographs of the panel in its stripped state, made in the course of cleaning in 1954, reveal no major damage in these areas. The principal defects in condition are (i) an irregular area about 1·3 cm. deep across the top of the panel, necessitating the repainting of the circular window above the central arch, the upper half of the second window from the right and the whole of the right-hand window; (ii) diagonal scratch running upwards from a point to the left of the star over the head of Saint Dominic, now made good; (iii) a horizontal scratch or split across the whole width of the panel above the linked hands of the two Saints; (iv) local retouching in the Franciscan and Dominican habits and on the left foot of the friar on the extreme right. The panel was accepted as by Angelico in 1909 by Berenson (1909, p. 107) and was subsequently (1963, p. 15) listed as a ruined autograph work. Certified as a work of Angelico by Borenius, Fiocco, Longhi, Perkins, A. Venturi and Van Marle, it is described by Shapley (p. 97) as 'attributed to Fra Angelico', and is regarded by Meiss as the work of a follower. Salmi (1958, pp. 36, 111) regards it as a partly autograph derivative from the panel of the same scene in Berlin. The attribution to Angelico is accepted without comment by Baldini (in *Mostra*, 1955, No. 41, p. 67, and 1970, p. 103). It may be noted that the form of the panel (which is square, but has a gold surround which cuts across the corners) corresponds exactly with that of the *Naming of the Baptist* in the Museo di San Marco; that the dimensions of the panels are virtually the same; and that the haloes are closely similar. A case can thus be stated for supposing that the present panel is part of the same predella as those in the Museo di San Marco and in the collection of the Duc des Cars. The latter panels are autograph works of notably high quality, and the San Francisco panel may also be in part autograph. Like the two other panels, the scene is illuminated from the right. It is generally regarded, by those who accept the attribution to Angelico, as a late work. The *Naming of the Baptist* must, however, date from before 1435, and the San Francisco panel should logically be a work of the same time.

Turin, Pinacoteca Sabauda (Nos. 103, 104). *Two Angels.*
Panel: 25 × 13 cm. each. Fig. 103
Coll.: Metzger, Florence; Gariod (till 1846).

Damaged, gold ground renewed. The two panels evidently formed part of a frame of the type of those surrounding the Linaiuoli triptych and the Parma *Madonna*. They have been tentatively identified as part of the ciborium on the high altar at Fiesole (Salmi, 1958, pp. 12, 99), and are accepted by Schottmüller (p. 24), Berenson (1896 and subsequent editions), Van Marle (x, p. 46), Salmi (loc. cit.) and Baldini (1970, p. 92) as autograph. Datable ca. 1430 rather than at any earlier time.

Turin, Pinacoteca Sabauda. *Madonna and Child.* Fig. 105 v
Panel: 100 × 60 cm.
Coll.: Sandrini; Prince Michael Boutourlin, Florence;
Garod (till 1852).

The character of this painting was transformed by cleaning in 1951, and there is a sharp contrast between criticism of it produced before and after that time. The panel is assumed by Salmi (1958, p. 104) and Baldini (1970, pp. 102–3) to have been reduced in height. It is denied to Angelico by Crowe and Cavalcaselle (iv, p. 93 n.), Beissel (p. 61) and Muratoff (p. 42), and is omitted from the Angelico catalogue of Berenson in editions prior to 1963 (p. 15), when it is accepted as an in part autograph late work. An attribution to Angelico is sustained by Schottmüller (p. 90) and Salmi (1950, p. 81), who relates the pose of the Child to that shown in a miniature of about 1434 by Belbello da Pavia in the Vatican. The validity of this association is doubtful. In the first edition of this book a note rejecting the panel was supplemented by a corrigendum, after cleaning, in which it is described as an autograph late work of about 1450. This dating is established by the architecture of the background and by the types of the two figures, for which a point of reference is supplied by the fresco of *The Virgin and Child with eight Saints* at the head of the staircase in San Marco.

Vatican City, Pinacoteca Vaticana. *The Stigmatisation of Saint Francis.* Fig. 48
Panel: 28 × 33 cm.
See under Altenburg, p. 220 above.

Vatican City, Pinacoteca Vaticana (No. 253). *Madonna and Child enthroned with nine Angels and Saints Dominic and Catherine of Alexandria.* Fig. 106
Panel: 23 × 18 cm.
Coll.: Bisenzio, Rome; Earl of Dudley (till 1877).

Given unanimously to Angelico. Muratoff (pl. xxxix) places the panel about 1425, and Schottmüller (p. 228) and Van Marle (x, p. 58) note that the composition depends from that of the central panel of the polyptych at Fiesole. In the first edition of this book the panel was given to Zanobi Strozzi. Its autograph status is reaffirmed by Redig de Campos (in *Mostra*, 1955, p. 11, No. 5), Salmi (1958, p. 99: 'Stupisce come un'opera di così alta qualità sia relegata fra le cose apocrife dallo Schneider e che sia ascritta allo Strozzi dal Pope-Hennessy'), and Baldini (1970, p. 95). Central to this issue is the dating of the panel. It is related by Salmi to the *Madonna della Stella*, where the types both of the Virgin and the Child are strikingly dissimilar, and is dated by Baldini ca. 1435. The only valid analogies for the type of the Child occur, however, in the Pontassieve *Madonna* and the Bosco ai Frati altarpiece. The redating of these paintings to a period after 1449 involves a consequential redating of the panel in the Vatican. Its handling closely recalls that of the Annalena predella in the Museo di San Marco, which is associable with miniatures by Strozzi,

and Strozzi seems also to have been responsible for the present painting.

Vienna, Tucher Collection (formerly). *Annunciatory Angel; Virgin Annunciate.* Fig. 100
Panel: dimensions not recorded.

The two figures are enclosed in quadrilobe gesso surrounds, and formed part of the upper register of an altarpiece. They are ascribed by Van Marle (v, fig. 101–2) to the school of Fra Angelico, and are identified by Salmi (1958, pp. 11, 98) as part of the early Fiesole high altar. This identification is accepted with an interrogative by Baldini (1970, pp. 88–9). An attribution to Angelico about 1425 is very plausible, but there is no means of establishing from what complex the panels come.

Washington, National Gallery of Art (Mellon Collection), No. 5. *Madonna and Child with two Angels.* Fig. 107
Panel: 61 × 45·5 cm.
Coll.: Steinkopff; Countess of Seaforth; Mellon.

The official ascription to Fra Angelico (*The National Gallery of Art: Preliminary Catalogue of Paintings and Sculpture*, 1941, pp. 5–6) is endorsed by Berenson (1963, p. 15). Salmi (1958, pp. 17, 102) likewise accepts it as Angelico 'sebbene il dipinto si presenti in precario stato di conservazione', as does Baldini (1970, p. 89). Neither the composition nor the types of the Virgin and Child are consistent with an attribution to Angelico. It was observed in the first edition of this book that 'the painting is closely related in style to the Cosmas and Damian predella by Zanobi Strozzi in the Museo di San Marco'. Re-examination of the Washington painting leaves no reasonable doubt that it is by the same hand as the Annalena predella, which, on the strength of its connection with documented miniatures, can be given with some confidence to Strozzi, and that it dates from about 1440–5.

Washington, National Gallery of Art (Kress Collection), No. 371. *The Entombment.* Fig. 109
Panel: 89 × 55 cm.
Coll.: Bardini, Florence; Grassi, Florence; Duveen, New York; Goldman, New York; Kress Collection (1937).

Worn and extensively repainted throughout, and especially in the sky and landscape. The ascription of this much damaged panel to Angelico is due to Schottmüller (1924, p. 266), who tentatively identifies it with a panel listed in the Medici inventory of 1492 (Müntz, *Les Collections des Médicis au XVe Siècle*, 1888, p. 85: 'Una tavoletta dipintovi il Nostro Signore morto chon molti santi che lo portano al sepolchro, di mano di fra Giovanni, f. 15'). The closest analogy for it occurs in the posthumous section of the Annunziata silver chest, where, in the *Entombment*, the crown of thorns, nails and hammer are

also displayed on a linen cloth in the centre of the foreground. The silver chest panel is inscribed with a sentence from St. Luke's Gospel describing the setting down of the body by Joseph of Arimathea and its transport to the tomb, and the present panel must therefore be regarded as an *Entombment* not a *Lamentation over the Dead Christ*. It does not represent the *Deposition*, and cannot therefore, as suggested by Salmi (1958, pp. 122–3), be identical with the missing painting of this subject from the Chapel of Pope Nicholas V (see under Lost Works). Berenson listed the panel initially as a work of Fra Angelico (1932, p. 22), later gave it to a close follower of Fra Angelico (Ms, opinion, 1955), and subsequently recorded it as a ruined work possibly by Fra Angelico (1963, p. 16). The attribution to Fra Angelico is questioned by Van Marle (x, p. 143), and is rejected by Offner (in *The Arts*, v, 1924, p. 245) and was dismissed in the first edition of this book. A number of the critics who accept the attribution to Angelico have assumed the presence of a second hand, according to Schottmüller that of Pesellino, according to Ragghianti (in *Critica d'Arte*, xxvii, 1949, p. 81) that of Filippo Lippi, and according to Fiocco, Perkins and Suida that of an unidentified artist, possibly (Longhi) Jacopo del Sellajo. The compositional procedure used in the foreground has a precedent on the silver chest in the scene of the *Maries at the Sepulchre*, where the foreground is filled with the receding rectangle of the tombstone set on a floriated field. Though the style of the panel can, in this limited sense, be looked on as a pastiche of the style practised in the second half of the fourteen-fifties by Angelico's followers, the wide faces of the two men standing on the right, and of the Virgin and of the holy woman behind her are generically Lippesque. They find a parallel in a homeless painting of the *Man of Sorrows* given by Berenson (1963, fig. 1101) to Sellajo, and it is likely that the whole painting is, as Longhi seems to have supposed, an early work by this artist, executed about 1460 under the strong influence of Fra Angelico and Fra Filippo Lippi.

Zagreb, Strossmayer Gallery (No. 34). *The Stigmatisation of Saint Francis and the Death of Saint Peter Martyr.* Fig. 111
Panel: 24·3 × 43·8 cm.
Coll.: Strossmayer.

The attribution of this panel to Angelico is supported by a number of students, who include Crowe and Cavalcaselle (iv, p. 96), Frizzoni (in *L'Arte*, 1904, pp. 426–7), Berenson (1963, p. 16, as restored, and earlier editions), Schottmüller (p. 202), Salmi (1958, pp. 25, 105), Berti (in *Acropoli*, ii, 1962, p. 301), and Baldini (1970, p. 95). Proposed datings vary from before 1440 (Salmi, Baldini) to the artist's last phase (Schottmüller). Though Salmi singles out for special praise 'la più sintetica struttura geologica delle rocce, la successione netta dei piani, e la profondità ambientale', the picture is in these respects untypical of Fra Angelico. The picturesque landscapes, which shelve away from cliffs at the sides to a distant panorama in the centre, have no equivalent in the artist's authenticated works, and recall the compositional procedure of Benozzo Gozzoli at Montefalco (1452).

DRAWINGS

Barcelona, Francisco de A. Gali Fabra (formerly).
The Dead Christ.
Pen and wash, with red heightening.

Published by A. Venturi (1931, p. 246) as an autograph study by Angelico for the *Deposition* now in the Museo di San Marco, the sheet is rightly dismissed by Degenhart (*Corpus*, 1968, I–ii, No. 394) as a copy after the painting.

Buffalo, Albright Art Gallery.
Two Scenes from the Legend of a Holy Hermit. Fig. 112
Pen and ink, and water-colour on vellum: 25·4 × 13·6 cm.

This drawing forms part of a roll, of which three other pieces are in the Fogg Museum of Art, Cambridge (Mass.), two were formerly in the Van Beuningen collection, and one is in the collection of Walter C. Baker, New York. The roll is dated 1417, and illustrates the journey of a Dominican friar, Fra Pietro della Croce, to the Holy Land. The drawings are regarded by Popham (*Italian Drawings exhibited at the Royal Academy, Burlington House, London*, 1931, Nos. 11, 12) as by a single hand. Clark ('Italian Drawings at Burlington House', in *Burlington Magazine*, lvi, 1930, p. 175) notes that 'the only painter with whose style they have anything in common seems to be Fra Angelico'. A direct ascription to Angelico is advanced by Longhi (p. 173). It is unlikely that the roll is an early work of Fra Angelico. The best analysis of it is that of Degenhart (*Corpus*, 1968, I–ii, Nos. 173–9).

Cambridge, Fitzwilliam Museum.
Recto: *Saint Matthew.* Bistre heightened in white on greenish prepared paper.
Verso: *Saint Luke.* Bistre and wash on white paper.
Dimensions: 16·3 × 15 cm.

The *recto* is related by Hind (in *Vasari Society*, II, v, 1a and 1b), to the Saint Matthew in the Chapel of Nicholas V. Berenson (*The Drawings of the Florentine Painters*, 1938, iii, p. 16, No.

161a) accepts the St. Luke as by Angelico and the St. Matthew as by Gozzoli. Degenhart (*Corpus*, 1968, I–ii, No. 402) gives both *recto* and *verso* to Gozzoli, and regards them as derivatives from lost studies by Angelico for the Vatican frescoes made in connection with Gozzoli's later fresco cycle at Montefalco. While the *recto* is a characteristic drawing by Gozzoli, the study on the *verso* is rendered with a freedom and delicacy which suggest that we have here to do with a preparatory drawing by Angelico for the fresco of St. Luke. A companion sheet, with figures of St. Mark and St. John the Evangelist, is in the Musée Condé, Chantilly. In this both *recto* and *verso* are by Gozzoli.

Chantilly, Musée Condé.
Recto: *Christ as Judge and two Angels: a kneeling Angel.* Fig. 113
Verso: *Head of a Monk.*
Bistre wash and silverpoint heightened with white on buff prepared paper: 26 × 15·5 cm.

Schottmüller (p. xxxiii) as Angelico. As recognised by Berenson (*The Drawings of the Florentine Painters*, ii, 1938, No. 530, p. 48), a characteristic sheet by Gozzoli. Douglas (p. 199) wrongly regards the *recto* as a study for the Corsini *Last Judgment*. Berenson (op. cit., i, p. 7, and iii, p. 48) connects the angel on the *recto* with the Orvieto *Last Judgment* and regards the *verso* tentatively as a portrait of Angelico. It is argued by Degenhart, with great plausibility, that the *recto* of the sheet is a copy by Gozzoli from Angelico's preparatory drawings for the Orvieto frescoes, not a copy from the fresco (*Corpus*, 1968, I–ii, No. 398). This would explain the appearance of an angel which seems to depend from Angelico's design, but does not recur in the Orvieto fresco.

Dresden, Kupferstichkabinett.
Recto: *Archangel (Saint Michael?) holding Sword and Globe: naked Putto.*
Verso: *Lion and naked Youth.*
Bistre wash on white paper rubbed with red chalk: 24·5 × 14 cm.

Douglas (p. 199) and Schottmüller (p. xxxii) as Angelico. Berenson (op. cit., iii, No. 532, p. 48) as Gozzoli. The case for an attribution to Gozzoli is argued in detail by Degenhart (*Corpus*, I–ii, No. 399).

Florence, Uffizi, Gabinetto dei Disegni (No. 111F).
Seated Boy facing to the left.
Silverpoint and brown ink: 7·4 × 5·5 cm.

Conjecturally ascribed to Fra Angelico by Degenhart (*Corpus*, I–ii, 1968, No. 370). This attribution is not convincing. The sheet is given by Berenson (*The Drawings of the Florentine Painters*, ii, 1938, No. 175A) to Andrea di Giusto or the Master of the Carrand Triptych (Giovanni di Francesco).

London, British Museum (Pp. 1–18).
Horsetamer.
Metalpoint on blue prepared paper heightened in white: 36 × 24·6 cm.

Variously ascribed to Pollajuolo (Waagen), Masaccio (Schmarsow), Granacci (Berenson) and Pesellino (Ragghianti), the sheet is assigned by Popham and Pouncey (*Italian Drawings in the Department of Prints and Drawings in the British Museum: the Fourteenth and Fifteenth Centuries*, i, 1950, No. 152) to the shop of Fra Filippo Lippi. It is reattributed by Degenhart (*Corpus*, 1968, I–ii, No. 373), following A. Schmitt, to Angelico. This ascription is not convincing.

London, British Museum (1895–9–15–437).
King David playing a Psaltery. Fig. 114
Pen and brown ink and purple wash on parchment: 19·7 × 17·9 cm.

Accepted as Angelico by almost all writers on the artist, and regarded by Berenson (op. cit., i, p. 4) as 'the only drawing by Fra Angelico which leaves no ground for doubt'. Popham (*Italian Drawings in the Department of Prints and Drawings in the British Museum: the Fourteenth and Fifteenth Centuries*, i, 1950, p. 2) points out that the drawing is on a piece of 'waste parchment, and is not necessarily a study for an illumination'. The forms in the drawing are closely related to those of illuminations by Angelico in Missal No. 558 at San Marco, and suggest that it is by Angelico, not, as proposed in the first edition of this book, by Zanobi Strozzi. The architecture of the seat would be consistent with a dating ca. 1433. The sheet is accepted by Degenhart (*Corpus*, 1968, I–ii, No. 369) as a work by Fra Angelico of about 1430.

Paris, Louvre (R.F. 430).
Recto: *Christ despatching the Apostles.* Fig. 115
Verso: *Perspective Scheme.*
Pen and wash, heightened in white on pink tinted paper (*recto*), and pen and wash over red chalk (*verso*): 13·5 × 17·9 cm.

An attribution to Fra Angelico proposed in the 1881 catalogue of the His de la Salle collection (No. 47) is rejected by Berenson, who gives the sheet to Domenico di Michelino, but is reaffirmed by Degenhart (*Corpus*, 1968, I–ii, No. 372). While there is no reason to suppose that Angelico was incapable of the very deep perspective construction on the *verso*, it has no close parallel in his completed works. In the first edition of this book (p. 207) it was suggested that the drawing might be

235

connected with the lost frescoes of scenes from the life of Christ in the Chapel of Saint Nicholas in the Vatican. The ascription of the sheet to Angelico or to a member of his shop is very plausible.

Vienna, Albertina (S.R. 20).
Christ on the Cross. Fig. 116
Bistre and red wash: 29 × 19 cm.

Douglas (p. 199) as a study for the fresco of *Christ on the Cross* in the upper corridor at San Marco. Berenson (op. cit., I, p. 4) as 'more probably by some unknown and charming imitator', rightly drawing attention to weaknesses in the folds of the loin-cloth which preclude Angelico's authorship. The sheet is accepted by Degenhart (*Corpus*, I–ii, 1968, No. 371) as a work of Angelico of ca. 1438–46. A late Gothic column on the left of the sheet is explained by Degenhart as an indication of the space in which the *Crucifixion* was to be painted.

Windsor Castle, Royal Library (12812).
Recto: *Head of a Saint.* Silverpoint and bistre heightened in white on buff prepared ground. Fig. 117
Verso: *Studies of Saint Lawrence, a Woman carrying a Child and a standing male Figure.*
Dimensions: 18 × 16 cm.

The studies on the *verso* correspond with the figures of St. Lawrence and the woman carrying a child in the fresco of *Saint Lawrence distributing Alms,* and that of the standing man with a male figure second from right in the fresco of *St. Lawrence before Valerianus.* Berenson (op. cit., ii, p. 17, No. 163 and i, pp. 4–5) accepts both drawings as by Fra Angelico, and regards the *verso* as a preliminary study for the corresponding parts of the two frescoes. Popham (*The Italian Drawings of the XV and XVI Centuries in the Collection of His Majesty the King at Windsor Castle,* 1949, p. 172, No. 10) follows Papini ('Dei disegni di Benozzo Gozzoli', in *L'Arte,* xiii, 1910, p. 290) in giving both *recto* and *verso* to Gozzoli. Venturi (p. 81 n.) tentatively connects the *recto* with the lost frescoes in the Cappella del Sacramento. An attribution to Gozzoli is accepted by Degenhart (*Corpus,* 1968, I–ii, No. 397). The *recto* is markedly superior in quality to the early drawings by Gozzoli executed in the same technique such as the verso of the sheet

at Chantilly. There is a high degree of probability that this is an authentic autograph drawing by Angelico. The figures on the *verso* cannot be regarded as preliminary studies for the two frescoes to which they relate, and were perhaps, as suggested by Degenhart, copied by Gozzoli from separate drawings by Angelico.

WOODCUTS

Meditationes Reverendissimi Patris Domini Johannis de Turre cremata sacrosancte Romane ecclesie cardinalis posite et depicte de ipsius mandato in ecclesie ambitu Sancte Marie de Minerva Rome. First published by Ulrich Han, Rome, 31 December 1466 (or 1467).

The volume contains thirty-one woodcuts of scenes from the Old and New Testaments, supposedly copied (Orlandi, pp. 131–43) from frescoes commissioned by Cardinal Torquemada for the cloister of Santa Maria sopra Minerva, Rome. The frescoes are described about 1467 by Gaspare Veronese (*De Gestis Pauli II,* in *Rerum Italicarum Scriptores,* III–xvi, 1904, p. 36): 'Claustrum sanctissimae Mariae super Minervam pulcherrimis epigrammatibus historiisque egregie exornavit.' The relation of the woodcuts to the lost frescoes is not altogether clear, and it is denied by Kristeller (in *Archivio storico dell'arte,* v, 1892, p. 100) that the former are based upon the latter. Even if a connection be admitted, Orlandi's further argument, that certain of the woodcuts are so closely related in style to the works of Fra Angelico as to demonstrate his responsibility for the cloister frescoes, with which he would have been concerned after 1453, is fundamentally unsound, since none of the woodcuts has any demonstrable affinity to, e.g., the compositional practices employed on the Annunziata silver chest. The woodcuts in question are:

c. 7b	*Adoration of the Magi*
c. 8b	*Presentation in the Temple*
c. 9a	*Flight into Egypt*
c. 10b	*Christ disputing with the Doctors*
c. 11b	*Baptism of Christ*
c. 14b	*Transfiguration.*

LOST WORKS BY FRA ANGELICO

Brescia, Sant'Alessandro. *The Annunciation.*

An altarpiece of the *Annunciation* supposedly painted by Angelico for Sant'Alessandro at Brescia in 1432 is the subject of the following payment transcribed by Marchese (i, pp. 349–50): 'Io. 1432. Omissis aliis. Item la tavola della Nunziata fatta in Fiorenza, la quale depinse Fra Giovanni, ducatti nove. Item ducatti ij sono per oro per detta tavola, quali ebbe Fra Giovanni—Giovanni de' Predicatori da Fiesole—per dipingere la tavola.' The history of this commission is beset with doubt. On 26 April 1432 the church of Sant'Alessandro was ceded to Padre Francesco Landino, of the Servite community in Florence, who established it as a Servite house. The commission to Fra Angelico must date from this time. The present painting of the *Annunciation*, however, on the first altar on the right of the church, is by Jacopo Bellini, and subsequent payments in 1443 and January and February 1444 refer to this painting, not to the work commissioned from Angelico. They include sums for the cost of transporting the picture from Vicenza ('Spesa fatta per me et frate Gioseffe, col Prior di S. Salvatore quando andassino a Vicenza per la Nunziata'), and for the painting of the predella, which is not by Jacopo Bellini. For these payments see particularly A. Morassi, *Catalogo delle opere d'arte e di archeologia, Brescia*, Rome, n.d., pp. 58–60. The balance of probability is that Angelico's painting was not delivered, and that the substitute altarpiece by Jacopo Bellini was commissioned at a rather late date.

Florence, Badia. *Saint Benedict.*

A lunette of St. Benedict in the cloister of the Badia is described by Vasari (ii, pp. 513–14: 'Nella Badia della medesima città fece, sopra una porta del chiostro, un San Benedetto che accenna silenzio'). Milanesi (in Vasari, ii, p. 514 n.) and Paatz (i, pp. 287, 312) identify this fresco with an almost effaced half-length figure of St. Benedict above a doorway in the cloister, since removed from the wall. By the Master of the Chiostro degli Aranci (Giovanni di Gonsalvo?).

Florence, San Barnaba. *The Crucifixion.*

A small fresco of *Christ on the Cross* is noted by Richa (vii, 1758, pp. 65–6) and Paatz (i, p. 325). This had disappeared before 1819.

Florence, Certosa. Three altarpieces.

Three altarpieces painted by Angelico for the Certosa are described by Vasari (ii, pp. 506–7): 'Una delle prime opere che facesse questo buon Padre di pittura, fu nella Certosa di Firenze una tavola che fu posto nella maggior cappella del cardinale degli Acciajuoli, dentro la quale è una Nostra Donna col Figliuolo in braccio e con alcuni Angeli a' piedi, che suonano e cantano, molto belli; e dagli lati sono San Lorenzo, Santa Maria Maddalena, San Zanobi e San Benedetto; e nella predella sono, di figure piccole, storiette di que' Santi fatte con infinita diligenza. Nella crociera di detta cappella sono due altre tavole di mano del medesimo; in una è la Incoronazione di Nostra Donna, e nell'altra una Madonna con due Santi, fatta con azzurri oltramarini bellissimi.' Collobi-Ragghianti ('Domenico di Michelino', in *La Critica d'Arte*, xxxi, 1950, p. 369) identifies two damaged panels with *Saints Francis and Jerome* and *John the Baptist and Onophrius* in the Certosa (panel: 142 × 70 cm. each) as parts of one of Angelico's lost altarpieces. These panels do not conform to the descriptions given by Vasari, and are not by Angelico. It has been shown by J. van Waadenoijen (in *Burlington Magazine*, cxvi, 1974, pp. 85, 89) that the altarpiece in the Acciajuoli chapel ascribed by Vasari to Angelico is identical with a triptych by the Maestro del Bambino Vispo, of which the lateral panels, with *Saints Lawrence and Mary Magdalen* and *Saints Zenobius and Benedict*, are respectively in Berlin and Stockholm.

Florence, Santa Maria Novella. Frescoes.

Frescoes by Angelico in Santa Maria Novella are noted in the *Libro di Antonio Billi* (p. 21: 'In Santa Maria Nouella tralle tre porte del tramezo, cioè del ponte, quando lui era giuanetto. Et in decta chiesa, doue loro tengono le reliquie, fecie più ornamenti'). This description is elaborated by Vasari (ii, p. 507: 'Dipinse dopo, nel tramezzo di Santa Maria Novella, in fresco, accanto alla porta dirimpetto al coro, San Domenico, Santa Caterina da Siena, e San Pietro martire, ed alcune storiette piccole nella cappella della Incoronazione di Nostra Donna nel detto tramezzo'). This and other works in Santa Maria Novella are discussed by Paatz (iii, p. 836). The 'storiette piccole' seem to have formed the predella of a Daddesque altarpiece of the *Coronation of the Virgin* now in the Accademia (No. 3449).

Florence, Santa Maria Novella. Organ shutters.

Two organ shutters with figures of the Annunciation are noted in Vasari's life of Angelico (ii, p. 507: 'In tela fece, nei portelli che chiudevano l'organo vecchio, una Nunziata, che è oggi in convento di rimpetto alla porta del dormentorio da basso, fra l'un chiostro e l'altro').

Florence, Santa Maria Novella. Paschal Candle.

A paschal candle (or casing) painted by Angelico is noted in Santa Maria Novella by Vasari (ii, p. 513: 'e in Santa Maria Novella, oltre alle cose dette, dipinse di storie piccole il cereo pasquale').

Florence, Santa Maria Nuova. Painted Cross.

A document published by W. Cohn ('Nuovi documenti per il beato Angelico', in *Memorie Domenicane*, 1956, pp. 218–20) reads: 'A frate Giovanni de' frati di san Domenicho da fiesole per dipintura d'una croce fine del giugnio 1423 lire dieci.' There is no other record of this work.

Florence, Santo Stefano. Altarpiece.

A document published by W. Cohn ('Nuovi documenti per il beato Angelico', in *Memorie Domenicane*, 1956, pp. 218–20) records a payment on February 15, 1418, of seven florins to Guido di Pietro as the balance of a sum due for a painting executed for the Gherardini Chapel in Santo Stefano. The payment is related by Orlandi to a *Madonna* now in the Museo di San Marco (Fig. 60), which is certainly of later date. There is evidence that in 1412 the painter Ambrogio di Baldese, who had been employed earlier in the Bartolucci (1389) and Luparini Chapels (1409) in Santo Stefano, was engaged on work in the Gherardini Chapel, and it is possible that Angelico was trained prior to 1418 in Ambrogio di Baldese's workshop.

Florence, Spedale degli Innocenti. *Madonna and Child.*

A small *Virgin and Child* owned by the Spedalingo of the Spedale degli Innocenti is listed by Vasari (ii, p. 512: 'Il molto reverendo Don Vincenzio Borghini, spedalingo degl'Innocenti, ha di mano di questo Padre una Nostra Donna piccola, bellissima').

Florence, Casa Gondi. Three paintings.

Three paintings by Angelico are noted by Vasari (ii, p. 512: 'e Bartolommeo Gondi, amatore di queste arti al pari di qualsivoglia altro gentiluomo, ha un quadro grande, un piccolo, ed una croce di mano del medesimo'). A. Venturi (in *L'Arte*, xii, 1909, p. 319) suggests that the Thyssen *Madonna* may have been one of these three paintings.

Florence, Palazzo Medici. Six paintings.

The following paintings by Angelico appear in the 1492 inventory of Lorenzo de' Medici (Müntz, *Les Collections des Médicis au XVe Siècle*, 1888, pp. 60, 64, 85, 86):
(i) 'Uno tondo grande cholle chornicie atorno messe d'oro dipintovi la nostra Donna e el nostro Signore e e' Magi che vanno a offerire, di mano di fra Giovanni, f. 100.' This panel is probably identical with the tondo of *The Adoration of the Magi* in the National Gallery of Art at Washington (see p. 219).
(ii) 'Uno tondo chon una Nostra Donna piccholo, di mano di fra Giovanni, f. 5.'
(iii) 'Una tavoletta dipintovi il Nostro Signore morto chon molti santi che lo portano al sepolchro, di mano di fra Giovanni, f. 15.'
(iv) 'Uno colmo per uso di tavoletta d'altare lungho bra. 2 alto bra. 1½ corniciato e messo d'oro dipintovi dentro la storia de' magi di mano di fra Giovanni, f. 60.'
(v) 'Una tavoletta di legname di bra. 4 in circha, di mano di fra Giovanni, dipintovi piu storie di santi padri, f. 25.' This panel is identified by Longhi (pp. 173–4) with the well-known panel of the *Thebaid* in the Uffizi. While the entry in the Medici inventory perhaps refers to a picture of this subject, probability favours the view (advanced by Procacci, 'Gherardo Starnina', in *Rivista d'arte*, xviii, 1936, p. 79, and reaffirmed by Salmi, 1950, pp. 78–9) that the Uffizi painting is by Starnina.
(vi) 'Una tavoletta quadra dipintovi . . . uno Christo in croce con 9 figure d'attorno, di mano di fra Giovanni, fior 12.' This is possibly identical with a panel in the Metropolitan Museum of Art, New York (q.v.).

Rome, Santa Maria sopra Minerva. Two altarpieces.

Two paintings by Angelico in Santa Maria sopra Minerva are listed by Vasari (ii, p. 516: 'Nella Minerva fece la tavola dell'altar maggiore, ed una Nunziata, che ora è accanto alla capella grande appoggiata a un muro').

Vatican, Cappella di San Niccolò. Frescoes.

The frescoes executed by Fra Angelico in the Cappella di San Niccolò or Cappella del Sacramento in the Vatican are described by Vasari (ii, pp. 516–17): 'Fece anco, per il detto papa (Niccolò V), la cappella del Sagramento in palazzo, che fu poi rovinata da Paulo III per dirizzarvi le scale: nella quale opera, che era eccellente, in quella maniera sua aveva lavorato in fresco alcune storie della vita di Gesù Cristo, e fattovi molti retratti di naturale di persone segnalate di que' tempi; i quali per avventura sarebbono oggi perduti, se il Giovio non avesse fattone ricavar questi per il suo museo: papa Niccola V; Federigo imperatore, che in quel tempo venne in Italia; Frate Antonino, che fu poi arcivescovo di Firenze; il Biondo da Furlì, e Ferrante di Aragona.'
A further reference to the frescoes occurs in the *Codice Magliabechiano* (p. 127): 'Et a riscontro di detta cappella (Sistina) v'era una cappelletta; che si diceua la cappella di papa Nichola, ch'era tutta dipinta di mano di fra Giouannj Fiorentino, frate dell'ordine di San Marcho di Firenze, ch'era veramente un paradiso, con tanta gratia et honesta erano dipinte dette fiure. Come anchora qualche parte, che venne restata, si può uedere, che ne tempi di papa Pagolo s'è rouinata la maggiore parte per fare quella sala grande che è innanzi alla chappella di Michele Agnolo.'

There is no documentary evidence for the date of the frescoes. The now demolished Cappella di San Niccolò (which lay on the opposite side of the Scala Regia to the Sistine Chapel) appears to have been founded by Nicholas III, and was rebuilt and redecorated by Eugenius IV in or after 1433–4. Since Angelico, as indicated by a document of 9 May 1447, was working in Saint Peter's seven days after the election of Pope Nicholas V, the commission for the frescoes in the Cappella di San Niccolò may (as assumed by Pastor, *Geschichte der Päpste*, i, 1886, p. 270, and Beissel, p. 89) have been due to Eugenius IV. It is, however, argued by Egger ('Capella Sancti Nicolai (Cappella del SS. Sacramento)' in Ehrle and Egger, *Der Vatikanische Palast in seiner Entwicklung bis zur Mitte des XV. Jahrhunderts*, 1935, pp. 133–5) that the presence in the frescoes of a portrait of the Emperor Frederick III presupposes a dating after the Emperor's visit to Rome of 9–24 March 1452. The portrait of Ferrante of Aragon was perhaps included at the instance of Calixtus III (elected 8 April 1455), and has been cited as an argument in favour of the view that the frescoes were completed by assistants after the death of Fra Angelico on 18 March of that year. Though a dating for these frescoes between 1452 and 1455 is widely accepted, the arguments with which it is supported are in the main iconographical. If Angelico was in fact summoned to Rome in the second half of 1445 by Eugenius IV, the project in which he is most likely to have been involved would have been the decoration of the Cappella di San Niccolò, with which the Pope was directly concerned. There is no documentary evidence of Angelico's activity in the Vatican in the years immediately before his death. It is suggested by Egger (loc. cit.) that traces of the frescoes may survive on the former north wall of the chapel.

A drawing in the Louvre (His de la Salle No. 47), given by Berenson (*The Drawings of the Florentine Painters*, ii, 1938, p. 245, No. 1752) to Domenico di Michelino and containing on the *recto* a study for a composition of *Christ despatching the Apostles*, is perhaps connected with these frescoes.

INDEX OF PAINTINGS AND DRAWINGS
BY OR ASCRIBED TO FRA ANGELICO

WITHDRAWN